DA VINCI'S LAST COMMISSION

Da Vinci's Last Commission

The Most Sensational Detective Story in the History of Art

FIONA MCLAREN

MAINSTREAM
PUBLISHING

EDINBURGH AND LONDON

First published in Great Britain in 2012 by
MAINSTREAM PUBLISHING COMPANY
(EDINBURGH) LTD
7 Albany Street
Edinburgh EH1 3UG

ISBN 9781780571133 (Hardback edition)
ISBN 9781780575230 (Trade paperback edition)

A catalogue record for this book is available
from the British Library

Printed in Great Britain by
Clays Ltd, St Ives plc

1 3 5 7 9 10 8 6 4 2

This book is dedicated to all those who have had the courage of their convictions in a shared pursuit of truth.

'Truth Against the World'

Acknowledgements

The early years of the research and writing of this book was a lonely affair. My only companion on that first section was my mother. Then into the frame stepped Judith Welsh. She offered me encouragement and sent me on the way to the next section. Again a lonely affair until lovely Jenny Brown, my agent, entered stage left. Jenny shone light onto it and helped me shape this book into what it is now. Thank you Jenny; you walked with me, over rough road, through dark forest until the book was borne into the light and into the care of Bill Campbell of Mainstream Publishing. A great publisher and I am eternally grateful to him and his team at Mainstream. Their enthusiasm and energy for this project was compelling.

My thanks too must go to Judith Sharpe, a friend of 30 years standing, who gave me optimism when I sorely needed it. Thanks too to Paul Greenwood of the Ancient Yew Group who gave me confidence when I was shadowed with self-doubt, thank you, Paul.

Then, once more, I must thank Judith Welsh. Bizarrely she was there in the beginning and ultimately was there to welcome me at the end. It was meant to be Judith. What a happy encounter that has been.

Then there is the power of the universal consciousness which gifts us with intuition; where would I have been without that!

Finally my gratitude goes to my mother. She and I are caught in the net of a shared destiny. Without her this book would not have been written.

Until next time then . . .

There is in Italy a power which we seldom mention in this House, but without considering and understanding which we shall never rightly comprehend the position of Italy. I mean the secret societies. The secret societies do not care for constitutional government . . .

It is useless to deny . . . a great part of Europe – the whole of Italy and France, and a great portion of Germany, to say nothing of other countries – are covered with a network of these secret societies, just as the superficies of the Earth is now being covered with railroads. And what are their objects? They do not attempt to conceal them. They do not want constitutional government. They do not want ameliorated institutions; they do not want provincial councils nor the recording of votes; they want . . . an end to ecclesiastical establishments . . .

Benjamin Disraeli in the House of Commons, 14 July 1856,
Hansard

So God created man in his own image; in the image of God he created him; male and female he created them.

Genesis 1:27

Contents

Author's Note

I am well aware that, because I am not a scholar, some presumptuous people will think that they can find fault with me and accuse me of ignorance. Bunch of ignoramuses themselves!

Leonardo da Vinci, 'Codex Atlanticus', 119 v-a

Questions have plagued my mind for the last ten years as to the truths in this story which I am about to put before you. In the broad light of day and in the twilight hours I have asked and sought the truth. Seek and you shall find . . . ask the right question and wait for the right answer; I believe that to be true.

Some will level against me the criticism that I am not an academic. That is true and for me it is one of my greatest strengths, for if I were this book would never have been written. In my view, experts tend to have been subjected to a conditioning in thought and are therefore restricted to the field of that limited expertise. To deviate from the mode of thinking of their peers exposes them to the risk of vilification. Consequently, it takes a brave academic to step above the parapet and challenge the perceived dogma of his colleagues. To that end, I believe I have been privileged to see beyond that limited focus and feel that my strength is that I have a peripheral vision which gifts me with an overview of a very complex field. I admit I take leaps of imagination, but that is what colours this life of ours and takes it from the monochrome to the full spectrum of what it is to see.

It is a vast arena that I invite you to participate in. You see, we need to shake the truth out of what lies at our feet. All work is academic to a certain degree and all inevitably is full of conjecture, some rhetoric and hypothesis. However, what I would wish for is an evolution in thought, a renaissance, to use a well-coined word, to work together to

season our views and ultimately get as close as we can to the truth. Purposefully I have not followed the waymarked routes of those of an academic bent, I am following my own path: that of an independent thinker.

The painting and works of art that form the skeleton of this book have been used as symbols to communicate to us. Each symbol being a universal one, intended to sign to us in a universal language of revelation. It is by taking the signs/symbols together that we can understand what is being said. Inevitably there is more than I can see and your input once you have read this book will be invaluable. Please do join me in this quest: a quest that has taken me far further than I would ever have believed, and for which I am immensely grateful.

The search doesn't finish here, nothing in life which is worth looking for ever does, but it has set me on a road towards a vision which I believe is the goal of a life's journey. A journey of remembering . . .

In all this time, I have asked for guidance, read copiously, tried to go back to other times and used my imagination to get me there. This is a global quest and has the potential to bring about a great good; I hope you will be part of it.

Am I convinced of what I have discovered? How can I be? None of us can be sure of anything. However, I believe we must never cease to question, we must never close our eyes or imagination in our pursuit of knowledge. I will forever remain true to what this story has awoken in me. It has taken me courage to bring it to you. I would be a fool if I weren't aware of the contempt and ridicule this book will attract, and of course know that it wouldn't if it didn't contain some truth to it. Speculation – yes, that has been my luxury, to take that leap of faith, and undoubtedly at other times I certainly have felt that I have been guided by intuition. That shouldn't invite derision; intuition and imagination are invaluable tools. Just ask Einstein!

I have an exciting, challenging story to tell you, so please bear with me as I attempt to communicate it to you to the best of my ability. I would not be doing so if I didn't find it compelling, for it would be so much easier just to turn away, evade the responsibility I feel and live a quiet life.

So please take this in the spirit in which it is intended. All I would ask is that it prompts thought and a compulsion to question. Throughout our lives people tend to tell us what we should believe,

not to question. Now I am asking of you the very opposite. Hear me out, then feel free to question as you see fit and follow that questioning. That is freedom, that is a renaissance, which surely should be our shared human goal. In my view, not to question is anathema, and in my opinion a conditioning we have been subjected to for far too long.

Preface

I have her before me now: a Renaissance portrait in oil on wood of a beautiful young woman holding her son on her knee. Beside them stands a boy, with a lamb to his right.

At first glance, it appears to be a generic depiction of the Madonna and Christ, similar to thousands that can be found in galleries all over Europe, but in fact it is far more than this. The title of 'Madonna and Child, with John the Baptist', which was the name my father always used, was to be her mask. Under the mask lies a far more intriguing picture, with an extraordinary story that has waited a long time to be told. Let's go there now.

My father, a general practitioner, has been dead for over 30 years and it has taken me that long to solve the mystery of the painting of the Madonna and her child. In that time, she has journeyed with me. We have travelled from England to Scotland, across the Channel to France and then north again to Scotland.

This exquisite painting was a present from my mother to me on my fortieth birthday, together with all else of which I write, and the time has now come for me to tell what I have discovered of my gift. Five hundred years separate me from the artist's creation of this young woman, which is something I find almost unimaginable; the thought that she was in existence when Mary, Queen of Scots was born, had heard many bards before Shakespeare put pen to paper, before Vivaldi scribed his scores, is electrifying.

For all those centuries, like some wonderful ancient yew tree, she has observed and been viewed, borne silent witness to events throughout our history and watched the generations ebb and flow beneath her gaze. Laughter, tears, terror, drama – she has endured it all, and now, a little tired, she watches me, measuring our precious

time together. Her home is a rather modest one, nestling in the Scottish hills, her guardian a woman.

It has taken 500 years, but now, finally, the time to tell her story has come. Be warned, though: what I am about to tell you takes us back in time some 2,000 years and dramatically undermines the foundations of perceived thought and religious doctrine. More than this, it is the most exquisite story I have ever heard, one that I hope is set to bind us in a brotherhood of man and nations; maybe even direct us on a path towards a Peace on Earth. What a realisation of a dream that would be! Peace on Earth – why not follow that waymark? What better direction could there be than towards balance and harmony for a fractured planet?

The Story of a Painting

The Beginning

From what I can remember, I must have been about eight years old when she arrived. My father had been out on his rounds, I was doing a jigsaw on the sitting-room floor and my mother was sewing. Then my father came in and I can vividly remember he was incredibly happy and holding something large in his hands. I can see him now, pale-blue eyes sparkling with excitement, his dimples that had turned to lines scoring down to his lovely big smiling mouth. My mother sensed something exciting and got up to greet him. I watched from the floor, intrigued.

With great care he placed the painting against the back of the William and Mary black-velvet sofa and stood back, his arm around my mother's shoulders. All I could see were their backs. Moments later, he turned to me. 'Come and look, Fifi! She's beautiful!'

I can remember even now the awe I experienced when I first saw her. I was spellbound, for even to my young eyes she was, well yes, beautiful, mesmerising and strangely powerful. My father's hand clasped mine. I can feel his strength still. There was a smell of him: of surgical spirit, and of the tobacco cigars that were to play their part in his death. I heard the sounds of the open fire spitting out dying embers. I can even recall feeling a little nervous, sensing that this was a significant happening and one that I would remember.

This mysterious picture that held us spellbound was a gift from a private patient of my father's, and most importantly she didn't come alone. My father went out and fetched a big cardboard box from the car. He lifted the lid and brought out first engravings, including a map, then a leather folder, then a quaich. He placed each item on the carpet. As we went through it, we didn't know what was going to turn up

next. It seemed incongruous that the box holding these treasures was made of simple cardboard, and my father explained that the engravings, at least, had been kept in a print holder in the drawing room of their previous home.

Their owner, my father's patient, had specifically wanted Dad to have them. That may sound strange now, but life was very different then; it was quite common for patients to give my father a vase, a painting, some much-loved thing they hoped would demonstrate how deeply they had appreciated his care. Looking back, it amazes me how hard my father used to work. Doctors complain now, but my father had only one half-day off, a Tuesday afternoon, each fortnight, and only every other weekend. Given that, I suppose it was no surprise that patients wanted to thank him. I'm pleased they did, because it shows what a good man he was.

My Father

One of the many things I admired about my father was that he had interrupted his medical studies to go to war. He needn't have, for he could easily have behaved as so many other medical students had and sought exemption, but he chose to serve his country. When the war ended he was 26 years old. By that time, his peer group had already qualified and he had to begin again. It took him seven long years. He failed twice, persevered and finally qualified at the age of thirty-four, by which time he had a young family of three. Things were difficult. He never spoke of the war to me, only that he had been at Dunkirk. But my mother told me what he had endured there, and to this day it sends shivers down my spine.

They had marched for days, and Dad had witnessed unimaginable horrors – a teenager cradling some of his brains in his helmet, whimpering for help. The last look of a friend as his head was shattered by gunfire. A beach crammed with worn-out, terrified men. A sky flecked with German bombers, the gunmetal grey camouflaged by a matching leaden sky. My father, as an officer, let his men go first to the waiting boats. He shook hands, bade them farewell and watched them fade into the mist like disappearing spectres, then buckled into the sand, totally spent. Fishing smacks, trawlers and little boats punctuated the Channel, piloted by brave men passing sinking vessels to evacuate our soldiers. Some were taken to waiting destroyers. Eventually, my father boarded one of the little boats, in fact Mum insists it was the last

boat out of there, and fell into an exhausted sleep. He woke to his first sight of England: the white cliffs of Dover. He looked out and saw a woman pegging out her washing. The wind was catching the sheets in a dance. He was home. Just the other day my mother told me that in recognition of his bravery and courage he was mentioned in dispatches. I feel very proud of him. A lifetime spans the void between us now, but yet every once in a while we touch and I remember him.

I can't even imagine what it must have been like for my mother, suspended in time waiting, hearing news of boats coming home, but yet no news of him. Then a telephone bell. It was him. Believing fate might not be generous, and loving each other, they married the following February.

Terras Templaris de Swainstoun

After the war, my parents lived in Swanston, a picturesque little hamlet in the Pentland Hills, just a few miles outside Edinburgh. For me, the name conjures up memories of skylarks, curlew song, the free-wheeling flight of the buzzard soaring the summits, the pine-scented sap of the woods, and the babbling whisper of the burn. By the time my parents settled in Swanston, they already had two sons, Campbell and Richard, and my father was a medical student once more. It was a frugal life nourished by a wealth of experience and hardship. Washing was done in the little burn that ran down between the cottages; there was no electricity, no water, no lavatory. Yet it was beautiful, even idyllic, and for my mother one of the happiest times of her life. Recently she said to me that she felt privileged to have been part of it all, of having experienced a way of life that has now passed and can never be recaptured.

My father had resumed his studies, at Edinburgh University, now with a family to support. To help out, my mother made hats and lampshades for a shop in Rose Street in Edinburgh and my father, when he wasn't studying, would rogue potatoes for a local farmer. It was quite a specialised job spotting those that were diseased. My mother told me that he used to sleepwalk in those days, wandering around the cottage saying that he was looking for the ulnar nerve. They were there in the harsh winter of 1946, when the village was cut off for eight weeks by huge drifts of snow. So stricken was my mother that one day my father went outside and dug down to the grass in an attempt to show her that the greenness of nature and life had not completely deserted them.

At first, they rented a place called Rose Cottage, but when the owners came back they moved to a house called the Roaring Shepherd's Cottage. Many years before, it had been lived in by an infamous shepherd called John Todd, who gained his renown by his unbridled shouting at folk. Apparently, he and Robert Louis Stevenson, who lived close by in Swanston Cottage, became great friends. I can remember tales of Todd's ghost haunting the cottage and of how my parents would hear his return home, his heavy boots clomping on the wooden flooring of the honeysuckled, trellised porch as he prepared to come in. They used to wait until they heard him and then open the door. Hoped to catch a glimpse of him, but alas nobody was ever there.

Robert Louis Stevenson first came to the area in 1867, when his parents rented Swanston Cottage, dividing their time between the country and Heriot Row in Edinburgh. As L. MacLean Watt writes in his *Hills of Home*, introducing Stevenson's 'Pentland Essays':

> [T]he influences and associations of green hill and grey rock, of misty peak and quiet and still places, took a large part in the moulding of his thought and of the form of its expression. Very early the love of nature and of lonely places had possessed him . . . The voice of Spring especially would call to his willing heart –
> 'Come with me over the hill so free,
> Where the winds are blowing,
> And the streams are flowing
> On to the shining sea.'

One day, a Mrs Jack, who owned the big house, the farmhouse, which has now been converted into flats, asked if my parents wanted to move in there. She told them they could have a clutch of rooms but would also have the burden of keeping the boiler stoked. It was in that idyllic place that I was conceived, upstairs in a bedroom with a beautiful bay window that looked out over the Pentland Hills.

The farmhouse, indeed the whole area, is rich in historical associations. My mother often talks of the 'monk's bathroom', as it was always called, which housed a stone bath, but what she didn't know, until I discovered it, is that the farmhouse had at one time been owned by the Knights Templar and had been lived in by Culdee monks. Record has it that in the Middle Ages it had been known as the Grange

of Whitekirk Abbey and formed part of the Temple lands of the Knights of St John. In a charter of James VI recording the possessions of the Knights Templar, a reference to it is made: 'terras templaris de Swainstoun'. As you will discover, this is just another one of the extraordinary coincidences that were to mark my amazing quest, for, as you will see later, this link to my birthplace and the Knights Templar monks is quite astonishing. To think back to finding my first penny bun mushroom in the T woods above Swanston makes me smile, for at the time I never appreciated that the letter T stood for Templar. One can only wryly reflect that there is no such thing as coincidence!

Exile in England

In 1952, at the age of 34, my father qualified as a doctor and looked for jobs in Scotland. His two elder sons were at his old school, George Watson's College. Sadly, he couldn't find a position, and the family were forced to move south to England. A doctor had died of polio, and Dad was to take over his practice. Tragically, my father and mother were never to return to Scotland together, save for holidays, and he was to die in England.

I have fine memories of the house we moved to. It was a family home where my mother cooked delicious meals and we played in a wonderful garden. Andy, the youngest of my three brothers (who had been born four years before me at Swanston), and I would stage plays in the garden shed, and I had a den in the small dog kennel by the woodpile. I wrote my first book there, a short narrative about our neighbour Mr Bragg, beautifully illustrated by the young writer's hand! A railway line ran along the bottom of the garden, and I watched steam trains charge northwards on their journey to Scotland. Thinking of that house brings back sweet memories of growing up, of searching for treasure, of hide and seek, of feeding hens, of childhood, of playing with my three brothers, being teased by them too.

When I was about eight, Andy provided me with something that I was to treasure throughout my life. It must have been a Sunday, as we always had breakfast in the dining room on Sundays (it served as the patients' waiting room through the rest of the week). There would be bacon, eggs, mushrooms and lamb's liver. I was standing in the bay window that looked out onto the rhododendron bushes and the gravel driveway. Andy came in with a school friend, a rather pale, frail-looking boy. He had something he wanted to show me. It was a very old silver

coin. He asked me if I wanted to buy it. From what I can remember, his father had excavated it on a dig somewhere.

I can remember feeling quite grown up about it; I didn't collect coins, but for some unknown reason I did want this one. It was an important transaction which cost me ten shillings, fifty pence in today's money, which was a whole month's pocket money. That boy never came to the house again and was not one of my brother's gang of friends. I now wonder why I said yes, for though I can remember the episode distinctly I can't remember what compelled me. It just seemed, I suppose, the natural thing to do, as though it was meant in some way, that it was something special and not to be missed.

That coin has been my talisman for nearly 50 years and has been authenticated as having been minted in 390 BC. One side bears the image of Apollo, and a simple rose decorates the other. Apollo, the sun god, is a representation of the Divine Masculine principle, the rose a symbol of the Divine Feminine: two sides of the same coin. When I researched the coin, I discovered that it is a silver didrachm of Rhodes. According to *Greek Coins*, by Ian Carradice, in the Middle Ages people said that Apollo was Christ and the rose was the Rose of Sharon; for them the sun's rays adorning Apollo's head represented the crown of thorns suffered by Christ, then, according to the author, they somehow leapt into being associated with Judas Iscariot and his 30 pieces of silver. The association of the rose links us to the Song of Solomon from the Old Testament, which forms a transcending link to Christ: 'I am the rose of Sharon, and the lily of the valleys.' In my opinion there are multiple metaphors in the link between one and the other, the prime one being the feminine. However, in the Middle Ages I would suspect, for that is all I can do, that the rose had many interpretations – all of which undeniably represent the feminine.

In retrospect, one could even imagine that the coin, given its associations with Apollo, the Divine Feminine and the Crucifixion story, was some kind of sign to me as to my destiny or purpose in life. It was certainly a forerunner of greater relics that would come under my care in the future.

It has little monetary value, but that coin is priceless to me. I have never been parted from it, save for a period of a few months. I gave it to a niece when I was in France and told her to keep it safe. I am embarrassed to admit that I had to ask for it back before long; I couldn't bear to be without it.

The Gift

The coin was the first mysterious artefact that came into my possession. The second, which I was to inherit later in life, was the painting. I have vivid memories of my mother and father poring over it and leafing through various reference books to try to discover who could have painted it. Why did the painting also show a fleur-de-lys and a frond of palm? There were also labels stuck to the back of the painting – what were they? My parents' research bore no fruit. They hung her evocative image in their bedroom and so she passed out of my immediate world. From time to time, though, my mother would suggest to my father that they bring out the box of engravings, and they would study and admire these one by one, then put them back under their bed for another time, another wet afternoon.

I don't know much about the man who gave these precious things to my parents, except that, according to my mother, he was a Master Freemason and a widower. I suppose one can assume that he and my father spent a great deal of time together, perhaps talked of shared experiences, lost dreams, who knows? Could that have been because he was terminally ill and lonely? I do not know. I doubt that he, as a Freemason, would have talked to my father about the fraternity – he was sworn to secrecy – but perhaps he felt that his friend the doctor would understand the significance of his bequest. Certainly I would imagine he would have attempted to embroil my father in the brotherhood.

According to my brothers, all of whom are doctors, they were all repeatedly targeted at medical school, and even to this day, to join up. From what I can gather from Masons and men in various disciplines there is quite a committed recruiting force. No surprise there really, because they obviously want men in pivotal roles in society. To be, if you will, the movers and shakers in this world. Certainly, from what I can glean, they have successfully infiltrated every stratum of our society, including the art world. My mother does remember that my father was often targeted but had neatly side-stepped the whole issue. So too my brothers. I don't know, in a way it appeals to me and I think in his place I maybe would have said yes. But then, of course, I wouldn't be free to do what I am doing now, so being a woman does have its merits – this being one of many!

I wonder now, in the light of what I have found out, if it wasn't his patient's dying wish that one day the true story behind his bequest

would be assembled – that my father would reveal what his patient, as a Freemason, was sworn never to tell. For truth to win out. That would, I believe, have been my father's wish as well. Truth, he was always in the pursuit of truth, and I can remember him saying me 'to your own self be true', and it seems a worthwhile edict to live by.

The Dying of a Light

We moved house in the late 1960s when our old home was found to be riddled with dry rot and in need of demolition. I can remember standing at the end of the street that faced it and watching it being pulled down. It was a disembowelment of all that had been my life. I remember the pale-blue paint of my room, the electric fire, the garden where the tortoise, the dog, the numerous birds had been buried. I revisit that house in my dreams, walk the abandoned rooms, conjure up meetings with my father there.

The house we moved to proved to be a tragic place. A new chapter was opening and it was to be my father's last. My three brothers, all older than me, completed their medical studies and one by one they emigrated until only I remained. My poor father and mother watched them leave, knowing that they would probably never return.

In the early 1970s, I left school and moved away from home to go into nursing. The house was not a home any longer; the family had flown, all of us taking our turn on the roads that lay ahead. Some, in retrospect, were the wrong turns. The sons and daughter who had been the spokes of the wheel that carried the family forward turned in different ways. Things broke. The Madonna watched from her new position on the landing. She even got sprayed by white paint when I emulsioned the walls, spots of which still remain. The house that had been full of noise and activity had been rendered an empty shell.

The connection with the haunting presence within the painting was once more severed. Years passed. I qualified and lived my life, though I returned home as regularly as I could. The light in my father's eyes faded and they were encircled by a cloud that was taking him from us. Hands that had been hard padded out to softness, bones that had been strong were weakened. The years of smoking were taking their toll. He was diagnosed with lung cancer and brain secondaries. My dear father gradually misted from my view. He died in 1979, on 31 March at 3 a.m.; it was a bad death, both for my father and for my mother.

That was 33 years ago now, and in the intervening time my mother and I have become the greatest of friends. She was by my side when I began my quest to find the true identity of the Madonna and uncover the story she has been waiting to tell, and she has been a great support throughout.

New Beginnings

The fuse to this quest was ignited some 11 years ago. I had been living in France, where my mother had joined me, and when we returned to the UK we moved into a rented farmhouse in Scotland. Money was a bit tight. I had always suspected that my beautiful painting must be extremely valuable. Indeed, whenever I had moved I had always instructed the removal men to take extra special care of her. So I invited Harry Robertson, who was then the director of Sotheby's in Scotland, to come out and make an evaluation of the Madonna.

When I showed it to him, he was staggered, speechless, save for a sigh of exclamation. I remember he had an associate with him (unfortunately, I can't remember her name) who immediately commented on the fleur-de-lys in the baby's halo. When Harry had finished a preliminary inspection of the painting, he asked whether I would allow him to take it down to London for a closer examination by their Old Master experts. In his view it was an important work and a beautiful one, certainly something very special and well worth investigating. As to age, in his opinion it was early sixteenth century; as to attribution, a sigh, a shake of the head. They would need to investigate.

Obviously I was pleased by his response and enthusiasm, but as things turned out I later contacted him and declined his offer. My reasons were manifold; I didn't relish the ordeal of transport to London and, I don't know exactly, I just had a sense that I should hold off, at least for a time.

I'm glad I did, because if I had let her go maybe the selling machine would have taken over and she would now be in the custody of somebody else. I like to think that it was my instinct that protected me from acting, for if I had the discoveries I have made would never have seen the light of the day – and that sends a shudder through me.

After that initial visit, the picture receded to the back of my mind. I concentrated on building up a new business venture: a specialist shop called Pinocchio, and I would not see Harry again for some six years. My

new business was located in a detached building in Comrie, a pretty little village that lies on the Highland Boundary Fault in Central Scotland. I had owned the building since the early '80s, when I had run a small restaurant there. It was all that time ago that I had become involved in a successful campaign to halt a commercial afforestation plan that had been set to blight one of my favourite glens. That proved to be a fork in my life's journey, taking me into the world of the media and investigative writing. It was at that point that I started writing seriously for magazines on environmental issues. During my campaign to stop the forestry enterprise, I had become only too well aware of how iniquitous policy-makers can be, and had also realised that we cannot relinquish our own responsibility for what lies around us. Then, as now, I felt there was an imperative to alert other people to these issues, and so I covered various aspects of country life, including farming and shooting, as well as other ecological concerns, both in the press and the broadcast media. It was something that I will be eternally committed to and which engenders as much passion in me now as it did then.

When I had made my decision to come back from France, it was with the idea of selling wooden toys. I had been enraptured by some beautiful shops in Cordes, the medieval village where I had lived. I thought maybe with a little tweaking I could transfer the concept and a little of their magic back to Scotland. It was something France could give to me, her gift to bring home: her specialist shops. Of course, she had given me many other things, too, including the inspiration to write several books, one of which I had been particularly proud, titled *Leap of the Imagination: Crisis/Opportunity*, which had focused on environmental concerns. I had also written three novels.

It's strange looking back, don't you find, as to how dreams and aspirations, those intangible things in life, tend to invisibly steer us. It certainly is true in my case and one of those episodes was my going to France and making a life there, with the hope of maybe buying a farm and doing bed and breakfast. Sadly, not all dreams are sweet and unfortunately when I went out there it was the week of Black Wednesday in 1992, when the pound crashed. That caused me to delay buying anywhere and just to rent a place. Sometimes in a lifetime the current takes you in its wake. For all the lack of realised dreams, though, it did give me the joy of writing and the rich experience of living in France, and with a backward glance I can see how pivotal it was to me in writing this book.

The shop was to be a gamble that would give me plenty of sleepless nights, but I felt I could make a go of it, and fortunately so did the bank. I had great plans: ten per cent of the profits to go to a charity for children, franchise after two years, set up another business, call it Geppetto and make wooden toys, even furniture, with Scottish materials and Scottish labour. One year into running the shop, I set up an online business. It was hard work, six days a week, but I loved every minute of it. My customers, not enough of them as it turned out, were almost like friends and I still have the letters that they sent me.

After six years, the business hit a plateau, even began to slip. More competition came in – cheap toys from China, mail-order catalogues – and try as I might to make it work, the business began to struggle. Inevitably, I came to realise that my ambitious dreams would never bear fruit.

During that time of transition, when it was quiet I used to read, and one day I found myself immersed in a book that had been loaned to me, *The Holy Blood and the Holy Grail* by Michael Baigent, Richard Leigh and Henry Lincoln. The man who loaned it to me told me it was something I just had to read and that it would make me question all that I had previously taken for granted. I could see why he had said that when I read the summary on the back cover and knew immediately that I would be hooked. Described as 'One of the most controversial books of the twentieth century', *The Holy Blood and the Holy Grail* posits the theory that Jesus was married to his greatest disciple, Mary Magdalene, and had children with her; and that instead of dying on the cross and being resurrected, Christ survived Crucifixion. The authors also believe that Mary Magdalene and her children were forced to flee to Europe and ended up settling in the Languedoc region of France where their bloodline, the bloodline of David, became intertwined with that of the French royal family. This became known as the Merovingian bloodline, who the authors claim are descended from members of a hereditary group of monks who were direct descendants of Christ. As you will see, this matches the point I will be making in a later section about a fraternity of monks called the Culdees. It is one of the most compelling points of this book and one which I can't understand isn't more familiar to us all.

According to Baigent et al., a body called the Priory of Sion was formed to protect the bloodline of David and after further research I discovered that the emblem of that organisation was the fleur-de-lys. This immediately sparked the memory that Harry Robertson's

associate had pointed out the fleur-de-lys in the baby's halo in my painting. Could there be a connection? It is a wry point most probably worth mentioning that my mother told me the other day that I had been loaned the book back in the early '80s when it had first been published but that I had dismissed it as sacrilegious and never read it. This shows for me how time has her seasons and also why I respect that many will find this work a difficult one to digest. Sometimes you have to wait until you are ready to hear something.

Experience is our teacher, I suppose, and it was whilst living in France that I had noticed the heraldry featuring the fleur-de-lys and learned of it being an emblem of the French monarchs. Fortunately, having travelled extensively around the area of Provence and the Languedoc, I also knew of the special allegiance the French paid to Mary Magdalene and the lore of her having settled there. The tantalising opening of *The Holy Blood and the Holy Grail* and its premise of some kind of secret knowledge centred on Christ's survival of his Passion released a shutter to inspiration in my mind. Maybe, just maybe, that painting, the enigmatic one that had shadowed my life, held more mystery and intrigue than I had imagined. There was more too.

One wet, stormy day early in my research, my mother suggested we bring down the box of engravings and other items and artefacts and go through it. After all, if the painting had a special significance – and I had begun to believe that it did – then maybe so too did the other things.

Initially, they looked, as they always had done before: like a collection of various decorative artworks. But then we began to see that these seemingly disparate objects shared a common theme. Everything in that box had something in common with the painting, and that something was the fleur-de-lys. There was a pewter quaich, in the bowl of which a fleur-de-lys was engraved, a map with the fleur-de-lys in the key, a tan leather folder bearing the fleur-de-lys on its front and several engravings. One of them was of Louis XIV of France (1638–1715), the Sun King, surrounded on all sides by the fleur-de-lys, and then there were others with religious subjects: one of a monk's cell and another depicting a monk in a garden. On closer examination of the latter I could just make out a fleur-de-lys on a plaque, discernible only with the help of a magnifying glass.

The leather folder was at the bottom of the box. The fleur-de-lys

emblazoned on the front was decorated in red and encircled by a golden oval frame surmounted by a five-star crown with another fleur-de-lys in the centre. On the other side was a much smaller image of a rose set in a square. Excitedly, I opened the folder, hoping to find some as yet undiscovered note. I was disappointed; it appeared to be empty.

I then explored the hessian wallet inside the leather folder. Nothing on the left, but then, in the right slip, there was something – two stamps. Not just any old stamps, though. They were 5d commemoration stamps for the Declaration of Arbroath in 1320, which as I discovered later set out Scotland's case for independence. Nothing else. What on Earth had that to do with anything?

I slid them back into their hiding place and went to find out. I Googled the stamps and found they had been issued on 1 April 1970. That was years after Dad had got the box, so it must have been he who had bought these stamps and hidden them in the folder. But why? Presumably because he was a Scot and the Declaration was important to him – but why hide them in the folder? I asked my mother if she knew anything about it, but she had no idea. Coincidence, most probably, but worth exploring.

What seemed obvious to me now, though, was that nothing in the box had been placed there randomly. The items were all pieces of a puzzle, a puzzle that my mother and I were seemingly destined to piece together. The central piece was the painting, from which all others fanned; it was the main focus, but the other things by forming the peripheries made it complete.

The Holy Blood and the Holy Grail had been the catalyst to an enlightenment of thought and initiated the quest of many thousands of people to discover the true story of Jesus and Mary Magdalene; it had now sparked the same line of enquiry in me (and for that I will be eternally grateful).

In my view, it had to be a possibility that what the authors had postulated in their work could relate to my painting. The question posed itself: with the inclusion of the fleur-de-lys in this painting could this be a portrait not of the Virgin Mary, as I had always assumed, but of Mary Magdalene, the woman whom Baigent et al. declare was the companion to Christ? Even more challenging then came the thought: in that case could this be a portrait of her holding their son?

Out of the gloom of despondency came the flicker of a light and

adrenalin once more started to pump through my bloodstream. Out of crisis an opportunity had strangely presented itself. The wheel of life was turning again, taking me away from the shop to concentrate on other things.

I started to examine the painting more closely, and certain inevitable questions presented themselves, questions that needed answers. I researched other contemporary portraits in an attempt to discover artists with a similar style and to see how many other paintings bore the fleur-de-lys. I examined other paintings of the same period and of the same subject and it became increasingly apparent to me that there was a similarity to artists of the Italian Renaissance period. More than this, I feel that my Madonna compares in her beauty and execution with the best I have ever seen.

Thankfully, my work as an investigative writer provided me with the tools I needed to find out what story the painting had to tell, and so with a new resolve my business was put up for sale and my years of research began, during which I consulted the world's experts in every sphere that relates to what is to come.

Initially, I planned to allow myself a year; it has taken me very much longer. But now my work is complete and, astonishingly, another picture has emerged, one set to match that of the Madonna. It is a staggering one that still takes my breath away.

To relate the story to you, I will start with the beautiful Madonna and her child, then go on to explore the other artefacts to conclude with the map.

The ancient Druids had a saying: 'Truth against the world.' The revelations that have been forthcoming to me are in pursuit of that ancient doctrine and hopefully the truth will win out in the end, however small my contribution proves to be.

TWO

The Sacred Feminine

The First Clue

I'm looking at her now, gazing at her face until I gain a feeling of being at one with her, of having walked the bridge of time that runs between us. I don't know what will happen on this road we now share, how far we will travel together, but in my heart she will always be there. Partly because of that sense of vulnerability, I feel an urgency, a deadline looming in my allotted time in which to tell her story. How I wish she could speak to me and confide her innermost thoughts. Thankfully, this seems also to have been the wish of the artist who created her, and to accomplish this I believe he placed symbols in the painting to communicate his true meaning to future generations. My job has been to learn the language of symbolism.

To most people this painting would seem to be a generic Madonna and Child with John the Baptist. I now believe it had to appear so, for this was to be the cloak that would protect her as she travelled incognito under the very noses of those who would wish to destroy her, among them an all-powerful authority that over the centuries has sanctioned and orchestrated some of the most heinous slaughters known to man. Chillingly, millions have died at its hands, and for what reason? Well, put quite simply, the victims' mortal crime was that they dared to question the perceived wisdom and teachings of the Church. That's right; they dared to question. Well, that is what I am going to do now.

Let's open up the picture and see what story she has to tell us. For starters, this work is fairly substantial in size, measuring 58 cm by 72 cm, and painted on wood. There is a beautiful, gilded, ornately plastered frame, which, unfortunately, is not in the best of repair, and was made even worse by an earlier attempt on my part to restore it. One expert in the field of antique picture frames claims it to be of

Italian origin, possibly dating from the baroque era (1680–1720). Another specialist in antique frames thinks it is French, Louis XV-style and nineteenth-century. His take on the moulding is intriguing: 'The moulding on the knull, or highest point, of your frame, is Gadroon ornament, said to represent blood spilling from a sacrificial altar.'

Now to the mother. Well, she is ethereal, certainly beautiful, with a luminous quality about her, and when I look at her I sense I am looking beyond the material shell of her and catching glimpses of her soul. The artist has captured not only the beauty of a woman but also those less tangible qualities of a mother. For me, this woman exudes a sense of sacred knowledge and infinite wisdom. There is also, however, a sadness there which I find disturbing; in a way it seems like a psychological portrayal of someone who is wanting to communicate something to us.

As I shall explain, my research has led me to believe that the same model has possibly been used in other paintings and it is my view, given what I now perceive in the symbolism, that she personifies a possible vision of what is known as the Sacred Feminine, or the feminine principle of our world's faiths. This is a beautiful concept that I was unaware of until I embarked on this journey; it is one which in Christianity at least has been submerged but which was previously prominent, for the reverence to the Sacred Feminine was in perfect balance with the Sacred Masculine, the Yin to the Yang. Certainly, if you think back over ancient history, that awe for the two supreme energies, or deities if you like, has always been there: the pantheons of gods in Greece and Rome. Indeed, unless I am mistaken, other cultures had strong female role models. One male deity was balanced by a female counterpart to make a whole, a complete oneness of being. In the Book of Genesis God says man is made in his image: male and female. Yin and Yang making the whole, completing the circle. Indeed, it was another revelation to me that though the Christian model doesn't really revere female models (apart from the Virgin) in their just role as a counterbalance to the male, Islam certainly does. In fact, the position of reverence to the feminine is repeatedly emphasised in Islamic symbolism. For instance, Friday, which is sacred to the planet Venus, is the Muslim holy day, and according to Manly P. Hall's definitive book, *The Secret Teachings of All Ages,* green is the colour of the prophet and, being symbolic of nature, is associated with Mother Earth. More importantly, and this ties in with what is to come in

relation to the Cathars of southern France and their allegiance to the moon, both the Islamic crescent and the scimitar represent the moon, or Venus, both aspects of the feminine. The moon as the reflected light of the sun, Venus as the morning star. The crucial factor being the sharing of the light, and the symbolic form of the crescent, the feminine symbol of the Goddess giver of life. Of course this isn't an entirely new concept. Venus the Goddess of love is I think known about by most people, and the moon having power over the oceans too. Again, Mother Earth is part of our shared vocabulary. The interesting point being that they all span back over millennia in our shared consciousness.

As for the moon, well Robert Graves, that giant amongst classical writers, wrote a marvellous book titled *The White Goddess*, in which he set out the case for the moon being much the same as the Mother Goddess, which is represented by the phases of the moon. All of which would seem to me to be some kind of pagan waymarker to keep us from straying out of our depth and cut off from our true source. Manley P. Hall's book defines the star of Venus as the mother of the gods, explaining that at some times of the year it could be seen defined as a crescent with the naked eye and that this would tie in with the crescent which is often seen in connection with the goddesses of antiquity. What I find even more astounding, and immensely reassuring, is that according to Hall the Ka'aba stone at Mecca has the figure of Venus engraved upon the crescent. Isn't that incredible? How the reverence for the feminine has endured, but tragically not to the same extent in the Christian faith. The only subliminal message I see is in Monday, which signified the day of the Moon, but unlike other beliefs Christianity has very few feminine saints' days and is consequently left cast adrift from female representation. Yes, there is the Virgin Mary, but as a vessel of the divine, not as an equal. To this day, the Christian Church seeks to deny the feminine as anathema, and, as I shall demonstrate, even though there is ample evidence that Mary Magdalene was an apostle, even apostle to the apostles, still it retains its misogynistic stance. Staggeringly, this was demonstrably shown when *The Guardian* reported on 15 July 2010 that the revised Catholic rule put female ordination in the same category as heretics and paedophile priests: 'The Vatican today made the "attempted ordination" of women one of the gravest crimes under Church law, putting it in the same category as clerical sex abuse of minors, heresy and schism.'

Denying the sacred instead of embracing it. No wonder we are in

such a mess. I, and I sincerely hope that others would agree, would like that focus to be brought back into a shared clarity of vision and a balance restored, one to counter the attributes of the other – balance being the operative word in the restoration of harmony. That harmonious relationship of opposite energies was revered for millennia before our own, symbolised by the male/solar principle balanced by the female/lunar one. The male God complemented by the Sacred Feminine, in the attainment of the whole, and thereby the completeness of creation.

Some may find that concept a difficult, unorthodox one to comprehend, especially as we live in a patriarchal society, but it doesn't mean that it doesn't apply and must be carefully explored. We witness that balance all around us in creation, the male principle in an interdependence with its feminine counterpart. Mary and Christ may have been symbols of that bipolar cohesion, as were Isis and Osiris, which has been played out in various representations for millennia. This book in part pays service to that quest, that journey of bringing home the feminine to the equation of our shared spirituality. Some would argue that the Sacred Feminine is the life-sustaining power of all creation, and is after all why we call this planet of ours Mother Earth and that when she is reintroduced we could hope for a more harmonious relationship in reverence to that philosophy.

> It is impossible for anyone to get established in the experience of reality, being-consciousness, except through the power of grace, the Mother.
> Other than through grace, the Mother, no one can attain reality. Which is truth. Except through that exalted light, which is grace of consciousness, the supreme power, it is impossible to transcend the conceptual sizing power of the mind. The ego can only be destroyed by the power of grace.
> Bhagavan Sri Ramana Maharshi (1879–1950)

So let's reflect on this beguiling portrait of a woman. I have studied many Madonnas and in my view she stands with the very best of them. Fortunately, I am not alone, for numerous authorities, from art experts to writers in this complex field whom I have contacted in the course of my research all agree that she is fascinating, enigmatic and puzzling.

Over the years, I have got in touch with everyone I could think of who might be able to help me discover more about this painting, from curators of the royal household to leading art academics and specialists in the Renaissance period, and even those who would be labelled conspiracy theorists. The question I posed to them was a simple one: I was researching the painting and would appreciate any insight that they could give me. With some, that correspondence deepened and I was able to share my own observations with them, but I tended not to proffer my opinion initially, for fear of influencing what they had to say; save Anthony Weld Forester, managing director of Sotheby's Scotland. For I, perhaps too early, laid my cards on the table to him. He didn't baulk at my suggestion and actually gifted me a book, *The Secret Supper* by Javier Sierra, and did confess at a later stage that the Magdalene was 'nudging him'. I have a great deal to thank him for, for it was Anthony who informed me of the delicious content of the pieces of paper stuck to the back of the painting – of which more later. With each line of thought and further research my conviction that this was Mary Magdalene strengthened.

But what of Mary Magdalene, who was she? I needed to know much more than I did. Possibly like you, I needed convincing. Why? Well let's see, all my life I have been indoctrinated into the belief that she was a sinner, a prostitute, and used as an example of Christ's charity, that at best her role was a penitent and redemptive one. I had been schooled too in the knowledge that she had anointed Christ's feet at the Last Supper and that she had accompanied Jesus on his journey to Calvary, where she stood weeping at the foot of the cross, and of course I was aware of her witnessing his resurrection, the basic tenet of Christian belief. Basically though, in a sense her role appeared to be as a relatively minor but colourful figure. Living in France had given me another angle on her status and opened my eyes to the suggestion that she was not a prostitute but a woman of grace and most importantly a companion to Christ. It was also whilst living in France that I became aware of the account of her arriving on France's shores. However, I am sorry to say that I hadn't taken it particularly seriously; it wasn't then in my scope of thinking. Don't you find that any form of indoctrination has that effect and that there are differing timescales involved before the blinkers and shackles which blind and restrict us are released and fall to the ground? Mine have now fallen and I can clearly see from all angles.

The fact is that the image of Mary Magdalene as a prostitute couldn't

be further from the truth, and I make no apologies about being so emphatic in my assertion. It is a pleasure for me to be able to take this opportunity to tell you why, and fortunately I am not alone nor the first to encounter and immerse myself in these revelations. A great scholar and writer, Margaret Starbird, blazed a path for me to follow. It was a difficult, torturous one for her and others, as it meant slashing and burning all that has been placed there to confront and block our progress. It takes courage to break through it all, but the light of truth subsequently shines through in the form of transformative enlightenment to lead you on. Margaret Starbird's faith was severely challenged by her revelation, as was mine, but fortunately she had a clarity of vision to sustain her, as indeed do I. This is taken from her groundbreaking book, *The Woman with the Alabaster Jar: Mary Magdalen and The Holy Grail*:

> I cannot prove that Jesus was married or that Mary Magdalen was the mother of his child . . . But I can verify that these are tenets of a heresy widely believed in the Middle Ages; that fossils of the heresy can be found in numerous works of art and literature; that it was vehemently attacked by the hierarchy of the established Church of Rome; and that it survived in spite of relentless persecution.

She adds in her preface: 'The scorned and forgotten feminine is begging to be acknowledged and embraced in our modern age.'

The truth of Mary has now dawned on me and her light shines through. She was no prostitute, she was Mary of Magdala, a landowner of considerable wealth who helped finance Christ's ministry. Indeed, an archaeological dig recently unearthed a synagogue at Magdala dating to the time of Christ; could she have preached there, Jesus too, one at the side of the other?

> Mary, known as Mary of Magdala . . . These women provided for them out of their own resources.
>
> Luke 8:2, 3

So what more of her could I glean? Well, one of the most important sources of information I consulted about Mary Magdalene is a thirteenth-century text called *The Golden Legend* by Jacobus de Voragine. This book, of which thousands of copies have survived, is a

collection of biographies of saints, and of Mary Magdalene the author writes:

> She was born of most noble parents who were indeed of royal descent. Her father's name was Syrus, and her mother was called Eucharia. Together with her brother Lazarus and sister Martha she owned Magdalum, a fortified town two miles from Genezareth, Bethany, near Jerusalem. And a large part of Jerusalem itself.

That makes it pretty clear: she was exceedingly wealthy, which is why she could afford the expensive spikenard with which she anointed Christ prior to his Passion. Of course Mary's devotions to Christ are well known, her perseverance and impassioned search for him at daybreak on Easter morning are well documented, but not so much is known about the reverence paid to her.

For beautifully, Mary Magdalene was the companion and disciple of Christ. The disciple who was the first to witness one of the tenets of the Christian faith – the resurrection – she also received the paschal privilege of announcing it. Her companion apostles had asked of Christ:

> They said to him, 'Why do you love her more than all of us?'
>
> Gospel of Philip

> Amen I say to you, wherever in the whole world this gospel is preached, what she has done will be told in memory of her.
>
> Mark 14:9

That was the highest commendation by Jesus of anyone in the Gospel stories. He was speaking of a woman. His Mary Magdalene.

What is clear in history is that Mary Magdalene was far more important in early Christianity than she has been given credit for over the centuries. Her identification with 'the woman caught in sin' is a creation of later generations, and finds no justification in the earliest texts.

Still today, in the Byzantine Christian tradition of Eastern Orthodox and Byzantine Catholics, Mary is referred to as 'Equal to the Apostles' and 'Apostle to the Apostles'. This exalted status was not honorary. Some scholars suggest that Mary was the head of a church community and may even have been the author of the Gospel of John. You will see that at the end of this book I come to the same conclusion. The earliest

stories say that Mary spent the last years of her life in Ephesus (modern-day Turkey) with Jesus's mother. However, by the 8th century AD, legends grew up in the south of France that Mary Magdalene and others fled there to avoid persecution in Judea.

As we shall later see, much was said of her position when she resettled in southern France, but as introduction this quote from *The Golden Legend* will suffice:

> She got up quite calmly and with serene expression on her face and with measured words, began to turn them from their idol worship and with great single-mindedness to preach the Gospel of Christ.
>
> Everyone there admired her for her beauty, for her eloquence and for her sweet manner of speaking. And it is no wonder that the lips which had pressed kisses so loving and tender on our Lord's feet would breathe the perfume of the word of God more copiously than others.

An anonymous Cistercian author drew on the *Vita Apostolica* to describe Mary Magdalene's preaching activities in Gaul:

> She preached to the unbelievers and confirmed the believers in their faith . . . Who among the apostles clung so firmly to the Lord? . . . It was fitting then, that just as she had been chosen to be the apostle of Christ's resurrection and the prophet of his ascension, so also she became an evangelist for believers throughout the world.

Franciscan Eustache d'Arras suggested that Mary merited the golden crown of preaching because she had converted so many to the faith, and so in consequence it was becoming increasingly evident to me that there has been a well-established cult or belief in the imperative of Mary's position for a very long time. It was the cult which the French royal bloodline subscribed to, and which the Cathars of southern France died for, she the moon to that of Christ's sun. She was no repentant sinner, no prostitute, for Mary was a woman of means and more than this was, I believe, the bride and Jesus the bridegroom:

> Can you make the bridegroom's friends fast while the bridegroom is with them? But a time will come; the bridegroom will be taken away from them, and that will be the time for them to fast.
>
> Luke 5:34–35

And again we find in the Gospel of John 3:29, John the Baptist calls Jesus a bridegroom:

> He that hath the bride is the bridegroom: but the friend of the bridegroom, which standeth and heareth him, rejoiceth greatly because of the bridegroom's voice: this my joy therefore is fulfilled.

In conjunction with all this we also have images that have filtered down through the symbolism which was used to denote her, one of the symbols being the fleur-de-lys which had set me on the trail of this being a heretical painting. This was the symbol that Sotheby's had noted so early on, in the halo or nimbus of the child in arms, which was elaborated on by Baigent et al. and which they used as evidence of a royal bloodline, one symbolised by the fleur-de-lys, and the protectors of that line: the Priory of Sion. This I will explore in greater detail later, but it was that symbol which chimed for me and woke me up out of a mere acceptance of the painting as a generic portrait. Happily, it was underscored by the revelations I encountered in my reading of Margaret Starbird and countless others, which gave me the confidence that I could now look at this picture with a bright, investigative eye. A focus which at the same time was researching the other things in my possession and which were all conspiring to say the same thing. So with that self-confidence I delved ever deeper into the fabric of the painting.

What follows is what I believe the picture was designed to say to me, which in turn I will strive to communicate to you.

This beautiful mother's hair is the auburn of autumn-tinted leaves, the colour as I have always understood it, even from as far back as being a little girl, of Mary Magdalene's hair; and that is certainly how she is commonly artistically portrayed, with long flowing red hair, though I can find no mention of her hair colour in biblical texts. I have even wondered whether this isn't yet another artistic ploy to convey something else. I mean red hair is a relatively rare genetic trait, so one does have to ask; does it say something more? For instance Boudica, the Celtic queen of the Iceni tribe in Britain who so courageously took up arms against the invading Romans, was described as having red hair. Goodness, for now anyway I will let that one lie and will take the lead from the Old Master artists who chose to portray the Magdalene with that distinctive hair colour. In the context though of the Sacred

Feminine and the connection to its being communicated by the symbol of Venus, it can't escape my notice that the Venus depicted by Botticelli in his *Birth of Venus* painting also has long, auburn hair; portraying the comparable vision of the feminine. Is it also why one symbol of the Sacred Feminine I have encountered is represented since antiquity by the letter V?

The long hair in my painting relates to the episode where she famously washed and then dried Christ's feet with her hair at the Last Supper. The Madonna in my picture is robed in the colour of the Magdalene, her own colour of red, and blue. There is a reason for this. The papacy, fearful of the cult of Mary Magdalene, had Thomas Aquinas decree that the Virgin Mary should always be depicted in blue and only Mary Magdalene in red. It's from that that we get the term 'scarlet woman', a besmirching of womankind that has seeped into our minds and vocabulary. In fact, the true scarlet women were high priestesses of the temples of an ancient Mesopotamian mystery religion who wore red robes and could not have been more holy or revered.

There is a sermon attributed to St Thomas Aquinas which explains this. Even if it is not authentic, it is surprisingly beautiful. The text which is commented on for the feast of St Mary Magdalene is that of the rainbow, the symbol of the covenant renewed between God and his people as they emerged from Noah's ark. What is a rainbow? It is the meeting of the sun with clouds that are full of water. And so it is in the meeting between the Risen Jesus and Mary Magdalene: he is the rising sun come to meet the tears of the woman weeping: here we have fire and water. And as in the phenomenon of the rainbow, here too, colours are created. For Mary Magdalene they are blue and red. Dark blue (*coeruleus*) is the colour of humility, the blue water of compunction; whereas red is traditionally the colour of faith. Indeed, we see this in painting: the Magdalene is always dressed in a red mantle with a tunic that is often blue.

Furthermore, the Vatican reaffirmed this in a decree circa 1649, stating that the Virgin was not to be portrayed in red.

Importantly, there is no justification for the labelling of Mary Magdalene as a prostitute to be found anywhere in the Bible, and can only have been taken as an interpretation of the fact that Christ exorcised seven devils from her (Luke 8:2). Surely this must be open to interpretation. Words and meaning change. Could it have meant he had cured her of a fever, of a toxicity, or could it follow a hermetic

principle of the number seven? The seven oracles of being and of knowledge which are represented by the planets, eight then being the number they align with spirit and completion. Was it a grounding of her status as a priestess? As with a great deal of what I discover, this ties in with a later section of pilgrimage and enlightenment. Maybe 'cast out' meant 'reveal'. Oh, the luxury of thought and contemplation. Seven after all is a mystical number; seventh heaven is an echo of that hermetic philosophy. Prostitute is surely one of the most derogatory of terms to apply to a woman, particularly one who was a devoted disciple and, I believe, the wife of Jesus. It can only have been instigated as a method of undermining her credibility and position; however, ingeniously, by making her a penitent it had the added bonus of allowing access of 'sinners' to the Church, in a symbolic proclamation that all could be saved. To that end, Mary Magdalene was cold-bloodedly sacrificed in the pursuit of power by the misogynistic Christian Church. The Church was misogynistic for it was fearful of the power of a woman, a powerful, revered woman who could bring back the restorative balance of the Sacred Feminine.

For me, it was an unforgivable thing to have maligned someone so fine, and one ultimately utilised to give credence and power to a man: St Peter. This bias was one which they could endorse by the Gospel of Matthew, in which Jesus said: 'You are Peter the Rock; and on this rock I will build my church, and the powers of death shall never conquer it. I will give you the keys of the kingdom of Heaven,' Matthew 16:18–19. However, this was closely followed in verse 23 with: 'Away with you, Satan; you are a stumbling block to me. You think as men think, not as God thinks.' Remember too it was St Peter who famously denied Christ three times and kept his distance from the Crucifixion. One Apostle did not, that was Mary.

That whole premise of God's Church has always unsettled me. Why choose Peter, a man who didn't even have the courage to support Christ in his hour of need? It just doesn't make sense unless it was the ultimate denial of the Sacred Feminine and, I feel, callously executed to disavow her of her true position. The one we are evidencing in this portrait.

Let's cast our eyes back once more at the painting. My eye is drawn to the beauty of the woman's hands, the angle of her fingers, the grace with which she holds the flower, and the way her other hand lovingly secures her beautiful son. At first, I thought that flower a rose, but later,

through my communication with Michael E. Abrams, a writer and botanical authority, I discovered it to be a carnation. This has a relevance too, because apparently in medieval and Renaissance Europe the carnation represented various things including mourning. However, according to *Hall's Dictionary of Subjects and Symbols in Art*, the carnation in portrait painting of the fifteenth and sixteenth centuries refers to marriage. The carnation in this painting had to be a symbol of the latter because here the child is in arms and so concurs with a marital status rather than one other attributed to it, that of mourning.

The etymology of 'carnation' is the medieval Latin *carnalis*, meaning 'of the same blood or descent'. Interestingly, if we follow the Freemasons' rule, which a Mason confided to me, of 'say what you see', we have, simply, 'carnation' or 'incarnation', suggesting a bloodline, a return to earth and an effigy or a sacred embodiment. Could it be that in a master stroke the artist was possibly implying two things – a marriage and a bloodline?

The suggestion that Jesus and Mary Magdalene married is one that recurs in history, and certainly from my reading of the biblical texts it makes perfect sense.

I have looked everywhere for other depictions of the child with a fleur-de-lys in the nimbus. I can find only two: *The Madonna of the Carnation* by Albrecht Dürer and a painting by Cesare da Sesto (an important pupil of Leonardo da Vinci's) titled *The Madonna and Child with St John the Baptist and St George*. (Another portrait which I found interesting and which is not mentioned in any of my books on Leonardo is one attributed to a senior pupil of his, Boltraffio. Called *The Head of the Saviour*, it is exhibited in the Museo Lazaro Galdiano in Madrid. Here, too, is the embellishment of the fleur-de-lys, remarkably similar to the earlier one in Cesare's painting. As I say, it is assigned to Boltraffio, but in my opinion it could equally be Cesare's. It is however of an adult, not a babe in arms.)

It's striking that Dürer also featured a carnation and that his Madonna wears red. Are he and the creator of my painting therefore both saying the same thing? I believe that they are, and that what they are conveying is that this is not the Virgin Mary, the mother of Christ, but Mary Magdalene, his wife.

On this point of the Madonna wearing red there are numerous examples, including Leonardo da Vinci's *Madonna with Carnation*, where the depiction of the hand is strikingly similar to the one in my

painting, and as Harry Robertson of Sotheby's humorously commented when I saw him for a second time (post the discovery of the papal bull on the back of the painting, of which more later) and accompanied by the new Director of Sotheby's in Edinburgh, that possibly they were all saying the same thing; primarily that they are all depictions of the Magdalene. Indeed, perhaps they are . . .

The inevitable evolution of my thinking was therefore that this picture could possibly be a portrait of Mary Magdalene with her son – and with that came the subsequent realisation that if that were the case it was a depiction of one of the greatest perceived heresies of all time.

At this stage I must admit to feeling rather daunted by it all. I doubted my conviction to risk so much in saying all this. Undeniably, thoughts were weighing heavily on me as to the consequences of what I was proclaiming. Would they be positive . . . or destructive? After all, over 20 years ago I had dismissed *The Holy Blood and The Holy Grail* as sacrilegious, so I had to cross-examine myself about what I was doing and ask myself if I was ready to commit to telling this story.

Personally, I have always had a strong Christian faith, even at one point thinking of becoming a nun. I was only little then, but it was all the more surprising because the rest of my family never went to church, and as a child I used to go alone. Maybe it was genetic. My grandfather had planned to go into the Church before he lost his faith in the trenches of the Somme, and my great-grandfather had been a minister in Aberdeen. More importantly, my great-aunt, Dr Gertrude Campbell, was a medical missionary who devoted her life to the poor in India, where she founded hospitals and centres for single women and their children. I have vague memories of her talking to my father when she came to live with us for the last few remaining months of her life. Amazingly, she had reread the Bible in Braille. My mother remembers Gertrude telling her that the most important book in the New Testament was St John's Gospel. While I have been writing this book, that has had great resonance for me, as I find that Gospel particularly apposite in its handling of Christ's Passion.

I suppose that instinctive belief system, a part of my cultural inheritance too, has always structured my views and, disconcertingly, what I was discovering was undermining it, forcing me to take responsibility and challenging me to question things afresh. Over the course of my lifetime, I have queried many things, but never before

had I supposed men of God could have orchestrated their own truth, nor had I conceived of the notion that there was another fraternity, namely the Freemasons, who were part of that same conspiracy, the one in opposition to the other. Black versus white on the chessboard of our secret history. Now, though, hesitantly, through a glass darkly I was beginning to see . . . and, more importantly, to really question.

My consolation was that what I was witnessing had not shaken my faith; on the contrary, it strengthened because in order to write this book I have had to read multiple books, including huge sections of the Bible and other sacred texts. In so doing I now feel I know Christ a bit better, his suffering, his immense courage and most importantly his teachings. There is such wonder in our history and in time, and I have subsequently found that it is only by questioning everything and not relying on blind faith that we can achieve a far stronger connection to the power which is there to guide us all. A divine will – yes, that is it, of a guiding hand of deliverance to that road of enlightenment. For my quest, or in a way pilgrimage, to find out more about the picture has challenged me to take another direction, and that route has cut back on itself and led me to the essence of truth.

As Jesus tells us:
Seek and do not stop seeking until you find.
When you find you will be troubled.
When you are troubled,
You will marvel and rule over all.

The Gospel of Thomas

So, although at times it would have been much easier for me to turn my back on all this controversy I sense a very real compulsion to face the responsibility of conveying that truth, which I fortunately believe is a sublime one of beauty and grace. It is namely one of the balance provided by equal measures of the masculine and the feminine, and of their combined sacrifice, in the name of Jesus Christ and Mary Magdalene, to be amongst us. In plain words, of Jesus loving Mary Magdalene, much as Isis loved Osiris, Apollo loved Aphrodite, the Sun in balance to the Moon. It has been recorded through time and we need to reconnect with it, to make it as tangible as we can in order to walk in its light.

Now, with that knowledge, with that truth I can gaze at the

bewitchingly sublime image of the Madonna and look ever deeper into what she truly represents, erase the image that has veiled her and concentrate purely on the symbolism that is the key to what she has to communicate. As Margaret Starbird kindly pointed out to me in the course of our correspondence, nothing is there by chance, everything is meant to convey a truth, a story.

Mary Magdalene: The Madonna in southern France

Let us look at the painting in greater depth. Well, she has been portrayed outside, with the hills and a small town to her back. It could be anywhere.

There is a plethora of symbolism in this painting, which, once you get your eye acclimatised, entices you in ever deeper. It is hard to keep your eye steady, to concentrate, too easy to jump from one thing to another. I decided to take it little by little, study the backdrop, work my way forward and then take it as a whole. Consequently, I entered into the spirit of the picture, looked to the hills in the hope 'from whence cometh my help', Psalm 121:1. The hill in this case was a white massif, very distinctive in shape, which could well have been specifically chosen to tell us something.

Then it struck me, or rather a small inner voice cajoled me, if I could pinpoint where it was, we would have a major clue. With a magnifying glass, I studied it. The mountain is luminous white, yet the foreground is reddish clay. There is a small village or town at the base of the mountain. How on Earth would I know or find out where it was? Of all the small towns in the world, was it likely that this was one I could identify? A needle in a haystack, perhaps – yet there was something familiar about it.

What I did know was that Mary Magdalene had supposedly lived in Provence. Could it therefore be Provence?

Thunderstruck, I had my answer. Could it be Montagne Sainte-Victoire in Aix-en-Provence? Mary Magdalene was associated with Aix. I had been to Aix and it certainly reminded me of the magnificence of Sainte-Victoire. No, it was too good to be true. Could I possibly have identified it, found the needle in the haystack? The Internet provided photographs. Yes. The contour matched. But surely I couldn't be right? The Madonna as Mary Magdalene and child depicted in southern France – that would be brazenly sacrilegious, surely, and far too risky to place in the public domain. Mary Magdalene in Provence was known of, but to

have her portrayed with a child at arms was a golden thread to her being the consort of Christ. For me it was further proof of its content and what the artist was wanting to portray; he had given me symbols and now even a location. How could I confirm it?

I contacted the tourist office in Aix-en-Provence with a photograph of the painting attached and a request for them to tell me whether in their opinion this could be Sainte-Victoire. They forwarded my request on to Monseur M. Fraisset, director of l'Atelier Cézanne, an expert in his field, and his reply was electrifying:

> *C'est effectivement très intrigant. Il pourrait s'agir d'une representation de la montagne Sainte-Victoire avec la ville d'Aix-en-Provence a ses pieds. On pourrait reconnaitre à droite le clocher de l'eglise gothique Saint-Jean de Malte et les moulins qui dominaient la ville au nord.*

Which reads in English:

> This is very intriguing. It could be a representation of the mountain St Victoire with the city of Aix-en-Provence at its base. One can possibly recognise, to the right, the Bell Tower of the Gothic Church of St John of Malta and of the windmills that dominate the city to the north.

That he found it intriguing was terribly exciting, that the mountain could well be Saint-Victoire, with the town of Aix at its feet, and that he thought he could even make out the Gothic Church of St John of Malta, and the windmills which dominated the town from the north. Sure enough, the building in the painting does appear to be arrow-headed, as is the Church of Saint John of Malta, which has a tower that stands some 200 ft tall.

I find the church in the painting interesting, too, and another confirmation of the location, as the arrow shape of the bell tower is in keeping with the architectural style of the popes of Avignon. This church of St Jean of Malta has strong connections with René d'Anjou, of whom we shall hear much more later.

Hoping to consolidate my discovery, I searched websites on Aix and here is some of what I found:

Oriented east to west, this limestone range has a sheer drop down to the Arc basin on its south side, while the north side slopes gently in a series of limestone plateaux towards Durance Plain. There is a striking contrast between the bright red clay at the foot of the mountain and the white limestone of the high ridge, particularly between Le Tholonet and Puyloubier.

> http://en.aixenprovencetourism.com/aix-sainte-victoire.htm
> (accessed May 2012)

For me, this latest bit of news about the location of the painting was one of the most exhilarating. It felt as though a massive bolted door had been unlocked and was swinging open to shed light on this amazing secret and helping me to access it. I had the coded number to punch in, could now turn the handle and have the door give way. I was entering a different world and was, little by little, learning its language. The site goes on to say that a priory was built here and it is known as a pilgrimage site. I suppose in a way this pilgrim was becoming an initiate to the sacred knowledge which has underpinned the last two millennia. What thrill could match that? For me, this backdrop of Aix brings us much closer to the artist's true intention. This cannot be the Virgin Mary with Jesus. If it were, there would be no fleur-de-lys, and certainly no carnation, but most importantly she would not be portrayed in Provence. Why would she be? It has never been suggested that the Virgin Mary was in Provence with the baby Jesus. No, I believe the carnation symbolises marriage, the backdrop France, the fleur-de-lys borne by the child in arms tells us he is one of the royal Davidic bloodline, the palm inserted in the nimbus in between the three fleur-de-lys, which I haven't as yet really touched upon, symbolising victory over death. Why victory? Because Christ never died on the cross, his progeny was living proof of his life essence, his survival over death. It was for that reason that the crowds carried palms when Jesus rode into Jerusalem, as mentioned in John 12:12–13. The palm means new beginnings, of victory and a future.

But what of John the Baptist, why did the artist include him? Well, I believe he had to. His reasons would be twofold; he did it as a camouflage for the rest of the painting, but also, importantly, as another silent code. In a master stroke he depicted John the Baptist in a different dimension from the mother and child – on wooden shelving which he shares with the lamb, the animal of religious sacrifice. The

lamb looks to John, not the child, and is preparing to get up to go with him. It signals to us that it was John the Baptist who was the sacrifice, the one who died. To this end, could this other dimension almost symbolise a form of altar, a simple wooden one as of old, the lamb and John the Baptist bound together in this shared dimension, set apart from mother and child? He is there now, in the light of this new purpose, for us to witness the silent dialogue between the boys. One of this world, the other of the next. It makes sense, for we know for certain that John the Baptist never set foot in France. It is, however, well documented that Mary Magdalene did.

It is important at this juncture to reaffirm the strong belief that was held by some that John the Baptist was the sacrificial lamb, the one who died. I was interested to see it portrayed once again in a portrait by Jean Clouet in his depiction of King Francis I as John the Baptist, quite clearly holding the lamb. The Knights Templar revered John the Baptist and there is a cult following of him that goes under the name of the Johannites. This cult following is based on the fact that it was John who baptised Christ, and that Christ therefore was second to John, and that of course it was John who died by decapitation. It is why some postulate that it may well be his head the Templars venerated. Many at the time believed he was the saviour and likened him to the second coming of Elijah, that included Herod, who feared the cult of John, which is why he imprisoned him. As a forerunner or messenger of Christ he forms a link between the Old and New Testaments, being regarded as the last in the line of the prophets in the Old and the first of the Saints in the New. It is all very convoluted, as there is also a link between John and the God Bacchus, which is too much to go into here and would take a book on its own, but which I do urge you to investigate. One of the best reference points is Manly P. Hall's *The Secret Teachings of All Ages.*

Absorbed by the painting, I now looked at the tree to which John's reed cross appeared to be pointing. At first I thought it was a cedar ('the righteous flourish like the palm tree and grow like the cedar in Lebanon', Psalm 92:12), but I'm not absolutely sure. It could equally well be a yew, which is renowned for being a sacred tree and one that holds significant symbolism of life everlasting and possibly the tree of life. The introduction of the yew was another one of the gifts which this book has given me. What a wondrous mystical being it is, and yet now apparently falling into neglect. It tends to be found on sacred sites

and for that reason thought to protect us from evil and connect us to the life hereafter. They live for thousands of years, overseeing the sometimes feeble history that is enacted before them. I do urge you to learn more about them. A good starting point is Fred Hageneder's book *Yew: A History,* and the Ancient Yew Group are always only too happy to help in any way they can to engender a greater knowledge of this mystical tree. I contacted the Ancient Yew Group to ask their view; Paul Greenwood said the tree in my painting very possibly was a yew, and explained to me the sanctity in which that tree is held.

In any case, the tree looks imperilled, undermined on red, sandy soil, with the roots weakened. The reed cross of John the Baptist points to its core. It suggests a connection to the theme of vulnerability, perhaps, and also a connection to his depiction, together with the lamb, on a platform of wood. That had always struck me as strange, even as a little girl. It is entirely out of context with the general composition. It is not a table. What does it represent? I questioned whether John's reed cross was pointing directly to the undermined tree to somehow draw our attention to the fact that the tree, possibly the tree of knowledge, is being undermined, weakened and in peril. That too brings its questions as to whether it is representative of the Tree of Jesse, which symbolises the genealogy of Christ and his descent from King David. 'And there shall come forth a rod out of the stem of Jesse and a Branch shall grow out of its roots: And the spirit of the Lord shall rest upon him.' (Isaiah 11:1–2). These words comprise a convincing allegory that depicts the bloodline in continuity, the genetic integrity intact to pass to the next generation. Yet the depiction here in the painting surely affirms to us that the line is under threat. It is also strikingly similar to the tree which Leonardo depicts beside Bacchus in his portrait of him. But from whom does the threat come? The answer must be the Romans, or certainly initially so in the timeline of this representation, but contemporary with the painting it was also signalling that the threat still existed from the Church. I would ask whether you never thought it bizarre that if Christ was the son of God, why was it categorically stated that he was of the line of David, the tree of Jesse? This is an anomaly which seems to contradict the idea of the divine, immaculate conception which we are expected to believe without question.

However, let's continue. Rome would go to great lengths to sever the Christos line and the belief system that it carried, known as The

Way, which was an early term for Christianity derived from Christ's saying of 'I am the Way'.

I am the way, the truth and the life.

John 14:6

It is of course why Mary and her compatriots were refugees and in exile. Amazingly, as we shall see in a following chapter, their exodus didn't end in France. Rome had a strong foothold there and the refugees from Judea had to continue in a migratory flight with their oppressors forever at their heels. This is a spellbinding story of subterfuge and refuge. Rome wanted global status, and the dominion that went with it, anything that undermined that pursuit of power was an enemy to the state and liable to be silenced.

The cross which John holds certainly aligns itself with the fleur-de-lys and the palm. It is another waymark for the eye to follow. I hope you can sense the charge and immense integrity in this work. For me it is both frightening and ecstatic, causing me at times to feel as though I am at a cliff edge looking over a panorama and being offered wings to fly, wings gifted to me by the artist who dared to illustrate his sacred beliefs and pass them to the next generation who had ears to hear. How miserable it is to reflect that even now, 2,000 years after Mary's deliverance of Christ's child, we still only catch their shadows as they flee persecution, not bodily but conceptually. I believe millions have given their lives in the belief of this sacred union, and it is to those I dedicate this in memoriam.

Apostolorum Apostola: Mary Magdalene

Do you see how the ear of the woman in the painting is exposed? I believe this follows from Jesus's words, 'He that hath ears to hear, let him hear.' To me, this can be taken to refer to the understanding of allegory, to the idea that for those who are prepared to seek out hidden meanings, deeper truths are waiting. The words are usually attributed to Matthew 11:15, but they also appear over and again as a beautiful refrain in the Gospel of Mary Magdalene, a tiny, exquisite gospel of just ten pages (half of it has been torn away by an unknown hand at an unknown time) which you can read at the end of this chapter.

This gospel, which itself declares that it is the Gospel of Mary Magdalene, was discovered as if by a miracle in an antiquities shop in

Cairo by a German academic in 1896. It was authenticated almost half a century later by the discovery of a collection of Gnostic texts at Nag Hammadi in Egypt in 1945. The Gnostic Gospels are a fabulous collection of about 52 texts based upon the ancient wisdom teachings of spiritual leaders, including Jesus, spanning the second to the fourth centuries AD. Gnosticism for me is almost a metaphor for the House of God, for it brings together the teachings from all the rooms of sacred teachings, proffering an invitation to enter them all and to learn as much as we can from each and every one of them. Importantly, it affirms the belief that we are in the House of the Lord and therefore God is within us. Therefore obviating the need to look for him outside ourselves. However, it does acknowledge that we do need a guide to lead us there, to that essence of our being. To be shown 'the Way' if you will. These books set out to enlighten, but they were suppressed by the Church councils that established the current New Testament. Fortunately, they were hidden for posterity and now we can see alternative sacred texts. It is no coincidence that as the translations gradually came into the public domain, the former position of the Church – that Mary Magdalene was a prostitute – became untenable, and they subsequently withdrew this claim in 1969, although this does not seem to be widely known.

Mary Magdalene's gospel is largely allegorical, to the point that it has been declared too mysterious to understand, but for those who 'hath ears to hear', its meaning is brilliantly clear and simple; we have the gift to listen to the truth and perceive it, it's whether we choose to or not. 'He that hath ears to hear, let him hear.' The prominent ear in the painting draws our eye. It's just another clue, a key to understanding the language that she is speaking. In the context of this oil painting, it is communicating to the initiates of this knowledge whilst at the same time recording the truth for posterity.

As I read more and more, I found that, despite the Church's attempts to suppress Mary Magdalene's role in the history of early Christianity, it did in fact subscribe to the story of her as an evangelist in France. For in *The Golden Legend* it is recorded that in a collection of saints' lives the Archbishop of Genoa in the thirteenth century, Jacobus de Voragine, talks of the evangelisation of Gaul by Mary Magdalene. This brings the backdrop of our painting into ever-clearer focus:

> Then, fourteen years after the passion and ascension of the Lord,
> long after the Jews had killed Stephen and expelled the rest of the

disciples from Judean territory, the disciples went off to spread the word of the Lord in the various regions inhabited by the Gentiles. At that time blessed Maximinus, one of the Lord's seventy-two disciples, was with the apostles, and it was to his care that Peter had entrusted Mary Magdalene. When the disciples went their separate ways, the blessed Maximinus, Mary Magdalen, her brother Lazarus, her sister Martha, Martha's maid Martilla, and the blessed Cedonius, who had been blind from his birth but was cured by the Lord together with many other Christians, were put on board ship by unbelievers and set adrift on the sea without pilot so that they should be all drowned. But by God's will they reached Marseilles. There they found nobody prepared to take them in, so they sheltered under the portico of a shrine where the people of the region worshipped. When the blessed Mary Magdalene saw the people streaming to the shrine to sacrifice to their idols, she got up, quite calmly, and with a serene expression on her face and with measured words, began to turn them from their idol worship and with great single-mindedness to preach the Gospel of Christ. Everyone there admired her for her beauty, for her eloquence and for her sweet manner of speaking. And it is no wonder that the lips which had pressed kisses so loving and so tender on our Lord's feet should breathe the perfume of the word of God more copiously than others.

The Golden Legend, Jacobus de Voragine

Joseph of Arimathea is also recorded as being on that boat. It was of course Joseph who spoke with Pilate before Christ's Crucifixion, to ask for permission to take the body of Christ from the cross, and he who went to the tomb with medications after Christ's Passion. Joseph is someone who will figure largely in this story and of whom more later; but for now it is worth just reflecting that he may have been the great-uncle of Christ, who traded in tin to Cornwall, and who probably took Christ on a trip there with him. It is Joseph who is so bound to the Glastonbury story and that of the holy grail.

Tradition has it that Lazarus, Mary's brother whom Christ brought back from the dead, went on to become the Bishop of Marseilles. The French word 'lazariste', meaning 'priest', is derived from his name, and there is a link too, I believe, to the establishment of the Order of the Knights of Lazarus.

Maximinus is said by Voragine to have become the Bishop of Aix.

Mary Magdalene preached and the Cathedral of St Maurice in Angers preserves the font in which she is believed to have baptised the ancient rulers of Provence, a font which, interestingly, René d'Anjou, a later Count of Provence, donated to the Church.

In one sacred drama, *Rappresentazione della conversione di S. Maria Maddalena*, Maximinus, on arriving in Marseilles with Mary, beseeches her, 'And you, Mary, you who are so eloquent, would you preach to these people first?'

And yet Rome continued to depict her as a repentant sinner and harlot until as late as 1969, all this despite its being well documented that she was of royal stock.

In the Gnostic Gospel of Mary, the Magdalene is both a prophet and the moral conscience of the apostles:

> Peter said to Mary, 'Sister, we know that the Saviour loved you more than other women. Tell us the words of the Saviour that you remember, which you know and we do not. We have not heard them.'
>
> Mary answered, 'What is hidden from you I will reveal to you.'

Mary, however, was fearful of Peter. In the Pistis Sophia, another Gnostic text, she says: 'I am afraid of Peter, for he threatens me and he hates our race.' The Gospel of Philip underscores one of the reasons for Peter's dissent:

> And the companion of the . . . Mary Magdalene . . . loved her more than all the disciples and used to kiss her often on her . . . The rest of the disciples . . . They said to him, 'Why do you love her more than all of us?'

Neither of these gospels was included in the Bible. The man who made the decision as to what should be omitted and what included at the Council of Nicaea was Emperor Constantine, who famously boiled his wife alive and murdered his son, surely not one who we could entrust to choose which books should or should not be included. Having read a large number of the Gnostic Gospels, it appears clear to me why he left them out: they challenged the rule and dominion of the Church over the autonomy of an individual's own dialogue with God. No man should stand between a man and his God, there is no divide, no

mediator and consequently no power of one over the other, the Church does not hold the truth in its hands, it is within us all and can be found in an inner dialogue and communication with the divine. In my view it is well worth reading the Gnostic Gospels, the books that were left out, to get a thorough overview of sacred writings.

The Angevin monarchs (among them René d'Anjou) were particularly devoted to Mary Magdalene. For them, Mary was the grail that delivered Christ's blood to French shores. They believed that they were part of that Merovingian line. Remember, this derived from a monkish line, and in accordance with that belief if ever there was a spiritual son of Mary Magdalene then it was Charles II of Anjou, who reigned from 1285 to 1309. He spent the last 30 years of his life erecting devotionals to Mary throughout Provence and the Kingdom of Naples.

It was thanks to Charles II that on 9 December 1279 an ancient sarcophagus in the crypt of the Church of Saint Maximin near Aix-en-Provence was opened. Charles made sure he was there and, according to legend, a green palm shoot was found growing from Mary Magdalene's tongue. History holds that the body was confirmed as being that of Mary Magdalene.

Philippe de Cabassoles, Bishop of Cavaillon and protector of the Italian poet Petrarch, explained what he believed was the significance of the miraculous palm in his *Life of St Mary Magdalene*, written in 1355. His suggestion was that the frond growing from her tongue symbolised her role as *apostolorum apostola*, the apostle of the apostles, for the Church preached that it was she who brought the news of Christ's resurrection to the disciples.

Charles's dedication to the cult of Mary Magdalene was so impassioned that, with great pomp and ceremony and in the presence of the archbishops of Narbonne and Aix, the saint's relics were moved to an opulent setting. Her skull was placed in a golden reliquary crowned with a royal diadem encrusted with jewels, pearls and other precious gemstones. Verses commemorating the relationship between Mary and Charles II were inscribed on the reliquary itself. They read, in part:

In the year 1283
The Prince of Salerno
From kindness and out of love for the Lord

Displayed her in gold
Decorated with a sacred crown
Therefore, Mary, be our pious patron
Protecting him while living and in death.

The bestowing of the crown was a mark of recognition of her as a ruler and queen, as the embodiment of the Sacred Feminine.

The Enigma of the Skull

The mention of Mary Magdalene's skull as a holy relic leads us to the enigmatic Knights Templar, the warrior monks who were known to have excavated beneath the ruins of Solomon's Temple and who were known to worship a skull. As a group of warrior monks who set out to protect the pilgrims in the Holy Land, their number was initially very small, only nine. Many speculate that they were based in the Holy Land to explore the foundations of Solomon's Temple, which was located at the Temple Mount, where they were stationed, for lost knowledge or treasure.

When their last stronghold in the Holy Land came under Muslim control, they established their headquarters in the Languedoc in southern France. King Philippe le Bel (1268) of France was a man who envied the Templars' power and owed them money. He cold-bloodedly and systematically set out to discredit them. Armed with a list of charges against them, among them denying Christ and worshipping the devil, Philippe ordered the Templars arrested.

At dawn on Friday, 13 October 1307, the Templars in France were to be seized and placed under arrest, their assets to be seized by the king. (It is for this reason that Friday 13th is still held to be one of the unluckiest days of the year!) The Templars appear to have been warned in advance, because there were some who fled, taking their documents and some of their treasure with them. Evidently, some fled by sea, and we know what happened to at least one of the ships. It was commanded by a knight named Henri de St Clair, who then settled in Scotland. It was one of his descendants who built Rosslyn Chapel. This could add weight to the theory held by many authors that some of them may have sailed to America, as this would explain the decorations of sweetcorn and aloes which are carved on the walls of the chapel, and which were unknown in Scotland. Where they found the navigation maps to take them there is another mystery. The obvious possibility is

that they found manuscripts of maps hidden in the basement of the Temple in Jerusalem.

The Knights Templar, quite deservedly, hold a unique position in our history, for they were an enigmatic, powerful, mysterious brotherhood of whom relatively little is known. They shall remain obscure, shrouded in the mist of time, but their shadows intermittently break cover to emerge from the lightening darkness to show the direction from which the light shines. I believe they are still in existence in another form and in the guise of the Freemasons. This brotherhood of knights holds a pivotal role in the story of the painting as a link in the chain of events which hold the secret of the Magdalene. Why? Because when they lived in Jerusalem in 1100 they supposedly excavated under the temple of Jerusalem. Many believe they were looking for something in the form of birth records or marriage certificates, anything that proved the bloodline of Jesus as the rightful king of Israel, Jesus's lineage, or even perhaps Jesus's body.

From some accounts it would appear that they were successful and took their findings back to Europe. Some say they hid their find in the vicinity of Rennes-le-Château, a Templar outpost in the Pyrenees, near Montségur, the last of the Cathar strongholds; others, I amongst them, believe that they relocated to Scotland. The tantalising map commissioned by the Sun King, Louis XIV, which concludes this book, may be key to answering whether any of their treasure, whether it be documentation or riches, lies hidden in southern France.

I suppose the obvious question to ask is why did they find it imperative to find and confirm this bloodline, and on finding it keep it secret? After all, over 1,000 years had passed since the death of Jesus. The only answer I can come up with is this: if Jesus Christ had descendants they would have been scattered over Europe and possibly further. It would be a unifying bond and brotherhood to peace. This would be of little importance if he were not after all the Son of the One True God, but if, as is widely believed, his genetic inheritance was a sacred one this would make the House of God a truly global one that covered the Earth. It would also mean, most importantly, that no religion could divide us. That is the threat the Church could not countenance, for they had and have fallen into the trap that power corrupts and absolute power corrupts absolutely. To relinquish their take on this would mean a disempowerment and a surrendering of position. Ultimately I believe we will all come together under the

auspices of a loving God, sharing his house but living in different rooms, but with community binding us. After all, faith shouldn't be an adversarial competition, one pitted against the other, but a shared acknowledgement of what is.

Interestingly, the Knights Templar were known to have worshipped a beautiful gilded head of a woman and inquisitors who questioned them under torture declared that they worshipped Baphomet. What Baphomet is, is obscure. Baigent et al. point out that the Moorish Spanish word 'Bufihimat' means 'father of understanding' and that in Arabic it signifies 'source'. However, as Dr Hugh Schonfield, one of the original researchers into the Dead Sea Scrolls, revealed, when the word is transcribed in Hebrew and the Atbash cipher applied, it converts to the word 'Sophia'. Intriguingly enough, there is sound evidence that the Atbash cipher was in use well over 1,000 years before the establishment of the Templar order, which points to secrets concerning the true timescale of their origin. The Templars themselves utilised this ancient code.

This is where it gets enthralling, because Sophia was the goddess of wisdom and considered to be the bride of God. From my research, I have gleaned that the Knights Templar were followers of the goddess principle and committed to re-establishing the link to the Sacred Feminine that the Church had severed. To put it into context, this was a romantic period in our history of chivalry, and as we shall see in a later chapter where worship of the feminine, in the name of Mary Magdalene, was steadily gaining strength.

Schonfield's office (he is now deceased) responded to a jpeg of the painting: 'One might see in it evidence of the Magdalene cult – then it could be Magdalene . . . especially because of the colour symbolism of the dress and the fleur-de-lys.'

It is also said that Bernard of Clairvaux when giving 'The Rule' to the Templars laid down a specific requirement that all knights should swear 'obedience to Bethany and the House of Mary and Martha' (Graham Hancock, *The Sign and the Seal*), in other words, could this be to swear allegiance to the dynasty founded by Mary Magdalene? On this basis, the Mary to whom they dedicated their cathedrals was Mary Magdalene, not the Virgin.

From the outset and throughout my research and writing of this book I have been troubled, sometimes amazed, by some of the things which I have discovered. This is, even for me, material which is hard to

digest. We have all been channelled into a certain way of thinking, and what I am asking you to do is to think again. To question.

Let's reconsider what I am laying before you.

The artist who painted this picture would have been, by definition of the Church, a heretic. By concurring with its theme we, by definition, are heretics too. But that is tyranny, surely, because nothing but the truth should determine what we think. We all have the God-given right to think, to question. To be unfettered in our personal quest for truth. However, that is not what the orthodox Church deems permissible: the Roman Church defined heresy as the arrogance to question their teachings, that we must be unquestioning in our belief to their proscribed teachings. For me, that is anathema. The gift for me is what this magnificent painting is demanding of us, what our forebears are demanding of us . . . to question and to think. In the next chapter I will tell you who I think the artist is.

> Thought, I love thought.
> But not the jaggling and twisting of already existent ideas.
> I despise that self-important game.
> Thought is the welling up of unknown life into consciousness,
> Thought is the testing of statements on the touchstone of consciousness,
> Thought is gazing onto the face of life, and reading what can be read,
> Thought is pondering over experience, and coming to conclusion.
> Thought is not a trick, or an exercise, or a set of dodges
> Thought is man in his wholeness, wholly attending.
>
> D.H. Lawrence, 'Thought'

The Gospel According to Mary Magdalene

Composed probably in Greek in the second century AD. Pages 1 to 6 of the manuscript, containing chapters 1–3, are lost. The extant text starts on page 7.

Chapter 4

. . . Will matter then be destroyed or not?

22) The Saviour said, All nature, all formations, all creatures exist in and with one another, and they will be resolved again into their own roots.

23) For the nature of matter is resolved into the roots of its own nature alone.

24) He who has ears to hear, let him hear.

25) Peter said to him, Since you have explained everything to us, tell us this also: What is the sin of the world?

26) The Saviour said There is no sin, but it is you who make sin when you do the things that are like the nature of adultery, which is called sin.

27) That is why the Good came into your midst, to the essence of every nature in order to restore it to its root.

28) Then He continued and said, That is why you become sick and die, for you are deprived of the one who can heal you.

29) He who has a mind to understand, let him understand.

30) Matter gave birth to a passion that has no equal, which proceeded from something contrary to nature. Then there arises a disturbance in its whole body.

31) That is why I said to you, Be of good courage, and if you are discouraged be encouraged in the presence of the different forms of nature.

32) He who has ears to hear, let him hear.

33) When the Blessed One had said this, He greeted them all, saying, Peace be with you. Receive my peace unto yourselves.

34) Beware that no one lead you astray saying Lo here or lo there! For the Son of Man is within you.

35) Follow after Him!

36) Those who seek Him will find Him.

37) Go then and preach the gospel of the Kingdom.

38) Do not lay down any rules beyond what I appointed you, and do not give a law like the lawgiver lest you be constrained by it.

39) When He said this He departed.

Chapter 5

1) But they were grieved. They wept greatly, saying, How shall we go to the Gentiles and preach the gospel of the Kingdom of the Son of Man? If they did not spare Him, how will they spare us?

2) Then Mary stood up, greeted them all, and said to her brethren, Do not weep and do not grieve nor be irresolute, for His grace will be entirely with you and will protect you.

3) But rather, let us praise His greatness, for He has prepared us and made us into Men.

4) When Mary said this, she turned their hearts to the Good, and they began to discuss the words of the Saviour.

5) Peter said to Mary, Sister we know that the Saviour loved you more than the rest of woman.

6) Tell us the words of the Saviour which you remember which you know, but we do not, nor have we heard them.

7) Mary answered and said, What is hidden from you I will proclaim to you.

8) And she began to speak to them these words: I, she said, I saw the Lord in a vision and I said to Him, Lord I saw you today in a vision. He answered and said to me,

9) Blessed are you that you did not waver at the sight of Me. For where the mind is there is the treasure.

10) I said to Him, Lord, how does he who sees the vision see it, through the soul or through the spirit?

11) The Saviour answered and said, He does not see through the soul nor through the spirit, but the mind that is between the two that is what sees the vision and it is [. . .]

Pages 11–14 are missing from the manuscript.

Chapter 8

. . . it.

10) And desire said, I did not see you descending, but now I see you ascending. Why do you lie since you belong to me?

11) The soul answered and said, I saw you. You did not see me nor recognise me. I served you as a garment and you did not know me.

12) When it said this, it (the soul) went away rejoicing greatly.

13) Again it came to the third power, which is called ignorance.

14) The power questioned the soul, saying, Where are you going? In wickedness are you bound. But you are bound; do not judge!

15) And the soul said, Why do you judge me, although I have not judged?

16) I was bound, though I have not bound.

17) I was not recognised. But I have recognised that the All is being dissolved, both the earthly things and the heavenly.

18) When the soul had overcome the third power, it went upwards and saw the fourth power, which took seven forms.

19) The first form is darkness, the second desire, the third ignorance, the fourth is the excitement of death, the fifth is the kingdom of the flesh, the sixth is the foolish wisdom of flesh, the seventh is the wrathful wisdom. These are the seven powers of wrath.

20) They asked the soul, Whence do you come slayer of men, or where are you going, conqueror of space?

21) The soul answered and said, What binds me has been slain, and what turns me about has been overcome,

22) and my desire has been ended, and ignorance has died.

23) In an aeon I was released from a world, and in a Type from a type, and from the fetter of oblivion which is transient.

24) From this time on will I attain to the rest of the time, of the season, of the aeon, in silence.

Chapter 9

1) When Mary had said this, she fell silent, since it was to this point that the Saviour had spoken with her.

2) But Andrew answered and said to the brethren, Say what you wish to say about what she has said. I at least do not believe that the Saviour said this. For certainly these teachings are strange ideas.

3) Peter answered and spoke concerning these same things.

4) He questioned them about the Saviour: Did He really speak privately with a woman and not openly to us? Are we to turn about and all listen to her? Did He prefer her to us?

5) Then Mary wept and said to Peter, My brother Peter, what do you think? Do you think that I have thought this up myself in my heart, or that I am lying about the Saviour?

6) Levi answered and said to Peter, Peter you have always been hot tempered.

7) Now I see you contending against the woman like the adversaries.

8) But if the Saviour made her worthy, who are you indeed to reject her? Surely the Saviour knows her very well.

9) That is why He loved her more than us. Rather let us be ashamed and put on the perfect Man, and separate as He commanded us and preach the gospel, not laying down any other rule or other law beyond what the Saviour said.

10) And when they heard this they began to go forth to proclaim and to preach.

The Artist

If I am correct in my theory about what the picture depicts, the next burning question to be addressed is the identity of the artist. One of the academics I contacted during my research, Michael E. Abrams, PhD of Florida A&M University, who discovered an anomaly in the dating of a Joos Van Cleve painting of the Madonna and child by his examination of a floral insertion, a very clever piece of investigative work, commented on my painting:

> How magnificent. It is brimming with sensuality, full of expression. If these fleur [the fleur-de-lys] are original with the picture, the owner or artist perhaps was taking a great risk of heresy, especially after the Pope was re-established in Rome. The artist may well be burned at the stake in an Inquisition.

I believe that the artist who created this painting risked everything. Just as our contemporary war photographers endanger their lives to tell us a story, so too did he, the difference being that he had to use symbolism to communicate his meaning. As the religious historian Mircea Eliade writes in *Images and Symbols*:

> Consubstantial with human existence, it came before language and discursive reason. The symbol reveals certain aspects of human reality – the deepest aspects – which defy any other means of knowledge. Images, symbols and myths are not irresponsible creations of the psyche; they respond to a need and fulfil a function, that of bringing to light the hidden modalities of being.

As with my parents before me I too had always wondered about the identity of the artist and now once again it was *The Holy Blood and the Holy Grail* that provided me with what I felt might be a clue. Michael Baigent et al. had listed Leonardo da Vinci as one of the Grand Masters of the Priory of Sion – the body formed to protect the bloodline of David – and I knew that Dan Brown had used this as inspiration while writing *The Da Vinci Code*. Was it possible that my painting was also connected to that great master? The MD from Sotheby's had dated my painting to the period during which da Vinci had worked, but had not explicitly mentioned his name. *The Templar Revelation* by Lynn Picknett and Clive Prince suggested that Leonardo had hidden covert symbolism in his painting *The Last Supper*, a theory that Dan Brown focused on in his fictional blockbuster account, and I had now come to believe that my painting also contained hidden symbols. Maybe it could be linked with that underground stream of esoteric thought and maybe even be by a contemporary of Leonardo, or – a wild thought – maybe even Leonardo himself. This was a crazy hunch, but one that I would pursue.

I began by trying to find out more about Da Vinci's work, starting with *The Last Supper*. *The Templar Revelation* by Lynn Picknett and Clive Prince opened my eyes further to the potential hidden depths in this masterpiece. Picknett and Prince are convinced that the figure seated next to Christ but leaning away from him is not St John, as long believed, but in fact a woman: '*Surely this is a woman we are looking at* [original emphasis]. Everything about "him" is startlingly feminine.' I had to agree, and the longer I looked at *The Last Supper*, the more I felt there was a connection between it and my own painting.

I appreciate that it must appear quite a leap of faith to think that I could possibly have a work by one of the most charismatic artists of all time, but the more I have examined and contemplated this enigmatic portrait, the more I am convinced of it. Fortunately, as you will see, others too believe it bears his style.

Finally, after all this long time and exhaustive research, I sense Leonardo's hand is in this, whether in his philosophy of thought or, what I feel more and more certain of, by his hand. For you to believe me you will need to have a certain trust. As I have said, I am no scholar and have not the entrenched conditioning that so many have. I am just a woman who would not have embarked on this daunting task if I didn't feel a commitment to do so. Let's face it, it would be so much

easier to turn away from the knowledge that I have but then again how can I when I feel an onus is upon me to pass it on. I have researched many things in my life, and none of my suspicions have been unfounded; that integrity stands me in good stead now.

So what of the man who has inspired such curiosity? Is it possible, as I believe, that he was part of a brotherhood of knowledge who sought to convey those truths in his paintings? As I have already mentioned, it is thanks to Dan Brown and Michael Baigent et al. that my eyes were opened to the intangible glimpses of what may be the truth, and it was that which inspired me to set sail on this remarkable journey. Who was the figure sitting beside Christ in *The Last Supper*, was it a woman or a man? For me it seemed clear, and I firmly subscribe to the theory that it was a woman. In which case, what courage Leonardo showed in placing such a message right under the noses of the Establishment and Church. That whole painting is full of coded messages, murmurs of a past age that he must have placed there to communicate something. Ponder it for a moment: this was to capture the last meal which Christ had with his disciples, which was the event that the Church revisited every time the wine and bread of Communion were consecrated, to become a symbol of Christ's body and blood, but yet there is no wine on the table, no chalice and the bread is in small pieces. The painting was symbolising Christ's great sacrifice, but yet the symbols aren't there. No chalice – but then again, is there one somewhere? I don't know, but there is something above the head of the first disciple, hidden in the column, which looks decidedly like a chalice. I may be being fanciful, but each time I look at it, it glares back at me. You'll see what I mean when you spot it, that is if you haven't already. Another interesting point, which almost matches the music I queried in Leonardo's portrait of *The Musician* is that a man called Giovanni Maria Pala believes there is a musical score incorporated in the scattered pieces of bread. An intriguing possibility and one well worth considering. The figure to Christ's right (interestingly, Leonardo referred to Christ not as Christ but as the Redeemer) was supposedly St John the beloved, who apparently rested his head on the chest of Christ but in this instance leans away and is surely feminine. This figure also is the mirror image of Christ in what she wears in colour and, as Dan Brown pointed out, the figure they outline in this scene does make the letter M. Leonardo risked much in portraying the scene like this, so what conviction compelled him to? And what too of the

disembodied dagger? Goodness, it is full of secret murmurings which must be trying to convey a message, and to have cut the wine from the story is very much at odds with Christian orthodoxy. It is like focusing on baptism but with no water!

We have other instances, too, of Leonardo's bravado in his compositions. The *Madonna of the Rocks* is one example. The Confraternity of the Immaculate Conception who commissioned this for their chapel in the Church of San Francesco Grande in Milan were so angry at the finished product they refused to pay and a 20-year lawsuit followed, but why? For again he is unconventional in his depiction, which is supposed to show the Virgin Mary seeking refuge on her flight into Egypt encompassing John the Baptist and the Angel Uriel, but it is skewed with Christ appearing to pay homage to John. The group are positioned around what some say is a pond, though I think it looks more threatening than that. For Christ to pray to John is an alarming heresy and is almost subliminally passing on a message, possibly that it is to John we should look? This would also tally with what I am going to cite in my painting, namely that John was the sacrifice and that the lamb is partnered with him. This is a philosophy which the Knights Templar held, which is why they revered John the Baptist and had the lamb as one of their emblems. For me there is even a resemblance between the boy child in the *Madonna of the Rocks* and the one in my painting. Same anatomical proportions, a similar look. More than this, extraordinarily these two female representations, the one in *The Last Supper* and this one, bear the same profile as the Madonna in mine, even the same distinct V in the hairline. Coincidence? Well, I don't think so; I think they are part of the same message that this extraordinary man wanted to communicate. Take the lead, it holds firm and will do as we continue along this road of discovery.

Another new theory I have to put before you is the score of music in Leonardo's *The Musician*. One of the experiences I have enjoyed in this venture is looking at the wonderful works of art which Leonardo created and there has always been something about this particular portrait which has intrigued me. Why did nobody seem to be interested in the musical score in the hands of Leonardo's portrait of *The Musician*? The man portrayed is believed to be a great friend of Leonardo's – a Franchino Gaffurio. Yet again we have a work on which he wouldn't have scribbled any old thing, so I decided to ask some musicians I knew what their view was. Some came back saying they

couldn't make it out, but eventually it was father and son team Stuart and Tommy Mitchell (who had famously deciphered the musical score in Rosslyn Chapel) who came up trumps. What they came up with is astonishing: they took the score, placed it to a mirror and thought they could see the words *Agnus Dei*, the lamb of God. According to Stuart this music could be *Ut Quesant Laxis*, written by Paul the Deacon in the eighth century to honour St John the Baptist. From what I understand it was later banned by the Church. After some 500 years, and with a little push from me, we have it. Research is ongoing but as I understand it, Stuart, who composes wonderful music, hopes to incorporate it in a later composition. This is not definitive, of course, but we are on to something here and I would love to hear what anyone else has to say. It is a wonderful demonstration of how Leonardo relished leaving messages for us to pick up: he would be delighted to know it was a man of Stuart's calibre, and his father, who had unmasked it – and me, of course!

In both *The Da Vinci Code* and *The Holy Blood and the Holy Grail* there is mention of the Priory of Sion, a secret society founded in 1099 in the shadow of the Knights Templar, about which it is staggeringly postulated that Leonardo da Vinci had been one of the Grand Masters. A secret society charged with protecting the knowledge of the Christos bloodline! What I was unearthing seemed to be giving more credence to all this. Of course, naturally I checked myself against wishful thinking, for what were the odds that I would have in my possession something so fine, which with gathering force was communicating to me over a timespan of 500 years? Practically zero, but yet as you will see it is amazing what lies at our feet waiting to connect to us, for its whispers to grow and communicate across the centuries. What I was to find out underscored the hypothesis cited by Brown and Baigent et al., that of Mary Magdalene bearing a child – very possibly more than one.

It has been a thrilling honour to examine Leonardo's vast repertoire of achievements, to gauge some of the reasonings that he incorporated into his work, even the vaguely humorous way he gave clues to the study of his portraits, for example by placing a juniper bush (*ginepro*) behind Ginevra de Benci, or the ermine he placed in the arms of the *Lady with an Ermine* (as the ermine represented the mascot of her lover, Ludovico Sforza, 'il Moro') and I believe in my painting he gives compelling clues too: the background and the fleur-de-lys. Both of these and more are his

pointers to us as to the identity of our sitter. More than this, my painting, this divinely enigmatic portrayal, holds a special awe. For my mother and I have always revered her and focused prayer on her. I still do when I see her, but then equally spellbinding is the knowledge that she holds not only my reverence and prayers but those of generations who have prayed to her or through her, no matter their religious beliefs or creed. She holds that energy, that magical wondrous element of divinity. That is something which cannot be disputed!

Little by little over this seven-year-plus span I have been getting to know this genius, catching glimpses and insights to his thinking. That on its own was an adventure of a lifetime, but it was going to prove much more than that, for this painting, I have discovered, was also the catalyst which connected to the other artefacts in my charge and which led to an explosive discovery. This painting blazes that path, as it was intended to, and conspires with all else to speak out to initiates. I am not shy to say it, I feel that what is happening is meant to have happened, destiny deems it so. Let me explain.

When I seriously decided to pursue this research, I contacted the highest authority on the subject that I knew of, Professor Carlo Pedretti, the world-renowned expert on Leonardo da Vinci. Everything that I had discovered on my own pointed to him and now was the time to confront an expert to see what his thoughts would be. So, with a certain sense of trepidation, I sent off an email missive to him with a photograph of my painting attached; I also attached one of the back of the painting, on which appear several postings. What follows is his reply:

> It is a good painting that certainly deserves to be examined in a reputable laboratory and eventually to be cleaned. It is by a Leonardo pupil of a later generation, possibly from the beginning of the 16th century and it would be most interesting – even important – to read whatever is on the back.

So, first things first, after firing off my email to Professor Carlo Pedretti I set myself to learning as much as I could about this wondrous complicated man, Leonardo da Vinci.

Leonardo da Vinci is most probably best known for his enigmatic portrait of the *Mona Lisa*, or *La Gioconda*, a portrait he revered so much that he kept it with him until the day he died. We will never

know for certain who commissioned it or even whether it was his very own testimony to a belief he held, I even wonder whether it may not have been a portrait of his mother Caterina and whether that might be why it bears a resemblance to Leonardo. Theories abound, and I am not going to enter onto that stage of conjecture here, but that connection to his young mother does provoke a line of thought which never fails to astonish me, and it is this: just imagine, if he hadn't been born the illegitimate son of a notary and a 16-year-old peasant girl in Vinci near Florence, he might well never have become the man he did, he would most likely have followed a conventional education and followed in his father's profession as a notary.

Leonardo was born on 15 April 1452. He took inspiration from the countryside around him, delving, musing and playing with what surrounded him. According to him, his earliest memory was of being in his crib and a hawk flying down and flapping its wings in his mouth:

> I seem to have been destined to write in such a detailed matter on the subject of the kite, for in one of my earliest childhood memories, it seems to me that when I was in my cradle, a kite flew down and opened my mouth with its tail and struck me many times with the tail on the inside of my lips.

> Codex Atlanticus 66v b

I can almost imagine him there as a little boy playing and interacting with the surrounding countryside, that small village of Vinci gifting him with the learning tools and inspiration that were to fashion him into the man that he became. His father took charge of him but it was his Uncle Francesco who provided this unsettled little boy with a mentor and someone who showed him love and affection. Love and affection that would endure. It was in Vinci that he developed his passion for nature and his aesthetic qualities thrived. His father watched these aptitudes of his growing boy and his gift for drawing, and on their relocation to Florence entered him into the auspicious workshop of Andrea Verrocchio. Being ripped from the bosom of his natural home must have compounded his earlier trauma of being taken from his birth mother Caterina. What sadness he must have carried within him, not only of his mother but the early demise of the first woman his father did marry, who died young and childless. Then this the unknown, unfamiliar environment of a concentrated city life and re-exposure as

an illegitimate child. No longer a home, just lodgings at the workshop, no longer his uncle as ally, just other apprentices and mentors. His compensation though, was his art. Now he could really learn his craft and excel. Here his endless curiosity would feed on a fresh diet and morph into the man of the Renaissance who would excel all others.

It is hard to imagine that time; 500 years is a huge leap back, especially when it was an emerging period of such exciting times. Europe was emerging from the Middle Ages into the awakening of the Renaissance and flowering of thought and inspiration. Florence was the largest city in Europe.

Into that milieu came this creation, whose destiny was to be ever-present on the world stage, more than just a bit actor – a shining star. For this man not only painted and sculpted major works of arts that are coveted by collectors worldwide, he was also a gifted inventor of machines, of diving suits, bikes, flying machines, war machines, water courses and constructed maps. How many individuals can we count as artist/engineer/scientist/philosopher/musician/inventor all at once? Yet all these attributes can be laid at Leonardo's feet. Leonardo was undeniably a genius, and not only of his time for there is still nobody to compare to him. His study of the human anatomy was the first of its kind and impressively accurate, and there was more, something which is not so well documented: he was a great thinker, a thinker of whom his later patron, King Francis I of France, paid due respect to.

> I must repeat what the king told me personally, in the presence of the cardinal of Ferrara and the King of Navarre. He said that never had there been a man who knew as many things as Leonardo, not only about sculpture, painting, and architecture but also about philosophy, for he was a very great philosopher.
>
> Benvenuto Cellini, *Autobiography*

To balance/counter that attribution Vasari, Leonardo's biographer wrote:

> Celestial influences may shower extraordinary gifts on human beings, which is an effect of nature; but there is something supernatural in the accumulation in one individual of so much beauty, grace and might.
>
> Giorgio Vasari, *Lives of the Artists*

This book is primarily concerned with Leonardo's thoughts and beliefs, which I am now convinced he incorporated, as Dan Brown opened my eyes to, in his paintings. Of course, how can anyone presume to know the thoughts and aspirations of others, and undoubtedly the evolution of Leonardo's must have been lengthy and torturous, but what I am sure of is his courage in the pursuit of those ideals. His convictions were self-evidently non-conformist, born maybe from his illegitimacy and subsequent free thought. Not only did he stand apart from the norm by being illegitimate, and think of the stigma that would have held for him, but he was left-handed, a vegetarian and latterly used to dissect dead bodies – anathema to the Church of the day. With that knowledge of him and a growing intimacy as my research has progressed, I have been gifted by an exhilaration as I have delved deeper and deeper into what he may possibly be trying to convey.

Again Vasari said of Leonardo that he had: 'formed in his mind a doctrine so heretical that he depended no more on any religion, perhaps placing scientific knowledge higher than Christian faith.'

Or in Leonardo's own words:

> Though human ingenuity may make various inventions, it will never devise any inventions more beautiful, nor more simple, nor more to the purpose than Nature does; because in her inventions nothing is wanting, and nothing is superfluous, and she needs no counterpoise when she makes limbs proper for motion in the bodies of animals.
>
> The definition of the soul I leave to the imaginations of friars, those fathers of the people who know all secrets by inspiration. I leave alone the sacred books; for they are supreme truth.
>
> Leonardo's Notebooks

I wish I could convey to you how thrilling it has been for me as I have felt a connection with him, one strengthened with each symbolic word I have found which has enabled me to open up a 500-year-old dialogue with one of the greatest thinkers and creators of all time. Is my translation of that script correct? I sincerely hope so, for my intuition feels it so. Will I be able to give a voice to his deepest-held beliefs? Well, in the pages that follow I will make a genuine attempt.

Am I 100 per cent certain that he painted this? How can I be? But I

honestly do believe this to be part of his school of thought and I am at liberty to feel that he is in this. There is evidence to bear me out; look for yourselves and see what you think. Then, if you will, stay on this road with me and join me in what lies ahead.

Fortunately for me, most of the authorities I have contacted have all subscribed to the notion that this is indeed 'of the school of' Leonardo, Lucy Whitaker of the Queen's Collection amongst them. But no one would take me seriously as to this possibly being his last commission. That mystified me, because everything pointed to the fact that it *was* a possibility. After all, Leonardo spent the last few years of his life in the Loire under the patronage of King Francis I, and yet surprisingly there was no painting attributed to him during that period. More than that, what I was discovering about the philosophy of the French kings and aristocracy of the time fitted with this portrait. Surely it made sense that the king would wish the great Leonardo to paint something for him. Miserably, most of the people I approached looked at my painting seemingly without the required knowledge to tie it all together. This is the problem I think: experts have their own speciality and tend not to leave the perimeters of that expertise. As an independent scholar I can go where the trail leads and harvest what I find. Then one man, a past director of Christie's Scotland, joined me in my assertion. Sebastian Thewes, once presenter on the *Antiques Roadshow*, graciously came out to my house to view the painting. He was the first who was so painstaking in his investigation of her. Methodically he examined her, then leant back and looked at me.

The suspense was tangible, then he said she was beautiful, of the period, but there were things that concerned him, namely poor restoration, which may have been good when it was undertaken (in the 1800s), but now detracted from her. Then again, to restore a painting in the 1800s would signify that it was of value, and to my mind it underlined the tickets on the back, which indicated that she had gone to Paris in the mid 1800s, from Italy, but more of that later. Some of the picture was beautifully executed, but some other parts not quite so. Yes, it was unfinished, and he could still see the under-drawing but then he concurred with me – yes, in his humble view, Leonardo's hand was in this. Not only that, he later agreed to go on camera to confirm it.

At last, someone with the courage and confidence to declare it! He advised me to send the painting to the Hamilton Kerr Institute in

Cambridge to be fully investigated, which is scheduled to happen in 2013.

So Sebastian Thewes, a man I much admire and trust, reaffirmed as others had done before him that the picture was early sixteenth century, connected to Leonardo (but this time more directly, possibly an under-drawing but possibly not the whole) and that the fleur-de-lys and location were most intriguing. Moreover, he reaffirmed what all other experts had said: namely that no picture had gone to auction bearing what this picture has, a papal bull attached to the back. You will discover more of this later in the chapter. Interestingly, the other point he mentioned was that the 'art world' would have been wary of me, someone outside the art establishment, making such fanciful claims, and that I would not be taken seriously as, in their view, I was not credible.

Funnily enough I had already come to that same conclusion!

As I discuss this enigmatic portrait of a Madonna (mother) and her son I would urge you to bear in mind that each symbol on its own is just a word in a sentence, it is that sentence which holds the truth, in isolation they are just words, together they form the story, the kernel of the truth that the artist wished to convey. Some, the scallop shell and the fleur-de-lys, encapsulate the essence, but others are less ambiguous.

As I have mentioned, Leonardo was evidently a great thinker, an idealist, and one who met the lions of men of the Renaissance stage but we have until recently taken his work at face value: as commissions and works in progress. The excitement of it all comes alive when you see what is coded in them, then with that script you start to look around and then amazingly you can see it reaffirmed in other mediums. That has been his personal revelation to me, and one which I will be forever thankful for; mine to him will be to try to convey to you what I truly believe was so evidently central in his life, and for him to know that the truth can now be spoken. Muffled at times but struggling for freedom.

What can I tell you that will help me do that? Well, we have seen his life had an inauspicious start: illegitimacy was born of sin and diabolical in the eyes of the Church. To this he added in later life the sin of being a vegetarian, of dissecting corpses and let's not forget he was also left-handed, which amazingly was still seen as wrong when my mother was at school. She is left-handed and it was known in her Convent school

72

as the devil's hand and those who 'suffered' it were schooled to use the right hand. (There is also the Devil's chord in music which the Church apparently deemed that we should not hear as it took us to realms outside their control.)

There was of course one other charge laid against Leonardo, again heretical and one which was punishable by death. This one though I reluctantly write of, for I feel that someone's sexuality is a private concern and none of ours. However, it has been levelled at Leonardo that he was a homosexual and that his male companions were his lovers. This unsettles me, for there is no proof or testimony to this and it is therefore a bogus remark. Yes he was arrested for sodomy after an anonymous accusation, but no charge was ever brought. He was imprisoned for a couple of months and for some time after that there is no record of his whereabouts. Evidently he was traumatised by the slur.

For my part I don't believe he was a homosexual and tire of sexuality being introduced into cameo portrayals. My view is that I believe after all these years that Leonardo's sexuality was most probably in line with his philosophy, that possibly the physical should be denied in pursuit of the spiritual. He was very possibly a neo-Platonist who believed in a divine love as defined in the *Symposium* (which was written by Plato and was a discourse on love) but it is our paltry interpretation that classifies that as physical, it is testimony to our lack of ideals that bids it so, but that doesn't make it true. In fact, I tend to subscribe more to the view of the fiction writer Javier Sierra in *The Secret Supper*, who alludes to Leonardo being a Cathar in his belief system. Cathars, again of whom more later, believed in dualism, ideally were vegetarians and adhered to a view that the ideal was to follow a spiritual path, a Gnostic one, where the physical was to be denied as far as possible. The Cathars stemmed from a belief system held by the Bogomils, who were Italian-based.

One thing though is certain, a charge was brought and this added to the line of his heretical profile. Indeed, Vasari, a biographer of Leonardo, said of him that he was of a heretical frame of mind, and my painting and that of *The Last Supper* would appear to back that up.

The philosophical soup of the time was neo-Platonic and most importantly one of Leonardo's friends was René d'Anjou, an Angevin who was a devotee of the beauty and grace of Mary Magdalene, and a man who urged the Medicis to scour the country for educational

manuscripts. Consequently, under his direction, Cosimo de Medici established a library of works by Plato and Pythagoras. Additionally, Leonardo's most stalwart of French patrons were King Louis XII of France and King Francis I of France, who also revered the brotherhood of chivalry in the Magdalene's honour. King Francis even christened his daughter with her name. It would surely follow therefore that the painting I investigate subscribes to that lineage of thought. Bear with me, for all my fallibilities in conveying it all to you. You will hear more of René and King Francis I for they are central to this fascinating story.

One of the points in my investigation is that Leonardo is known for leaving his works unfinished and my painting is certainly not complete: there is a blank area to the right of the left of Mary's shoulder. This added to my hypothesis at an early stage that this could be a further indicator that it was by his hand; after all, he never completed *The Adoration of the Magi*, *St Hieronymus*, *The Battle of Anghiari* and a sculpture of a horse. Yet though it added to my catalogue of thought, I think that what this blank area testifies is that something happened for the portrayal to have been aborted. One can still see the under-drawing in places and I think it shows that the artist focused on relevant data, focal points as imperatives. That time was running out, if you will, and this would back up my view that it was a last commission: Leonardo's Last Commission. It is conjecture and will remain so, but circumstantially I hope to prove to you that it makes sense.

As I started this exciting journey with obvious trepidation in entering new uncharted waters, I held to me the knowledge that symbolism was part of art, and that nothing was ever placed in a picture at random, but always with intent. The language of art had been in my core since I was a child. Every picture does tell a story, but I never imagined they could be so dramatic. I have quizzed myself continually, and still do, as to the validity of what I place before you. As a non-academic I can't just present to you, I must attempt to convince you. At this stage, as we now journey on together, I would ask that you place any contempt of my vision to the side until you have appraised the whole. Contempt prior to my whole investigation would invalidate seven years of concentrated effort, effort that I would not have continued without just cause. That is a big ask I know, and I appreciate your patience. This is a difficult road I am asking you to embark on, but if we walk together we can shake the truth free of what has lain too long at our feet.

Remember, this is a man of extraordinary talents. His vision lives on and is one he would want to share.

Please cast your eyes back to the portrait. In one of my inspired moments I found when looking at my painting you automatically take a lead from the mother, following her eyes to her son. Notice, too, how her head is inclined a little. For some reason, I decided to take a tracing of the controversial figure seated beside Christ in *The Last Supper*. Remarkably, the tracing matched exactly with the outline of the woman in my painting. Not only that but both postures match Leonardo's own instructions on how to draw a woman: 'Women must be represented in modest attitudes, their legs close together, their arms closely folded, their heads inclined and somewhat on one side.' (Leonardo's Notebooks, 'Human Figures'). The head complies with that directorate and matches the posture of other models he has used, the legs aren't visible and the arms hold her child.

The majority of academic opinion dismisses the notion that the figure in *The Last Supper* is even a woman. Yet what my tracing shows is that both figures share the same facial contours. Mine is undoubtedly feminine, so I would submit that so too is the figure in *The Last Supper*. Maybe they are even intended to be the same person, the younger self in *The Last Supper*, aged a little through torment and motherhood in mine.

Staggeringly for me, I also discovered some time later that the profile matches another profile painted by Leonardo, that of the central figure in the *Madonna of the Rocks*. What electrified me about this observation was that they shared more than just matching profiles. Look at the hairlines in all three pictures. Do you see the V in the mid-hairline? It doesn't run on to form a parting; it is just a simple V. (Following that revelation, I checked other paintings by Leonardo and have not found any other which shares that trait.) What is he telling us by that symbolic sign? I don't know but, importantly, for me that is definitive proof that these works could surely all have been painted by the same hand: Leonardo's. Same profile, same V.

In *The Da Vinci Code*, as well as in several non-fiction sources, this is the archetypal symbol for the vagina, chalice, womb and female sexuality. The 90-degree angle that can be drawn between Jesus and Mary Magdalene in *The Last Supper* suggests a 'V' or Sacred Feminine.

Look now at the foot of the boy child. See how the second toe is longer than his big toe? This is a classic feature of a certain school of

artists, Leonardo amongst them. It is a highly significant symbol and one that has been largely ignored. None of the experts I have personally spoken to at Sotheby's have ever noticed it, and in no books that I have read is it ever alluded to. It falls into the same remit as the V in the hairline of our mother, that of the *Madonna of the Rocks* and the controversial figure in *The Last Supper*. I believe that the symbolism related to the toe must be an important one, as it is a rather obscure genetic trait that affects a small percentage of the population. Many believe it to have royal connections and it can even be found on the feet of the Statue of Liberty and dates from an idealised Greek form. Whatever it signifies, it is a genetic key and a link which evidently held significance for Leonardo, as he even made a study of it, for the foot of Christ in *The Last Supper*. That sketch now hangs in the Royal Library at Windsor Castle. It is also seen clearly in the *Madonna of the Rocks* and in other of his works. Not all, though; he is definitely conveying something to us by it.

René d'Anjou

Other authors have concentrated on the esoteric side of Leonardo da Vinci and one of these was Laurence Gardner, who in *Bloodline of the Holy Grail* introduced me to other players on the Renaissance stage who were new to me and gifted me with enlightened connections between René d'Anjou and Leonardo.

As we have already seen, René was a member of the Angevin family, but according to Baigent et al., he was also aligned to the Rex Deus family. This is Latin for 'King God', and in *The Holy Blood and the Holy Grail* they make the connection to its association with the European branch of the bloodline of King David, and the line they affirm is supposedly protected by the society called the Priory of Sion. This loops back to the fleur-de-lys, which the Priory of Sion takes as its symbol – the starter's pistol to my initial research.

This Rex Deus line included Jesus, Mary Magdalene and their offspring, and it is easy to envisage that the spring that burst forth from their genetic inheritance as their progeny must by now be a flood that washes our entire planet. As they had wished, they have peopled the Earth, but this too is being kept from us. What a miraculous concept to comprehend. Just think of it – Jesus and Mary may well have by now peopled every corner of the Earth, black and white, on this chequerboard of life, and all the colours in between!

The body that protects that knowledge and the philosophy it carries with it I have come to believe has morphed from group to group, or brotherhood to brotherhood, to evade persecution and demise. Most importantly, their knowledge has been passed subversively into cultures in the form of stories and games, a notable example being the Arthurian legends and grail lore. Latterly, I would even add Michael Baigent to that tradition, in his informing this generation of the truth that should be known. As a Freemason, he is privy to that underground stream of knowledge which I believe they are releasing into the public domain little by little in their continued orchestration of this exquisite truth.

Born in 1408, 'Good King René', as he was known, was one of the most influential personalities of the Renaissance period. One of the many things that interested me about him in the context of our painting was his association with Leonardo da Vinci. It was René who revived the ancient Order of the Crescent, which had been founded by Charles I of Naples and Sicily in 1268. It was a chivalrous brotherhood that in many ways could be compared to the English Order of the Garter, which was and still is the highest order of chivalry in the British Empire. Both these orders were established on esoteric principles and knowledge, both revering the feminine. This is where, according to Laurence Gardner, René d'Anjou invited Leonardo da Vinci to join the Order, thus forming an enduring connection between them.

These two Renaissance men presumably forged close ties and were, unsurprisingly, affiliated to yet another order, that of the Priory of Sion, the controversial organisation dedicated to the safeguarding of the royal line of David. At various times, both men were figureheads, both men sharing the same honour and duty, that of securing and protecting the sacred destiny of their charge.

As Laurence Gardner points out in his book, *Realm of the Ring Lords*, René d'Anjou was deliberately excised from the history curriculum in schools and other places of learning by the Church, which approved or censored all subjects of study within educational establishments. I am not sure exactly why that would be. René was a man with pronounced gifts for painting, literature and philosophy, and was apparently generous, chivalrous and illustrious. I can only think that it must have been his knowledge, his philosophy, which caused the Church to disavow him. In addition to all these accomplishments, he was also a great fighter, with large land holdings in Anjou, Calabria and Lorraine, and was Count of Bar, Guise and Provence. Quite a formidable

man, who is also to be remembered for giving Christopher Columbus his first commission and for allying himself with Joan of Arc. While some commentators believe that he and Joan were lovers, one thing which is certain is that he was at her side at the siege of Orleans.

Much lesser, dimmer historical figures than King René have attained lasting renown. Yet even today, schools teach little of him. I certainly had not heard of him and when researching didn't find much about him. Certainly, it would appear from his involvement in esoteric knowledge that the Church may well have considered that his colourful philosophy would be better kept under wraps.

In the context of this book it is relevant to note that in 1439 René formed the Order of the Fleur de Lys. This order, bound to the French nobility by its association with the Fleur de Lys, was composed, surprisingly, of a group of Scottish knights who had fought with the French against the English. The reason for this will become clearer in later sections, for as we shall see, this is not the first or last that we shall see of the Scottish involvement in this extraordinary story. This was just a further underpinning of my growing thesis, for to demonstrate their allegiance to the French cause, they wore the fleur-de-lys emblazoned on their left breast to signify their shared knowledge of the significance of the symbol and the Scottish commitment to this Magdalene story. As far as I could find, they also fought with Joan of Arc at Orleans.

In about 1840 the Earl of Eglinton, a Scottish aristocrat from one of the few families entitled to bear the fleur-de-lys in their heraldry together with royalty, and the then Sovereign Grand Commander and Grand Master of the Masons, rewrote the statutes of the Order of the Crescent, transforming it into a private order of chivalry, which it remains. (The Earl of Eglinton is a Montgomerie, and to this day the holder of the title is a leading Freemason. Accordingly some of the earliest Masonic texts are the Eglinton Papers.)

For me, it would make a certain sense that over time, given their shared interests and passions, and given the fact that Leonardo was made a Knight of the Order of the Crescent, he and René could well have become close friends, and it was that thought that prompted me to wonder whether Leonardo ever stayed with René in Aix. There is no known record of it, but I feel that it is highly likely that Leonardo would have stayed in Provence at some stage in his life. For that very reason, it has even occurred to me that maybe this painting was executed or sketched by Leonardo en route to Amboise, where he

took up a place in the court of Francis I. A commission by René? It could be, or equally a gift for him, but I think not, though I certainly would not be surprised if René had some involvement in it. Conjecture, I admit, but it is my luxury to be able to indulge in imaginings once in a while. The question does, however, hold a certain resonance as a possible further piece in a puzzle that is taking shape and slips into the frame of Leonardo's last years, when he left Italy to go to France as court painter to King Francis I. Admittedly the piece needs pressing home and is a little fanciful, but in that vein here is my last indulgence: could it even be that the portrayal of John the Baptist in this painting is a young version of René? The likeness to him as portrayed in a triptych in the cathedral in Aix is compelling. Same squat features, rather bunched up, even a little ugly, but not in a bad way. One thing I do know is that patrons often wished to be portrayed in their commissions, usually as gods or saints. King Francis I was painted as Mercury and as John the Baptist, and Louis XIV was portrayed as Apollo, the Sun God. Again fanciful, I agree, but once one starts to question things the synapses fire, and where there is a potential connection I feel it should be noted. Some blind alleys are bound to invite exploration. That holds no problem as long as the investigator can retrace and reassemble their facts accordingly; it is the light of investigation that is the imperative, and key to unravelling the knots of misinformation that have tied us for generations.

As we will discover in a later chapter, René d'Anjou had a strong alliance with William St Clair of Roslin, a Knight Templar and leading Freemason who was associated with the building of the famous Rosslyn Chapel in Scotland. For those of you who haven't heard of this fabulous building, it is an extraordinary testament to man's commitment to communicate and one which has been described as a Masonic secret relayed in stone. Here once again we have a loop back to other components of this amazing story, because it was also a St Clair who captained one of the Templar ships that escaped from France during the Order's persecution by Philip IV; he landed the ship on the Isle of May in the Firth of Forth. Rosslyn Chapel will come into its own later in our story.

Amongst his many talents, remember René d'Anjou also had a profound influence on Cosimo de Medici, another of Leonardo's patrons, who, with René's encouragement, dispatched agents all over southern Europe to retrieve ancient manuscripts. This is why the

Renaissance was so electric, there was a retrieval of knowledge, an awakening to the imperative of knowing, of connecting with our past, and that knowledge is, I feel, as relevant now as it was then. Perhaps even more so.

Cosimo commanded that the University of Florence teach Greek, and was responsible for setting up an academy for the study of ancient Greek philosophy. He also established Christian Europe's first public library, the Library of St Marco in Florence, and this all bears testimony to René d'Anjou, because for the first time, books (and the ability to read them) were becoming widely available and knowledge was set free and able to nourish the populace at large.

As I have already mentioned, René was also a painter, and Arcadia was one of his favourite themes – the symbol of a Grecian paradise. In one picture he even portrayed himself standing next to a gravestone that bears the inscription 'Dagobert's Revenge', another unifying thread to tie in with *The Holy Blood and the Holy Grail* and the Priory of Sion enigma that Baigent et al. explore. They postulate that Arcadia and its depiction may relate to some very factual information, a secret of some sort, and that this secret may be the Christos bloodline. Indeed, in keeping with that thought, René's reference to Arcadia is often symbolised by a fountain or a tombstone. This can be seen in his painting *Le Fountaine d'Anjou*, as well as in two of the illustrations from his illuminated manuscript 'Le Coeur d'Amours Espris' (The Book of the Heart Possessed by Love). There are many mysteries that centre on Marie de Blanchefort, all of them echoing elements of the Mary Magdalene story. What an enigmatic and central figure she is to the whole mystery that is interwoven into Rennes-le-Château for it was her headstone that bore the tantalising code of Arcadia and hint of the Priory of Sion which Michael Baigent et al. investigated in *The Holy Blood and the Holy Grail*. Nobody can deny something is going on here – pointers to a Golden Age of Knowledge. The relevance to this theme ties in with another strand in our story and aligns it with southern France and Rennes-le-Château. This will become clearer later. For now I must just remain with our literary siren René and more of him.

This gifted man was also an accomplished poet, and amongst his literary works are 'Battles and the Order of the Knighthood' and 'The Government of Princes', which exists today in translation in the Rosslyn-Hay Manuscript in the National Library of Scotland. Its

leatherbound oak cover bears the names 'Jhesus, Maria, Johannes' (Jesus, Mary, John).

René, as previously mentioned, was, like Leonardo da Vinci, a member of the Priory of Sion, the organisation controversially cited as having been formed to protect the holy bloodline of Christ. For the Angevins, as we now know, being her knights of guard, believed that Mary Magdalene carried the royal bloodline, by her consummation with Christ and the birth of their child. Not that absurd to me now and something I too subscribe to.

The Priory of Sion

At this juncture it is important to elaborate on the Priory of Sion. It would appear to me following my substantive research that it did indeed exist and was founded by Godfrey de Bouillon (1058–1100), Duke of Lorraine. Not surprisingly, in my opinion, it has been discredited, for obvious reasons, but I think it holds true. For *The Templar Revelation*'s authors the connection of the Priory's Grand Masters is too interconnected to be dismissed. Dismissed it has been by those who wish to discredit the whole bloodline controversy, but the links that track back over time are still intact and form another connection to guide us out of the confusing labyrinth of deception that we have been enmeshed by. According to Picknett and Prince and others, the founder was Jean de Gisors (born 1133, Grand Master from 1188 until his death in 1220), a leader of the First Crusade that recaptured Jerusalem – and who was of the Merovingian line. A line associated, as we know, with the lineage of Christ and Mary Magdalene.

I discovered from my reading of Picknett and the massive evidence put forward by Baigent et al. that the Priory was originally known as the Order of Our Lady of Sion and soon after the capture of Jerusalem, an Abbey of Sion was built there on Temple Mount. Its occupants were known as the Order of Our Lady of Sion. Five of the nine original Templars were members. In the view of Colin Wilson, a notable author in this subject, it is probable that the Templar order sprang out of the Order of Sion. When the Templars were persecuted in 1307, the Priory continued to exist, but in secret.

Yet again this painting bears testimony to the belief about the true facts of Mary Magdalene and her child, and of her importance as the symbol of the Sacred Feminine and carrier of the bloodline of Jesus

Christ and, more, of the teachings that have been kept from us and which I will be revealing to you.

Apart from the font which René d'Anjou donated to the cathedral in Angers, in which Mary Magdalene is believed to have baptised the ancient rulers of Provence, he also donated an urn that he had been assured Christ had used at the wedding feast at Cana and which had been transported to Provence with Mary. Why would she take the considerable trouble to keep this with her if it were not personally sacred to her? Yet surprisingly, given this, René's most treasured possession was not this font but a rock crystal wine cup, a loving cup if you will, from that same feast, on which he had engraved:

> Who drinks well
> Shall see God
> Who drinks at a single draught
> Shall see God and the Magdalen
>
> *King René d'Anjou and his Seven Queens*, E. Staley

Many believe, including the writer A.N. Wilson, that the feast at Cana was the celebration of the marriage between Jesus and Mary Magdalene. It would appear that René d'Anjou also believed this. We shall later see that the Scottish quaich, known as the loving cup, is a further symbol of this and one that I believe is recognised in the highest echelons of Freemasonry.

While I have now established some of the reasons for my belief that the painting might have been the work of Leonardo da Vinci, now it is important to connect him to the location of the painting, southern France. I have established he was an associate and friend of René d'Anjou who lived in Provence, but could Leonardo have actively visited that region, and set up his easel there to paint this, or at least to have noted it for future reference? I believe it is very probable that he did.

'Giuliano de Medici, il Magnifico,' Leonardo notes in the Codex Atlanticus, 'left Rome on the ninth day of January 1515, at daybreak, to take wife in Savoy. The same day the news reached us of the death of the king of France.'

The deceased Louis XII's heir was to be Leonardo's later patron, Francis I.

One of the first tasks the young King Francis set himself was to cross the Alps and take Milan. In July of that year, his army massacred the

Sforza army, that of Il Magnifico, and entered Lombardy in triumph. Francis was described as being over six feet tall, muscular and well built, with a strong face and laughing eyes. One could say he was tall, dark and handsome. When he took Milan, he wasn't even twenty.

Apparently, Leonardo was entranced by him, this man of whom the Venetian ambassador wrote: 'The Sovereign is so attractive that it is impossible to resist him.'

Their first encounter was to be the meeting between King Francis and Pope Leo, for which Leonardo had been commissioned by the papacy to create a mechanical lion. It could almost have been the first robot, for it strode forward a few paces to greet the king and then halted. On stopping, its chest burst open to reveal a bunch of fleur-de-lys – the emblem of France – according to Pope Leo's instructions. The lion was to represent the Pope bearing the heart of France in his breast. Even the papacy acknowledged the fleur-de-lys as the emblem of France.

The young King Francis was charmed and amused by the display. He, of course, knew of the renowned Leonardo and of the invitation Louis XII had extended to him to enter the French court, an invitation which Leonardo had declined. It is also likely that he knew of the warm relations between Leonardo and René d'Anjou, and that René had brought Leonardo into his Order of the Crescent, and possibly even of his affiliation to the Priory. The invitation to the French court was always open.

Eventually, on the death of Giuliano de Medici, Leonardo finally accepted his destiny and accepted yet another invitation, this time proffered by the young king, to enter the French court.

In the autumn of 1516, at the age of 64, Leonardo set off across the Alps and made for the Loire valley and the Château d'Amboise.

It was to be the longest journey of his life, lasting three months, and it was also to be his last. What an incredible adventure it must have been. Mules heavily laden with trunks containing all his best-loved possessions. Included amongst them were his paintings of the Mona Lisa and John the Baptist, and his various writings.

Were the king's emissaries at the side of his coach as they headed into the mountains accompanied by the sound of horses' hooves on stone and coach wheels turning? The last sight of Italy must have torn at Leonardo as he crossed the majestic skeletal vertebrae of the Alps. Would he see his academy again, could he conjure up the energy to

keep informing and instructing? In those three months of travelling, he must have been plagued with thoughts and misgivings. Were his words in the Codex Atlanticus, 'When I thought I was learning to live I was also learning to die' prophetic?

His companions were his protégés Count Francesco Melzi, the son of a Milan aristocrat who became apprenticed to Leonardo in 1506, and Gian Giacomo Caprotti da Oreno, nicknamed Salai or Il Salaino ('The Little Unclean One', i.e. the devil), who entered his household in 1490 at the age of ten. They must have been a great support to him for they were two fine young men with the energy and enthusiasm to bridge any misgivings he may have held at leaving his native home – and of course it was to Melzi and Salai that Leonardo was to bequeath all his works. Melzi wrote of him: 'He was the best of fathers to me. As long as I have breath in my body I shall feel the sadness for all time. He gave me every day the proofs of his most passionate and ardent affection.'

Talk must have filled the carriage. New ventures, the king. They had three months of meditation upon nature.

As for King Francis, he must have been thrilled to have finally persuaded this great artist to join his court. Benvenuto Cellini, the Florentine sculptor who worked beautiful commissions for him, one of special significance being of a gold scallop cup with a female sphinx handle, which ties in beautifully with what is covered in a later chapter, noted:

> King Francis was completely besotted with those great virtues of Leonardo's and took such pleasure in hearing him discourse that there were few days in the year when he was parted from him, which was one of the reasons why Leonardo did not manage to pursue to the end his miraculous studies, done with such discipline . . . I heard the king say of him, He said he could never believe there was another man born in his world who knew as much as Leonardo, and not only of sculpture, painting and architecture, and that he was truly a great philosopher.
>
> Benvenuto Cellini, *Autobiography*

Yet we are expected to believe that no painting was ever commissioned by Francis. Surely not? That would be incredible. It is true that in his travel diaries Don Antonio de Beatis, secretary to the Cardinal of

Aragon, made reference to Leonardo, an old man, showing him three paintings 'executed to great perfection' being in all probability the *Mona Lisa*, *John the Baptist* and *The Virgin with St Anne*. By this time in 1517, he says the artist could no longer paint, 'for he is paralysed in the right arm' but that he had a very well-trained pupil from Milan, that being Melzi, who worked wonderfully under his instruction. Even so, there must have been a commission, whether by Leonardo in entirety or with the assistance of his companion Count Melzi – after all, he was left-handed and so would not have been absolutely encumbered by a right-sided immobility. He was, in the view of Beatis, still able to draw, and Leonardo certainly would not have been able to countenance the prospect of doing nothing. 'Iron rusts when it is not used,' he wrote in one of his notebooks, 'stagnant water loses its purity and freezes over with cold; so, too, does inactivity sap the vigour of the mind.' On the corner of one page of his notebooks in about 1518, he wrote plainly: 'I shall continue.'

I believe the friendship and philosophies Francis and Leonardo shared were set in oil with this painting. A commission which said it all and spoke for both of them. And one which was to be his last. Leonardo da Vinci's last commission. An inevitable commission by a king who wanted his lineage to be portrayed by arguably the greatest artist and thinker of all time – Leonardo da Vinci.

Whether Leonardo had been to Aix before, perhaps staying with René d'Anjou, there is no record, and whether he and the king ever stayed there is again an unknown. Maybe they even met there and travelled on to the Loire together. I can imagine Leonardo setting up his easel to sketch the hills of St Victoire, the smell of strong cheese and wine to wash it down. The song of cicadas, the scent of wild herbs.

There is even the slim prospect that Leonardo maybe painted this for René d'Anjou and that it is a young René portrayed as John the Baptist. I mention this as an alternative to the king having commissioned it as I feel there is a likeness between René as portrayed in the triptych in Aix Cathedral to the young John the Baptist and because of course they were old friends in arms sharing the same ideals and beliefs. Perhaps one day we will discover the truth of the matter, and we may even be able to pinpoint the exact location of the painting, maybe if the tree depicted in it still stands. What a beguiling thought. The weight of the evidence though falls to its being a commission of the king.

Once in France, Leonardo became the inspiration to a chivalrous king. He wrote in his notebooks: 'Alexander and Aristotle were teachers to one another. Alexander possessed the power that allowed him to conquer the world. Aristotle had great learning, which enabled him to embrace all the learning acquired by other philosophers.'

It was this union of king and artist, friend and mentor which was to create the architectural design by Leonardo of the double helix staircase that would inspire those of Chambord and Blois. The double helix which represents the then supposedly unknown structure of our genetic DNA. The double helix which was also to be seen in the crafted Apprentice Pillar of Rosslyn Chapel in Scotland. A form known only to the initiates of the knowledge, the mysteries. Strangely, also the symbol of the genetic knowledge bound in our DNA.

With unbounded energy, Leonardo orchestrated grand pageants and spent time on geometric games. Games which would lead to further architectural studies of rose windows, or lunettes. To these forms he put the name 'Abstractions'. On a note on one of these drawings he ends a paragraph with 'et cetera' followed by his explanation: 'because the soup is getting cold'. The soup referred to was probably his favourite minestrone which Mathurine, his cook, used to lovingly prepare for him.

Some would counter that Leonardo had a leaning toward the beliefs of the Rosicrucians, a body also affiliated with the Priory, Freemasons and hermetic thought. In one sketch for Charles d'Amboise, then Louis XII's prime minister, Leonardo sketched a compass with its needle pointing at a sun with three fleurs-de lys and the motto: 'Who points to this star does not rotate'.

Rosicrucianism is yet another philosophical secret society, which was founded in late medieval Germany by Christian Rosenkreuz. Its roots are colourful: Rosenkreuz, apparently Christian, was an alchemist who inadvertently stumbled on ancient secrets which he confided to seven other men. An oath was made that they would keep the secret for 100 years. The Rosy Cross symbol is said to hold the secret, if analysed correctly! I leave you to make your own interpretation. It appears to me to be very similar to the belief system of the Freemasons and much aligned to them. There is undeniably a magic which runs through Rosicrucian thought which unsettles me. I have contacted them on various issues for they, like the Masons, are a vault of secret esoteric knowledge and unlike their counterparts welcome women into their

fold. They have at all times been most helpful, though often as not rather silent on certain issues. I even, at one time, thought of joining their ranks; and still do, though fear being limited by their boundaries. No, I prefer being a free thinker.

For Leonardo, this image was a metaphor: the sun was Apollo, the royal bloodline a symbol of Godly authority. This was one of the reasons why Louis XIV took the title the 'Sun King'. Leonardo also made another sketch which reinforces this belief, of an allegory of the wolf and the eagle, which again includes a compass. The rays that emanate from the eagle (wearing the French crown with the fleur-de-lys) are meant to guide the uncertain voyager, the wolf. The compass is also, of course, a well-known Masonic symbol.

We must bear in mind that Leonardo had mixed with the leading thinkers of his day. Lorenzo de Medici's court in Florence had been a hotbed of ideas, some of which were later branded heretical by the Church. Imagine the philosophical climate, the renaissance of ideas, the resurgence of debate. There was strong interest in Jewish culture and esoteric Hebrew texts that came to Florence when Lorenzo's grandfather Cosimo allowed Jews into the city. Indeed, René d'Anjou included Jewish cabalists in his court as well as astrologers, and even the physician Jean de Saint-Remy, grandfather of Nostradamus. Christopher Columbus was also a member of his court for a while and, as mentioned earlier, it was René who gave him his first ship's commission to Tunis. What sessions these must have been, what a delight of intellectual debate, rancour and discovery.

It is my view that in a shared venture, Leonardo and King Francis I set out to scale the ladders and bricks of air of religious dogma which had been set up to create the historical record to date, and to rebuild them to define the truth. The truth being that of Mary Magdalene's actual role in the life of Jesus Christ as the Sacred Feminine, and that they had a child, maybe even more than one.

The fleur-de-lys had to be central to this, for it was a sign of King David and the royal bloodline. It defined the French lineage, for France is where it first bore fruit. That vine then spread and blossomed forth, the roots forming a foundation to our global matrix growth.

The seed of Christ mercifully did not die at the Passion, but flowered.

The picture I am asking you to consider is, I believe, a profoundly heretical masterpiece. No artist would have accepted the commission

unless they had a powerful patron like the king of France and the assured safety of the French court, or that of the likes of the Good King René d'Anjou.

Leonardo da Vinci was part of the elect and would fulfil the commission happily. If not him, then certainly an artist schooled in the esoteric teachings which he believed and espoused.

There is another expert who has contributed to my confidence in my instincts about this painting. He is an artist, art historian, broadcaster and conservator who also agrees that it bears Leonardo's hand. The number is growing and with it my confidence that finally after 500 years a lost Leonardo has come to light to confide in us.

Before we look at the back of the painting, which is almost as intriguing as the front, I want to leave you with this tantalising find.

If you wouldn't mind taking another look at the painting: we have already discussed the V in the Madonna's hairline, and the implications of that being a sign of the Sacred Feminine, the V symbolising the vagina, the female pubis. I am a novice in Sacred Geometry but do know that Leonardo adhered to it, so I thought I would take a mathematical appraisal of the picture. I am glad I did, because can you see any other geometric signs?

No, nor could I, initially, but now it is blatantly clear and so cleverly camouflaged. It pulls all the major components together. Have you spotted it yet?

If you haven't then follow St John's cross down to the dead wood and the lamb. Now you have it. It forms a perfect angle of 45 degrees with the neck of the lamb; then follow it up past the genitalia of Mary's baby to her neckline.

Perfection. The artist has encompassed all that he would have wished for. The Sacred Feminine, with her child in the chalice of the V, Christ's child; the holy grail.

Now take another angle of 45 degrees from the cross-bar of the cross; it skims the Church of Aix, one associated as you will recall with the Knights of Malta, to align with Mary's ear. There will be more I dare say, and something you can have fun with; please let me know what you find.

Nobody, no art expert has commented or observed this, nor the hairline, nor the second toe.

Now to gripping evidence which shows how very important this painting is and was held to be in the sixteenth century by the Vatican

itself. It is time to turn the painting over and look at the back of the wooden panel.

The papal bull

What I am about to deliver up to you underscores the significance of this work of art. It is, from what I have established, unprecedented and begs the question: what work of art would have merited such a thing?

On vellum in faded ink on the back of the painting is a papal document! It reads:

Nomine Sanctissimae Individuae

Paulus episcopus servus servorum Dei . . . Camillus

According to all those I have contacted this is standard wording for a papal bull. That was fascinating, but I had no notion as to really what a papal bull was, except that of course it must hold a special significance of some kind. In fact it is a special type of letter or charter issued by a pope, who I was to discover was in this case Pope Paul V. Originally it was used for all kinds of public communication but, importantly in relation to the picture, after the fifteenth century it was only used for the most formal or solemn occasions. Given that information, what doubt could anyone have of the provenance and importance of this portrait and the message and history it carries with it? For me it is almost as important as the actual painting, for with its inclusion in this story the plot truly thickens. You will need a magnifying glass, but come with me as we try to figure this out.

To the left is an *impresa* or motif with the word 'immobilis' underneath it. There is also a pillar, crossed keys, a cord and centrally there is an acrostic with letters ciphered. It is hard to make out, but one can discern one line running diagonally which appears to be the letters IESU. Frustratingly, to date nobody has been able to identify which office this emanates from; not even the Vatican has been able to help.

The very fact that nobody has seen the like before adds to the mystery of all this. Why was that? Was it because only a small number were ever issued, or have ever seen the light of day before, or was it personal to the Pope, his office?

In trying to find out, I have contacted the leading authorities on

papal documentation. They have all been very helpful but it does still baffle me as to why the very institution that should know, the Vatican, feigns ignorance as to what the *impresa* signifies. How can it be that they don't have some resource or record about the seal? Could it be that they don't want to divulge its source?

> Unfortunately, that motif is completely unknown to me. Neither would I know where to search: there is no repertory for those kinds of device. A very old scholar who used to work for the Vatican Library would probably have known, but he died two years ago and took his memories with him to his grave.
>
> Sorry.

<div align="center">Dr Massimo Ceresa, Reference Librarian, Vatican Library</div>

Everyone I have contacted is fascinated. Here is a missive from Diane Apostolos-Cappadona, Professor of Religious Art and Cultural History at the University of Georgetown:

> I have done some preliminary work with my colleague, John O'Malley, S.J., a specialist on the history of the papacy in terms of your painting. Now we are at a disadvantage as I am sure you are aware because we are working from the jpg e-file you sent us. However, from your description of the text on the back of the wood panel, and after some consultation in a variety of Professor O'Malley's and my books on the history of the papacy, emblemmata, and iconography, we have determined the following:
>
> 1. The inscription more likely than not reads 'In nomine sanctissimae individuae Trinitatis . . . Paulus episcopus servus servorum Dei . . . Camill . . .' with the letters after the cipher(?) being IESI;
>
> 2. We are venturing the following as evidence that the reference is to Pope Paul V (whose name was Camillo Borghese) who served as Bishop of IESI (St Eusebius) from 1597 to 1599, hence also 'Paulus episcopus', while the phrase 'Paulus episcopus servus servorum Dei' refers simultaneously to his being Pope. Professor O'Malley confirms that only a Pope would sign with the phrase 'servus servorum Dei'. Additionally the cipher[?] you describe (and which we cannot see) sounds to us both like a papal emblem/

design, especially the two crossed keys (tied?) with a cord for St Peter, however this could signify either a pope OR one who holds a papal office which Camillo Borghese did from the time he became a cardinal in June 1596 when he was named both cardinal AND cardinal-vicar of Rome as well as his service as Arch-Priest of Santa Maria Maggiore and as a canon jurist.

I am also grateful to Professor Simon Ditchfield of York University:

I'm afraid we have not come to any conclusive solution but believe that we have made some progress and identified some pointers for further inquiry. As you say, the text contains the classic phrase beginning a papal bull/indult or brief and Paulus episcopus servus servorum dei must be either Paul III Farnese or Paul V Borghese (Camillo was of course the birth name of that pope and a reasonably common name in that family). Of course, these do not tie in chronologically with the image – which my colleague thinks is stylistically similar to Piero di Cosimo (particularly in its treatment of landscape). I am afraid that my palaeographical skills are not acute enough to date the inscription simply from the calligraphy – though this kind of officialese was written in a v. formulaic/conventional way that would make it difficult to date anyway.

The real puzzle, where we've had most fun, but without resolving anything conclusively, is the *impresa* at the end on the left. It appears to consist of a column surmounted by the papal crossed keys (which are joined at the bottom by a cord of some kind). In the centre there is what looks like four diamond-shaped squares surrounded by interlocking circles containing letters (some kind of acrostic?), two of which would seem to be an 'F', one an 'E' and the other a 'G'. At the bottom, on a scroll, is the word 'immobilis'. As you know, columns were often used to stand for the virtue of faith so that read this way the emblem would mean something like steadfast in faith. I have had a look at a book of cardinals' crests for the sixteenth and seventeenth centuries (Giovanni Sicari, STEMMI CARDINALIZI whose crests are taken from Giovanni Palazzi, FASTI CARDINALIUM, Venice, 1703) without, however, coming across anything like it (the column for the Colonna family looks different, by the way). In order to identify this *impresa* or emblem one would

need to look further at buildings, art or manuscripts commissioned by the Farnese and Borghese. In the case of the former, the Palazzo Farnese in Rome and that in Caprarola (particularly the latter) make extensive use of *imprese* – many of which were designed by Alessandro Farnese (Paul's grandson's) secretary, Annibale Caro. In addition, one could also have a look at papal medals (which were issued to mark important events during pontificates). My final suggestion would be to see if immobilis as a motto appears in Forcella's ISCRIZIONI NELLE CHISE DI ROMA – which I have not used myself so don't know how user-friendly it is. I am sorry I/we can't be more helpful but hope that these thoughts are not completely useless.

Unfortunately I couldn't find the *impresa* in the work he mentions. In a later email he agreed that it was highly likely that it was connected with the Secret Archives.

This from Professor Robert Swanson of Birmingham University:

I don't think I can be of much help. At first glance my response was 'There isn't really enough of the bull remaining to make anything of it: what you have is simply a fragment of the heading (in full, and in translation, '[In] the name of the most holy and undivided [Trinity] . . .'), with part of the address clause from Pope Paul (which? to whom?). 'Camillus' would be wrong as part of the address, though, if it is intended to be a Christian name, because the case is wrong – but I can't make out what it might be instead. I've just tried blowing up the picture a bit more. There seems to be '[I]MMOBILIS' under the mark at the right – heaven knows what that is for. On second thoughts, the fragments don't actually look like a bull, because there's no sign of any writing lower down – unless it has all been scraped off. I'm not entirely convinced of the reading as 'Camillus' either – the end looks to me a bit like '-ijs', but all very indistinct. In the end, flummoxing! NB: what's intriguing is that this is on the back of the picture: might it be a label of ownership ('property not to be disposed of?'), or even a certificate of a gift from the Pope to whoever?'

Robert Swanson and Dr Simon Ditchfield of the University of York are two of the most renowned authorities on papal documentation. Robert

Swanson is a medievalist and Dr Ditchfield is an authority on the Italian Church in the sixteenth century. Consequently, for them to be in the dark about this bull adds to its intrigue. My hunch? Well, that it is to do with the Secret Archives that Pope Paul V instigated, and that it is for that reason that experts are unfamiliar with it, and why the Vatican is reluctant to elucidate on it.

Dr Barbara Frale of the Vatican has confirmed to me that it can be attributed to Pope Paul V. She is the noted academic who discovered the lost papers issued by the Vatican absolving the Templars of heresy.

So nobody has seen anything like it before – that in itself is staggering and frankly, in relation to the Vatican, hard to believe.

Pope Paul V

I should make clear at this point that not all of the aforementioned authorities realised that the papal bull was attached to a painting. I wanted to see what their views would be without knowledge of what the document was attached to.

As we have seen, some postulate that it signifies a gift from Pope Paul V to a church. Yet it is worth bearing in mind that it was Pope Paul V who instigated the Secret Archives, a repository for his personal possessions and documents, for his eyes only and a location which today measures 52 miles of shelving! He also condemned the oath of allegiance of James I of England, twice, and met with Galileo Galilei and had him warned not to hold or defend the heliocentric ideas of Copernicus, that is that the Earth orbits the Sun.

So let's return to the consideration of this intriguing bull. It is, as acknowledged by the world's experts, a rarity. So, what does it all signify, must be the next question; could it indicate that the painting was intended as a gift? Maybe, but if, as I believe, the portrayal is, to say the least, heretical, surely its being a gift is out of the question. Then what on Earth does it mean, how does it add to or distract from this mystery? Well, it could indicate that this painting was seized and placed in the safekeeping of the Church, even that this painting could at some stage have been held in Pope Paul's Secret Archives. But this would beg the question, why didn't he just destroy it? Could we assume that he didn't destroy it because the artist who painted it was too well known and revered?

Whatever the truth, one thing is certain. This is no ordinary painting. It has undeniable associations with the French court, and the

attachment of an extremely rare papal document must surely signify that this work is of staggering significance, not only to the art world but also for our knowledge of our past.

Consider this: there are miles and miles of works in the Vatican which we are forbidden to see, and consequently endless speculation as to what lies hidden there. For me, the fact that this painting wasn't destroyed suggests that whoever painted it was of such eminence that it couldn't be destroyed. If it was a gift from Pope Paul V, then its provenance must have been exemplary and one which he could personally endorse. If it was heretical, well, it is one of the rarest works of art to have seen the light of day.

It is therefore no wonder that I have become more convinced that this simple portrait of a Madonna with her child is what the world has been waiting for: tangible evidence of the bloodline of the holy grail, that of the consummation of Mary Magdalene's and Jesus's love, and of the birth of a son.

Yet it is even more than this, for it is a portrayal of Mary Magdalene in her true role: that of a symbol of the Sacred Feminine, the goddess who has been so expertly erased from our psyche.

The Journey Continues

The papal bull is not the only attachment on the back of this 500-year-old painting. One of the other items is a wayfaring ticket with the destination of St Michel in Paris via the chemin de fer (railway) 1856 from Da Torino, the number 23 and Parigi. Part of the papal vellum seems to have been torn away to make way for these labels and what was lost we will never know. There is some indecipherable writing that I recently studied afresh with the aid of ultraviolet light. It is too difficult to read in its entirety but what I could discern was the word 'Madalena'. Madalena is Italian for Magdalene. I had never appreciated before that this was not separate from the bull but attached to it. How exciting that this sepia writing is in fact part of the more ornate titular page. If this is indeed part of the bull, the word Madalena written there, if it is Madalena, confirms the thesis of the whole investigation and also why the bull would have been attached. This was and still is a heretical work; the Pope had this bull posted to the back of it for a very significant reason.

However, for now there are more tangible facts to examine. What we know as fact is that this painting travelled from Italy to France in

the nineteenth century. One can only imagine her travels but as I have argued above, I imagine that this work started life in France under the protection of the French court. No artist would have dared create such an overtly heretical work under the gaze of the Vatican. It surely could only have been undertaken as a commission and for the commissioner's eyes only.

For me, and for the art experts I have contacted, the painting derives from the school of Leonardo. The potential backdrop of Aix suggests that it is likely to have been painted in France and if my theory as to the relevance of its content is correct then surely it would have to have been painted by an initiate of the heretical knowledge it contained.

It is therefore not too much of a leap to imagine that it could have been painted by the hand of the Grand Master himself, Leonardo da Vinci. It is worth bearing in mind that a number of his works have only relatively recently come to light, the most recent being the *Salvator Mundi*, recently unveiled at the National Gallery in London, and overall there has been, relatively speaking, very little attributed to him. I also hazard a guess as to whether the image of John the Baptist could be a youthful portrayal of Francis I. The king loved being portrayed in godly roles, once as John the Baptist by Jean Clouet and in another as the god Mars. It is not out of the question that he would have liked to figure in this. A young John the Baptist to balance the older version of Clouet's. Certainly, as mentioned earlier, John does bear some resemblance to the king, but another candidate could be René d'Anjou. I include him in my theorising because of his allegiance to the Magdalene; it's purely conjecture, and maybe a fanciful one, but there is a similarity between René and the figure in the painting, as well as a resemblance to Francis.

On Leonardo's death, I propose that the painting was restored to Milan as part of an inheritance to his pupil Melzi. Why did it not stay with Francis I? As it is evidently unfinished it may still have been regarded as Leonardo's and by implication of his last will and testament belonging to Melzi. As Leonardo's accomplished artist and protégé, Melzi may even have latterly been involved in the work. From there it must surely have been viewed by others, ironically maybe even in a church. Did it go to the monastery of *The Last Supper*? Or to the Church of San Francesco Grande in Milan to hang with the *Madonna of the Rocks*? Or did it remain in the French court? One has no way of knowing, only imaginings and intuition. With the evidence of the

papal bull we must assume it left France and went back to Italy. I appreciate this is mere speculation, but there is compelling documentary evidence to support it.

In 1576, the Confraternity's chapel in Milan was demolished. Is it possible the heresy was discovered at that time? It makes a certain sense. Works were transferred, including the *Madonna of the Rocks*, to another chapel in the church. Then in 1781 the Confraternity was dissolved and the Confraternity of Santa Caterina al Ruota inherited their possessions. At this stage some were sold. That church and convent were suppressed in 1798. What makes this even more complex and intriguing is that after Napoleon's government had been installed in Milan, the Fondo di Religione of the Republica Cisalpina confiscated some works. This introduces another colourful thread to our story: Napoleon was a Freemason and also a follower of the Merovingian bloodline, who consequently believed ardently in Mary Magdalene. The extraordinary evidence of this is in his history. Napoleon married the Hapsburg Princess Marie Louise of Austria in the hopes of carrying on the Merovingian bloodline, to be part of it. His plan was to become emperor of the world and to provide a Merovingian son to succeed him, but their child Napoleon Charles died at the age of 21 and Napoleon's dream was ended.

The great attempt of Napoleon, in 1810, to centralise in Paris all the archives of Europe was brought to naught, in 1814, by his fall. The thousands of wagon-loads which had come trundling over the Pyrenees and Alps and Rhine, from Simancas, Turin, Rome, Vienna, Holland, went trundling back again, not without some dropping of their treasures in the mud.

Is it outside the realms of possibility that the painting fell into Napoleon's hands? We do know that Napoleon ransacked the Secret Archives of the Vatican – it would follow that if the painting had been there he would have taken it; after all, it symbolised all that he himself believed in. During the Italian campaign, he had all the writings of Leonardo still in the Ambrosian library transferred to Paris, and from this time on people began to be as interested in the artist's writings as they were in his drawings. A new image of the man was created by this, as architect, engineer, scholar, philosopher and writer. Napoleon died in 1821, so if he had this painting it returned to Italy with the hoard and it would have been somebody else who then acquired it. We know it did return to Italy by the wayfaring stickers on the back.

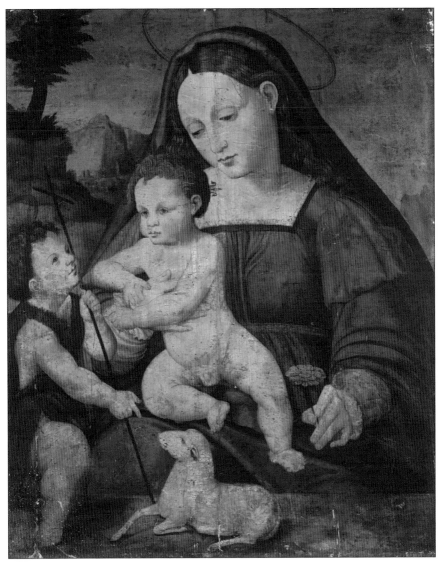

My painting, which started it all. It is, I believe, Mary Magdalene and her child with Jesus painted by Leonardo da Vinci shortly before his death. (© Fiona McLaren)

The rear of the painting with the wayfaring ticket, which shows the painting travelled from Italy to France in the nineteenth century. (© Fiona McLaren)

The Papal Bull, authenticated as being issued by Pope Paul V, who instigated the Secret Archives in the Vatican. (© Fiona McLaren)

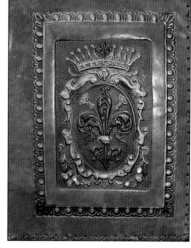

The leather wallet containing the stamps commemorating the Declaration of Arbroath. (© Fiona McLaren)

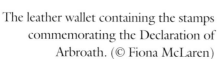

René d'Anjou painted by Nicolas Froment. Notice the scallop shells. Can you see any resemblance to John the Baptist in the painting?

Charles VIII of France painted by an unknown painter but possibly a pupil of Leonardo. Again, notice the prominence of the scallop shells. These chains of scallop-shell decoration are the emblems of the Order of St Michael.

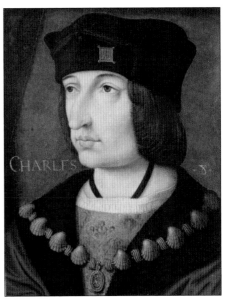

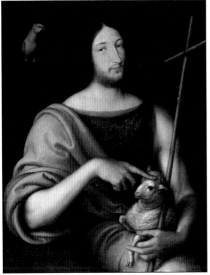

Francis I of France portrayed as John the Baptist by Jean Clouet.

Some of Leonardo da Vinci's paintings,
showing similarities to *The Last Commission*.

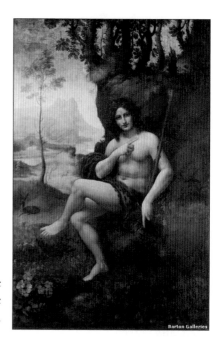

Bacchus, originally called John the
Baptist in the Desert. Notice the
similarity of the undermined tree.

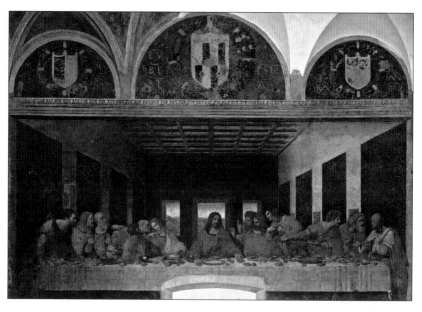

The Last Supper. Can you see the chalice in the picture? Look above the head
of the first disciple. Notice the hairline V of the Beloved Disciple.

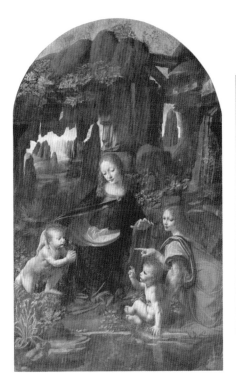

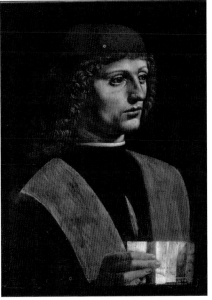

Madonna of the Rocks. Again, notice the hairline V of the Madonna. All three images bear the V, and the profiles are strikingly similar, the children too.

Portrait of a Young Man 'The Musician'. I have discovered that he is clutching a fragment of musical score in his fingers (enlarged below) which we believe is a Hymn to St John and which was banned by the Church.

cis. 4. Véntris obstrúso récubans cubí-li Sénse-ras ·Ré-

Hinc pá-rens ná-ti mé-ri-tis

. 5. Sit décus Pátri, genitaé-

ntri-úsque vírtus, Spí- ri-

ni Témpo-ris aévo. Amen.

the vestal women. A prophet, before bein born, you revealed this mystery to your parents.

Glory be to the Fath and to the engendered Son; glo similar to the Holy Spirit that is knot of both, for every century. Amen

Symbolism found in various churches connected,
or possibly connected, to this story.

In Kilmore Church, Dervaig, this stained-glass window seems to show Jesus and a pregnant Mary Magdalene. (Courtesy of Barry Durford, www.sacredconnections.co.uk)

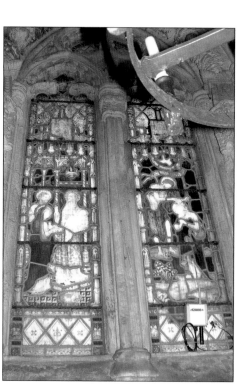

At Amulree Church at the mouth of Glen Quaich, one of the stained-glass windows shows a pilgrim with a scallop shell.

Stained glass at Rosslyn chapel; notice Christ's plaid bonnet!

An 1835 sketch of Rosslyn by Roger Griffiths showing the Apprentice pillar.

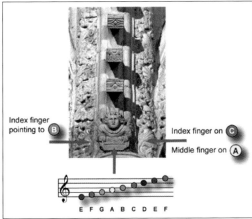

The Rosslyn Stave Angel. (Courtesy of Richard Merrick)

The Apprentice pillar today. (Courtesy of Richard Merrick)

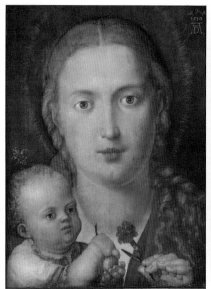

The Madonna of the Carnation by Albrecht Dürer. This shows the fleur-de-lys motif in the nimbus of the child, as does *Madonna and Child with Saints* by Cesare da Sesto.

Saint Mary Magdalene by Guido Reni.

We know some works were acquired by a comrade of Napoleon's, a Cavalier Melzi d'Eril of the illustrious Fenzi family. Francesco Melzi d'Eril, ninth Count, was made Vice-President of the Italian Republic under Napoleon Bonaparte in 1802 and Grand Chancellor of the Napoleonic Kingdom of Italy in 1805. On 20 December 1807 he was created Duca di Lodi by Napoleon in his capacity as King of Italy. I believe this Francesco was in all probability a blood relative of Leonardo's Count Melzi, which would make it a perfect circle. Did he then gift this painting to a gallery? Maybe in St Michel? It states St Michel on the wayfaring ticket. Was that why our painting made a second journey across the Alps, yet again with a high-ranking figure? Of course, this is all supposition, links in a broken chain, but it does seem to strengthen the line of connections even if it remains fragile.

Let's summarise the story so far:

We have a picture of Mary Magdalene with her son portrayed in Provence with her baby bearing the emblem of the French court, of the royal bloodline of David. The motif of the fleur-de-lys tells us this. The picture is telling the true story and affirming the belief held by generations that Jesus Christ and Mary Magdalene were married and had at least one child. She was a noble woman of royal blood whom he married, as exemplified by the carnation. The little boy represents their DNA, the genetic inheritance of the Christ child and one which lives on, as exemplified by the bearing of the fleur-de-lys. The papal bull having been attached to the back of the picture affirms its position as a work of enormous merit and significance. The question as to why it was put there places it in the realm of papal importance which would appear to be unprecedented, and underscores the basic premise of Mary Magdalene and Jesus Christ having been consorts in a sacred marriage.

The question has to be asked loudly – why hasn't this been part of our Christian teachings? Sadly, the answer would appear to be because the Church orchestrated another story to ensure its power base would be the foundation of Christian thought. It didn't want a woman to be the bearer of his progeny. So the feminine must at all costs be denied, vilified if necessary, but certainly censored out of the story. To do anything else would be to dilute the Church's power base. To recognise a bloodline that soaked European soil would disrupt and sidetrack the main objective, that of being a ruling global power. To a point, the Church has succeeded. That is, until now. From the shadows of the

last 500 years of conventional Christian hegemony comes new light; from the silence, whispers from voices not condemned to silence after all. What better vehicle to transport a truth through the ages than in the integrity of one of Leonardo's paintings?

As Edgar Wind, one of the greatest art historians, said: 'They [renaissance paintings] were designed for their initiates, hence they require an initiation.'

It was outright genius that Leonardo was able to conceal so much information and yet still render the work acceptable if it were to come under the scrutiny of the Church. It was a triumph of symbolism and a victory of truth against the world.

These same teachings Leonardo espoused were also taught in his academy and his disciples incorporated them into their work. You can see it beautifully executed in the works of Cesare da Sesto with the fleur-de-lys and with Andrea Solari, who painted a glorious portrait of Charles d'Amboise bedecked in a wondrous necklace of scallop shells.

So Baigent, Leigh and Lincoln were right, Margaret Starbird was right, Dan Brown was right, Robert Graves, and many more who have gone before, were right. So too the storytellers, the troubadours and the Cathars, and other uncountable and anonymous unsung heroes. This is the thread running through Western religious history. Here, at last, is that tangible evidence of that belief in the form of a painting. The symbols have broken the suppression and spoken.

Before we move on, let's take another look at the Madonna. See how melancholy she looks, eyes downcast looking almost mournfully at her son? She is obviously concerned for him. Exiled and cast adrift to die, she was well aware of the fate which would befall her child if the Romans got their hands on him. They were still not safe, southern France was a firm foothold of the Romans, they had to make yet another escape – somewhere where she would remain for a further 30 years.

The Church would have us believe that after preaching so eloquently in Provence, converting many to the faith of Christ, she simply disappeared to live in a cave for 30 years. *The Golden Legend* tells us she:

> . . . withdrew to barren wilderness where she remained in anonymity
> for thirty years in a place prepared for her by the hands of angels.
> In this wilderness there was no water, and there were no trees or
> grass, nor any comforts of any kind, so that it was clear that our
> Redeemer had meant to feed her not with earthly foods, but with

the sweets of heaven alone. Each day at the seven canonical hours she would be lifted in the air by angels and actually heard, with her bodily organs of hearing, the glorious harmonies of the celestial chorus. So, filled day by day with this exquisite heavenly fare, when she was brought back to her cave, she had not the slightest need for bodily nourishment.

Jacobus de Voragine, *The Golden Legend*

Are we honestly expected to believe that? Yet we have, much to the satisfaction of the Church. No, I believe the 30-year absence can be much more easily explained: Mary Magdalene headed west, along the Pyrenees, and then north. Joseph of Arimathea and others would have travelled with her. They were going to go to a country that was already known to him and where he knew they would be in safe hands.

This takes us on to the next chapter of this story and the next piece of this growing mystery, one in which each piece reaffirms the other. If it had not been for what is to come in the following chapters, I would not be as sure as I am about the story this painting tells. Each symbol in that painting is a word, which when connected provides the sentence. That sentence forms the first paragraph of the story that follows and is echoed in the other artefacts. It is what is so enthralling and extraordinary about this story: the painting provides the lead, its associated *objets d'art* confirm it and expound on it.

Though human ingenuity may make various inventions, it will never devise any inventions more beautiful, nor more simple, nor more to the purpose than Nature does; because in her inventions nothing is wanting, and nothing is superfluous, and she needs no counterpoise when she makes limbs proper for motion in the bodies of animals . . .

. . . The definition of the soul I leave to the imaginations of friars, those fathers of the people who know all secrets by inspiration. I leave alone the sacred books; for they are supreme truth.

Leonardo's Notebooks

The only really valuable thing is intuition.

Albert Einstein

The Engraving

Peace to their shades. The pure Culdees
Were Albyn's earliest priests of God,
Ere yet an island of her seas
By foot of Saxon monk was trod.

Thomas Campbell, 'Reullura'

The episode that this chapter introduces is a fundamental part to the story of the painting and the premise she suggests. Extraordinarily enough, what comes next adds to the story of the painting in the most exquisite way, for if the painting were not explosive enough in its own right, then what follows certainly is. Why? Because this is a secret history of what happened on the isles of Britain in the first century AD and the divine treasure house of British heritage. The truth does not lie on the surface of what we are told, it is far more complex, but beautifully this is the story of the Light of Truth which has never gone out.

This has been my true souvenir in the legacy which was gifted me, that knowledge, and without it and the chapters which follow on from it I would not have been so sure in my assertion that the painting is of Mary Magdalene, for each compounds the other in this electrifying sequence of events. I admit that taken separately they are just conjecture, as history has made no record of these events. However, reassuringly, together they form an undeniable dialogue which has been whispering to us over the void of time. A composite to a secret history which I believe must now come into the public domain.

So to the engraving which was included in the original gift to my father, and the story this picture has to relate, which centres on this rather weary portrayal of a monk. A man who is the lynchpin which holds the whole story firm.

I was vaguely familiar with the heretical tradition of Mary Magdalene having married Jesus. However, what the engraving about to be investigated did was to open my eyes to something else – something truly astonishing which relates to Britain's pagan past. This is a history which we should be proud of as it marked the glorious Christian heritage which was bequeathed to us in the first four centuries of the Christian era but which is tragically an episode that seems to have been edited out of our collective consciousness. What follows will hopefully enlighten us all to the wonderful truth that it was on the sacred island of Britain that the faith of Christ was firmly founded soon after his Passion and Resurrection; more, that here also the first Christian Church in all the world outside Jerusalem was erected by the original disciples and followers of the Incarnate Word. As previously stated, the family had landed in Marseilles, which in my opinion also deserves to be heralded in the flowering of Christianity on the Continent, yet as you will see it was to British shores that they migrated and founded their religion.

Rome would pursue them, for two reasons: to destroy the Davidic line, with the added bonus of exploiting Britain's rich mineral resources.

So to this next part of our voyage.

The Worshippers of God

I've always been intrigued by this engraving from the box, most probably because the figure of the man looking so intently at the skull has always grabbed my imagination. Together with the map, both of these pictorial enigmas cried out to be looked at more closely. What I didn't know (for how could I?) was that the man in this picture, this rather diminutive monk, is a direct touchstone to the Judean refugees who fled France at the start of the Christian era. The very ones whom Joseph of Arimathea led to England in flight from the Romans. Amazingly, I hadn't any clue about any of that, had never even heard that Joseph of Arimathea had come to England all those years ago to trade in tin on the Cornish coast. Should I be ashamed that I was ignorant of it? No, I don't think so because for some reason we don't laud it, don't know about it. Even ridicule it, as though to believe such a thing makes us look foolish. What fools we have been to dismiss it.

Extraordinarily, this portrayal of an old monk resting in his monastery garden is very probably a direct descendant of these refugees and his story is serenely enigmatic and central to a cleverly concealed secret,

and one which I am destined to reveal. Put simply, this man is a descendant of the apostolic lineage which carries the DNA of Jesus Christ and Mary Magdalene. The DNA which importantly carries in its genes coded heredity details and which is a symbol we will be hearing more about in later chapters.

It seems unbelievable that this seemingly humble monk could be carrying the DNA of Christ, doesn't it? But I do believe it is possible, and let me explain why.

> I adore not the voice of birds,
> Nor sneezing, nor things of this world.
> For my Druid is Christ, the Son of God,
> Christ, Son of Mary, the Great Abbot,
> The Father, the Son, and the Holy Spirit.
>
> St Columba of Iona (attr.), *Christ is my Druid*

St Columba is the man who is still credited with delivering Christianity to the barbarous Picts of Scotland, but this, as you will discover, is a false history. He did indeed establish his own ministry on the island of Iona on the western seaboard of Scotland, but it was founded and layered on a ministry that was already well established some 500 years before – that of the Druids. It is why the above quote is so relevant, for two important things are written here. First, that in St Columba's eyes Jesus was his Druid, and second, he refers to Christ as being 'the Great Abbot', but surely an Abbot is head of an abbey of monks? One wonders therefore which abbey? Where? What monks?

Well, the clue is in this engraving and just as in the painting of the Madonna it was a personal revelation for me.

I haven't been able to establish much about the man, Anthony Walker, who engraved this picture in the mid 1700s. It has written on it that it was for Chap iv; Pl 1, but I don't know which book it was intended for, and I can only assume that it was for a book on the great mysteries. What little I have found out about Anthony Walker is that he was an English printer who was born in 1726 and who died in 1765. Apparently he was highly esteemed in his day and was regarded very much as a pioneer of the printing process, and even today much of the technology of printing owes itself to him.

On face value, this is a depiction of a monk in the gardens of a monastery. The building behind forms the perspective of the picture.

Almost in our peripheral vision we notice the monk. Let's look again, step into it and let it speak to us.

The aged body of the monk rests against the cool white limestone of the cloister wall. I feel that, because he appears to be in charge of the relic of the skull, he must belong in the higher echelons of his order, so he could possibly be an abbot. Not yet in the shade, this old man is catching the last rays and heat of a setting sun. His vision appears to be concentrated on the skull, his arms crossed in contemplation, with his head inclined as if willing it to answer some profound question he has asked. Some garden tools stand clean to his left, suggesting the day's work in the garden is over. It is easy to evoke some sounds of the day: perhaps the mournful screech of a peacock breaks through the stillness as it gently ruffles and fans its watchful display of tail feathers, the extravagant eye of each plume shimmering in the sunlight; the low drone of a bee as it works the flowers. To his left on the stone seat lies a book, perhaps the Bible or some sacred tome. But his concentration is firmly focused on the skull. Trellised above him are vines with ripening grapes, which would infuse the air with their heady perfume, and at his feet are vegetables, I can't be sure what, maybe cabbages. Opposite him, against the wall, is a rose bush with a ladder to its side, one so high it even breaches the wall and would take the monk who climbed it to the other side and another view of life. Soon the sun will sink lower, the nightingale will start to sing and the shadow of the wall will envelop the contemplative. He will gather his relic and methodically walk back through his carefully tended garden. Cicadas will strike up and accompany the lowering light of the end of a day. There will be evening prayers, a simple meal and then he will return to his cell and contemplation. But what of him? What can he tell us?

Studying him, I felt sure there was something odd about him, something distinctive. He has a long grey beard and his head is shaven to leave a hairline which follows his ears. That struck me as unlike the usual tonsures of Christian monks, who have shaven crowns in symbolic representation of the Crown of Thorns placed on Jesus's head. More research was necessary and I discovered that this particular tonsure is known as the St John's tonsure, as distinct from the crown (or Petrine) one. This meant that this monk was a Celtic Christian, for they had adopted this custom from that of their Druidic predecessors. The name of St John was tantalising too as it seemed to reconnect to what I had already discovered about the skull. Seemingly the Celts also

revered particular skulls, as did the Knights Templar and the Freemasons, the skulls literally symbolising 'Godhead'. So was this one linked to St John, Baphomet, Sophia or someone else?

The answer to this would have to wait. My priority was to unearth some more information about the monk. It took a great deal more research and enthralled me for weeks. Now I can confidently name his order: he is a Culdee, a Celt from a fraternity of monks known as the 'snail men'. They were called 'snail men' in reference to the trail of wisdom and knowledge they left in their wake as they travelled throughout Europe. These men and women were recorded as the first true Christians on these islands of Britain landing here as refugees *c.* AD 36.

Why, I wondered, had I never heard of them? Why haven't they been lauded in the history of Christianity? That will soon become all too clear.

Let's see what story the picture has to tell us. We'll leave the monk to his thoughts for now and walk up under the shade of the vine, immerse ourselves in the atmosphere of this sacred place, aware of the peace underpinned by the haunting songbirds. The day has been searingly hot and the sky's light is still diamond sharp even in the lowering sun. A lizard darts out and runs between our feet, a butterfly rests on a vine. Momentarily they distract us from what lies ahead. When we look up, we are faced with it. It is breathtakingly beautiful and stops us in our tracks. There, laid against the crumbling fabric of the monastery, hidden from view in an inner sanctum and only for the eyes of the higher order of monks who worship here, is a temple of Egyptian design. It is seemingly out of context, out of scale. This ornate façade of classical decoration is set amid the simplicity of the monastery. How incongruous it is to see it here.

But for the moment, let's continue our walk, past the entrance to the monks' cells, past the steps that lead up to the refectory, into the cool shade and to another entrance. This, almost as balance to the incongruity of the temple, bears a plaque above a door. In scale it is really rather large but to see the detail on the engraving you need a magnifying glass. Looking closer, it is surprising to see what it is: three fleurs-de-lys. A scaled contemporary rendering of the ancient and typical 'plume' symbol on the roof of the temple, an Egyptian motif which is similar to the rendering of the fleurs-de-lys. So this building, the abode of this fraternity of monks, bears the emblem of the fleur-de-lys, the same symbol as we had in our painting and one connecting

it to an ancient heredity as represented on this temple. We know this symbol: it is of the bloodline of David, royal blood, but what is it doing here? What is the association of the Culdee monk with this royal bloodline? More research, more books pored over, more investigation – then I had it, something which I believe is almost as important as the tale of the painting but yet is another chapter in the same story.

It goes back to the exile of the followers of Christ, revealing where the fruit of the grand ancestral tree of the royal bloodline seeded itself and took root. The ancestral line from David which is universally acknowledged as being symbolised by the fleurs-de lys. What we have in this picture are vital components of that story: the fleur-de-lys, the skull, the fraternity of the Culdee and the temple. It adds up to our hidden heritage, to a story that has never been fully told.

I am still as moved and excited by this history of Christianity in its purest form as I was when it first started to unravel. It's a jewel that connects us all on a global level. For that reason I must admit at times to feeling out of my depth, of having that chilling sensation of black waters coursing fathomless beneath me. Frankly, I felt scared and still do, at times scared to go on due to fear of what I would be responsible for. But it's too late; turning back is unthinkable. I'm well aware that there will inevitably be a crashing down of fortifications, entrenched conditioning and I don't relish that. However, we have, undeniably in my view, been starved of this knowledge for almost 2,000 years and now it must see the light of day. It is a gift which, had we been given it earlier, would have changed the course of our fractious world – and maybe, God willing, still can. It starts, in the context of this engraving, with the story of the Druids.

Around the time of Christ, according to George F. Jowett in his illuminating book, *The Drama of the Lost Disciples*, Druidic universities were the largest in the world, both in size and attendance, with a listing of 60 or more large universities with an average attendance of over 60,000 students. I find that staggering but apparently, according to Greek and Roman records, they were held in the highest esteem. Just imagine it, the aristocracy of Rome and Greece sending their children to study law, science and religion in Britain, to the island we have been tutored to believe benefited from Roman occupation. Amazing to think that ancient Britain had acquired a stature of learning which rivals that of the USA today! In fact now I am incensed whenever I hear the statements of how the Romans brought civilisation to Britain.

What absolute tosh. There was an amazing civilisation thriving in Britain prior to them, which they sought to obliterate. How on Earth have historians missed that – I just don't get it. If I know that, why don't they? At times I feel betrayed by historians and academics who have promulgated the untruths of the victorious Romans. A brave people stood up to them and their ideals and we, their compatriots, record them as barbarians. How absolutely extraordinary is that? It leaves me, momentarily, speechless!

This is not the only surprising point in regard to the Druids and our undisclosed history. Have you, like I have, heard the story that Pontius Pilate, the governor who oversaw Jesus Christ's Crucifixion, had a connection to Britain? It is a colourful part of Celtic lore that he was born in Fortingall, a location close to a mountain called Schiehallion in Perthshire, which we will be hearing more of later. It is a story I have scorned all my life, until now, when my mind is less fearful of ridicule. If it is true, and it does make a certain sense, it would explain his discourse with Christ regarding the truth, which again I will come to later, as this was a central tenet of the Druids he would have encountered in Scotland. I don't quite understand why we seem to enjoy prejudice against such facts and consequently dismiss things so easily. I've certainly been guilty of a certain contempt prior to my investigations, which says more about me than it does of the subject matter. So in the spirit of investigation I am now blessed to consider things. According to archaeologist J.O. Kinnaman and cited by Isabel Hill Elder in her definitive book *Celt, Druid and Culdee*, Pontius Pilate studied in Britain under the instruction of the Druids. I mention later in this book my observation of his statement quoted in the Gospel of John 'What is Truth?' which he proposed to Jesus Christ as possibly a way of communicating his shared philosophical view with Christ: truth against the world. It is worth considering.

These Druids were awaiting 'Yesu', the name of the one who would symbolise the future, and it was this brotherhood which took as their own the Judean refugees who landed on Britain's shores around the year AD 36. These Judean refugees were led by Joseph of Arimathea, and, having fled first to France, headed to Britain on the last leg of their journey to safety.

They were not strangers to each other: Joseph had traded in tin with Britain and so would have been acquainted with the Druids who dominated British culture. Joseph would have known and respected

their teachings, their authority and their wisdom, and so what better place to find sanctuary than in Britain? Thinkers of the time journeyed to far-flung corners of the Earth to discover the mysteries of this world. The corners of the Earth included Scotland, where there were mystery schools run by the Druids. As a child, Christ may well have come with him.

As you will see, these refugees became known as Culdees, the true 'Worshippers of God' and were the line of people who chose exile and accompanied Joseph of Arimathea and the 'family of Christos' to England via France after their flight from their homeland and from the Romans. Reassuringly, this is on record. In the ancient British historical 'Triad' stories, Joseph and his followers were identified as 'Culdees'. It was they who founded the church at modern Glastonbury, the first one founded by the followers of Christ and known as the Culdee church. It was the first church of its kind in Western Europe. The very first – and it was in Britain. Stunning to contemplate, isn't it?

(This reference to the Triads is an interesting one, because they appear in Wales in the Middle Ages and are said to contain Welsh lore, mythology and history, and are called Triads because they are bunched together in threes. It seems to me that this almost poetic device is one that has been in use since time immemorial, I suppose the reason being that they can be committed to memory by the listener and then passed on.) Three is also a divine number, as in Trinity.

On reaching the shores of England, the courageous group made their way to Glastonbury Tor and the sacred isle of Avalon, its shores sheltered in apple orchards. The isle derived its name from Aval, Celtic for apple, which was the sacred fruit of the Druids and the emblem of fertility: a good omen for a spot they wished would be destined for their teaching. There they were met by an assemblage of the Druidic priesthood, King Guiderius and his brother Arviragus, King of the Silures of Britain, and an entourage of nobles.

Again it is recorded that the first act of Arviragus was to present Joseph, as a perpetual gift, free of tax, twelve hides of land, a hide for each disciple, each hide representing 160 acres, a sum total of 1,920 acres.

This was the first charter given to any land to be dedicated in the name of Jesus Christ, defining them as the Hallowed Acres of Christendom, AD 36, and is recorded in the British royal archives. It was later recorded in remarkable detail in the Domesday Book, on

recognition of William I, first Norman king of England AD 1066.

Miserably, school history books still erroneously teach that the Augustan mission, sent by Pope Gregory in AD 596, marked the introduction of Christianity into Britain. Actually, it marked the first attempt to introduce the papacy into Britain, for it is well recorded that St Augustine vouched for the Christians and reported back to the Pope in a letter that there was an island in the West Country of Britain where there was a church. A 'Mother Church' where some of the original disciples of Jesus had worshipped and a building which it was said that Christ himself had established. Semantics perhaps, but surely of significance.

> In the western confines of Britain there is a certain royal island of large extent, surrounded by water. In it the first Neophites of Catholic Law, God acquainting them, found a church constructed by no human art, but divinely constructed, or by the hands of Christ Himself, for the salvation of His people. The Almighty has made it manifest by many miracles and mysterious visitations that He continues to watch over it as sacred to Himself, and to Mary, the Mother of God.
>
> St Augustine, *Epistolae ad Gregorium Papam*

Consider the implications: Jesus Christ built the church, was there at its foundation and dedicated it 'sacred to Mary, the Mother of God'. The island of Britannia, the Pope was informed, was already occupied by a body of priests and their disciples. A body who were distinguished and respected by the populace for the pure and simple apostolic religion which they professed and practised – the Culdees.

Some sources claim the name is derived from Cultores Dei or Céile-Dé, both meaning Worshippers (or Friends) of God. Here they had merged with the Druids and their first church in Western Europe was founded around the year AD 36.

At this juncture I have to subscribe to what the former President of the United States, Franklin D. Roosevelt, proclaimed: 'All histories should be rewritten in truth.'

I find it extraordinarily beautiful to reflect that in AD 36 followers of Christ were here on these shores, that it is a matter of record. Yet I was finding out about it for the first time. Not only that but Mary Magdalene, I believe, was amongst them, as indeed was Christ. This is

a leap over a chasm that has never been broached, but it is a leap that I feel equipped to take. Why? Because all these stories that have been linked form an article of faith which meshes to form the body of this work. That of the true resurrection principle and of Christ's survival of his passion and of Mary as his consort. They travelled as a unit with Joseph to Britain.

In further testimony of this it is recorded that the remains of St Joseph of Arimathea lay undisturbed in Glastonbury until 1345, when Edward III gave permission to John Bloom of London to dig them up. Proof if proof were needed of the validity of it all.

Yet we seem to glorify the Romans who invaded us, as though before them we were an island of savage tribes, perpetually fighting with each other. In fact, the opposite is the case: we were an island of great learning, a remarkable civilisation of Druidic universities and of men and women of Christ. It was for that reason that predictably on the heels of the refugees a Roman invasion of Britain took place, but, unlike Julius Caesar's brief campaign decades earlier, which came but never conquered, this one (in AD 42), commanded by the Emperor Claudius himself, was fully equipped to succeed.

Before we explore that invasion it is just worth pointing out that the supremacy of the foundation of Christian integrity in England has never been denied by the Vatican popes and was reaffirmed by papal statement as late as 1936.

The Roman Invasion

The holy infiltration of The Way or the word of God as given by Christ spread so rapidly that Rome was disturbed; it could no longer ignore the challenge to its own pagan policies and imperial security, for remember Rome was still pagan in its beliefs, worshipping Bacchus and Minerva, the gods of Rome, so understandably what was happening on Britain's shores was a perceived threat which had to be eliminated.

Consequently in the year ad 42, the Emperor Claudius dispatched two of his finest legions to destroy the British Druids and Celtic Christians. His fateful decree was to destroy Christian Britain, man, woman, and child and its great institutions, and to burn its libraries. In particular and of immense importance, the edict stated to include any person descended from David.

Who was Claudius after? Was he in pursuit of Mary Magdalene and a child, a threat to his temporal, earthly power? The implication is

surely undeniable – that the ultimate Roman authority knew they were there and was after them. I believe the statement means only one thing – anyone descended from Christ of the Davidic line, a Christ-child, of his royal blood, perpetuating it. This is surely evidence that Mary Magdalene and her child by Jesus Christ were in England at the time of this Roman invasion. Included in the Roman agenda was the intention to eliminate that bloodline, to destroy the woman in my painting and her child.

In AD 61, Gaius Suetonius Paulinus, the Roman Legate in Britain, proceeded to carry out an order from Rome to extirpate Druidism, recorded in Annals XIV (Chap. XXX) by the Roman historian Tacitus. In AD 383, Magnus Maximus, Governor of the Roman troops in York and 'Dux' (Duke) of the Five Provinces of Britain, asked his old friend Justinianus to give him an abridged version of the history of Roman occupation in Britain. His reply is relevant because it refers us back once more to the Judean refugees. He wrote:

> Caligula aborted an invasion at the last moment (in the year 40) but the island did not become part of the Empire until Claudius personally oversaw its conquest (in 43) . . . These plans were all preoccupied with the south-east corner of the island, and with the usual confused mass of pretexts and objectives – the political glory conferred by a victory won beyond the narrow strip of Ocean, *the military need to destroy a possible refuge for our enemies.* [my emphasis]

Britain at the time of Claudius's invasion was not regarded as an enemy of Rome. So one has to reasonably question whether those enemies seeking refuge were in fact Christ's people, the Judean refugees. It certainly would tie in with what follows. Is this what gave the people the courage to withstand the occupation, especially in south-west Britain? The knowledge that a 'Christhood' was on British ground? Is that why Celtic monks are only known in Scotland and Ireland, the two places the Romans were unable to penetrate very far?

In that vein, I have worked for several years researching, writing and reading. Ironically – but not surprisingly – I haven't had much help from theologians. The ones I have contacted have been pleasant but have, to a man, admitted to knowing practically nothing about the Culdees! This is astonishing given that the major religious centres in Scotland were founded by them.

As the fog of misinformation lifts we can cast our minds back and visualise that this era also included that of Boudica the rebel queen of the Iceni tribe circa AD 60 and reflect again on the massive Roman incursions against the Druids, and the subsequent subjugation of the rulers of Britain's own native peoples. In a strange way we seem to laud the Romans when in fact they should be vilified for their planned extermination of what was good.

I begin to see why the Iceni fought so vociferously, it wasn't just to retain their power; they were fighting for something that transcended that, fighting for what they believed in – a belief which transcended all else. Fighting in the spirit of 'Truth against the World'. Imagine if Boudica had succeeded, Britain would have been Celtic and not Roman. She was possibly the best queen we never had!

The Romans remained on our shores for 400 years but they never penetrated the outer reaches of Scotland, nor Ireland. There, the pure faith survived and thrived.

Mary Magdalene and Family in Britain

Why seek refuge in Britain? The answer could be quite simple. As in the case of the Church dismissing Mary Magdalene for 30 years of her life by proposing that she lived naked in a cave and ascended to heaven each day, they are also surprisingly silent on the life of Jesus between the ages of 12 and 30. The only incident recorded is of his visit to the Temple at the age of 12. The last New Testament account of the boy Jesus is found in Luke 2:52: 'And Jesus increased in wisdom and stature, and in favour with God and Man.'

There has to be a possibility that he left the shores of home and travelled. Multiple legends exist to support this theory, and religious leaders in India claim that he studied there before travelling on to what is now Tibet. Ancient religious books record Jesus visiting Nepal. Other traditions take Jesus to Egypt.

However, the most persistent tradition places Jesus on the mystical isle of Avalon, the little Somerset county town of Glastonbury, England. He went there with his great-uncle, Joseph of Arimathea, his mother's uncle, who, we have been led to believe, traded in tin. Indeed, it is probable that Joseph took Jesus on business trips, possibly in the 20-year vacuum during which we know nothing about him.

Of course, this would make sense in the context of our story, for that would provide a reason for the Judean refugees to flee there.

Joseph had already had experience of the Druids, so too, most probably, had Jesus, and they knew they shared the same foundation of thought and belief.

William Blake, a renowned Freemason, made good record of this in his poem 'And did those feet in ancient time', which was then adapted and set to music to become the well-known hymn of 'Jerusalem':

> And did those feet in ancient time,
> Walk upon England's mountains green:
> And was the holy Lamb of God,
> On England's pleasant pastures seen!
>
> And did his countenance divine
> Shine forth upon our clouded hills?
> And was Jerusalem builded here,
> Among these dark Satanic Mills?
>
> William Blake, 'And did those feet in ancient time'

Blake's inspiration for that poem was the story of Jesus's visit to Britain during his 'lost years', and is linked to an idea in the Book of Revelation describing a Second Coming, wherein Jesus establishes a New Jerusalem.

Everything I have just stated would certainly explain why St Columba referred to Jesus as his Druid. He would have known the history of the Culdee migration to Scotland, to the isle which he took as his own, to the Druid isle of Iona. The Druids are another section of our history that have been much maligned, even ridiculed.

It is my view that they stand with the Culdees as our finest spiritual forefathers.

Their status as keepers of wisdom was, ironically, acknowledged even by Julius Caesar himself. Fortunately, stone fossils attesting to their wisdom still mark our visual landscape, standing stones and circles transcending time to conduct our vision to the sacred, to partake in the numinous mystery. Sanctity marked on the chessboard of our world to a formula only they understood, celebrating ancient mysteries which we can no longer comprehend. Shadows cast by summer suns towards full moons, Earth energies germinating life.

These unhewn stones stand as silent sentinels, marking the sacred groves where the Druids once worshipped and which they so very obviously held in such reverence and awe, silent save for the gentle

whispers of time which still try to communicate. I find that these tracings of past energies connect us to a lost people: God worshippers who believed in a trinity and a godhead that was represented by a skull. Their emblem was three golden rays of light to represent that belief. Crucially, that trinity comprised, according to E. Raymond Capt, in his book *The Traditions of Glastonbury*, '"Bel", the Creator as regards the past, "Taran" the controlling providence of the present and "Yesu" the coming saviour of the future.'

We dismiss the Druids as pagans, yet Druidism anticipated Christianity and pointed to the coming Saviour under the very name by which Christ was called. Isn't that an irony? We have been schooled to dismiss them in that almost derogatory term of pagan, yet they were part of a belief system which anticipated the coming saviour of man with the exact name by which Christ was called.

For me this all makes perfect sense. Jesus must have had experience of the Druids, learnt of their ideals, and subsequently found that they very much mirrored his own. He of course would have conversed with them and later expounded on these beliefs. After his Crucifixion, and his fulfilment of the Scriptures I believe it was an obvious place for Joseph and Mary Magdalene to go. This would be a land where there would be a welcome, a land where their way was already prepared and which Joseph was already familiar with.

This is reaffirmed in 'Victory of Aurelius Ambrosius' by Gildas Albanicus (ad 425–512). A British historian, Albanicus asserts that Britain received the Gospel in the time of Emperor Tiberius and that Joseph with others went there. The date given: 'about the year of our Lord 37'.

This date dovetails with the Judean refugee flight from France and is yet another piece of the puzzle which slips into place in formation of this extraordinary story. And don't forget, the man in this engraving is a Culdee, who took his tonsure from his Druidic forebears. Was this a form of tribute to them in homage for the twining of their beliefs in an emerging new order? I can't know, but it would appear to be a probability. As E. Raymond Capt said: 'But for Druidism, Christianity might never have flourished. Druidism nourished it through all its early stresses, giving it the vigour to endure through adversity.'

There is more to reaffirm and push this piece of the puzzle home:

St Philip . . . Coming into the country of the Franks to preach . . .

Converted to the Faith and baptised them. Working to spread Christ's word, he chose twelve from among his disciples and sent them to Britain. Their leader, it was said, was Philip's dearest friend, Joseph of Arimathea who buried the Lord.

Translated from *De Antiquite Glastonbiensis Ecclesia*, 1240

'The apostles passed beyond the ocean to the isles called the Britanic Isles.' Eusebius of Caesarea, *Demonstratio Evangelica* (*c.* AD 311), writes: 'Christianity was privately confessed elsewhere, but the first nation that proclaimed it as their religion and called it Christian, after the name of Christ, was Britain.'

This too, for which I thank George Jowett: in AD 520, Gildas wrote in *De Exidio Brittanniae*: 'We certainly know that Christ, the True Son, afforded His Light, the knowledge of His precepts to our Island in the last year of Tiberius Caesar.'

Crucially important is the fact I mentioned earlier and which is recorded in the Domesday Book of Britain AD 1086, that King Arviragus granted Joseph and his followers 'twelve hides of land in Yniswitrin' (that is, the isle of Avalon).

The Doms Dei, in the great monastery of Glastonbury, called the Secret of the Lord. This Glastonbury Church possesses, in its own villa XII hides of land which have never paid tax.

Domesday Survey folio 249 b.

I wonder why the Church was called Secret of the Lord? Could it be from Psalm 25, which starts:

1 Unto thee, O Lord, do I lift up my soul.
2 O my God, I trust in thee: let me not be ashamed, let not mine enemies triumph over me.

and then continues:

14 The secret of the Lord is with them that fear him; and he will shew them his covenant.

Why, when even St Augustine confirms that a body of priests existed already when he visited, does history still insist that Christianity began in Britain with Augustine in 597 and in Scotland with St Columba in 563? This strange distortion of ancient Britain is one of the most extraordinary paradoxes in history. One could be forgiven for thinking that certain academic minds had deliberately entered into a joint conspiracy to distort the history of Britain and her inhabitants. If not them then certainly a powerful organisation pulling strings and making us dance to their tune.

For Rome, their case was the stronger for omitting the truth and fabricating their own. Rome did not want the masses to know that Christ's relations had journeyed to Britain and united with the Druids.

From all we have seen it is obvious, at least to me, that the first early church of Christianity was in Britain, not Rome. There was a church founded, not by Peter in Rome but in Britain by Christ.

The one who was chosen was Mary Magdalene, the Apostle of the Apostles . . . The apostle whom Maximinus insisted should preach and who converted Provence to Christianity. Mary, the one Christ loved, the one to whom he trusted his intimate thoughts and beliefs. Mary, the woman who was to become his wife at Cana and who was to bear his seed, the woman who witnessed Christ's deliverance from death.

With this secret, which would have taken power from Rome, this truth that the Church so vehemently denied, came the keepers of it in the guise of René d'Anjou, Leonardo da Vinci and thousands more. A brotherhood which, to survive over the centuries, has morphed into different bodies, including a powerfully dedicated fraternity which has risked much in passing that truth down through the ages. Ironically, given that this is the case, it is a secret I am also becoming personally wary of revealing because they seem set on keeping it. I have a slight trepidation in revealing it – or as much as I know, for I am sure there is much, much more.

The consequences of what I am doing in revealing these secrets are twofold: one is antipathy from the very people I laud in their legacy, the Freemasons, for they are undoubtedly the custodians to a wondrous secret and my understanding of their position is that they have taken great risks to keep it and to nurture it. What concerns me now is whether that secret has given them a power they now don't want to relinquish and that as a consequence they are now as derelict in the role they play as those whom they oppose. It is worth bearing in mind

the words of the founder of the modern Illuminati, Adam Weishaupt, regarding the need for secrecy:

> The great strength of our Order lies in its concealment: let it never appear in any place in its own name, but always covered by another name, and another occupation. None is fitter than the three lower degrees of Free Masonry; the public is accustomed to it, expects little from it, and therefore takes little notice of it. Next to this, the form of a learned or literary society is best suited to our purpose, and had Free Masonry not existed, this cover would have been employed; and it may be much more than a cover, it may be a powerful engine in our hands. By establishing reading societies, and subscription libraries we may turn the public mind which way we will. In like manner we must try to obtain an influence in all offices which have any effect, either in forming, or in managing, or even in directing the mind of man.
>
> John Robison, *Proofs of a Conspiracy* (1798)

The other consequence is that I am undermining a belief system which has structured people's thinking. I find myself rather aptly caught between a rock and a hard place, between two institutions which may have fallen prey to the same malady and submitted to corruption – the Church of Rome and the Freemasons, for, as the saying goes, power corrupts, and absolute power corrupts absolutely. I do, however, have a certain confidence in one of those bodies.

However, what I have discovered I find so exciting and inspirational that I want to share what I know of the Culdees and who they were, that they carried the sacred bloodline of Christ and Mary, the universal wash which now runs through so many of us, and also speak loudly of those who carried the torch of enlightenment before them and prepared the way: the majestic, courageous Druids. I also want to take a further leap and present the distinct possibility that another brotherhood emerged from their shared demise: the Freemasons.

Masonic Connections

The brotherhood in England initially went under the guise of the brotherhood of the Druids/Culdees, and that trunk held firm over tens of hundreds of years. It weathered fierce storms but sank its roots deeper still. Rome sought to extirpate them but succeeded in name

alone, for their beliefs survived as new buds formed and branched out. The name of that tree is now Freemasonry. The spread of its branches is now universal and the roots have become part of the fabric of this Earth.

When I set out on this journey, I consistently fought the instinct to explore the world of the Freemasons. It was partly because I was scared of sailing on uncharted waters that I feared might hold monsters. However, eventually, after winning battles, I lost the war. This story has to include the Masons, for they are central characters in it. The Druids are at the heart of that onion which was eventually coated by the outer skin of the Freemasons.

In 1924, antiquarian Dudley Wright in his work *Druidism: The Ancient Faith of Britain* made comparisons between the ceremony of initiation of the Druids with that of certain Masonic symbolism, and noted that the tonsure was part of this ceremony, as all the hair in front of a line drawn over the crown from ear to ear was shaved or clipped. Masonic writer Albert Pike demonstrated a further mirroring when he pronounced that the lost word of Freemasonry is concealed in the name of the Druid god Hu; it is Egyptian in root and as we will see it is symbolised in Rosslyn Chapel in Edinburgh. This lost word connects us to the all-seeing eye, the god whose name cannot be spoken.

> The meagre information extant concerning the secret initiations of the Druids indicates a decided similarity between their mystery school and the school of Greece and Egypt. Hu, the Sun God, was murdered and after a number of ordeals and mystic rituals was restored to life. There were three degrees of the Druidic mysteries, but few successfully passed them all.
>
> Albert Pike

Those three degrees were poet, bard and Druid. It makes sense to me now why Sir Winston Churchill, a well-known Freemason, was also a member of a Druidic order who apparently took his orders very seriously; he was allied to the two principles, one forming part of the other, by being committed to both openly.

The doctrines of the Druids were the same as those entertained by Pythagoras. They taught the existence of one Supreme Being; a future state of rewards and punishment; the immortality of the soul, and metempsychosis (reincarnation). The object of their mystic rites was to

communicate these doctrines in symbolic language, an object and method common alike to Druidism, the ancient mysteries and modern Freemasonry. As you will remember, we have already seen that the Druids had long believed in the coming of a Messiah – a Messiah named Yesu. They also shared the Judean reverence for sacred geometry and astronomy. We know too that they referred to God as 'the ancient of days'.

I think this strongly points towards the possibility that these two groups' traditions had a shared origin. This would of course also support the notion that the Druids and the Culdees merged in the belief of an all-powerful creator God, one belief system morphing into another, which it would do again to safeguard its sacred knowledge.

Raymond Capt again:

> Culdees are recorded in Church documents as officiating at St. Peter, York, until AD 939. According to some Church authorities, the Canons of York were called 'Culdees' as late as the reign of Henry II (AD 1133–1189.) In Ireland, a whole county was named 'Culdee.' The names 'Culdee' and 'Culdish' cling tenaciously to the Scottish Church, and its prelates until a much later date.

What follows are some of the fundamental assumptions held about the Culdees, as collected and preserved by Arthur Edward Waite in his *New Encyclopedia of Freemasonry*. A.E. Waite was a prolific writer on many subjects and widely respected. Most importantly in our context he was a leading Freemason. In his book he states:

- The Culdees were identical with the Chaldeans mentioned by the prophet Daniel.
- They were priests in Assyria and can also be traced to Babylon.
- They were Casideans, Essenes, Therapeutae, and Magi.
- Beneath their cloak of Christianity they concealed a secret doctrine.
- They were mathematicians and architects at the time of the early Roman emperors.
- They were the builders of King Solomon's Temple.
- The Culdees of York were all Masons.
- The Culdee monks were the schoolmasters and architects of their time.

- It was thought that the historical allegory of the Round Table, as well as the quest for the holy grail, referred in mystical terms to Culdee rites.

A.E. White, *New Encyclopedia of Freemasonry*

What the above implies is that these monks were almost Templar-like. Yet, and this is important, the Culdees pre-date the Templars by some hundreds of years. The Knights Templar only established themselves after the dissolution of the Culdees.

In their migration northwards there are many locations associated with the Culdees, however their stronghold in Scotland was the mystical island off the west coast now called Iona. Could this be the place of the abbey that St Columba refers to? 'Christ, Son of Mary, the Great Abbot'? Was it to Iona that Mary Magdalene went, in fear of the Romans at her heels? In Scotland, she would certainly have found safety and freedom. No Romans got further than central Perthshire. Fortunately, the Culdees left in their wake strong traces for us to follow, though tragically these are fading. But way markers are still there, flagging their presence. At Abernethy, the capital of the kingdom of the Picts, they founded a monastery in 600, of which the only Culdee round tower in Scotland still stands (the Magdalene is symbolised by a tower, is that where the architectural form came from?), and subsequently other principal seats in Scottish towns, including Dunkeld and St Andrews. They also founded the town of Muthill in central Perthshire, where they had a vast monastery. There now still stands (just) a castle of their name on the land they once inhabited. There is also evidence of the existence of Culdee monks on St Kilda and other far-flung outposts. They were known as anchorites in reflection of their lives lived in contemplation. The Culdees and the Celtic movement also fanned out over Europe, taking their teachings with them. St Gaudens in France is another central hold of theirs, as were other regions of France.

The most sanctified of these places was and remains Iona. Glastonbury welcomed them but Iona became their own. The island of the dove, the feminine, the Druids' isle, the sacred isle which lies to the west of mainland Scotland. The island which St Columba made his own. Here, these worshippers of God scribed their illustrious manuscripts, wrote books on medicine and surgery, and undoubtedly one of the most wondrous books: The Book of Kells.

In this glorious work we find definitive proof of the monks' ancient

lineage and therefore our link to Egypt and to Coptic script and another reason for the inclusion of the Egyptian Temple in the engraving.

I want to share it with you so you can see what I mean. Our history lies waiting to bear testimony to the truth of Britain's Christian heritage, some circumstantial and some fact.

The Book of Kells

This masterpiece is a book as valuable to our culture as the Dead Sea Scrolls and is one stallion of a work from a stable of Insular, Roman Island, indicating post-Roman manuscripts. The Book of Kells is the most recognised and remarkable artefact of medieval Celtic art. It features page after page of lavish, colourful lettering, illumination, decoration and illustration. It was transcribed by the Culdees in their scriptorium on Iona around AD 800 and contains the four gospels of the New Testament together with various texts and tables. Think of it as you look at these enigmatic magical illustrations; waves were crashing all around them on this windswept isle on the edge of the world. This land on the edge of the Roman Empire but beyond its stretch. Quite astonishing to picture it all and one of the greatest miracles is that it has survived.

The work, not of Men, but of Angels.

Giraldus Cambrensis, c. AD 1150

The men in the scriptorium where this was created were the best there were in the craft of calligraphy and illustration and yet part of the same equation. I have never had the privilege of seeing the genuine article but just reading about it and looking at the pictures it holds resonates with a divine majesty of giant proportions. According to the holders of this book, the whole monastery would have been involved in its creation and it is without doubt the greatest gospel book that has survived. I am staggered when I think back and try to imagine the time of its inception and to reflect that the period when this was born was known as the Dark Ages, another blind to the true history of the time, a history which took place on the tiny island of Iona.

What struck me in my research was that there are seemingly a number of interesting anomalies between the text in the Book of Kells and that to be found in the accepted Gospels. For instance in the

genealogy of Christ, which starts at Luke 3:23 Kells names an extra ancestor. Then in Matthew 10:34 the standard is, 'I came not to bring peace, but the sword', but the Kells manuscript reads *gaudium* (joy) which translates as 'I came not (only) to bring peace, but joy.'

To argue that these devout monks made an error is for me out of the question. They were meticulous in all that they did and created a masterpiece, a pictorial museum of 680 vellum pages which was to be unique in every aspect. In this book there lie hidden texts and symbols, which, as in my painting, were planted there to germinate until our understanding could conceive of them, they were intended for initiates and certainly if you didn't know they were there you would miss them.

I find it difficult to comment eloquently when I am still so awe-inspired by it all. The way it has been designed sets you out to walk through ornate arcades before reaching the four sacred texts of the Gospels.

The cover was of gold and precious stones, and some of the colours used in the illustrations were imported from the Mediterranean, in the case of the lapis lazuli most probably north-east Afghanistan. This gilded cage houses a truth and the core of the ancestry and beliefs of the Culdees. That is why I strongly feel that these manuscripts should be questioned and studied to a much higher degree. There is evidently much more here than meets the eye and yet more to examine which has never been discussed.

The decorations are exquisitely complex. In one decoration that occupies one inch square of a page there are an amazing 158 complex interlacements of white ribbon with a black border on either side. Some can only be seen with a magnifying glass, which is truly mystifying given that lenses with the required power are not known to have been available until hundreds of years after the book's completion. One can also find in this gem of creation one of the earliest surviving portraits of the Madonna and Child in Western art. As you scan the images, it is apparent that this work has been influenced by Oriental and Egyptian/ Coptic art, and that it is a link to the Coptics' genealogy and the migration of the Judean refugees/Culdees/Chaldeans to Britain circa AD 36.

The visual images in the Book of Kells demonstrate that connection. Not only the images are similar but the interlacings are very much shared with those of Coptic/Byzantine manuscripts. Interestingly, there has been a new discovery in Ireland in a peat-bog excavation –

fragments of Egyptian papyrus in the leather cover of an ancient book of psalms. According to the National Museum of Ireland, the papyrus in the lining of the Egyptian-style leather cover of the 1,200-year-old manuscript 'potentially represents the first tangible connection between early Irish Christianity and the Middle Eastern Coptic Church. It is a finding that asks many questions and has confounded some of the accepted theories about the history of early Christianity in Ireland.'

Raghnall Ó Floinn, head of collections at the museum, said the manuscript, now known as the 'Faddan More Psalter', was one of the top ten archaeological discoveries in Ireland.

Yet again I am staggered by this. Why do they feign such bewilderment at this find? Perhaps I have it: a collective amnesia orchestrated by those in the higher echelons of our society to steer our thinking to their way. Well, I want us to break free and think again. The record is clear that there was a migration, that of Judean refugees, so surely they would use their own craft, which is evidenced here in the papyrus and in the design of the illustration in the Book of Kells. What a frustration it is to have to point out the obvious to historians and theologians who should have been celebrating this very fact for the last millennium and more. That is what academia too often does, it leads to entrenchment of thought and a compliance with peer review and desire for acceptance.

> Illuminated Irish manuscripts from the earliest period exhibit Coptic motifs along with patterns from Celtic and Anglo-Saxon metalwork in a fortunate blend of north and south, Christian and pagan, that was to culminate in the consummate artistry of the Book of Kells . . . The intricate knotwork patterns that play such an important part . . . are much older than Egyptian Christianity. The Copts themselves, building their churches within the ruins of Pharaonic temples, inherited a long tradition. In the fourteenth century BC artists in stone carved interlacing patterns on the tomb of King Tutankhamen.

> Katharine Scherman, *The Flowering of Ireland: Saints, Scholars and Kings*

This is underlined by Margaret Stokes in *Early Christian Art in Ireland*:

It is a remarkable fact that all the books in the Library of the Abyssinian monastery of Sourians, on the Natron Lakes in Egypt, were recently found by an English traveller in a condition singularly resembling that of the 'Book of Armagh'.

Another reaffirmation by the Rev. John Stirton in his essay, 'The Celtic Church and the Influence of the East', published in 1923:

The illuminations of those splendid manuscripts in the Book of Kells, now in Dublin, and of the Gospels of Lindisfarne are all Eastern in character. In these and in the Book of the Deer, the figures of all the Evangelists reflect the Eastern type and the Egypto-Greek title O agios is attached to some of them. The theory of such an origin is facilitated by the early commercial intercourse which is known to have existed, between this country and the east.

He underlines this point by saying:

Everything, on the contrary tends to confirm the belief of an intimate connection with the further East . . . the earliest type of monumental cross in Scotland is an Egyptian or Coptic wheel cross . . . The crescent, the serpent and the elephant must all be Eastern in origin and these are commonly met with on the Celtic bearing stones.

What also interests me is that that cultural cross-over can also be seen in music. Here, Rev. Father David Michael, in an essay entitled 'Eastern Bishops and the Celtic Order of the Culdee', 1998, states:

A piece of Celtic Psalm music from the Inchcolm Antiphoner, originating from the West Highlands . . . resembles in scale, key, melodic movement and general embellishments a chanted psalm sung by an isolated Christian group in Ethiopia. It is generally believed by historians that the isolated Ethiopian Church retained the most ancient of Christian music, possibly from original Palestinian or Temple sources.

To me, this underscores the evidence to confirm the migratory routes

of an Eastern belief system – the beliefs absorbed by the Druids from the Judean refugees, the Culdees.

This would explain some other pictorial evidence in the Book of Kells. Is that why throughout the book there are multiple images of chalices, some 40 in all? The chalice, of course, representing the consecration of the blood and body of Christ, and which by me and other investigative authors could be seen to represent the womb of his consort Mary Magdalene and the progeny of their shared union. Sometimes they appear with peacocks (a symbol of Christ) and vines (the fruit of Christ's life). Here the vine represents, according to scholars, the blood of Christ as symbolised by the grape. Often the vines are flowering. There are snakes too, which are symbolic of wisdom and of the resurrection as seen by the sloughing of the snake's skin.

Giraldus Cambrensis maintained that close study of the Book of Kells would reveal 'ever fresh wonders'.

Let's just probe a little deeper into the iconography.

In folio 34r, mice appear holding or fighting over the Eucharistic host. On folio 48r, a cat catches a mouse with a host. Could this signify that the Eucharist is under threat? This suggests to me that the host is in danger, but I admit this is merely conjecture. Without the scribes to tell us, all we can do is intuit their meanings, imagine their remit. Contemplate in the spirit of sacred reverence of the truth, or that is how I sense it to be. In that I will be guided by St Columba:

> There are some, although few indeed, on whom divine favour has bestowed the gift of contemplating, clearly and very distinctly, with scope of mind miraculously enlarged, in one and the same moment, as though under one ray of the sun, even the whole circle of the whole Earth, with the ocean and the sky about it.
>
> Bernard Meehan, *The Book of Kells: An Illustrated Introduction*

Throughout the book there are images of struggle – the pulling of beards and in folio 96r a peacock (symbol of Christ) with hands around its throat. There is a threatening image of a feminine figure locked in the legs of an ensnared man, both struggling for freedom. Every image is multilayered.

This lush manuscript has recurring images of birth, maybe of Christ's progeny too, his sacrifice and his resurrection. The book is itself a

constant motif, depicted over 30 times. It is in the hands of Christ, of angels, the evangelists and others.

In the beginning was the word . . . Another thing which I have mentioned earlier is the architectural symbolism in the Book of Kells of the Canon tables set out in arcades of arches, as it is a cultural icon of mystic symbolism and a symbol of Masonic significance. As we look ever deeper it is beguiling how coded this text is. In the St Matthew Gospel, for instance, it starts with the book of the generation of Christ and here we have letters and words concealed in the artwork. They are very hard to see and only found if you know that they are there. Again, at the beginning of St Mark we have the lettering concealed in the decoration. It represents the word for 'in the beginning' and if you look carefully you will find the letters spelling out the word INITIUM. At the end twist of the labyrinthine illustration we find the title of the Christ, the anointed one, the smallest of all. It is all quite miraculous and given the genius employed in coding this material it is reasonable to conclude that there may well be more coded imagery still lying unobserved, awaiting discovery. As St Columba said, though: 'Those who seek the Lord shall not lack any good thing.'

What we must do is ask more questions: why the red discs? Experts admit they have no idea what they signify. What does the text actually say? What other truths, which some would say are inaccuracies, lie in the text? Why is Christ generally portrayed as having blond hair when it was well documented that he was dark? These elitist scribes knew their task in hand, they knew their remit, why are the haloed head, the feet and hands of another figure placed centrally *outside* the border? Why was he holding a flowering rod? Would that point to Joseph of Arimathea or is it in fact a woman and the flowering rod a symbol of birth? I don't know, but I'd like to.

In folio 32v there is an all-encompassing portrayal of Christ. A cross is above his head and he is flanked by peacocks, their wings marked with Eucharistic hosts. These symbols of the peacock, chalice and vines appear on many other pages and are obviously of importance in conveying a message. However, what I find exciting about this portrayal of Christ are the figures that are given prominence beside him.

Women – one on either side, each with an angel in attendance. The woman to Christ's right bears a strong resemblance to a generic portrait of the Virgin Mary. Note that her feet are pierced with a red dot; why a red dot? It certainly signified something. That red disc is an important

symbol, yet who knows what it signifies. However, another woman wearing a red robe with a blue cape decorated with what appear to be bunches of grapes and carrying a flowering rod appears on the other side. So here, in a rare illustration, we have Christ with women at his side. Women celebrated beside him amid chalices and vines, one alone bearing the flowering staff. Christ's left hand is out of frame, indicating or protecting her. Their garments even mirror each other's, with grapes uniting them. I believe this to be Mary Magdalene, and a reaffirmation of what we already have been told by my painting: that she married Christ and bore his children. The evidence is there . . . but there is more.

It has been suggested by scholars of the Book of Kells that the figures in folio 7v may be ancestors of Christ. They have an ecclesiastical appearance, a monastic bloodline. That would support my thesis, my conviction, which I will explain in more detail later in this book, that these Culdee monks are holders of the knowledge of Christ and Mary's migration to Britain. Evidence of a truth which has been submerged from our vision but which can be caught in our peripheral gaze if we turn away from perceived doctrine. Each frame contains five figures, of whom two wear purple cloaks, two wear red and one wears a robe of mustard shade. A disc is placed between the heads of the top figures in each frame and red discs appear on the cloaks of six of the figures. That red disc again!

In folio 202v, there are 34 faces. And again it has been suggested that they too may be ancestors of Christ, the body of the Church.

It would certainly appear from this visual testimony that the Romans had been right to be concerned about 'any person descended from David'. The line of David was in Britain. The line survived, as is evidenced in this exquisite book. The line of Culdee monks had been the repository of it, and they had passed it on and on and on. A vast fisherman's net of DNA had been cast upon the oceans, to gather up and imprint his spirit in ours. The Romans had chased them northwards, built walls to confine their prey, but didn't penetrate beyond the hills of Perthshire and never fulfilled the remit to destroy 'any person descended from David'.

One further tantalising observation I have made: Christ is represented by the letter X. This letter to symbolise Jesus was new to me and something I found very enlightening. As you will see later, this is important, but at this stage, and in connection with the provenance of the Book of Kells and its origination in Scotland, it strikes me that this

is the reason the oldest flag in Europe, the Saltire, the Scottish flag is represented by an X. It makes a certain sense in the light of what I believe. Once again, when your eye is accustomed to the work you find more. A saltire cross is on 187v and 290v. The X is also found in the Coptic wording for Christ in the ChiRho, which is formed by the letters chi and rho, X and P being superimposed. This interesting symbol is probably the earliest symbol of Christianity and one that also has a link to the early Egyptians, being an adaptation of the ancient ankh. It is believed to have been a symbol of the Sun God, Mithras, and for that reason it was a handy tool for Emperor Constantine to employ to humour the followers of Mithras (who was much revered by the Romans) as they were encouraged to turn to Christianity. As with all things, it was a ploy to soften the blow of one belief system usurping another and was given immediate prominence when Emperor Constantine, who apparently saw the symbol in a dream, adopted it. This word has been found inscribed in Pictish artwork and is a cultural icon meaning 'the word made flesh'. I always thought writing Xmas in place of Christmas was a sloppy derogatory way of representing Christ's name, but it isn't a derogatory term at all, just another form of writing it using his symbol as a shorthand.

To summarise then.

From the engraving we have determined that the monk is a Culdee, a monk descended from the Judean refugees of the Christos family who landed on Britain's shores. The symbols placed in the picture are there to speak to the initiates or to educate those in search of meaning – that's me. So we have the vines representing Christ, the temple, a link to Egypt, the fleur-de-lys to the line of David, the skull, to ancestry and historical record – all of which have connected us to a truth, that of the Judean refugees and their hidden story. The cross behind the skull could allude to its being symbolic of St John, who of course is the patron to the Freemasons and the Knights Templar and others too. In William Sharp's seminal work *The Divine Adventure: Iona; Studies in Spiritual History* he states:

> An anonymous Gaelic writer, in an account of Iona in 1771, alludes to the probability that Christianity was introduced there before St Columba's advent, and that the island was already dedicated to the apostle of St John for it was originally called L'Eoin, i.e. the Isle of John, whence Iona.

The ladder, which I have not as yet explored, is symbolic of degrees of initiation and I daresay the vegetables and more that is hidden in this picture are significant too. The ladder, though, is in our collective consciousness, for it appears in our scripture, most notably with Jacob in the book of Genesis. It has obvious meaning of spiritual ascent and as a bridge between heaven and Earth. I find it a rather wonderful symbol as it does what it says on the label and doesn't demand too much analysis. There are thirteen rungs on the one in the engraving, possibly fourteen, and I think the ladder is partially covered by the foliage of the rose bush which it clears at the seventh rung. I could be being fanciful, but maybe this is reference to the seven planets to enlightenment that once broached take you on to the spiritual realm. I wonder why the Culdees chose Iona . . . Certainly the Druids were there and the isle was sacred, but was there more?

From the searing heat of our engraving and what it had to tell us we now go to the brooding, windswept island of Iona.

The Island of Iona

> To tell the story of Iona is to go back to God, and to end in God.
>
> William Sharp, *The Divine Adventure: Iona; Studies in Spiritual History*

I think then that in all probability when St Columba referred to Christ as being an abbot, he was referring to his ministry of an abbey and that the location of that abbey was on Iona. Oh yes, I appreciate that sounds extraordinarily far-fetched, but is it?

William Sharp, who wrote under the pen name of Fiona Macleod, relates in his essay on Iona:

> When I think of Iona I think often, too, of a prophecy once connected with Iona . . . the old prophecy that Christ shall come again upon Iona, and of that later and obscure prophecy which foretells, now as the Bride of Christ, now as the Daughter of God, now as the Divine Spirit embodied through mortal birth in a Woman, as once through mortal birth in a man, the coming of a new Presence and Power: and dream that this may be upon Iona, so that the little Gaelic island may become as the little Syrian Bethlehem . . . the Shepherdess shall call us home.

I subscribe to that narrative and dare to say so. It is because of the presence of Christ and his family on Iona that in AD 83 Demetrius of Tarsus had been asked by the Roman emperor to sail around the north of Scotland, to draw a map. Demetrius then apparently spoke to Plutarch, who also made maps of the British Isles, and stated that he had come across one island that was a retreat for holy men who were considered inviolate by the native peoples living nearby. Could this have been Iona? If not, what other island on the western seaboard could it have been?

The west coast of Scotland is known by the inhabitants as the 'thin place'. I have asked many people what this rather romantic description implies and have learned that it signifies a place where two worlds shyly touch, two worlds connecting, and there is certainly an otherworldly feel about the barren beauty and an almost tangible spiritual magnetism associated with the west coast and Western Isles. Why? Well, as we will see in the chapter about the pilgrimage to Santiago, it could be because it is part of a planetary oracle, the planets which of course were studied so intensely by the Druids; equally it could be because it is set in the west, the ordination of the setting sun.

Commenting on the Druid and Culdee presence on Iona, a nineteenth-century Scottish travel writer, C.F. Gordon-Cumming, observed:

What attraction it can have offered, to induce the priests of the Sun to select it as their abode, it is hard to imagine, but, from time immemorial, it was known as the Sacred Isle of the Druids . . . It certainly is a strangely perplexing mystery, to find an insignificant little island, in this remote corner of the Earth, exalted to a position of such extraordinary honour . . . to anyone versed in the lore of the past, every corner of this isle seems haunted by the spirits of Druids and Culdees . . . My favourite evening stroll was a solitary expedition across the moor towards the western side of this isle, to the wildest rocky valley, where a small circle of stones is still dear to the islanders, as the Cappan Cuildich, or Tabernacle of the Culdees, for here they say it was that the Standard of the Cross was first planted, and that the little band of Christians were wont to assemble in secret, to worship after the new fashion taught them by these strange Missionaries. The circle was, however, probably of older date still; its avenue of carefully placed stones seems rather to

belong to the buildings we call Druidic, and whether as temple or tomb, was probably associated with the earlier form of worship.

C.F. Gordon-Cumming, *In the Hebrides*

So here again we have reference to the early Christians, the Culdees.

Iona was long known as the Isle of the Druids and was of prime importance to them because in Druidic rites an island sanctuary reached only by boat, that boat being a rudderless one and called a coracle, formed a sacred place of initiation and one which could be described as a holy sanctuary. Why a holy sanctuary? Simply because it had no need of walls because the sea surrounds it. Those who visited the island and those on the island are the initiates and drink mead and wine offered to them by the lord of the sanctuary.

The word 'Iona' alluded to the Hebrew word for dove. It is of course an allusion to the founder of what had been known as the Isle of the Druids, St Columba. Rather bizarrely, in the Middle Ages, it was known as I. Bizarrely because why did they choose to name it that? Was it in reference to the feminine, because I in Gaelic represents the feminine? The letter I is also the eighth letter of the Gaelic alphabet, signifying a yew tree – the mystifying, sacred yew under whose boughs Mary Magdalene preached, as did her followers.

William Sharp believed Iona may have derived its name from Ioua, the moon, again as we have seen earlier alluding to the feminine. You will see a connection to that hypothesis meshes with beliefs on the Continent in a later chapter.

This sacred isle, the microcosm of the Gaelic world, still waits for us on our western shore. There, the reverence of our God-worshipping ancestors is still tangible and from it one can sail to Fingal's Cave, God's own cathedral, where I believe they would also have worshipped.

Is there more proof for this? Well, yes. On the isle of Mull there is a stained-glass window in the church of Kilmore in Dervaig. On it is portrayed a pregnant Mary Magdalene with Christ standing at her side, the inscription underneath reads: 'Mary has chosen that good part, which shall not be taken away from her.' (Luke 10:42)

This is undeniably a portrayal of Christ and Mary Magdalene. What are we to take from it? Did they have another child on Iona? I can't see why not.

To conclude this brief account: the early Roman invasion of our shores was history, walls had been built to contain and entrap Rome's

enemies who had migrated to the north, where their scripture could be taught, and their bloodline, that of David, could continue. Their legacy had also crossed back over the ocean to flood the continent in the alluvial wake of the snail men.

First it was the Druids that Rome had to annihilate, now it was the Culdees. It would take them nearly a millennium, but it had to be done in order for them to rule supreme and totally erase the heritage of the true Christian faith, leaving us in a state of amnesia as to the true facts.

I hope I have partly conveyed that splendid truth. As Isabel Hill Elder comments in the preface of her book *Celt, Druid and Culdee*:

> There are many perversions of truth relative to the past which the British people have long since settled to believe, with the result that the modern sceptic hastens to cover with the chilling mantle of disbelief any attempt to present a true account of early British affairs.

I agree entirely with her. Britain was not a barbarous nation prior to the Roman invasion; it was a proud and worthy one. Someone or some organisation has been in dereliction of their duty in not informing us of that proud heritage.

The Demise of the Culdees

Naturally, in the light of all this, the brotherhood of the Culdees was destined to be consumed by the power bases threatened by its pure spiritual heritage. So along came Pope Eugenius III, who in 1147 conceived his own plan to end the legacy of the Culdees. He increased the power of the Augustinian monks in Scotland by giving them the right to elect their own superior and also decreeing that on the death of a Culdee canon, Augustinian regulars should be appointed in their place. Fait accompli, the last nail in the Culdee coffin was nailed home.

This had a twofold effect in the devastation of the Culdees, because up until then the positions in their hierarchy had been hereditary, passing along the bloodline in a true brotherhood of belief. And that is precisely why the Pope did it, to sever the bloodline. The building blocks of DNA that they carried in their genetic make-up had to be wiped out; the remit was still to destroy the line of David. This was hard to do because happily by that stage the world was awash with it and still is.

Unbelievably, in 1150, King David I of Scotland endorsed this policy, an extraordinary decision given that he was a Freemason and knew of the integrity and lineage of the Culdees. He must have done so for political reasons, but he did mitigate this decision and balance that action by introducing another important order to Scotland: the Knights Templar. Do you see the thread that is being woven, one connecting back to a foundation that holds firm? It is a thread that takes us from a shared alignment of Druidic/Culdee belief through to the Masons and Knights Templar.

The one would be blended with the other and fortunately as proof of it we can see strong similarities between the two: both groups were said to possess a secret doctrine, both groups denied the Christ as decreed by the Church of Rome, both groups were architects, and both groups were associated with the holy grail, as well as with Solomon's Temple.

Unlike the Templars, the Culdees and Druids before them were peaceful in their pursuit of their ideals and pacifist by nature. However, there is an undeniable continuity of belief, purpose and action between the groups and certainly the mystery school of thought surrounding them appears to be the same philosophy. But if these groups represent different manifestations of the same esoteric tradition, it is not simply a tradition whose origin came about after the Crucifixion of Christ. It journeys far beyond the horizon of our limited vision to the days of the ancients and their mystery teachings and deserves more investigation than I can possibly devote to it here. In the coming chapters I will try to elucidate further on it.

One last thing which I believe is important. The story I am telling you is not one I had ever heard of; I am not trying to prove any hypothesis, only attempting to relay to you where the story has taken me. As with other writers who have covered this terrain I have no vested interest in this, only a quest for what is true.

Revelation is the best term. The honest revelations of a literary pilgrimage.

I've just remembered a prayer I used to carry in my possession:

Help me, my God! my boat is so small and Thy ocean so wide!

Amen I say to that for the waters I am charting may swamp me or carry me home.

Finally, on this may I leave you in thought:

> What a book it will be! It will reveal to us the secret of what Oisin
> sang, what Merlin knew, what Columba dreamed, what Adamnan
> hoped: what this little 'lamp of Christ' was to pagan Europe; what
> incense of testimony it flung upon the winds; what saints and
> heroes went out of it; how the dust of kings and princes were
> brought there to mingle with its sands; how the noble and ignoble
> came to it across long seas and perilous countries.
>
> . . .
>
> A young Hebridean priest once told me how, 'As our forefathers
> and elders believed and still believe, that Holy Spirit, shall come
> again which once was mortally born among us as the Son of God,
> but then, shall be the Daughter of God. The Divine Spirit shall
> come again as a Woman. Then for the first time the world will
> know peace.'
>
> William Sharp, from his essay 'Iona', 1910

It would appear there has been a collective amnesia which has cloaked
us for generations and I would hope that we can pull ourselves free of
it. Many millions have died in defence of this truth, the Druids initially,
and the people of Britain, but even more recently the Cathars of France
laid down their lives for their belief in the Christos family. They are
worthy testament to this and appear in a further chapter. I appreciate
we have a chasm to leap but you will, I hope, sense an exhilaration
when you take that jump. I am humbled by our past history and the
emotional underbelly, which though most sensitive, has survived.
Druidism was not merely a religion, it was the hub from which all else
radiated, Christianity combined with that and rolled on, a fact which
seems to have been largely ignored.

I will let this permeate your thoughts to filter down as it couldn't be
put much more simply or clearly than this, when Cardinal Reginald
Pole in Queen Mary Tudor's reign affirmed:

> England was the first country to receive Christianity. The
> Apostolic See from which I come hath a special respect to this
> realm above all others, and not without cause, seeing that God
> Himself as it were by Providence hath given to this realm
> prerogative of nobility above all others, which to make plain unto

you, that this island (first of all islands) received the light of Christian religion.

John Foxe, *The Acts and Monuments of the Christian Church*, Vol. VI p 568

Fortunately, as with all migrations, this one is charted. Bizarrely though, rather like Leonardo's back-to-front writing, this too is a mirror image and we need to turn it on its head to find the real direction. It was the quaich with the scallop handle which provided this lead and gave me something I don't believe has ever been in the public domain before and is by virtue of that very exciting.

We go there next.

Path of the Pilgrims

Lonely! Why should I feel lonely? Is not our planet in the Milky
Way?

Henry David Thoreau, *Walden*, 1854

We are now at the next turn on this mystical journey of mine and for
this next stretch you will need heavy boots and a strong staff to
accompany you; it is a challenging section with tough terrain to
cover.

At this stage of my quest there is one thing of which I am absolutely
sure, and that is that there is without doubt an important secret which
is and has been tenaciously guarded by fraternities for centuries. In
consideration of all the connections that this story has to tell, it is
blatantly clear that this must have to do with Christ, his life, love and
mission on Earth. As I hope to demonstrate to you, this chapter is
further proof of that exquisite truth for it reconnects us with the holy
grail, its quest and a definition of what it really represents.

As a woman I have never been particularly interested in the fictional,
or at least what I always believed to be fictional, Arthurian legends, so
tried to veer away from their involvement in this; yet as in all else, this
book has dictated what should be included; so here goes!

It was the quaich which came into my world that led me through
this next maze of intrigue, for the quaich is derived from what once
was a scallop shell, and has for handles decorative designs called lugs,
which in Scots translates as ears. So the next stage had to incorporate
investigation into its original form, the scallop shell. An ancient cup
. . . with boundless meanings. For fear of repeating myself I must
repeat: I never imagined that my research and writings would take me
into the realms of the holy grail, as in all things I actually resisted its

calling to investigate what it stood for. The pull of it is too strong to resist and so I sprang up and paid attention.

As many others I had heard various stories about its being a possible allegory, of an ancient artefact, brought by Joseph of Arimathea to Britain, the cup that collected Christ's blood and that it was possibly hidden in the Chalice Well in Glastonbury. However I had scoffed at all this and dismissed it as medieval fiction and filed it away in my subconscious as fanciful storytelling. It gathered dust with the other folklore I have heard through my life alongside Pilate having been born in Scotland, of how the 12 tribes of Israel came to my country. All utter nonsense – or so I thought. Now that I have followed the lead that my artefacts have gifted me I cannot deny the connections they make and have to admit to being thrilled by the realisations. Thrilled but also challenged as to my legitimacy in confirming them. I have had to consider all facets of this quest which has been handed to me: its power, its magic in this fractured world of ours, and after much consideration and contemplation feel assured that I should tell this tale. I hope that you will feel that this gentle rain of enlightenment resonates with you and that my vessel of love, which I desire this book to be, holds true. As I have said throughout this work all I would ask of you is to question, and shake out the truth that lies within our history. Blind faith is not what God, nor Jesus, would wish of us, they would, I feel anyway, ask us to know them, to make that pilgrimage in our lives towards their light and love. That is what the scallop shell also symbolises, the rays of that light, spreading out to all corners of this planet, just as his apostles did. Some of the threads which I am attempting to weave together are now frayed, others broken, but the picture still appears and fixes us with its image. This is all very challenging, but worth the battle. The quaich and its associations with the scallop shell turned my attention to what the scallop shell symbolises. The scallop shell I knew well has been used as the emblem of the Camino de Santiago or the Pilgrimage to Santiago on the western seaboard of Spain, so this is where we will go to now. We will then rejoin the story of the quaich as this chapter concludes.

To journey westward into the Pyrenees from France's eastern seaboard is a thrilling experience. It's wild and raw, making your heart beat faster and your pulse to thud in your neck. The landscape changes dramatically, as ribbon roads twist and turn, sometimes with perilous drops that fill you with dread and the sense of impending doom.

Craggy rocks, sculpted by the sun and rain, peer down, reminiscent of the silhouette of the bleached skulls of long-dead mountain goats, with their weathered horns piercing the blueness of the sky. Gently scattered across the pastoral landscape are small churches, many dedicated to Mary Magdalene. It is hard to imagine that through this extraordinary landscape over hundreds of years pilgrims have made their sometimes arduous journey to windswept Galicia on the Atlantic coast of northern Spain. Many went in pursuit of the beautiful, seeking a legend and spiritual fulfilment, and others travelled for redemption. I can identify with their vision: that compulsion to travel to a particular place and the consequent surrender and dedication to achieving that goal. For me that focus may not even be a recognised pilgrimage site, just a place that summons us to journey there for some indefinable reason, to climb the mountain, experience the exhilaration in what it inspires, or to look seaward with the waves carrying our thoughts. Even to gaze heavenward to the stars.

That compulsion has to be driven by something profound, founded on philosophy and thought, maybe even the quest for the sacred and what it means to be alive, or maybe stemming from a feeling of being lost and wanting to be found.

It is that sacred knowledge which I believe is the legacy we are tracing chapter by chapter in this book, step by step as we walk in the present and the past. Tragically, many thousands have perished in searching for that truth. For that truth against the world, that light that for so many centuries has been held in the hands and safekeeping of a brave, select group of people – the Druids, the Culdees, the Cathars, the Knights Templar and, in our own time, within the fraternity of the Freemasons, and the Church. Others too, the Buddhists, Hindus, Muslims and others, deep within their teachings lie the words to lead us, sometimes cryptically, to that truth which lies at our feet.

On this journey of mine, the light is growing dim as the sun begins to set and the dusk moves in. In a surreal light I stop for the night and to wait for the dawn to journey onward with pilgrims on the route to Santiago de Compostela.

Santiago de Compostela

The Church of Rome would have us believe that St James the Elder, who was one of the original 12 apostles of Christ, is buried at Santiago.

It was James, together with Peter and John, who witnessed Christ's Transfiguration on the mountain top and who slept in the garden whilst Christ prayed. Slept though Jesus had begged them not to. Three times he asked them to stay awake – but they slept. Slept when he was going through his anguish, slept despite his asking them not to.

St James was tried in Jerusalem in AD 44 and executed by Herod Agrippa. A series of legends associate him with spreading Christ's teachings to Spain and he was evidently a major player in Christ's following and highly significant in the hierarchy of his ministry. According to legend it is he who is buried at Santiago de Compostela. The Church maintains that due to Roman Christian persecution the early Spanish Christians, heretics according to Rome, were forced to abandon the shrine which lay forgotten until 813. A legend then tells of a hermit – led by a beckoning star and celestial music – discovering it. This revelation then provided a convenient rallying point for a confrontation with the Moors who then occupied most of the land. St James was portrayed by the Roman Church as a Moor-slayer. It was a schizophrenic switch of his character from the man chosen by Christ himself to spread the Word in God's name, a chosen man of God and therefore of peace, to a man of war. It was even said that his apparition appeared riding a white horse in 844, leading the Christian charge in battle against the Moors. This unsettles me and obscures any truth it may hold, as for me, my understanding of Christ's teachings was that peace should reign on Earth not war. I have to wonder whether this manipulation of a truth served a dual purpose: first, as a justification for acts of violence against the Moors, and second, in the conception and establishment of a pilgrimage site. To this end, much was made of St James and, as in all such legends, there was a grain of truth to it all. In a masterly form of genetic grafting, the first church was erected in 829 over a shrine that had been sacred for thousands of years. Sure enough, within a century pilgrims were coming from all over Europe, and by the twelfth century it had become the centre of the greatest pilgrimage site in medieval Europe. Triumphantly the Benedictines built monasteries and hostels to host the pilgrims. In fact, to all intents and purposes it could be argued that this was the first seeding of a tourist industry, one based on the veneration of holy relics possessed by the Church. Together with Lourdes in the Pyrenees the site is still venerated, and the mass of souls who convene here is very moving to see, for even today, the beautiful old city of Santiago de Compostela is

charged with an atmosphere and energy of devotion and sanctity. Heady incense perfumes the air, museums hold medieval artefacts including talismans made from black jet that the pilgrims carried with them. The stalwart pilgrims also carried with them the other important symbol associated with this wonderful place: the scallop shell. This symbolism and ritual is not Rome's creation but one that the Roman Church appropriated as its own. They affirm that it is connected to St James and his story. I don't believe this to be true and accordingly the real significance of the scallop shell will be fully explored later, including its association with the quaich, the loving cup of Scotland.

For the moment let's look back with a longer lens at this mystical place and attempt to bring it into clearer focus in its part in our story.

Legends point to the fact that the Camino de Santiago (the pilgrimage of Santiago de Compostela) mirrors the Milky Way; and interestingly in many esoteric and spiritual traditions this is the abode of the souls in the sky, the gods' 'superhighway' through the heavens. Apparently this route to Santiago was a Roman trade-route and was nicknamed by travellers *la voie ladee*, the Milky Way, as it was the road under the stars. A Roman cemetery or early Christian necropolis is known to have existed under the site of the present-day cathedral in Santiago, which is where the remains of St James are still believed to be housed today.

News of the discovery soon spread. It was encouraged to do so, moreover, both by Archbishop Gelmirez and the cathedral authorities, who were anxious to promote the town as a pilgrimage centre, thus attracting money to the area, and by the monks of Cluny, who saw in it the opportunity to assist the Spanish Church in their long struggle against the Moors. Both factions were also helped by the fact that the Turks had seized the Holy Sepulchre in 1078, thus putting a stop to pilgrimages to Jerusalem. All this makes a sense and I believe that there is certainly someone of great esteem buried there, but I increasingly believe, in the light of the clues presented to me, that there is more to the pilgrimage than meets the eye. Let's look again at what is known of it.

The Milky Way is, according to writer Tim Wallace-Murphy, the name of the true pilgrimage, one which did not end at Santiago de Compostela but continued northwards – to Scotland. Scotland the land of the quaich, the quaich associated back to the scallop shell. Connections knitting together. Surprisingly, I first heard of the

pilgimage route when living in France, from a pair of pilgrim tourists who were trekking down through the Tarn from another part of France to join the route in the Pyrenees. I can remember talking to them about the scallop shells hanging around their necks, about the significance of the walk and their saying that the true pilgrimage was north from Santiago to Scotland and that one day they hoped to complete it. It stuck in my mind and when researching this book I investigated further. Tim Wallace-Murphy, the well-known author on Rosslyn and the holy grail, covered this pilgrimage in his book *Rosslyn: Guardian of the Secrets of the Holy Grail*. According to him it was an ancient path of initiation that started, not ended, at Santiago and which then headed northwards. For me that is a strong likelihood as it ties in with the quaich and I do feel that this northward route holds a major significance in our story and may well be the true route.

According to Wallace-Murphy, this ancient route begins at Compostela, the site of the moon oracle of the Druids. Once again the moon! I admit to having found all this mystifying, as I had no idea really about oracles except for them being portals through which gods/goddesses communicated with mankind, so tried to visualise and then explore their context in this example. There is even reference to an oracle in the Second Book of Chronicles in the Bible 5:7–9 in reference to the Ark of the Covenant. According to the Hermetica, which are the teachings of Hermes and contained within the Book of Thoth, on death we journey through seven planets, which I suppose is where we get the term 'seventh heaven', and this coincides with the oracles of the pilgrimage north. At each stage there is an evolvement of spirit until we finally reach perfection at the eighth sphere. This also mirrors the beliefs of the Cathars and many other esoteric religions. It would in the context of my belief tally with the route ending ultimately at Iona.

The following quote from 'The Life and Writings of Thoth Hermes Trismegistus' quoted by Manly P. Hall in *The Secret Teachings of All Ages* puts it beautifully in context, in which the divine stretches out its guiding hand over the ocean of time as the conduit to the afterlife and to true spiritual attainment.

> After the lower nature has returned to the brutishness, the higher struggles again to regain its spiritual estate. It ascends the seven Rings upon which sit the Seven Governors and returns to each

their lower powers in this manner: Upon the first ring sits the Moon, and to it is returned the ability to increase and diminish. Upon the second ring sits Mercury, and to it are returned machinations, deceit and craftiness. Upon the third ring sits Venus, and to it are returned the lusts and the passions. Upon the fourth ring sits the Sun, and to this Lord are returned ambitions. Upon the fifth ring sits Mars, and to it are returned rashness and profane boldness. Upon the sixth ring sits Jupiter, and to it are returned the sense of accumulation and riches. And upon the seventh ring sits Saturn, at the Gate of Chaos, and to it are returned falsehood and evil plotting.

Then being naked of all the accumulations of the seven Rings, the soul comes to the Eighth sphere, namely, the ring of the fixed stars. Here, freed of all illusion, it dwells in the Light and sings praises to the Father in a voice which only the pure of spirit may understand. Behold, O Hermes, there is a great mystery in the Eighth sphere, for the Milky Way is the seed-ground of souls and from it they drop into the Rings, and to the Milky Way they return again from the wheels of Saturn.

This obviously indicated that this was an ancient site of divination, or an energy on Earth and therefore a good starting point on a road of initiation which treks northwards through Toulouse (symbolising the planet Mercury) and onwards to Orleans (Venus), Chartres (the Sun) to Notre Dame in Paris (Mars) to Amiens Cathedral (Jupiter) and finally to Rosslyn Chapel (Saturn). The eighth in compliance with Hermes being the link to Saturn and Christ is an interesting one because in The Sworn Book, a book written in the Middle Ages by Honorius Thebes and which concerns sacred white magic, this is the planet associated with Christ, a possible affirmation of my thesis of his being in Scotland. According to Tim Wallace-Murphy these oracular sites correspond to the Earth's chakra areas and form a path of awakenment from the base to the crown, a trail of initiation of esoteric knowledge. For him the moon oracle was the ancient centre of spiritual death and rebirth. I pause to wonder why Neptune does not feature – a planet known to the ancients – and I would also have expected Glastonbury to be part of it, but maybe the Christos family gave it its unique sanctity. However, Neptune is the Father of Belus in Druidal lore, the name later given to Beltane, the Festival of Fire that celebrates

the ancient migration of the Gaels to Britain, as well as the first day of summer in their calendar (nowadays it is May Day – 1 May – and associated by Christians with the feminine, i.e. 'Mary'). Beltane is also linked with the feminine Sons of Belisena that will be mentioned in the following chapter. In my view, the omission of one of the major planets points to a further destination on this pilgrimage, that of Iona, making that small island the true goal, but I have to admit to being no scholar of oracular knowledge. Could it be that Rosslyn was the culmination of the initiation but Iona the final destination? That is what this story does to you, it makes you question, tread your own path of initiation, oftentimes stumbling, sometimes getting lost but continuing ever onwards to the challenge of true enlightenment.

This line of enquiry loops me back to thoughts of the Judean refugees who landed with Joseph of Arimathea on the shores of Britain. Are we retreading their route as they migrated northwards? Is that why the map of Marseilles (one of the engravings that was gifted to me with the painting) that I discuss in a later chapter bears the insignia of the scallop shell in its heraldry? Does it all affirm the story of Mary and the Christos family landing at Marseilles, then journeying along the hill range of the Pyrenees, to the land of the setting sun and the site of the moon oracle, then north? Perhaps here I too am experiencing divine revelation, in following them some 2,000 years later.

So from the ancient texts of Hermes I now understood its significance. That was a gift to me as I now can contemplate the seven rings when I meditate on life. However, I needed to know more about what this original pilgrimage route of the Milky Way signified.

Primarily, it represents an ancient initiation, from the energy point of Compostela at the base, ever moving upwards to the crown at Rosslyn and even Iona, with each stage representing a period of intense spiritual devotion culminating in true enlightenment. It was fascinating to discover that planetary oracles have been respected for many thousands of years and as such should be taken very seriously. These were genuine sacred pilgrimage routes, not ones constructed or later hijacked for Roman Christianity's own hidden agenda.

The question remains: why is the pilgrimage of the Milky Way in direct opposition to the pilgrimage that the Church of Rome advocates and promotes?

I believe the answer is that the Church would not want to identify, nor align itself with, ancient pagan beliefs and most importantly wanted

to bury any sign of the history of Joseph, Mary Magdalene and the others ever walking the route. So in a brilliant tactical ploy to send people in the opposite direction from their true goal, they orchestrated their own route in opposition to the original but still grounded in a certain consoling sanctity, for Santiago is without doubt of great spiritual significance.

At this stage I found the quotation below gave me great solace: 'There is a principle which is a bar against all information, which is proof against all arguments, and which cannot fail to keep man in everlasting ignorance – that principle is contempt prior to investigation.' Attributed to nineteenth-century philosopher Herbert Spencer, it says it all.

What we have then is an alternative route to the perceived pilgrimage, one that is much older and has Santiago de Compostela as the first oracle of this journey north, holding a position synonymous with the moon. It is the essence of the Sacred Feminine and the crucial starting point of Mary's journey to her ultimate destination in Scotland. It was a route that closely followed ancient sacred sites and so carried with it the sacred imprint of enlightenment. In ancient culture we have seen that the moon oracle was the focus of spiritual death and rebirth, and so beautifully symbolised the opening of the next chapter in their lives, one safeguarded and governed by the planetary oracles under the physical vaulted dome of the Milky Way. Their shared objective was to spread the word of God and take it to the island of Britain, an island that we now know has archaeological evidence of enlightened cultures spanning millennia, the latest being the awesome find on Orkney of a Neolithic temple which predates the Pyramids and which shows a remarkable level of sophistication and knowledge. The site is known as Ness of Brodgar and was constructed in the Stone Age. Experts now believe this could have been central to Neolithic culture, and with jewels like that in our crown it is hardly surprising that the sanctity of the British Isles would have been known of, even revered. Others of the group would head north from Marseilles through the Rhone valley, but for this divine family their goal, magically, mystically was Britain. Remember it is on record, both historically and in myth. The transport of the holy grail to Glastonbury has been the stuff of legend and lore for centuries, and the beauty is that unbelievably it was based on fact! The quest of the holy grail, the Arthurian legends more and more come into a shared

focus with history, the holy cup of Celtic lore of a collective unconscious memory of spiritual clarity which was intended to provide eternal nourishment for our souls.

With every stage of the journey taken by the divine family there would likely have been a record of them, gentle murmurings kept well out of earshot of Rome. There would have been symbols in whatever medium they could use, maybe this is when the scallop shell became a symbol and keepsake of their transit? In their journey northwards out of Spain, through France to their departure from the Continent as they journeyed to English shores, Glastonbury and then ever north to Scotland, and their completion of their own pilgrimage of further enlightenment there would have been souvenirs to commemorate them, carved in stone, in wood, in oral history. Are they still there? One enduring souvenir I am sure is the quaich, a symbol of the grail and aligned with the treasured goblet of René d'Anjou, of which it was said that a sip from the goblet would enable the drinker to see God but if they drained it they would see Mary Magdalene. What an intriguing, tantalising puzzle this is, so full of the faintest of echoes which are hard to discern but then, as the whispering gains strength voice the most exquisite truth, or at least, so it appears to me.

Tim Wallace-Murphy says:

> The enlightenment which flows from the opening of the crown chakra is the supreme and total fulfilment of the grail search, and was awarded at the seventh site, Rosslyn Chapel, the ancient and revered site of the Saturn oracle itself. The initiation ceremony for this degree took place in the hidden chamber under the chapel which was deliberately created by William St Clair as the focal point for every known path of initiation. Rosslyn Chapel – the Ompahalo or spiritual umbilicus of the world.
>
> Tim Wallace-Murphy, *Rosslyn: Guardian of the Secrets of the Holy Grail*

Obviously, in the context of the Christos family, Rosslyn was not yet built, but it is clear that this was an ancient and significant sacred Druidic site – and this is perhaps why the interior of Rosslyn may well have replicated an ancient woodland, with its open canopy to the heavens.

It's a lot to take on board, but my belief is that we can trust this.

Divine knowledge has mirrored and mapped the Earth's energies, marking them with their sacred places of worship, places such as the Pyramids, the temples of Greece and Rome, the temples of the Mayans, and of course of Orkney and Stonehenge. These are places that have been venerated for thousands of years, whether they were shrines, megalithic constructions, earthen mounds or simple remote forest glades.

This continuing and powerful attraction which pagan people felt for their sacred places must have resonated with Mary and her family. They too were imbued with the ancient mysteries and would have held a deep respect for the Earth's energies. I can understand this, I can feel that power when I am amongst these amazing sacred sites or when I stand in a church built on one. There is an exquisite beauty which touches you. With me it sometimes brings tears of emotion as the sacred communicates itself to you.

Paradoxically, it was for this very reason 400 years after that migration of God's people and under continued pressure from the weight of natural devotion that these sites inspired, that the Church tragically went to great lengths to scourge the land of any structure that might be deemed sacred yet not of the Church. The second Council of Arles, held about AD 452, issued the following canon:

> If in the territory of a bishop, infidels light torches, or venerate trees, fountains, or stones, and he neglects to abolish this usage, he must know that he is guilty of sacrilege. If the director of the act itself, on being admonished, refuses to correct it, he is to be excluded from Communion.

The Council of Tours, in 567, declared much the same:

> We implore the pastors to expel from the Church all those whom they may see performing before certain stones things which have no relation with the ceremonies of the Church, and also those who observe the customs of the Gentiles.

King Canute in England and Charlemagne in Europe conducted a most vigorous campaign against all these pagan worships. This is Charlemagne's edict:

> With respect to trees, stones, and fountains, where certain foolish people light torches or practise other superstitions, we earnestly ordain that that most evil custom detestable to God, wherever it be found, should be removed and destroyed.

After the initial wholesale destruction of pagan shrines at sacred places, it slowly dawned on the Christian Church that they could not reform the pre-existing cultures merely through the use of brute force and so they developed the method of securing religious control of the people by placing churches and monastery foundations upon the pagans' sacred sites. Santiago de Compostela is an example of this, as are Chartres, Rosslyn, even Rennes-le-Château and many others, including Iona.

An excerpt of a letter from Pope Gregory to Abbot Mellitus in AD 601 illustrates that this reasoning had become policy for all of Christendom:

> When, by God's help, you come to our most reverend brother Bishop Augustine, I want you to tell him how earnestly I have been pondering over the affairs of the English: I have come to the conclusion that the temples of the idols in England should not on any account be destroyed. Augustine must smash the idols, but the temples themselves should be sprinkled with holy water and altars set up in them in which relics are to be enclosed. For we ought to take advantage of well-built temples by purifying them from devil worship and dedicating them to the service of the true God. In this way, I hope the people, seeing their temples are not destroyed, will leave their idolatry and yet continue to frequent the places as formerly.

This callous usurpation of pagan holy ground for the building of Christian churches was practised throughout Europe, even though the true Christians, the Culdees, had founded the first church in Glastonbury in AD 36. Maybe this is why the direction was given and in deference to this it is interesting to note that nearly all pre-Reformation cathedrals were placed upon sites of ancient pagan shrines and were directionally oriented according to the astronomical alignments of the shrines and celestial observatories they replaced. Maybe this intercession was a fair move in a fashion of the new religion

overlaying the old, but what is so sad and shameful is the attempted obliteration of the sacred in any form in which that appears, even though these sites were dedicated to Christian saints whose feast days coincided with the days that local pagans had traditionally recognised as important. I believe a great deal was lost in this overthrow, and both could have married in a holistic philosophical belief sytem that would have sustained one and all, encompassing the divine in all her guises. This policy was carried out primarily at major pagan shrines that could not be destroyed because of their location in villages and large towns, while venerated power points in remote, uninhabited places were still destroyed according to a decree of Nantes in AD 658: 'bishops and their servants should dig up and remove and hide to places where they cannot be found, those stones which in remote and woody places are still worshipped'.

Yet centuries later, St Bernard of Clairvaux intriguingly stated with clear personal conviction: 'Trees and stones will teach thee more than thou canst acquire from the voice of Magister,' this the man who founded the Knights Templar and whose order of the Cistercian monks wrote of the quest of the holy grail.

I find it horrifying to think how many pagan sacred sites were lost due to the religious fanaticism of early Roman Christianity, but it's a consolation that by erecting their religious structures upon the foundations of ancient megalithic ruins (even using the broken-up dolmen and menhir stones in their church walls), the Church ensured a continuing knowledge of the locations of the major sacred sites.

From our perspective, though, and for the telling of this story, it was even more fortunate that the designers of the larger churches and cathedrals, the Freemasons, were skilled in sacred geometry and therefore built their structures with the universal mathematical constants of that mysterious science, and imbued the stone with carvings which would communicate with the initiates. Of course they would, for they were initiated Masons.

Paul Devereux, writer of *Sacred Geography*, is quoted on the website 'Sacred Geometry':

> The formation of matter from energy and the natural motions of the universe, from molecular vibration to the growth of organic forms to the motions of planets, stars and galaxies are all governed by geometrical configurations of force. This geometry of nature is

the essence of the sacred geometry used in the design and construction of so many of the world's ancient sacred shrines. These shrines encode ratios of creation and thereby mirror the universe. Certain shapes found in ancient temples, developed and designed according to the mathematical constants of sacred geometry, actually gather, concentrate and radiate specific modes of vibration.

Paul Devereux (attr.), on 'Sacred Geometry' (http://sacredsites. com/sacred_places/sacred_geometry.html, accessed May 2012)

So now we know why Santiago de Compostela became such a significant site. It had enormous sacred history and I firmly do believe there is someone of great esteem buried there, though doubt it is St James. I can't see why he would have been brought over from Judea, where he was executed, to be buried there. Logically, it would be the shrine of someone who died in Santiago de Compostela. Whatever the true facts, what is known is that the Church commandeered it for its own agenda. That doesn't really matter, for it is a sacred site, and for people to journey there on a pilgrimage of enlightenment is a worthy goal. BUT, what if the true story were known, how many more would undertake that pilgrimage? The Church knew, of course, of its real status in the book of our world and in a master stroke rewrote the pages to fit its own agenda: to help overthrow the Moors in Spain and blur the journey of the holy grail.

The true story, I believe, is stranger than fiction: that Mary Magdalene and her family took the route from Marseilles (Marseilles has the scallop shell in her coat of arms to prove it) along the Pyrenees to Santiago de Compostela to spread the word of Christ and His mission on Earth. This is underscored by the string of churches dedicated to her, which line the group's route along the necklace of mountains of the Pyrenees between Spain and France. I have more to lay at your feet in evidence of this so let's now take a closer look at the enigmatic scallop shell before examining its relationship with the Scottish quaich.

The Scallop Shell

The scallop shell has long been acknowledged as an ancient symbol of the Sacred Feminine. The reason for this is that it is associated with the moon because it dwells in the oceans governed by the

monthly cycle, and the shell is shaped like the female sexual organ. This is beautifully depicted in Botticelli's *The Birth of Venus*. So what has it to do with St James? Not much that I can see, which leads me to think that it may allude to Mary Magdalene but that the papacy took it as their own and embroidered their own story of St James around it. Certainly the link to the feminine and a possible grail mesh in well with what my story seems to be telling. The proposition has to be that the Church kept the symbol and just changed the story. I don't believe they ever thought it would be questioned. They hadn't factored in the brotherhood or indeed anybody having the courage to take them on, especially not at their own game of subversion. The Masons and associated brotherhoods are masters of this art, with strategy and tactics their key players. White Knights against the Black on the chessboard of strategy and gain. The Church of Rome had the first move, but it has always been a close game. Symbolism was taking hold; coded messages that undermined the complacent rhetoric of Rome. That is why, on the route to Santiago, in Santo Domingo de Silos we have Jesus Christ depicted wearing a scallop shell. He too is walking the Camino, along the Pyrenean choker necklace of France, yet the pilgrim route is supposed to commemorate an event after his death. The truth is far more compelling: it is my view that the pilgrims were retracing the steps of the Christos family, an awesome trail which still charges the soles of the feet which tread it. This land is the land of the grail – the holy grail. How can I be so sure? Put simply, it is because the signs are there, right under our noses, but only if there are ears to hear – and eyes to see.

There is a suspension of disbelief to a glorious revelation and acknowledgement of what a wondrous pilgrimage this truly is. The Christian Church had taken hold in Marseilles, Mary's brother Lazarus was bishop there, but consider this: in that case why is Britain the acknowledged site of the first Christian Church? It came after Marseilles, so is it because the one in England was founded by a more powerful figure than Lazarus, that it was Christ's family who founded it? Maybe it was Jesus making a Jerusalem in England's green and pleasant land.

What an awesome thought, which somehow makes perfect sense. More justification comes in yet more symbolism whispering to us. Whether I like it or not, I am involved in a quest for the holy grail.

The Holy Grail

Incredibly, this is displayed loud and clear in the very region of Santiago, for the holy grail appears documented in the armoury and banner of the kings of Galicia in the Segar Armorial, compiled in England as early as circa 1282. Initially the early coat of arms supported three golden grails over an azure field. I would submit that there can be no possible connection between these three golden grails and St James. It has to be connected to Jesus Christ and Mary. Has to be. But why three? Is it further proof that there was a child?

During the fourteenth century, the Galician arms changed from three to just one grail and was then represented on buildings. Then during the fifteenth century, angels and crosses were added to the background. Originally the number of crosses was six (three on each side of the chalice) plus a seventh one over the holy grail. It has suddenly occurred to me, is that something to do with the planetary oracles? Could that symbolise the holy grail being at Rosslyn?

Significantly, the coat of arms remained like this until the official design of the Galician coat of arms in 1972 by the Royal Academy of Galicia. Now we have the holy grail surrounded by seven silver crosses over a blue field, again representing a possible connection to the Milky Way.

The implications of all this, for me at least, are undeniable. With the evidence of the grail chalice, and angels and stars in their insignia, it can't really be much plainer. This route is to do with the holy grail, not St James, and that for me is incredibly exciting.

According to one legend, the holy grail was the cup used by Jesus to drink wine during the Last Supper. Then tradition has it that it was taken across the sea to Europe, 'where the world ends', and was eventually hidden in the island of Britannia. For many, this is cryptic language for Mary going to Marseilles and then travelling to Galicia before heading north to Britain. As a pagan symbol, the Eucharist dropping into the chalice has been interpreted as the sun setting on the sea, just as the sun sinks as it sets in the west. Hence the consecrated wafer (remember this represents Christ's body) is like the setting sun. The sun that then is taken by boat to the ends of the world. Both Finisterre, on the coast to the west of Santiago, and Iona comply with the geographical implications of that. It's worth reflecting on the image of the Eucharist in the Book of Kells, where it is being eaten by vermin. For me, that resonates with this new discovery – the truth was under threat, and still is.

O'Cebreiro

In illustration of this there is a colourful story on the route to Santiago de Compostela that I want to tell you; it tells of a miracle that happened in the French highland village of O'Cebreiro. This is the story.

The Church of Santa Maria at O'Cebreiro believes it has the holy grail, for according to local lore a miracle took place at that church in the fourteenth century. It is a rather beautiful story of how, during the consecration, a peasant came into the church out of a snowstorm in order to hear Mass. The priest criticised him for coming so far just for a little bread and wine. At that very moment, much to the consternation of the congregation, the bread and wine were literally turned into flesh and blood. The chalice which held the wine turned to blood was left unchanged until, 200 years later, Queen Isabella of Castile had a crystal shrine made to accommodate it, exhibited with the Madonna at annual religious processions on 15 August and 18 September. This extraordinary miracle was confirmed by Pope Innocent VIII in 1487 in a papal bull and again by Pope Alexander in 1496.

In acknowledgement and celebration of this miracle, O'Cebreiro's coat of arms illustrates a chalice with the Eucharist dipping into it, flanked by two scallop shells. Could this be yet another parable, that the body and blood of Christ passed that spot? There is a palpable timelessness about the place, with a strong undercurrent of sanctity. It is a place where amongst the mountain shrubbery you will find prehistoric stone huts: a sacred ancient place. This place forms the last pass before the descent past the Cistercian abbey of Carracedo and the Templar castle of Ponferrada to the plains below. I loved the thatched roofs of the buildings, the grey of the buildings which so perfectly merge with the landscape. The light is luminous and the views stunning. This primal landscape forms the watershed between the Atlantic Ocean and the Cantabrian Sea, and is the highest point on the surrounding sierra. It is an awesome, windswept place through which many thousands have walked, and a place that is weirdly charged. In the peace there, one can almost hear snatches of the whispers of times past, even turn at a sensation of being watched only to find nothing but an echo. In my wildest moments I sometimes wonder if I could live there, but then again I have the same feelings about Lochinver in northern Scotland.

Allegory and parables similar to this miracle underpin much of historic record and have been used since the beginning of time. In fact,

Jesus himself used them to illustrate his teachings, and the Gospel of Thomas is full of parables:

> Whoever discovers what these saying mean
> Will not taste death
>
> Gospel of Thomas, saying 1

Refreshingly, even our own magnificent Leonardo da Vinci left notebooks full of symbols. Symbolism in semantic form is merely a sign language to communicate what must never be forgotten.

Now, wonderfully, we are decoding their meanings and can speak the words out loud. But what a tragedy that such truths have had to be encoded in symbolism – and what great courage has been demonstrated by the millions of our forebears to keep that truth alive. Now, finally, at our feet we have them. Knowledge and in its shadow freedom to think and to question. The enigmatic power of the scallop shell, the grail and its link with a royal bloodline as conceived by Christ stand before us, transcending all else. Transcendence – what a sublime concept.

Yet another beguiling link to the importance of the scallop shell can be seen in the imagery of the Order of St Michael. It is represented by a gold necklace of scallop shells. This Order was the highest order in France, the first chivalric one, and founded by Louis XI in 1469.

The order was dedicated to St Michael the Archangel and every member was given a gold badge of the saint standing on a rock in combat with a serpent. This image was suspended from an elaborate gold collar made of cockleshells (copying scallop shells which were too large to be worn) linked with double knots. Originally the Order convened at Mont St Michel in Normandy. Legend has it that it was here that Jesus and St Michael confronted and beat the Devil. Mont St Michel is deservedly known as a 'Wonder of the Western World'. Unbelievably, the granite used in the abbey was transported by boat from the nearby isles of Chausey and apparently took more than 500 years to build, only being finally completed in 1521.

An ordinance of Charles VI of France in 1393 referring to the booths of the sellers of shells and the scallop shell is prominent in the coat of arms of the abbey.

Another significant point here is the connection between St Michael and Christ. Jehovah's Witnesses believe that Jesus and the Archangel

Michael are one and the same being. They base this belief on scriptural passages where the Bible refers to Michael as 'the archangel', a term meaning 'chief angel'. 'The Lord himself will descend from heaven with a commanding call, with an archangel's voice.' 1 Thessalonians 4:16.

In corroboration of the scallop's great standing in heraldic imagery, it is interesting to see that many Knights of the Garter have incorporated the scallop shell into their coats of arms. The two most recent ones being Sir Winston Churchill (Freemason and Druid) and Sir Anthony Eden, both having done so in honour of past descendants in their line.

> For the scallop shows in a coat of arms,
> That of the bearer's line,
> Some one, in former days, hath been
> To Santiago's shrine.
>
> Robert Southey, 'The Pilgrim to Compostella'

This introduction of the Knights of the Garter also amazingly can be linked to the holy grail for as Manly P. Hall in his book *The Secret Teachings of All Ages* points out, there is a connection between the Garter and the grail, the garter is not a garter at all, but the 'garder' or 'keeper' of the grail.

This then linked again with the feminine symbolism of the scallop shell also has strong associations with the Knights Templar, which is hardly a surprise given what we now know about the shared roots of both orders to the Judean refugees and to Mary Magdalene. In this respect it is important to note that only four per cent of heraldry bears scallop shells, which is a strong indicator of how select that brotherhood is.

It appears to me that the feminine seems implicitly associated with the grail, and I was amazed to read in *The Quest of the Holy Grail*, which was written in the thirteenth century by a Cistercian monk (from the Order of Bernard of Clairvaux, who founded the Knights Templar) that Perceval dreamt of two ladies. I would like to quote the interpretation of his dream now, for this comes from a godly man's story, telling of one of the most abiding myths of our time:

> Perceval, the meaning of the two ladies, whom you saw riding on such unwonted beasts as a lion and a serpent, is truly marvellous, as you shall learn. The one who sat upon the lion signifies the New

Law, that is set upon the lion which is Christ; it had its footing and its ground in Him, and by Him was established and raised up in the sight and view of Christendom to serve as a mirror and true light to all that fix their hearts upon the Trinity. This lady sits upon the lion, Christ, and she is faith and hope, belief and baptism. This lady is the firm and solid rock on which Our Lord announced that He would set fast Holy Church, there where He said, 'Upon this rock I will build my church.' Thus the lady seated on the lion denotes the New Law which Our Lord maintains in strength and vigour, even as a father does his son. Nor is it surprising that she seemed younger to you than the other, for she is not so old in age or aspect, since she had her birth in the Passion and Resurrection of Jesus Christ.

<div align="right">Pauline Matarasso (tr.), The Quest of the Holy Grail</div>

It's incredible what material is there, hidden in texts which allude to things we should know. Which is why, of course, books are so important, and which is why for that reason some are at times labelled heretical and burned. In my view the passage quoted alludes to Mary Magdalene, it is she who is the founder of the Church and the rock upon which it shall be built; is it fanciful to believe that church to be the one in Glastonbury? Not for me. It's all making perfect sense, my exposure to the research I have undertaken has made me receptive to it.

On a lighter note, and to digress for a moment, I found my research into the scallop fascinating – the humble scallop that most of us only think about as something delicious to eat.

I will praise Thee; for (all is) fearfully and wonderfully made;
Marvellous are thy works, and that my soul knoweth right well!
<div align="right">A. Gosse, Naturalist, 'When watching a Queen Scallop'</div>

The scallop with its 100 eyes, its agility in the water and its ease of propulsion certainly is a wonder of the natural world. Unlike any other shellfish, it is able to move in any direction, like a flying saucer of the oceans. To my mind, the medieval creative team had a stroke of genius to have it as a logo for sacred knowledge.

The markings of its shell certainly echo the rays of the sun, entombed within the crescent moon and the sun in representation of the two counterbalances of nature, the light and the dark, the sacred masculine

and feminine. There is also another link to the Sacred Feminine in the shape of the V that is formed at the point where the shell is hinged. Is it just coincidence that two types out of many are found in the seas on the western seaboard of Iberia: the *Pecten Maximus*, the great scallop; and the scallop of Santiago de Compostella that is known as the 'Viera', or 'Queen' scallop. Even that biological fact has a bearing here, do these names yet again refer to Mary as the Queen and Maximus as Maximinus, or Christ? A coincidence, possibly, but an uncanny one.

In the context of our story there is another legend which is associated with the pilgrimage route which maintains that it was seen as a sort of fertility rite, undertaken when a young couple wanted to have children. This too would of course tally with St Mary Magdalene, who was regarded as a fertility goddess in France – something she would surely not have been revered for if she herself hadn't borne children.

Journey across the seas to Scotland and the Grand Master Freemason William St Clair who built Rosslyn, with actual scallop shells used in the mortar of the very fabric of the building, and representations of scallops, fleurs-de-lys, roses and stars decorating the interior. More than this though, his coat of arms includes an engrailed cross, so I had to consider what that decoration signified.

Well, the cross is bordered by a waveform pattern delineating the lines and in the St Clair coat of arms it is described as 'scallops', and the scallop shape resembles a cup or dish, thus symbolising reception of something, drinking something; so it makes sense that their coat of arms would bear testimony to their inclusion of hidden knowledge. In this instance incorporating the scallop in a never-ending unbroken line could signify that the scallop passes in time and space in a linear fashion but always stays the same as it does so. The shape and pattern never change. So I had to consider whether this morphing of the zigzag into a scallop shape could mean receiving the 'light' and if the St Clairs name is from a Scots hermit who lived in France called William de Sancto Claro – which means (William of the) Holy Light. A clever trick. So the scalloped pattern means not just 'Light' but 'Holy Light', which the St Clairs are supposed to possess – amazing insights and knowledge into nature, the human condition and also the history of planet. Literally, divine knowledge. That is the significance of the scallop, the quaich, as a vessel of truth – for those who have ears to hear.

I may never have been intrigued by the holy grail before, but now my step was certainly on that quest.

There is a vast net of interconnecting threads here, and also caught up in it is Louis XIV (of whom much more in later chapters), who had scallop shells used to adorn his chapel at Versailles and had carved shells with classical heads in the middle placed on the great double doors of the Sorbonne. King Francis I also had them incorporated into architecture. They figure, too, in paintings of the Annunciation by Leonardo da Vinci.

If I was still unconvinced, and I have repeatedly questioned myself, I only had to ask why St James was portrayed as a pilgrim to his own tomb, for that is how he is shown on the church sculptures of Pontevedra. This is a church built in 1778 on a plan that was supposed to represent a scallop shell. Over the main altar is another clue, the pilgrim mother and child, a most curious effigy that I have come to believe is Mary Magdalene.

Outside she is represented again in stone, standing between the pilgrims of St James and St Roch. And again at Arles in Provence and in the cloisters of Santo Domingo de Silos in Spain there are statues showing Jesus Christ dressed as a pilgrim, bearing the scallop shell. St James is portrayed in stained glass at Chartres Cathedral, on the pilgrimage of the Milky Way carrying the scallop shell, and in Scotland in a small, modest church at Amulree in central Perthshire, at the entrance of a glen called Quaich, there is a depiction in stained glass of a person bearing the garb of the pilgrim, including the scallop shell, paying homage and requesting blessings at the feet of Grace.

This last example is without doubt evidence of the northward leg of the pilgrimage and its importance. A Freemason I know told me that this part of the world is known as the land of the grail! The connections certainly seem strong enough to bear the weight of what I feel they hold: it must relate to the Christos family, and to Mary Magdalene.

Curiously, scallop shells are still deposited in Rosslyn by those few who know their significance, and there was a curious archaeological find on the Isle of May in the Firth of Forth, of the skeleton of a monk with a scallop shell placed in his mouth. Another connection with St Clair, who captained one of the Templar ships which escaped from France and landed on the Isle of May. The skeleton of the monk shows the determination that the placement of the scallop shell merited, for it had to be wedged into his mouth, surely such a dramatic gesture by those who buried him must signify the importance of the act. I visited the island, as I had a feeling that the name May could well connect it

to Mary Magdalene. There are stories about a mysterious woman landing there, and of a pilgrim's beach, but though I sense it is true I can't be certain.

Back on mainland Europe is the wonderful example of the palace at Salamanca in Spain. Built in the early sixteenth century, it is literally covered with scallop shells and the town's coat of arms incorporates the fleur-de-lys, underlining again what has been said 100 times before: that Jesus Christ and Mary Magdalene were married, and that their bloodline was intact. A child was born, possibly more than one. Both symbols of the scallop and the fleur-de-lys allude to it.

Observations

It was incumbent on Christ and Mary Magdalene to produce an heir to carry their shared genetic code. It makes absolute sense. In recent times, Robert Graves, D.H. Lawrence and other literary icons have alluded to it. So too have Margaret Starbird, Tim Wallace-Murphy, Baigent and Lincoln, and countless others. A.N. Wilson, for example, says: 'The story of the wedding feast at Cana contains a hazy memory of Jesus's own wedding,' while the Muslim scholar Professor Fida Hassnain makes the following observation of the feast:

> The question arises, who is the guest and who is the bride? I would suggest Mary is the host, for she orders the procuring of the wine for the guests, which Jesus deals with. One wonders whether it is his own marriage with Mary Magdalen, and whether the whole episode has been kept under camouflage. I believe that Mary Magdalen behaved as the chief consort of Jesus, and he also took her as his spouse.

According to Jewish law only the spouse at a wedding has the authority to order the servants to distribute wine. It was indeed his own wedding. Even the Catholic theologian Margaret Starbird, who set out to refute the heresy of Jesus's marriage, ultimately published a detailed exposition of the conclusive evidence in her book, *The Woman with the Alabaster Jar*.

According to Tim Wallace-Murphy:

> Ma'madot (a branch of the Sanhedrin bloodline to which Joseph of Arimathea belonged) traditions recount that the children of

Jesus had been parted and sent to places of safety to ensure their survival. Jesus's son James had been entrusted to the care of Judas Thomas Didymos, according to some accounts Jesus's twin brother, and sent to the safe custody of King Abgar of Edessa. Jesus's pregnant wife, Mary Magdalene, had fled to Egypt, where she gave birth to a daughter called Sarah before eventually seeking refuge in France.

Tim Wallace-Murphy, *What Islam Did for Us*

His references here are Fida Hassnain, *A Search for the Historical Jesus*, and his own book, co-written with Marilyn Hopkins and Graham Simmans, *Rex Deus*.

This brings us back full circle to the evacuee Culdees, their dispersal throughout Europe and their subsequent foundations of Glastonbury and the holy grail, moving north to Scotland and Iona; the sacred Culdees and the preservation of their sacred bloodline.

As we witnessed in the chapter about the engraving, this was a bloodline that the Church sought to sever. They had the Culdees supplanted and went so far as to demand celibacy from the priesthood. This had a twofold effect of engendering a misogyny which came to the fore more fiercely than ever before and making absolutely certain that the sea of DNA engendered by the Culdees would be diluted.

The decision to decree that priests should be celibate doesn't make sense unless this was the main motivation. To check it I researched the history of the marriage of priests, and what follows confirms for me the method behind it. In the light of the fact that Peter, the first pope and apostle of Jesus, was married, as were most of his followers, and even in the third century most priests were married, it was interestingly in AD 325 at the Council of Nicaea that it was decreed that a priest could not marry. This was swiftly followed by a decree issued in ad 352 at the Council of Laodicea that women should not be ordained, which in its very statement implies that before this date they had been. In 590, in the light of ever-growing misogyny, Pope Gregory 'the Great' proclaimed that all sexual desire was sinful.

However, in France in the seventh century there are documents which show that the majority of priests were married and in Germany in the eighth century St Boniface reported to the Pope that almost no bishops or priests were celibate. Things went from bad to worse when in 1095 Pope Urban II had priests' wives sold into slavery!

Quite an indictment and certainly inconstant, for popes themselves were often married, right up until Pope Felix V, who had one son. Then of course, in a classic 'do as we say, not as we do', there were popes who were the sons of other popes or clergy. Even more hypocritical were the numbers of illegitimate children they fathered in the Middle Ages. Pope Innocent VIII in the fifteenth century had several, as did Pope Alexander VI. For me there are sufficient anomalies to make me question the reasoning behind the pronouncement against marriage.

Fleur-de-lys

Now we come to another central foundation stone in symbolism and this painting's story, the starting point for me on this mystical journey, which chimed for me when I took note of the fleur-de-lys in the nimbus of the baby's head in my painting. The enigmatic fleur-de-lys, the sign, as I am now certainly persuaded, of how the royal bloodline has been symbolically documented.

The fleur-de-lys is incorporated in heraldry and architecture, and of course in paintings. All speak of the unspeakable: of the Magdalene and the holy grail.

Just as with the scallop shell, I found that this too has been incorporated for centuries and descends from a sacred symbol adopted by the Egyptians, that of the deified scarab, the emblem of the moon gods, and it is perpetuated in that mystically magnificent badge of France, the female lily of lis or iris.

According to Hargrave Jennings, in the early armorial bearings of the Frankish kings the 'lilies' are represented as insects or bees. These, according to him, just as with the scarabei of the Orientals, were dignified by the Egyptians as the emblems of the 'Enlightened'. Enlightenment is of course the goal of all mystic groups and probably most people. The motto which is placed under the fleur-de-lys is '*Lilia non laborant, neque nent*', also the legend or motto of the Order of the Knighthood of the Saint Esprit, and are the words of Christ in St Matthew 6:28:

> Consider the lilies of the field, how they grow; they toil not, neither do they spin; and yet I say unto you, That even Solomon in all his glory was not arrayed like one of these.

So the bee and iris/lily are of a shared genealogy, and may also explain the connection of the imperial bees to Charlemagne and Napoleon, and even to those which appear in Masonic literature. The phrase 'Queen Bee' springs to mind and reassuringly ties yet another knot with the Sacred Feminine.

I sense that the fleur-de-lys which adorns the baby's head in our awesome painting, and which has instigated this amazing journey, has also dusted us with its pollen. Maybe now, as with the bees of ancient times, we should carry it on and help it blossom afresh.

The meaning of the fleur-de-lys is 'I serve' (interestingly, this is the same as the Prince of Wales feathers). Maybe when asking whom does the holy grail serve, that is the answer: the one who serves! Again according to Jennings, when arranged in threes the fleurs-de-lys represent the triple powers of nature: the 'producer' the 'means of production' and 'that produced'. Or, in other words, father, mother and child, as so beautifully shown in my painting.

In consequence of this revelation the next stage is the largest leap we take in this amazing history of Mary Magdalene. I am only too well aware of what I take on in writing it.

Christ's Passion

What I am going to now lay before you is the most difficult part for me. Over the years of my research and especially in the months leading up to the publication of this book I have struggled as to whether I should confront you with something which may shatter you, maybe even profoundly so. Before you proceed I would ask that you consider this: if I were to tell you that Christ survived his Crucifixion would you be happy, or would you be sad? A big question, I know!

Well, I assume you would be happy to know he survived to continue his teachings, but appreciate you may well feel that this undermines your belief in his divinity. I've looked at this from all sides now and feel nothing but happiness at the thought that he might have survived. For me, he is Divine. I am a Christian and I believe in him, in the Trinity and in gracious Mary Magdalene. Philosophically this is rich, fertile ground, leading to many questions and personal revelations. For instance, when did the divine enter Christ? Was it at birth? So was he a god as a toddler, an adolescent, or did the divine descend when he was baptised by John, symbolised by the descending dove? What makes sense, if there is sense to be found? Apart from this, surely the divine

couldn't be destroyed? How can we expect a god to suffer on the cross? He surely transcends suffering. Yet Christ evidently did suffer.

I have gained confidence and solace in my personal revelation that he survived by finding out that I am not alone in that belief. In Islam they say that he did: 'For surely they killed him not, son of Maryam', Koran 4:157. Hilal Khan and the Ahmadi Muslims certainly believe he continued with his teachings. For them he went on to India and in ancient Buddhist and Hindu texts there are references to his being there. More on this you will see in the next chapter, which concentrates on the Cathars, or Pure Ones, who lived in southern France, and also believed Jesus survived, and that with his wife Mary Magdalene passed through the Languedoc. We will see in that chapter that in the church of Rennes-le-Château there is further evidence of a mystery in connection with his death in the depiction of the Stations of the Cross.

His Passion? Yes, he certainly had to face his own death with a courage and sacrifice which he was willing to forfeit for scripture and man, but did he die? I don't believe that a loving God would demand the death of his son. More than this, wouldn't it be natural for those who knew of his perceived destiny to have hatched a plan to save him, even if he wasn't aware of it? At the conclusion of this book, in the Epilogue, I document material from the Bible which underscores my belief that he survived. So, I ask you to bear with me and consider that he did, for as he said to his disbelieving followers the day he rose from the tomb: 'Feel my wounds, I am not a ghost' (John 20: 27).

Think of this too. Joseph of Arimathea supposedly collected Christ's blood in the 'grail' cup, but dead men don't bleed. In that case, does the blood not signify something else, his line, his progeny? The grail being the container carrying his bloodline? It makes a certain sense, doesn't it?

So, following this hypothesis, what happened to him? Why is there no sign of him? Well, I believe there is, and this is why, yet again, I think it is carried through in lore and symbolism. These are my thoughts.

After all my reading and research, I have come to the conclusion that Maximinus, who accompanied Mary Magdalene to southern France, was the pseudonym for Jesus Christ. Until his appearance at her side there is no evidence of him, no biblical reference. This surely is extraordinary, given it was Maximinus who declared his wish to be buried at her side; it was he who, according to the Church, gave her the last rites. Yet there is scant information about this disciple named Maximinus, save that he arrived with Mary Magdalene on the shores

161

of Marseilles. Later he became Bishop of Aix and was founder of the Cathedral of St Sauveur in Aix-en-Provence; St Sauveur, St Saviour, Saviour – Christ. The original name for the town was Aquae Sextiae. It was only in the Middle Ages, relatively late, that it was renamed Aix (pronounced 'ex'). I believe it was called this to incorporate the Gnostic cross of Christ – a sign that he was involved in its creation. It is also incorporated into the Saltire cross that is the flag of Scotland, a flag that is acknowledged as one of the oldest in the world.

The letter X, as we have seen, is the letter denoted to mean Christ, and what better way in French to signal his sacred presence on their soil than by saying so? The French pronunciation for X is the same as for Aix, so we have X–en-Provence, Christ in Provence, Aix-en-Chapelle, Christ in Chapelle, and so on. More: René was part of that decision to change the name – interesting, very.

In testimony to this we have the evidence – look at the map that forms the final chapter of this book – of the coat of arms of Marseilles incorporating the scallop shell, where Mary Magdalene landed. Or, rather, where Mary and Jesus landed. This proves that the scallop shell isn't solely related to Santiago; Marseilles was the first footfall of their arrival on the east, Santiago theirs on the west.

> Seek and do not stop seeking until you find.
> When you find, you will be troubled.
> When you are troubled
> You will marvel and rule over all . . .
> > Jesus Christ in the Gospel of Thomas.

We are on the pilgrims' path of initiation, we are troubled. There is certainly a great deal to think about, but I have more to place before you to consider, and it is in relation to what else was bequeathed to me – the quaich.

The Quaich – The Loving Cup

> The word 'Gral' was obscure from the beginning. The lack of clarity of the name itself and its origin indicates precisely how sacred was a moment in history when a Majesty existed, known and understood, that was called Gral.
> > Franz Kampers, quoted by Otto Rahn in *Crusade*
> > *Against the Grail.*

At the start of this daunting project, I mentioned that amongst the items I had been given was a quaich. According to Scottish lore, quaichs were originally scallop shells and were and are known as loving cups, which are often given as wedding gifts even by Scottish kings to their wives. What has never been mooted before, to my knowledge, is that they are a revered element of Masonic regalia symbolising the holy grail, the mystical cup of Christ and of the union of two becoming one. In my view, given the evidence I have, they are reserved for use in the higher echelons of the brotherhood, and I have one bearing George Washington's heraldry and another from the House of Representatives of the United States which underlines the significance of these cups, and also that they are not unique to Scotland. I believe that the quaich is the most tangible contemporary symbol we have for the grail. It carries the theme of 'for those have ears to hear' through in its symbolism, for the handles to the side are known as lugs, which is Scottish for ears.

One of my quaichs has the head of a beautiful woman engraved on the inside; it is the fulfilment of the declaration made by René d'Anjou:

> Who drinks well,
> God shall see.
> Who drains at a single draught,
> Shall see God and the Magdalen.

My research has led me to collect many quaichs. Four others in my possession represent card decks, which ties in with the tarot, used as another way of relaying the story and one which, according to Manly P. Hall in *The Secret Teachings of All Ages* was used by the Knights Templar and part of their magical and philosophical lore. He also mentions that tarot cards may signify the royal road to wisdom as translated from the words *tar* meaning road and *ro* meaning royal in Egyptian. Manly Hall also declares that tarot cards have a definite Masonic interest. I have always steered well clear of these cards because of the Church's opposition to them, but now I see them in the light they are meant to be seen in, and for the light they shed in their symbolism.

As for the other quaichs that I have in my possession, one has the image of a Templar ship engraved onto the pewter, another a Madonna with her child, another, a brass one, just the simple emblem of the

rose. The handles tend to be scallop shells or serpents. One that I bought at auction has an engraving of St George and the Dragon. They are all decorative in nature but have in common the one central shared theme: each one is undeniably a representation of part of the grail story: whoever drinks from that cup will never be thirsty and will see the Magdalene, the Sacred Feminine. They represent yet another clandestine vehicle for the grail mystery. That of the true Magdalene story, the one which bears testimony to her beauty, her status, her virtue and her godliness.

Quaichs are wrongly only attributed to Scotland; they can be found all over the world and are universal in their symbolism. I have quaichs from as far afield as Brazil, so they are obviously a worldwide token by a universal brotherhood to a shared belief. I have researched these cups extensively and they all have something to say, whether they be armorial coats of arms, images or designs. They affirm a large brotherhood, one ever growing, who swear an oath of secrecy and allegiance to the truth.

To underscore the high esteem they are held in, here are the results of some more digging.

In Scotland, you have a modern take on this vessel represented by the Keepers of the Quaich, quartered at Blair Castle (a building which in itself displays Masonic symbolism) in Perthshire, and in France you find it as the Knights of the Taste. They are apparently now commercial organisations, but their roots run much deeper and reconnect us to Masonic lore and the mysteries.

When I started out on this journey, I never envisaged its becoming one about the quest of the holy grail, but that is what it has inevitably become. That quest for the intangible essence of the soul, a quest guided by enigmatic symbolism through a world of myth, legend and folklore. A world full of tales of cups, bowls and chalices. A world where the scallop shell shares central stage with the fleur-de-lys. A vessel like all others destined to give succour.

> The Water of Life Forever.
> Motto of the Keepers of the Quaich/ Blair Castle

I would suggest that in the world of Mammon, the grail is treasure and therefore material.

In the world of truth, it is a relic of our past and consequently spiritual.

The Quaich symbolises that cup of knowledge. A cup which has been used to symbolise it for millennia. The prototype was the scallop shell, then came the mazer, which is another form of ritual cup, now morphed into their younger cousins, the quaich and the wine taster/ *tastevins*. Quaichs and the French equivalent, *tastevins*, come in various sizes, I think probably the smaller ones were intended for the brothers to use as their own at ceremonial gatherings. They allude to drinking and seeing Mary Magdalene, and confirming their allegiance to her.

Many quaichs have the letters SQUAB inscribed at their centre. To most this is interpreted as 'drink up', again a reference to the René d'Anjou instruction, but interestingly it is also the Gaelic for corn. Corn is a Masonic element of consecration. It is recognised as one of the great supports of life, together with oil and wine. According to the Book of Revelation by St John it is also the food that will remain abundant in famine, while in Psalms bread gives strength:

> Wine that maketh glad the heart of man, and oil to make his face
> to shine, and bread which strengthened man's heart.
>
> Psalm 104:15

Hence Freemason's lodges, which are for them temples dedicated to the Most High, are consecrated to their sacred purpose by strewing corn, wine and oil upon the Lodge, the emblem of the Holy Ark. The corn alone is carried in a golden pitcher as a symbol of its importance over the others as being the 'Staff of Life' and more worthy of honour.

Now back to something I mentioned earlier. I need to spin the thread further to give details why the tarot trump cards appear on the *tastevins* from France.

The Tarot

In order to convey the truth of their undertaking, the Freemasons and associate brotherhoods have used everything in their armoury. It was imperative that one if not all lines of communication would ultimately convey the truth. Every form of sign language became part of their repertoire, even between themselves.

Miserably, the songs of the troubadours were silenced, the devotions of the Cathars destroyed. Yet music, dance, art and architecture survived, and cleverly the Masons even incorporated that language into games people play. And the tarot is just another example of this.

Margaret Starbird explains the significance of the tarot in her book, *The Woman with the Alabaster Jar.*

The suits of the tarot contain grail symbolism. The spade, the sword, the masculine blade. The graves of Knights Templar invariably have a sword. The heart symbolised the chalice – the holy grail – and the alternative church or Church of Love. Interestingly, numerous hearts appear in the Albigensian watermarks. The diamond was originally called the pentacle, the symbol for man. The symbol was sacred to Venus, and perhaps most significantly the club suit was the earliest version of the tarot flowering staff or rod, or sceptre. This symbol is the visual image of the budding staff of Jesse's root, the promise found in Isaiah 11.1. The trefoil-shaped club of our modern decks of cards is a clear reference to the royal lineage of Israel's kings and their divine mandate to rule. So in tarot cards seeds were being planted and their message conveyed to fertile ground where it would grow. Now of course the true meanings of these things have been buried and obscured. However, they are beginning to bud and root again. The tarot cards tell the story of the grail, of the push to the light. For a fuller account of this I wholeheartedly recommend you read Margaret Starbird's books.

I warned you this would be a challenge to undertake. It takes faith and a compulsion to be a seeker of truth. The strange thing that has resulted in this is that instead of worshipping God in the hills, which of course I still do, I have now made the decision to go to church on a more regular basis. You might think that rather contrary, but strangely now I feel at home there, now I have found my truth it all sits easy with me and I can take it in the spirit with which it is intended, knowing that I am on sacred ground with fellow seekers about me.

Now to the courage of the Cathars who were victims in the defence of the belief of which I have just written. Hundreds of thousands of them died in the first genocide of its kind. They were known as the Pure Ones and died in their belief of the grail story.

SIX

Children of the Light

A light haze drops from the night sky towards the mists of the valley, mingles with them for a moment, then flows on downwards while the exaltations of Earth rise one after another to disperse under the bright stars. Anything seems possible at such a moment: it is an image of reconciliation. I tell myself that this bulk, encrusted with old and precious shells, has beached at the end of the world, on the border of another universe – that here, estranged lovers will finally embrace, love and creation achieve perfect equilibrium.

Albert Camus

In the winter of 1991 I made my final decision to emigrate to France. It was a country with which I had a great affinity and which has and still does hold an indefinable attraction for me. My heart and soul are torn between Scotland and France. I can remember the moment I made up my mind, I was sitting on North Berwick Law a small hill overlooking the beach at North Berwick, south of Edinburgh. For some reason it has a whale jawbone on the top of it and the views over the land mass out to sea are incredible. As I was sitting there the sun came out and there was a crescendo in the sound of the gulls. Looking out to sea I felt that I was traversing two worlds. I had never been up this little hill before as I normally kept to the beauty of the beach and shoreline and can't remember why I had decided to climb it, but it was there, on that sunny day, that I made my choice. I was going to leave Scotland, and follow my star to France. Leaving one place that I loved for another, and in my analysing of it all I can recall thinking of Scotland as being in monochrome, and France in colour. Consequently, I was about to betray one in favour of the other, but the feeling of inevitability gave me the courage to do it. I

had reached a fork in my road and had to make a decision which route to take.

The catalyst to this major event in my life was a break-up with a man with whom I had been very much in love. That crisis in my life gave me the impetus and opportunity to act and turn my life around. So, with a certain trepidation, I followed my dream, sold my flat in Edinburgh, packed everything up, prepared my dogs, and headed down to Dover on my migratory route to an exile which would not see my homecoming for a further nine years.

Thoughts of exile send shivers down the spine, and yet that was what I was voluntarily embarking upon. It sounds dramatic I know but I couldn't countenance a return which would subject my dogs to a six-month term of imprisonment in quarantine and so I knew I was committed to this decision, for better or worse. (When I finally did come home it was with the safety net of Passports for Pets firmly in place and the knowledge that my dogs would be all right.)

The ferry journey was the vessel that took me from my native land in transition to becoming a stranger in a foreign one. I had no contacts whatsoever in France, save an estate agent, and yet, strangely the colour and people of France were in their own way a homecoming. I landed at Calais in excitement and contemplation at the span of land which yawned and stretched before me in my journey south. That night though I stayed in Honfleur and soaked up the flavour of being in France. I had done it, emigrated and it felt perfectly natural. I had a quiet dinner, walked along the sea front and watched the blue of the sea merge with that of the sky, then as a shimmering rain came in on a growing breeze I headed back, past the packed cafés, to my little hotel and a good night's sleep. The next day started at dawn for I had a gruelling long drive down to the south-west of France.

Fortunately for me I had been in the Tarn region of south-west France some years earlier, when I was researching a story on Robert Louis Stevenson's *Travels with a Donkey*, and was heading to the house which I had rented then. That at least was a comfort, to know where I was going to be settled. I stayed in that house for the first three months of my settling-in period in France and then moved to a rented farmhouse just outside Albi. Writing of it now conjures up nostalgic memories, of being sun-warm and experiencing the colour that I had dreamt of. I was surrounded by meadows and fields where flowers unfurled their beauty, fringed with woods which held the orchestral

majesty of birdsong. There I watched as every bud became a blossom, and walked in fields full of fritillary, courted by birdsong I had never heard before. Where was this Shangri-La I had uncovered? Well, it was the mystical medieval village of Cordes-sur-Ciel.

I was to discover that this fortified town, or *bastide*, was built in 1222 by the Count of Toulouse, himself a Cathar, the subject of this chapter. Wonderful Cordes looks like a beehive perching on a white chalk hill with houses swarming up its side. The place is out of this world in so many respects. For instance in the centre of this hilltop refuge, tendrilled by medieval cobbled streets, there is a covered market place, with a monumental roof supported by octagonal stone pillars. Here I discovered the town well, with a prominently displayed plaque recording that three inquisitors, sent in search of Cathars by the Bishop of Albi, were thrown down it. I imagine like many others before me I too looked down into the blackness of that death hole and conjured the monstrous scene, shuddered, then turned away from such brutality and escaped into one of the many exquisite artisan shops.

Each year in this gem of a place they have a sumptuous medieval pageant and I often wondered as I sat at a café table sipping coffee if I weren't catching glimpses of cleverly concealed ghosts mingling there. I cherish my experience of being part of it, however briefly, and have sweet memories which I will forever carry with me, souvenirs of people, handshakes, greetings and old men looking strikingly similar to the gnarled vines they tended.

Albert Camus, the famous French writer, visited Cordes in the 1950s and said of it that: 'In Cordes, everything is beautiful, even regret.'

That is so true, for it still captures every mood.

My rented farmhouse was a short drive away, through chalk landscapes, scrub juniper, sunflowers and vines. Cicadas surrounded the place and I find myself missing them, along with the hoopoe bird with its flamboyant headdress and the wonderful lizards which darted between my feet, then scurried to find cover and so too the frogs who gifted me with the experience of their beautiful song. The colour of the light was magically luminous, with big skies that swept over me. Skies white-blue through the day would become wild at night as the Autan winds battled then cleared to give way to gentle mornings and more sun. I loved the weekly markets with their carnival atmosphere,

the horny hands of the stall owners, the accordion music, the chatter. I relished the way the locals orchestrated their lives, the progression in social etiquette from handshakes to a kiss on a cheek and the customary '*bonjour*' on entering a shop. One particular aspect I deeply miss, which is so different from here, is the sense of past time. In France it was tangible; as though a veil that lifts a little to allow us to penetrate time and touch it. It is a 'thin' place, with 'thin' time, much like the west coast of Scotland but with a different flavour. You sense it in the architecture of the buildings, the archaeological sites, the vines and the people.

This came home forcibly to me when, within a week of my arrival, my neighbours invited me to dinner. My conversational French wasn't good at that stage, and didn't get that much better, but I understood what they were talking about – the Cathars. It was important to my neighbours that I should know about them, and for me to appreciate that the essence of them, and of their courage, lived on in the fabric beneath my feet.

On reflection it would seem the Cathars were my rite of passage and initiation into living in France. For my new-found friends the Cathars had been martyrs in a struggle, one which had ended the independence of the Midi, the old local name for the region still used today, and they likened them to the Resistance fighters of World War Two, in that both shared the spirit and passion of belief. A belief they were prepared to die for.

Happily, the Cathars' presence in this region of France is still palpable. Cathar routes map the countryside like veins on an old hand, and one is inspired to follow them. It's my ambition that one day we could emulate that in the United Kingdom with a similar network charting the route of the Culdees, thereby establishing a pilgrimage network uniting the whole continent. The experience of following the way-marked routes of the Cathars is extraordinary, there is a palpable energy which seeps into your spirit, sparking a connection to this belief system that existed over 800 years ago. It was a faith so benign that you can only wonder why anyone would seek to obliterate it, but they did. I was to learn that in a gross travesty of the creed of tolerance and universal adherence to the God of Love (their Church was named the Church of Amor [*sic*]), their sacred teachings were to perish at the mighty hand of the Church of Rome.

Bizarrely, it is this knowledge of their history which is key to unlocking

that distant period when the towns of the region included both Arab and Jewish communities living alongside the Cathars in a mutual love of, and commitment to, furthering knowledge of the mysteries and meanings of life. I am much persuaded by their beliefs and philosophy and have a vague feeling that maybe so too was Leonardo; however, more of that belief system later. Certainly one can understand why inevitably that knowledge casts a long shadow as one follows in their wake, prompting constant reflection on what could have been.

In retrospect I suppose my time in France is another coincidence in my life and part of the journey of how I came to write this book. Without that experience I wouldn't have had that intimacy with the Cathars' history and this quest of mine might well have missed them out, and their link in the chain of this unfolding tableau. Perhaps, without my even realising it, France was the eye of the needle which took that first thread. The history of the Cathars is therefore stitched firmly into the fabric of this story.

The Legacy of the Cathars

So who were the Cathars? Well, their lineage is a long and proud one that can be traced back to the Bogomils of Italy (which is one of the reasons I believe Leonardo would have known of them), France and the Iberian Peninsula, and as far away as the Middle East. From what I can gather, at their core all of these belief systems were fundamentally Gnostic in their mindset, which is to say that they were seekers of an inner knowledge that could be accessed on a personal level.

The shared tenet was a sensible, logical one that focused on the belief that it was far more important to seek God through knowledge rather than through blind faith. The Cathars undoubtedly believed in Christ, but they heard a very different message from the one expounded by the orthodox Church. They had strongly held convictions, but unlike many they did not insist they had the final truth in interpreting the world or God. As Gnostics, they felt that Christ's message was more spiritual than religious and that the place to find God was within oneself, in one's heart and head and understanding. The Pure Ones, or Perfects, as the higher initiates were known, rejected the dictate of the Church and the prescribed dogma that the Word was for the Roman Church alone to pronounce upon. For me the beauty of their interpretation was that we could experience the living Christ and God, not by a set of correct beliefs or creeds, but by seeking God and forming a relationship with Him. To

do this it is essential to know oneself and be touched by what the Gospel of Philip calls the transforming power of love and light for seeking God, because Christ and his message was the true act of faith. That is the Gnostic style and spirit found in the materials often called the Gnostic Gospels. Like Pythagoras before them, they believed in transmigration of souls, to an ultimate goal of spirit alone (more familiar to us now as a Buddhist belief). For that reason they tended towards vegetarianism, as indeed did Leonardo, and in compliance with a further tenet of their credo held to the belief in a dualistic content to this world, i.e. Good versus Evil. Evil, of course, is mentioned in the Lord's Prayer: deliver us from evil, and, of course, Christ encountered the Devil in the wilderness.

This is a stumbling block for me. I believe in good and evil but cannot subscribe to the cause that the material world is essentially evil, and that the true good and light is purely spirit. It brings to mind another point I can remember Leonardo mentioning, that of the pain of never being able to touch again – was he too coming to terms with the essential truth of the Cathars, the world purely of the spirit and not of the body? The ultimate goal: spirit, of man and woman in an androgynous union. The world of spiritual form without the physical semblance which our soul casts itself in. Anyway, in compliance with their faith they ideally followed the model of chastity.

I can certainly believe in the goal of leaving the material form of the body to attain a purely spiritual dimension, and of an existence of a series of incarnations to achieve that purity, but I cannot subscribe to the belief that the natural material world is ultimately flawed, not when there is such beauty around us. I am, for now, obviously missing a point!

Such was the impact of the Cathars' strongly held beliefs that by the twelfth century they had an impressive network of centres spreading from southern to northern France, Catalonia and the whole of northern Italy, with further scattered communities established from Lombardy south to Rome.

This spread of gnostic thought coincided with the emergence of the Kabbala, also gnostic in nature. The birth of these systems in this area of southern France transformed it into a new Alexandria, where diverse religions and philosophical movements flourished. It was a golden age of enlightened thinking, of harmony and exchange.

Barnstone and Meyer, *The Gnostic Bible*

In 1940 Simone Weil, the French philosopher, writer and mystic, saw Catharism as a Pythagorean or Christian form of Platonism and she wrote:

> The Manicheans [forerunners of the Cathars] have something more than can be found in the days of Ancient Greece and Rome, or at least that part of it known to us. Their beliefs contain a few splendid concepts, such as the idea of God descending among Man and the idea of the spirit being ripped apart and dispersed among matter. What makes Catharism a form of miracle, however, is the fact that it was a religion and not simply a philosophy.
>
> Letter to Deodat Roche, 23 January 1940

Not everyone saw Catharism in the same light.

> The seed is the word of God.
> The ones on the side of the road are those who heard.
> Then comes the devil, who takes away the word from their heart
> So they will not believe and be saved.
>
> Luke 8:11–12

Tragically, the theological ideologies of the Cathars were seen to present an extraordinary danger to the orthodoxy of the Roman Church, and that was primarily for one simple reason: they contested the power and authority of priests to forgive sins and spread the word. The Cathars believed there was no need for an intermediary between man and God, as for them the Holy Spirit was the innermost sanctum of every individual. This is Gnosticism in its purist form and was why the Roman Church was so nervous of it; for this simple concept undermined the very foundations of their power base. For the Church of Rome, power and control lay in the fact that it, and it alone, was the intermediary. As a direct consequence of this it demanded that the populace bow to its dictate that it alone could summon God's power. For the official Church it was an imperative to impose a single religion and a conformity to it. The 'Pure Ones' had engendered too much esteem, so the cry of 'heretic' was screamed out and a strategy drawn up as to how to wipe them out.

Accordingly, in the wake of the Church's quest for domination, the Midi region of France was to witness the first genocide of its kind and

the ultimate disappearance of an entire civilisation; the black irony being that it was orchestrated by the hand of the Church against the worshippers of God in an affirmation of what they believed, of good versus evil.

Adherents to the Cathar movement regarded themselves as the true apostolic Church, mirroring Christ's position as not being of this world and living a life of poverty. More than this, and as much of a challenge to the Church, was that belief in a dualist cosmogony and of the figure of a divine consort or wife of the God of Light, namely Mary Magdalene, forming a divine pair in the world with Christ in a shared sacrifice of spirit becoming flesh. According to Yuri Stoyanov in his book *The Other God*, the teaching and history of the divine wife of the God of Light is described as 'the great secret', possibly only known by the Cathar Perfects.

All of this was untenable to the Church of Rome, and something had to give.

Kill them all . . . God will know his own

It was in 1145 when Albi, which is just 23 kilometres from Cordes, became associated with the Cathars. St Bernard of Clairvaux went to preach there and proclaimed that: 'the people of this city are contaminated by a greater degree of heretical depravity than in any of the surrounding region'.

I wonder if he was forced to say that for the better good? For it was St Bernard who believed in the possibility of a Beatific Vision of seeing God face to face, which is a Gnostic foundation, and it was St Bernard who founded the Cistercian Order and who instigated the rise of the Knights Templar. The latter of course tended to an alignment with the very people he was condemning as heretics, and the former had an involvement in Arthurian legend. As it says in 1 Corinthians 13:12, 'For now we see through a glass darkly; but then we shall see face to face.'

The name of this city was subsequently given to the crusade that was to be mounted against the Cathars, the Albigensian Crusade. The participants in this mandate to rid the land of Cathars were bribed with eternal salvation and forgiveness of all sins. It wouldn't be that easy, for over 100 years later this relentless goal was still in place. Bishop Bernard de Castanet, who was the Grand Inquisitor of Languedoc, which was under his jurisdiction, proclaimed that 'not a week went by but that

some notable of Albi was seized, tortured or immured' (Joy Law, *The Midi*).

What bitter irony when we consider this was the man who instigated the building of one of the most beautiful cathedrals in Europe, Albi Cathedral, of which Rudyard Kipling said: 'The brick bulk of Albi Cathedral, seen against the moon, hits the soul like a hammer.'

It certainly does strike out at you, and the ghoulish imagery of the Christian concept of the Last Judgement inside the cathedral is one of the most terrifying I have ever seen. This is what you would be saved from if you took part in the crusade against the Pure Ones. One can well imagine the attraction of it.

I find it immensely dispiriting to think that for the Church the simplistic definition of heresy was not only the physical act but that it encompassed our very thinking. In fact, to question is, in their view, a heretical stance and is why during the Inquisition they euphemistically called the procedure of torture as putting the accused 'to the question'.

It must have taken tremendous courage in the light of such heinous threats that people did question the Church's teachings. The dogma was breached and an unstoppable tide of souls flooded from the orthodox Roman Church to join the *bon hommes* or 'good men' who lived what they preached in an austere life spent in contemplation and prayer. The indomitable Cathars preached salvation after the example of Jesus, whom they much revered. However, a main tenet of their faith, which deviated from the Orthodox Church, was their rejection of the Crucifixion and what it symbolised. For them Christ's sacrifice was his endurance of so much suffering in the flesh, and the thought of lauding the monstrous brutality of a suffering on the cross was anathema to them. It was his courage, love and commitment to God and the light which they held sacred, and on a par with that was the submission to the whole in the form of Mary Magdalene and the Sacred Feminine which held such resonance for them. In that light that was the ultimate sacrifice, one they both made, to incarnate in the material world and to infuse the world with the genetics and building blocks towards one which could be better. They forfeited their spirit to become flesh, that was their supreme sacrifice, to submit to this world.

Love not the world, neither the things that are in the world. If any man love the world, the love of the Father is not in him.

1 John 2:15

It was an essential belief of the ancients and the Cathars that the soul took a journey through time in various incarnations, and this credo included metempsychosis. This is the early doctrine of the transmigration of souls into different bodies – which included those of the animal kingdom. The aim for the soul is the release from this cycle of transmigration and this destiny is only finally attained when the soul embraces the world of both true and pure spirit. In many ways it is similar to both Buddhist beliefs and the Jewish Kabbalah and was a stream of thought which Pythagoras himself promulgated, as indeed did the Druids. For the Cathars then, Jesus and Mary Magdalene sacrificed their deliverance from this cycle to be light bearers. The terrifying ordeal involving the cross had neither killed him nor led to his resurrection, for they believed he survived and it was this that was in fulfilment of the true Scripture, to be in flesh, that was the true sacrifice.

> After that, Jesus, aware that all had now come to its appointed end,
> said in fulfilment of Scripture, 'I thirst.'
>
> John 19:28

This exemplified the love of God, for his gift was to have Christ in our midst as our teacher towards a Gnostic knowledge and transfiguration, not as a sacrificial lamb. The supreme sacrifice being that he and his DNA would circulate amongst us accomplished by his being once more incarnate, and with him, his children by Mary. The Cathars, like the Culdees, knew Mary Magdalene was his wife and priestess, bound together in a sacred marriage which resulted in children – a daughter Sarah in Egypt, whom they took to France, and a child born to them in Provence. One which I vehemently believe to be portrayed in my painting, the all-bearing testimony to their presence on Provençal soil. A portrayal worthy of a papal bull attachment to signify its supreme importance and the need for it to be secure in papal control.

Seen in this context the crucifix was therefore abhorrent to the Cathars as it symbolised Christ's agony and a false belief engendered by the Church's own making in a vicarious atonement. This was a view shared with the Knights Templar, who also scorned the cross. I admit I have always felt rather uneasy at reverently praying to an instrument of torture.

> I and my Father are one.
>
> John 10:30

Once more, this tenet in St John's Gospel is central to Gnostic belief: God resides within us all. Look within, ask questions and walk in the light of true, pure being. This stems from the wisdom of the Ancients, of Pythagoras and Plato and their school of thought. A school of thought with which Leonardo da Vinci had aligned himself, as is evidenced by the friendships he formed and his devotion to mathematics and geometric design.

I think that Pythagorean concept needs to be explored a little, so let's look further back into history.

Pythagoras and the Language of the Gods

The most many of us know of Pythagoras is gleaned from school and his geometric formula, yet Pythagoras was one of the most celebrated of the ancient Greek philosophers, and the founder of what has been called the Italic School. He was born at Samos in about 582 BC. In his youth Pythagoras was an exceptional athlete but as he got older he devoted himself to the study of philosophy. Following this principle of truth at all costs he travelled extensively in Egypt, Chaldea (modern southern Iraq) and Asia Minor (part of modern Turkey), and is said to have submitted to the mystery initiations in those countries.

On his return he created his celebrated school at Crotona, a Greek colony in southern Italy, which swiftly achieved such a reputation that disciples flocked to it from all over Greece and Italy. It was here that the doctrine of metempsychosis was taught. Tendrils of that belief system reached out and rooted themselves through the ages, through our early era of Druidic thought, to blossom in the later history of the Cathars. Pythagoras contented himself with proclaiming that he was simply a seeker after truth and knowledge, not its possessor. It is with him that we associate discoveries of mathematical formulae and the mystical power of numbers, yet at school that is usually the only thing which is discussed, when our teachers should instruct us in the immensity of his wisdom. It was Pythagoras who was the inspiration that generated René d'Anjou towards a resurgence of thought in Renaissance Europe and it was Pythagoras who gave birth to the attribute of philosopher, or lover of wisdom, the only title which he would assume. I believe it is relevant to this story that tradition has it he was visited by, and discoursed deeply with, the Druids from the western 'Islands in the Ocean'.

Unsurprisingly, the foundation of this system of thinking was so

strong that it broke through the foundations laid by the Church and broke new ground to shoot afresh with the Cathars. In their turn, they took it one step further by combining this philosophy with religion, much as the Culdees and the Druids had before them.

In horror, the Church witnessed a mass movement of their congregations towards the light of another truth. I keep having this niggling feeling that Leonardo was certainly aware of all this. Doesn't it follow that maybe his vegetarian diet and his lack of a female consort align him with that belief? Could he have embraced that same philosophy? No matter really, but some hundreds of years before him a light was shining bright in proclamation of a universal reality, and one which was recognised by the people. Its roots had a fine lineage dating back to antiquity.

What I must put before you in regard of this philosophical sacred belief system is something I mentioned earlier which is central to it. At the core of all this was the clear fact that they believed that the material world was evil and the spirit pure. In affirmation of this principle, the Cathars cited the episode in the Bible when the Devil tempted Christ with: 'All these things I will give you if you fall down and worship me,' (Matthew 4:9), clearly indicating that he, the Devil, was the master of them all, for how could he offer them up if he were not their creator? As I said earlier, I find that particular concept a difficult one to take on board. However it does cause me to think deeply about it, for bear this in mind, when John the Evangelist speaks of the 'children of God that are not born from flesh and blood', Otto Rahn asks, 'From whom do the children of flesh and blood come? Are not these children from another creator – the Devil – who according to Christ's own words is "their father"?' (John 1:12–13). Troublesome stuff, but is it true? And have you ever considered this dialogue between Christ and Pilate:

> Said Pilate: 'Your own nation and their chief priests have brought you before me. What have you done?' Jesus replied, 'My kingdom does not belong to this world. If it did, my followers would be fighting to save me from arrest by the Jews. My kingly authority comes from elsewhere.'
>
> John 18:35–36

It causes one to wonder, doesn't it? What realms are we talking about, and to what dimensions does Christ refer? Maybe this is the crux of

what the Cathars and the ancients believed, of realms beyond our understanding and certainly one that was to prove a formidable opponent to the perceived dogma of Rome.

Something had to be done and done swiftly.

Retribution

At the 11th ecumenical council held in the Lateran Palace in Rome in 1179 Pope Alexander III condemned the Cathars and everyone who followed their teachings and defended them. The faithful were called upon to oppose this 'pest' and even take up arms against them. This was the start of the first genocide of modern history, in which it is estimated that nearly one million people were brutally slaughtered.

The benign-looking building of the Palais de la Berbie in Albi was the seat of the Inquisition. Today it plays host to summer concerts, and carefree holidaymakers stroll past its portals, little knowing of the screams of agony that the stones still hold. We aim our cameras, unaware of what images should really be captured. Contentedly, we sip our coffee in roadside cafes, a thin curtain shimmering in a breeze being all that divides us from the horrors of the past.

> Lord God of Hosts, be with us yet,
> Lest we forget—lest we forget!
>
> Rudyard Kipling, 'Recessional'

Well, we have many authors to thank who help us not to forget and for what we can glean of the censorship applied by the Inquisition. They include people like Zoé Oldenbourg and her exhaustive account of the war against heresy, *Massacre at Montségur*, and Le Roy Ladurie's *Montaillou*, as well as my particular favourite, Otto Rahn. Otto Rahn was inspired by the writings of E. Aroux in his book *Mysteries of Chivalry and of Platonic Love in the Middle Ages*, which set out the thesis that courtly love in the Middle Ages was inspired by the Cathars, as a way of spreading their beliefs. Aroux maintained that the perfect knights of the round table of Arthurian legend corresponded to the Perfects (the highest echelon of the Cathars). More importantly from my perspective, he also subscribes to the same view as I do, that they are linked to what is now the Masonic brotherhood. Richard Barber in his excellent book *The Holy Grail: Imagination and Belief* postulates that the object of their devotion was their mother church, the Church

of Amor. Aroux's work inspired a work by Joséphin Péladan, who wrote a pamphlet titled 'The Secret of the Troubadours', which claimed that the Cathar and Templar troubadours of the Languedoc, the legend of Montsalvat (in Arthurian legends the home of the holy grail), and the ruins of the last Cathar stronghold of Montségur were secretly linked. Back to the holy grail again, and the Arthurian legends. Legend which I have never until now appreciated for the *tour de force* which they encompass. Succinctly, Otto Rahn believed that though Rome had destroyed the writings of the Cathars, we possess in Wolfram von Eschenbach's *Parzival* a literary work inspired by them.

I chime to the resonance of Rahn, for he held a passion for the Cathars that infuses me, a passion whose fuse was lit by the light of his ancestors, who were heretics. This was his touchstone, the genetic thread running through his corporeal body linking him to the truth. In his mesmerising works, he talks of the crusade that was waged against the Cathars as one of Roma (Rome) against its reverse Amor (love), in which the Church's triumph was with brutality not truth. This enigmatic man's lifelong search for the grail and the truth about the Cathars brought him to the attention of his compatriot, SS leader Heinrich Himmler. Himmler instructed Rahn to search for this elusive grail. Rahn soon became disenchanted with the way his country was going and resigned from his commission. By the end of his life, Rahn was so committed to his belief in the ideals of the Cathars that he took their name and eventually ended his own life in the snows of the Tyrolean Mountains. He died with his dream of a world united in the beauty of his belief. More of him later, as I took his hand many times on this journey of mine.

Further testimony to the power of the Cathar faith comes from Caesarius of Heisterbach, a Cistercian master of novices at the monastery of Heisterbach and one of the most widely read authors of the thirteenth century. He documented that the Albigensian heresy spread with such intensity that it had converts in almost 1,000 towns, and if it had not been suppressed by the Roman Church would have taken over the whole of Europe. It makes one wonder what a different world we would have inherited if the Cathars had not been crushed. The Church took the threat to its domination very seriously, for once the pursuit and destruction of this ideal was instigated, the riptide surged. Many victims were dragged back over rough sands and sucked from the faith, but then a new swathe of society would flood back to refresh their imprint. Like a many-headed serpent, wherever the Cathar

preachers appeared the people went in their droves, and when one was removed another would miraculously spring afresh.

A desperate Pope Alexander III was at a loss and cajoled people to kill the Cathars with the cynical lure of an indulgence worth two years' penance and the protection of the Church as a crusader. It was to no avail, for much to his chagrin 20 years later good was still triumphing over this perceived evil.

Ever more draconian measures were needed if the Church of Rome was to survive this continuing threat to its hegemony. So in July 1209 Pope Innocent III issued his terrible heresy decree. The town of Béziers was stormed and thousands of the inhabitants were brutally and indiscriminately cut down.

> After the capture of the grand and wealthy city of Béziers, the papal legate Arnaud Amalric was asked how to distinguish good Catholics from heretics among the seven thousand men, women, invalids, babies and priests crushed in the Church of the Madeleine, crying and praying and holding out crucifixes, chalices and bibles to demonstrate their orthodoxy, he could coldly reply, 'Kill them all. God will recognise his own,' and then, as the city burned, could write with pride to the Pope his master that 'nearly twenty thousand of the citizens were put to the sword, regardless of age and sex'.
>
> Paul Kriwaczek, *In Search of Zarathustra*

The Slaughter of the Innocents

Not only did the Roman Church obliterate a belief system, it also destroyed a glittering portion of the civilisation of western Europe: that of the troubadours, of art, of ideals. It must not be forgotten that this was the benign land of chivalry, courtly love and respect for women. As I have already mentioned, it was also the land which inspired the twelfth-century poet Chrétien de Troyes and which formed the basis for his work *Perceval*, the story of the holy grail. Medieval times were the era of truths masked by fiction, of King Arthur and Merlin, of the grail and all its ramifications, and mystery. Yet, for all the mystery of the Cathars, all they were guilty of, in the eyes of the Church of Rome, was their ideological deviation. That is all, for they were neither ethnically nor linguistically different from their oppressors, which makes the crimes perpetrated against them all the more chilling.

The question therefore has to be posed: was it just the viewpoint of the Cathars that the Roman Church abhorred? Or was it more? Is it conceivable that they also knew that the Cathars were initiates of certain knowledge? That they possibly held proof of the marriage between Mary Magdalene and Jesus Christ and maybe more than this, the birth of a child? Perhaps even more than one? That the Cathars, as the Culdees before them, were guardians of the holy grail, knowledge shared with the Knights Templar?

If they did, the secret has been kept, or to an extent it has. Some literature did survive, but the Church of Rome destroyed the bulk of it. However, the Cathars did declare themselves to be heirs to an ancient tradition and the Catharist rituals. Jean Guiraud, in his magnum opus of the Inquisition, shows that the Church undoubtedly did possess ancient documents which were inspired by an early Church, amongst them a Gospel, which for many is called 'The Gospel of Love' and which I first heard of in France. It is also known that the Perfects carried with them a Gospel of St John and that they revered St John's Revelations. But was there something else, something more than this?

Well, it would appear there was. At the last stronghold of the Cathars in Montségur there is strong evidence of treasure, which was not only material but which included sacred books, possibly manuscripts of great antiquity. There is postulation that one of the texts was a gospel held sacred to the Cathars and which hopefully was then hidden. This may be the 'grail', together with other objects they venerated that so many generations have sought.

If the Cathars and later the Templars were seen as guardians of the holy grail, then they were privy to a knowledge of which fragments are only now filtering through into the public domain. The painting at the heart of this book is central to that tenet of a secret tradition concerned with Mary Magdalene and the rescue of Jesus, that Jesus died no physical death on a cross. Was that the reason why Heinrich Himmler invited Otto Rahn, a historian of the Cathars, to research the legend of the holy grail and if he could to track it down?

Whom Does the Grail Serve?

As so often is the case we are left in a fog of censorship, so stretch through that mist to take grasp of it, that forever elusive and beguiling mission.

For the Cathars, I believe the definition of the holy grail would have been as an icon for the survival of the human soul. It was a union, an

embodiment exemplified in the relationship between Jesus and Mary Magdalene, of the male to the Sacred Feminine. For them it was symbolic of the Gospel of Love. Robert Graves wrote:

> Symbolism or allegory is 'truer' than realism in that the former allows more possibilities or interpretations. And more possibilities – implying greater freedom and less context dependence – translate to greater truth. Accordingly, it has been said, 'the more numerous the poetic meanings that could be concentrated in a sacred name, the greater was its power'.

That is the power of the holy grail. Nobody has ever seen it though all would recognise it, for it forms the fabric of our very being. We can palpably sense it, if we try. It is tangible. As has been claimed before, the 'holy grail' is the 'Sangraal', from the French phrase *sang real* meaning 'royal blood'. It courses through our veins, bonding us as brothers and sisters in Christ. This is the knowledge that people have been willing to die for. We are all a sacred family in Christ and Mary Magdalene, and all entitled to their universal teachings of love. For me, the Gospel of Love, for want of a better name, lies at our feet. We look all around us, but it is closer than we think.

What follows is an example of the harmony which could have been, but for papal intervention.

It wasn't only the Cathars that Pope Innocent III had his sights on; the sweep of his vigilance in overseeing his power base was considerable. King Richard the Lionheart came into sharp focus when he dared to refuse to take any further part in crusades waged against Palestine. His reason was a refreshing one, namely that the Muslim leader Saladin had become his friend and the king wanted his sister to marry Saladin's brother, Malek Adel, in a Christian–Muslim kingdom of Jerusalem. This would have meant Islam and a true Christianity in a brotherhood. Funnily enough, the Book of Revelation also plays a part in this section.

This enraged the Pope. Horns were locked and the two became irreconcilable enemies. In an audacious move, the papacy dared to alienate him and excommunicated him forthwith. In their eyes, the king of England, Ireland, Anjou and Cyprus was now a pariah of the Catholic Church.

On reflection, the king would have been wise to have considered the counsel of an illustrious monk named Joachim of Flora, who was the

best commentator on the Apocalypse of St John and who, when Richard had asked him to explain chapter 12 of the Apocalypse, had prophesied:

> The woman dressed as the sun, with a moon under her feet, and a crown of twelve stars on her head is the church, the large red snake with seven heads and seven diadems is the devil. The seven heads are the seven great persecutors of the Gospel: Herod, Nero, Constantine [who emptied the treasury of the Church of Rome], Mohammed, Melsemut, Saladin, and the Antichrist. The first five are dead. Saladin lives, and uses his power. The Antichrist will come soon. Saladin still triumphs, but he will lose Jerusalem and the Holy Land.'
>
> 'When will it happen?' asked Richard the Lionheart.
>
> 'Seven years after taking Jerusalem.'
>
> 'So have we come too early?'
>
> 'Your coming was necessary, King Richard. God will give you victory over your enemies and will make your name glorious. Regarding the Antichrist, he is among us, and soon he will sit on the throne of Peter.'

It would follow from that timeline that the Antichrist he speaks of could well have been Pope Innocent III.

Caves and Cathedrals

Admirably, the French have kept the legacy of the Cathars alive and the traces of their footprints still exist, so let's walk with them a while.

The people of the Languedoc were among the first to bear witness to the arrival on French soil of Mary Magdalene and, I increasingly believe, also of Jesus Christ. They share in the knowledge of the migration of those adherents of the Light, and for that reason and those shared beliefs for which the Cathars gave their lives, that common cause was also why the Knights Templar became their allies. Their heritage was also founded on knowledge and ideals. It was that knowledge that gave their faith the edge on all earlier dualist beliefs; it was their land, their territory which had hosted the light. It was to prove a strong allegiance that was to see some of the Knights Templar, together with their equerries, stand shoulder to shoulder with the Cathars at their last stronghold against the vicious onslaught of the

papacy at Montségur in the Pyrenees. It was there that many gave themselves to the flames of the Church rather than recant their beliefs.

Not surprisingly, given what we now know, the majority of landowners of southern France were converts to the Cathar faith. According to Otto Rahn, they were known as 'Sons of the Moon' and proudly claimed descent from the moon goddess Belissena, the feminine aspect of the Druidic male principal of Belis the sun god. On their shields they bore the earliest form of heraldry in the form of a fish, the Moon and a tower; the emblems of the moon goddess, the sun god and the power of the knights (worth reaffirming is that the very name of 'Magdalene' has an etymological link with 'tower'). This subscribed to their Church of Love, of Minne and the pure love they held as their credo to life. One unsullied by carnal knowledge and celebrated by courtly love. For Minne was to be the union of souls, not body. It was the celebration of the ultimate divine harmony, of the light of love and completion of the trail to the two becoming one in a unified whole.

Extraordinarily, hardly a castle in the Pyrenees was not aligned in some fashion with the Cathars. To a man they were troubadours, believing in divine love and singing of the Minne of pure love, sublime with the laws of which were guarded with the laws of Minne (*las leys d'amors*). This was in accordance with the goals and ambitions of their Church of Amor. As the Druids before them, their sacred areas were the forests and the caves, and, according to Otto Rahn's exhaustive research, in their chapels in the caves they would have altars with the first chapter of the Apocalypse according to St John opened at: 'In the beginning, there was the Word and the Word was with God and the Word was God' (John 1:1). Again according to Rahn, they heard New Testament readings and the congregation would ask to be blessed by the Perfect Ones and to be led to a good end as good Christians.

For them, good was God, and towards that ideal they strived, to that truth of apostolic thought, to the Chaldeans of the lineage of Abraham, and the Culdees. Contrary to the official Roman Church, they did not believe in a God who would set brother against brother, and believed too in the balance of woman to man in her sanctity and measure. The Pure Ones, the highest echelon of the faith, were anchorites, just as the Culdees were before them, living a hermetic life in the bowels of the mountains. According to Otto Rahn they wore

long black Persian-style garments and had a resemblance to Brahmans or acolytes of Zarathustra. After they had completed their ministrations they would read from the Gospel according to John: 'In the beginning there was the Word, and the Word was with God, and the Word was God. God is spirit, and those who adore him must adore him in the spirit. It may be that I die, because if I do not die, the Consoler will not come to you. But when the Consoler that I shall send to you comes . . . Dieu vos benesiga! God shall bless you!'

The true converts to the creed were strict vegans with a devout belief that the sacrifice Jesus made was in becoming flesh once more. For them this was the ultimate sacrifice, as they strove to attain to the kingdom of the spirit, to the pure light. To break this cycle of bodily incarnations they advocated chastity, but did not demand it. Men and women could achieve that perfection and the right to give the consolamentum, or the laying on of hands, but only if they followed this strict disciplined teaching:

> The children of God that are not born from flesh and blood.
>
> John the Evangelist

In this struggle to attain perfection we can see the first glimmer of a Renaissance as yet unborn. The moon; everlasting symbol of the feminine in our era. Mary Magdalene. Before her, Isis. The sacred marriage between two who are priestess and priest, queen and king: Mary Magdalene and Jesus Christ, Isis and Osiris. The sun and the moon. Perfect union of cosmic forces to bring balance to the universe.

> While ye have light, believe in the light, that ye may be the children of the light.
>
> John 12:36

> I am come a light into the world, that whosoever believeth in me should not abide in darkness.
>
> John 12:46

When their missions were complete, the Pure Ones would return to the humble abode of their caves to continue their lives in contemplation and prayer. Fortunately though for us breathtaking inscriptions have

been revealed in these underworld caverns. Listen to this: a boat with a sun on the sail; a fish, symbol of divine luminosity; a dove, the emblem of God the spirit (and of the moon goddess) and of Iona; a tree of life; the monograms of Christ in Greek or Latin characters; strangely the name Gethsemane, the garden where Christ was handed over to the authorities. Also the initials G.T.S. artistically entwined like a typical Celtic knot pattern, and divination runes which have yet to be deciphered. All in all an entrance to another world where there is, and we have, space to dream.

One of the most enthralling places of Cathar worship is at Lombrives, a cavern in the Ornolac valley. It is the largest cave of the Sabarthes region and is known to the locals as 'The Cathedral', and in size resembles Fingal's Cave near the island of Iona. Lombrives is an amazing subterranean kingdom of white stalactites, jasmine-like chalk and walls of dark brown marble, studded with brilliant quartzite rock crystal which shimmers and sparkles in altered light. This natural place of worship was a cathedral for the Cathars. On one wall is etched a sun and the silvered disc of the moon, the male and feminine sides of God who is Love and Light. A sacred spot which has since been further consecrated in their praise and reverence for the divine by those on the pilgrimage of life. A natural cathedral which could not be razed to the ground and supplanted with one from the established, all-powerful, Church of Rome. Chillingly, it is said that the exits were sealed by the crusaders so that the Cathars who had survived Montségur would perish in the bowels of the Earth.

Among the thousands of inscriptions are 111 mysterious symbols (perhaps a symbolic number in itself by representing a Trinity?) and also depictions of roses, pentacles and crosses. This brings to mind Rosslyn Chapel.

These caves since prehistory have been infused with legend and myth; in Scotland, close to the mystical island of Iona, is the mystically charged Fingal's Cave on the island of Staffa. In western Europe there are roughly 500 caves which have so far been discovered, and out of those about a third contain paintings, engravings and sculptures. Such stories are held frozen in their fabric – but what are they saying? The blurring of time has muffled them and the only route open to us is our own imagination. But if you stand still, in silence, you can hear your heart beat. A beat measuring out time, and in the gentle pause you can almost hear the murmurings of prayers being offered up. That is, if you

have ears to hear. So much we will never know about these mystical places, but yet we can dream in these theatres of our shared beginnings. If you are lucky enough to visit these sites you are part of a time capsule which holds an image, a negative of what was. Look around you in wonder, and let the place communicate to you. As you will see, caves hold a special significance as repositories of ancient artefacts and may have a bearing on the map which concludes this book. How can we be sure? The umbilical cord to our understanding has been severed. Why caves and forests? I can only think that it is because they are symbolic of another world, one which can be accessed through these particular portals.

Back in the light of day and with a backward glance it strikes me that the strong similarities between the Druids, Culdees and Cathars are undeniable. That cross-stitch can even be seen in the semantic example of the seats of learning of the Culdees, for they were known as 'Cathair Culdich' and we have seen in the vocabulary previously mentioned there is a connection in Belis, and Belissena. The superior figure in all these belief systems was called 'Good Father', and of course the Druids had spread into France and established their teachings and left the fingerprints of their sacred sites there, sites often taken by convention to belong to the Roman Church in origin. The bards of Druidism were poets and singers and were also called *privairds*, which in the language of Provence means *torbere*, which in English is troubadour. The Druids, Pythagoras and Zarathustra believed in dualism and the transmigration of souls. Druids, Culdees, Cathars, Knights Templar and Freemasons connect the truth and run the same gauntlet as the 'Sons of the Moon' had to as the keepers of the truth. Truth against the world, against the power base of Rome, which had callously founded their structures on the apparent ruins of their destruction of pagan temples and of truth.

Thus far 'tis right
That we by night
Our Father's praises sing;
Yet when 'tis day,
To Thee we may
A heart unsullied bring
'Tis true that now,
And often, Thou

Fav'rest the foe in fight
As from the smoke is freed the blaze,
So let our faith burn bright!
And if they crush our golden ways,
Who e'er can crush Thy light?
Goethe (tr. E.A. Bowring), 'A Druid' in *The First Walpurgis Night*

Let's not leave these giants of our past yet. I want to take you to Montségur, mountain of many myths, which we find in the Pyrenees.

Montségur

Montségur, the last stronghold of the Cathars, is a place that still exerts a powerful hold on our collective psyche. I made the perilous climb and was rewarded by the stunning views from its summit. Yet a sadness touched me, an emotion or connection to something which brought tears to my eyes. I remember it still for it was a momentous sensation, an aching of my soul.

The devotees of the Cathar faith who ascended Montségur to await the kiss of God (as the Talmud calls the scythe of death), lived in an immense fortified monastery, whose walls were the rocky walls of the Tabor which formed their incarceration. Yet before the hammer of the Church of Rome beat at their door they lived gently at its base in pastoral observance to their faith.

Intriguingly the word Tabor was the name given to Montségur in respect of the biblical mountain of enlightenment, here its roof was to be the blue of the sky, whose cloisters were caves, and whose Colegiata was the cathedral cavern at Lombrives. From here one hears stories of how the Cathars roamed the lands and lakes of their Druid forefathers, telling their converts stories of the treasures that their spiritualist ancestors had thrown into the depths of the water in a belief they shared of a rejection of material gain. Where needed they would help their brethren tend their chores and I dare say they spoke of the legend of Mary Magdalene landing in Gaul, of the courage of Christ's Passion and of their teachings, of the brotherhood of the Worshippers of God.

> Certainly there are no other sermons more Christian than yours and your customs are pure.
>
> Bernard of Clairvaux

In stark contrast to this a horror was stalking them, closing in, ever closer. Horrifically, almost 200 Cathars were destined to die in flames at the foot of Montségur, torched by the papacy. Mercifully, according to folklore, four Cathars managed to make a perilous escape, taking with them sacred texts which held narratives or other proofs of their beliefs. Some submit it was the holy grail. These sacred texts, if that is what they were, were so precious that they chose to die for them.

It is worth bearing in mind that Cathars were given the chance to recant their faith and live, but all chose to die in defence of it. I wonder how many of us would do that, how many of us have ideals we would die for? I suppose that is one of the reasons that Montségur has exerted such a powerful hold on our collective creative imagination. Certainly it allegedly inspired the writings of Wolfram von Eschenbach, a German troubadour who assimilated Montségur as the castle in the legend of the holy grail, an idea which was subscribed to by Otto Rahn, and indeed Himmler. Wagner, too, took the château as his model for Montsalvat (Mountain of Salvation) in his work *Parzival*.

It is, without doubt, a mysterious episode in our shared story and I believe, as in the discovery of the corpus of the Nag Hammadi library of Gnostic scripture and the Dead Sea scrolls, there will one day, God willing, be found the Cathars' lost scriptures, the so-called 'Book or Gospel of Love'. Maybe as in the case of other ancient texts in a cavernous repository somewhere, located in my map which furnishes the end of this book.

> The light was the true light, which illuminates every person who comes into this world.
>
> John 1:9

Epitaph to the fallen

After the burning of these innocent people, an ominous silence stalked the limestone rocks of the Pyrenees; yet a pulse, a faint one, could still be felt. Some escaped to Britain in the footsteps of Mary, others to Italy and Germany. True to their beliefs, they incorporated their secret knowledge in lore, as they had done in song and writing devotionals. Tim Wallace-Murphy noted that in Harold Bayley's book, *The Lost Language of Symbolism*, the company that manufactures bank notes for the Bank of England was founded by a Cathar family which had fled

the Continent to escape the Inquisition. Did they encode messages in the watermarks? Certainly it is a possibility, because another writer, Margaret Starbird, describes how heretical watermarks were devised by the Cathars to act as a system of transmission of their forbidden faith, and include numerous allusions to the holy grail and the *sang real*, holy blood. Harold Bayley states that despite the Albigensian Crusade and the 60 years of suffering imposed by the Inquisition, the Cathars survived for several centuries. Certainly links were forged with Rosslyn Chapel. What a wonderful vision to think of them there, possibly working in the scriptorium, maybe even encoding their secret doctrine onto paper, maybe copying out their ancient texts!

One thing I am sure of: their spirit lives on.

Rennes-le-Château

According to certain lore, the ghosts of the Cathars went on pilgrimage to Santiago de Compostela, the very route which the Judean refugees embarked on, and here is a fascinating location to explore en route – Rennes-le-Château. There are some who believe that the Cathars hid treasure of immense spiritual importance there. So important that it was worth a fortune. It could well be that they did, as it is certainly another location bound by ancient beliefs.

If they did, it is easy to imagine the threat that this would pose to the Church of Rome. The very fabric of the Roman Christian Church would begin to crumble and fall if proof were found – historical records – which differed from the doctrines and theology they expounded and for which they had killed innocents. In all probability it was this knowledge which gave a local priest called Saunière power over the Pope and transformed a sleepy village in the Pyrenees into an incomparable power base. I wanted to see what all the fuss was about, I drove to it and was enthralled, if not a little nervous of the hill climb and parking!

The terrain in this part of France is rocky and slightly ominous, which is in tune with the mysterious reputation of this small village of Rennes-le-Château. It was here in 1891 that Saunière is said to have found coded messages under the altar, one of which reads: 'To Dagobert II, King, and to Sion, belongs this treasure, and he is there dead.'

Even more surprisingly, Saunière then appeared to become vastly wealthy. He restored the sanctuary and constructed a number of

buildings, including the Magdala library, built intriguingly but understandably if he was now a Cathar initiate, as a tower. A considerable amount of money was also spent on upgrading the facilities of the village. According to Baigent et al., Saunière also discovered some mysterious manuscripts: the Gospel of Love maybe, together with other compulsive evidence? In consequence, he gained access to circles of people with an ardent love of the esoteric, such as Emma Calve, perhaps even those in high-ranking political circles. He is even said to have aroused the interests of the most prominent royal family of Europe, the Hapsburgs, and correspondingly the Masons. In accordance with this scenario he also used to journey to Paris, where he would spend hours standing gazing at Poussin's painting *Et in Arcadia ego*, which, we will see in a later chapter, also fascinated King Louis XIV.

The Bishop of Carcassonne demanded an explanation for Saunière's change in circumstance and when given none suspended the priest. Saunière, in an audacious move, appealed to the Vatican and remarkably was subsequently reinstated by the Pope! On 17 January 1919 Saunière suffered a stroke and what happened afterwards compounds the mystery. A fellow priest came to take his last confession and was seen to leave his room totally shaken by what he had heard.

Unbelievably, Saunière was apparently penniless at the time of his death, having evidently invested his entire fortune on his good works. Before his death he had restored the church, and erected his own, somewhat unorthodox, interpretations of the Stations of the Cross. He also commissioned and installed a statue of Asmodeus, a depiction of the Devil, inside the church and had the words 'Terribilis est locus iste' (this place is terrible) incised over the doorway.

Driving to this now acclaimed site one travels through extraordinary landscapes. Distant blue mountains, nearer green ones, red outcrops of rock which give way to white. But there are hardly any settlements, the landscape is now a wilderness of fossilised history; of castles which have borne silent witness to the extermination of the Cathars and the silhouettes of the sacred walking by.

It is in the church though, thanks to Saunière, that we are confronted with strong and strange clues. On the left at the entrance is a statue of the devil supporting a scallop shell (the symbol of the pilgrimage to Santiago) above his head. It is filled with water and is a *bénitier*, a font. Why is this grotesque figure featured here? At the time I nearly turned

away without even going in, it is hard even to look at him. His eyes are terrifying, blazing, and his posture agonised. I frankly admit to having felt intimidated by a presence I had always been conditioned to fear. Fortunately I persevered for the interior begs many questions: why is the Devil given charge of such an important symbol as the scallop shell, used in the Christian sacrament of baptism? A symbol which is, as we have seen, also a symbol of the Sacred Feminine and quest. Surprisingly, this diabolical-looking character is in fact a depiction of Asmodeus, the limping devil who guarded Solomon's temple. As you examine him you notice there are angels above him surmounted by a 'Celtic' cross. A thought-provoking entry indeed to this unsettling place, but one which offers some insight once confronted. Gathering composure we then can walk the Stations of the Cross. They in themselves are, to say the least, bizarre. I've picked out just some examples below.

Station 1 portrays Pilate washing his hands, but what is strange is that he is wearing a veil: a veil mentioned in the New Testament 'Acts of Pilate'. Does it represent the 'Veil of Veronica', the legendary cloth with which Christ's face was wiped whilst on the cross? A representation of his true image stained in sweat and blood? Behind Pilate is a man who is looking away. He has raised his hand above his head and in that hand is a golden egg, the symbol of Mary Magdalene as recounted in folklore, again twinning her with other ancient feminine symbols as a ubiquitous symbol of creation and fertility.

Station 8 includes a figure of a child who is wearing tartan. This for me holds especial relevance given what we have already explored about the history of Christ in Scotland. It is yet another reference point for us, but this time it is a child who is portrayed in plaid. This suggests what is already believed by many: that Mary had a boy child whom she took to Britain to protect him from the Romans. This tallies with the representation in stained glass at Rosslyn of Christ wearing a tartan bonnet, with the blessings of God on their child, with the portrayal of Christ on Mull beside a pregnant Mary. So had Saunière found out? Was this the dynamite he had ready to blow up the Church, for which they paid heavily to silence him? Could this have been what he found when he excavated the church? Documents, proof of a birth, moreover, a birthright?

Station 9 appears to depict a covert message as well. Here we have another reference to the Veil of Veronica – which myth tells us Mary

brought to France with her. Behind her is a soldier with his back turned and his shield held high. Henry Lincoln, a devout researcher and exponent of truth, believes this signifies a coded message, maybe indicating a location, a clue to buried treasure. Secret papers perhaps? Lost gospels?

Station 14 shows Christ being carried in the dark with a full moon shining in the sky. He died in daylight according to the New Testament. Is this depiction recording the removal of his body at night?

What, indeed, did Abbé Saunière find? Did he really find anything of earth-shattering significance? Or was he supported by some rich, clandestine patron or secret society? Or was he himself part of this tantalising mystery? According to Lincoln and his colleagues, Saunière found a treasure that included much more than only valuable antiquities. Buried in Rennes-le-Château were documents confirming that Jesus Christ had come to live in France with his family and that his child initiated a dynasty which eventually became known as the Merovingian kings of France. One of the secret messages stated that the 'treasure' (meaning the secret of the bloodline) belonged to King Dagobert II, a Merovingian, and to the Priory of Sion. The quote 'And he is there, dead' may not only suggest but actually indicate the existence of a sepulchre somewhere containing the body of Christ. Such a tomb, it was reasoned, was the famous one painted by Poussin, containing that mysterious phrase 'Et in Arcadia ego', and that phrase in itself could be anagrammatised into 'I! Tego arcana Dei' meaning 'Begone! I hold the secrets of God'. We saw in an earlier chapter how René d'Anjou also has links to this with his attachment to, and depictions of, Arcadia, and indeed how Louis XIV sought to get his hands on Poussin's painting titled *Et in Arcadia ego*. With such notions in hand, Saunière could have turned Christianity on its head and inspired a whole new interpretation of world history. So why not use it to blackmail the Vatican and obtain wealth by these means instead? What a shame he didn't tell us, too.

I must leave you to make your own interpretations of this church at Rennes-le-Château. All I can be sure of is that the child in plaid must have a direct bearing to Scotland, another piece of evidence of the migration along the neckline of France to Iberia then north to Britain; the ultimate destination being Scotland. This church is, of course, dedicated to Mary Magdalene. Saunière died without ever revealing his secret save to his housekeeper and the stricken priest. His coded

messages are all we have. That and the knowledge we have that he held a certain sway over the papacy. For him to do that he must have found something pretty crucial.

A question deserving consideration is: did he find the Gospel of Love? And if so, where is it now? Does the Vatican have it? Or is it still hidden? Did he indeed discover irrefutable proof of a Christ child, or a marriage between Jesus Christ and Mary Magdalene? The woman who was Christ's beloved and whom he called 'Woman who knows all'. Whispers abound that the Vatican still holds Gnostic gospels which state that very fact.

It all gives me much to think about.

One last thing. There is another aspect of this which I haven't addressed. It concerns the stone of Lucifer, a magic stone which dropped from the angel who fell to Earth. It is too vast a territory to cover, although I appreciate that I am failing in my responsibility, in a way, not to. However I have dipped my toe into the murky waters of this, and sensed I was going to be out of my depth. The oceanic proportion of this I find very threatening for it is the territory of the occult and magic, and frankly I am ill-equipped to handle it. I have consistently said I am a pilgrim on this quest and I don't feel I am ready for this particular dimension of the journey. That is my personal decision, you must make yours. In this realm we encounter the true dualist concept of Lucifer and magic. To compound this, historian Richard Barber mentions a work, 'The Sworn Book', or 'Liber Sacratus', written by Honorius of Thebes which may hold further clues to the universal quest for the grail. This mysterious book was written in the thirteenth century and contains the 1,000 names of God. The major part of its focus is on the occult and sacred white magic. Initially I was fascinated by it, excited even, until my small voice counselled me to leave well alone. I do however acknowledge that there is much more to this, I can only lay before you aspects of this grail search which I believe are either central or peripheral to the whole. One thing I am sure of, it is part of it. However the body of this is complicated and we must all take our own personal responsibility as to which turn we take.

The Declaration of Arbroath

Do not believe in what you have heard; do not believe in traditions because they have been handed down for many generations; do not believe anything because it is rumoured and spoken of by many; do not believe merely because the written statements of some old sage are produced; do not believe in conjectures; do not believe in that as a truth to which you have become attached by habit; do not believe merely on the authority of your teachers and elders. After observation and analysis, when it agrees with reason and is conducive to the good and benefit of one and all, then accept it and live up to it.

Gautama Buddha, spoken *c.* 2,600 years ago

Now we cross the channel back to British shores and Scotland.

The Leather Wallet

A simple tan leather wallet accompanied the Madonna. It's not at all grand and reminded me of the cover we used to put the *Radio Times* in when I was a little girl. When my mother and I took it out again, we turned it over in our hands, and as we did so it seemed that yet another layer of time started to shift.

Look closely at the photograph and you will notice that flowering from either side of the fleur-de-lys are what appear to be two roses. They feature again on the fleur-de-lys that decorates the crown above and is central to the panel on the reverse side of the wallet. The rose is well known as an iconic symbol open to various interpretations. One of them, though, I discovered is inherent in the great mysteries associated with the grail themes. I was astounded when I made this connection, for it is a thread in this tapestry which has been cast in

stories for centuries. It is of course fictionalised by accounts of King Arthur and the Round Table but, yet again, these stories are a way of keeping a truth alive, for there is a belief that they are a link to Joseph of Arimathea. According to legend and cited in *The Coming of the Saints* by J.W. Taylor, Joseph had a son, Josephus, and it is from that line, and the bloodlines of the other refugees, that King Arthur and his knights are descended. In the view of J.W. Taylor, whose references are impeccable, the families of the British kings or chieftains married the Judean refugees who by direct descent some 400 years later formed the knights of King Arthur's inner court. The grail is also linked to the cup which held Christ's blood and to the mystical quest for the power it holds. In fact, there are so many references to the grail legends that it would appear to encompass many facets of this picture that is forming before us, of enlightenment and truth, all interconnecting and firing new streams and visions of what it is. As to the Arthurian legends and the associated Round Table, the consensus would appear to be that it seated 12 knights to represent the 12 apostles of Christ and the signs of the zodiac. According to Manly P. Hall in his definitive book *The Secret Teachings of All Ages*, positioned in the centre of the table was the symbolic rose of the Passion, signifying the resurrection of Christ in that he 'rose' from the dead. Again, this has bearing in what is to come of early Masonic foundations and again according to Manly P. Hall: 'Arthur was the Grand Master of a secret Christian-Masonic brotherhood of philosophic mystics who termed themselves Knights.'

So much more could be said on the grail. The search for it has lasted centuries, and it would seem from my own quest that it carries a multitude of definitions, mostly symbolic, in an eternal pursuit of enlightenment. The Arthurian legends are just another way of relaying that story, just like the symbolism in art, song and dance. All connect us to an eternal quest for the truth.

There are, of course, other interpretations of the symbolism of the rose that are better known, such as victory and pride, and the one familiar to most is that of the rose signifying love, with the petals used to bless a wedding. However, it is also connected to secrecy, which reconnects to the grail tenet, 'sub rosa' meaning 'under the rose', implying that any information must be kept secret. According to a book I have on secret signs and symbols by Adele Nozedar, some Masonic lodges still conduct meetings with a red rose to remind them of the confidentiality of what is said, and there are three roses on the

ceremonial apron of the Master Mason, acting as reminders of faith, silence and secrecy.

The folio is framed by a border which is strikingly similar to that of the painting, with fleurs-de-lys decorating the corners. The central features of the design have evidently been coloured in, only on one side, and rather clumsily executed. I can imagine the person doing it, miffed with themselves for daubing too much gold on the rose heads. Whoever it was didn't have the time or the inclination to carry it through on the back, but they must have done this for a reason. I believe they were trying to signify something by the colours – and here I again plead guilty to conjecture, for all I can do is try my best to discover the implications of their artwork.

So, first off, the central fleur-de-lys is blood red; this may, in the light of what we have already considered, signify a bloodline and that in turn would concur with the flowering roses, which could symbolise offspring, which would entirely fit with the symbolism of the rose in the grail mysteries, and its relation to the secret which cannot be spoken of, the risen Christ. To pursue this further, surmounting the central fleur-de-lys is a crown. This too could signify a royal line, that of the 'grail', the one emphasised in so many grail traditions.

The rose emblem is given further, and central, prominence on the reverse, but has been left uncoloured. Lapis lazuli colours a decorative feature at the base of the emblem of the fleur-de-lys, which may be significant because blue among medieval Christians was associated with immortality, red being representative of 'divine love'. Blue is also, emphatically, the colour of Freemasonry. For them it is a symbol of universal friendship and benevolence. Blue also has associations with the sacred mysteries and religion of ancient Egypt, and Egypt as we are discovering is a cornerstone of all that has to do with Masonry and this story. There is white to be seen as well, which is a ubiquitous symbol of purity and often used in the garb of mystery sects – the Druids and Knight Templars in particular – as well as aesthetics, anchorites and various Christian organisations. Many would say that this colour scheme is purely decorative, the whim of an unknown artist, but I don't think so.

Equally as important as the outside of the wallet is what it conceals within. Initially, when I looked inside it appeared empty. In fact, it looked as though it had never been used. The narrow leather inserts are decoratively embossed with oak leaves, which yet again are linked to

Druidism, for the oak was sacred to them, but in the Christian context too it is seen as a symbol of the strength of faith. Disappointingly, at the time it seemed that there were to be no letters to enlighten me, no documents; I had drawn a blank. I slid my fingers under the hard leather just in case. As my fingers explored the interior they touched upon something. I pincered my fingers and pulled it out. It was a bit of an anticlimax when out of their confinement into the light came two stamps, just two five-penny commemoration stamps for the Declaration of Arbroath in 1320. They were still joined by their perforations as though they had just been brought back from the Post Office on their day of issue, 1 April 1970. It was initially an incongruous and rather disappointing discovery, but now I have researched the meaning of it I can see precisely why they form a part of this story. More than that – it also means that my father knew more about the bequest than I had realised, and that he had pieced some bits of the puzzle together before he died. The stamps were issued just nine years before his death and nearly twenty years after the painting and other artefacts had entered our house.

At that stage of my discovery I had to admit to myself, with some shame and chagrin as a Scot, that I had never even read through the whole of the Declaration of Arbroath. My mother confirmed that neither had she. We were two shamefaced women who had to find out if it was significant in our search. Now that I have familiarised myself with it, I am startled at its stupendous content.

Background to the Declaration of Arbroath

The encroachments of the power of Rome persisted on Britain's shores, not in physical might but in doctrinal domination, and resulted in a letter of Declaration, known as the Declaration of Arbroath. It was a letter by King Robert the Bruce to Pope John. Scottish independence, civil and ecclesiastical, are eloquently voiced. So articulate was this letter that some 700 years later it became the template for the American Declaration of Independence. This weighty document was instigated by the romantic, charismatic figure of Robert the Bruce, King of Scotland in 1320. As with all my researches, I found there was much more to this man than the history books tell us. King Robert the Bruce was a Master Freemason who founded several orders of knights, including in 1314 the Order of HRD (Heredom). Heredom is an interesting word of unknown origin which means:

Heredom *n*. [orig. unknown] 1. a significant word in 'high degree' Freemasonry, from French Rose Croix rituals where it refers to a mythical mountain in Scotland, the legendary site of the first such Chapter. Possible explanations include: Hieros-domos, Greek for Holy House; Harodim, Hebrew for overseers; Heredum, Latin for of the heirs.

Rev. George Oliver, *The Historical Landmarks of Freemasonry* (Vol. II) published in 1846.

There has been much speculation about the location of this mythical Mount Heredom. The theory I find most compelling is that it is Schiehallion, a mountain in central Perthshire and not far from where I live. This magical and mystical mountain is located at the geographical centre of Scotland. I have yet to find and explore the caves at its base, but I have climbed to the top. Heather-scented moorland gives way to peat tracks, which in turn transform to quartz, leading you to the upper reaches of huge boulders and rocks. According to local lore it is where the first Templars convened after they fled France. The views from the summit are staggeringly beautiful: smoking clouds steaming from wild summits, the sight of a red kite, the finger of the wild calling you. Could it possibly be that this is Heredom?

In the writings of the Chevalier de Berage, first published in 1747, on the origins of Freemasonry, and quoted in Nesta H. Webster's book *Secret Societies and Subversive Movements* first published in 1924 but still in print, she states:

> Their Metropolitan Lodge is situated on the Mountain of Heredom, where the first Lodge was held in Europe and which exists in all its splendour. The General Council is still held there and it is the seal of the Sovereign Grand Master in office. This mountain is situated between the west and north of Scotland at sixty miles from Edinburgh.

So seemingly it could be the iconic Munro of Schiehallion, the visually mystical mountain which stands out in the skyline like some wild primal natural pyramid.

> O! if there be on Earth a Paradise,
> Where righteous souls in glory wait in trust

Till the sweet resurrection of the just,
Methinks that region round Schiehallion lies,
And that good angels, hovering o'er its cone,
Impart to it that chaste and heavenly tone.

I love to view Schiehallion all aglow,
In blaze of beauty 'gainst the eastern sky,
Like a huge pyramid exalted high
O'er woodland fringing round its base below;

The Bible tells of Hebrew mountains grand,
Where such great deeds were done in days of old,
As render them more precious far than gold
In our conception of the Holy Land;
But every soul that seeks the heavenly road
May in Schiehallion, too, behold a Mount of God.

Reverend John Sinclair, 'Schiehallion'

Interestingly, after King Robert's defeat by English military forces at Methven, Perthshire, in 1306, the Scots king retreated into the mountain recesses of central Perthshire. There is a strong tradition that he took refuge in a small castle by the north slope of Mount Schiehallion.

The Rev. George Oliver says that the degree of HRDM:

> may not have been originally Masonic. It appears rather to have been connected with the ceremonies of the early Christians. These ceremonies are believed to have been introduced by the Culdees (Cultores dei) in the second or third centuries of the Christian era. Operative Masonry existed in Britain at that era, as is evidenced by the building of a church at York, and a monastery at Iona; and it was in active operation before the twelfth century.
>
> Rev. George Oliver, *The Historical Landmarks of Freemasonry*

So yet again we have a conspicuously strong link forged between the Culdees and Freemasonry.

In the history of the Order of Heredom there is reference to the dissolution of the Order of the Temple, an order that incorporated the enigmatic Knights Templar. And it is on record that some of the

Templars, persecuted by the Pope and the king of France in the early 1300s, sought refuge in Scotland, where they placed themselves under the protection of Robert Bruce, a man who himself had been excommunicated by the Catholic Church. There is convincing evidence that they assisted him at the Battle of Bannockburn, which was fought on St John's Day, 1314.

Mackey, in his *Encyclopedia of Freemasonry*, quotes from a manuscript about the chronology of French Freemasonry held in the library of the Mother Lodge of the Philosophic Rite, by C.A. Thory ('Acta Latomorum' I, 6):

> Robert Bruce, King of Scotland, under the name of Robert I, created on the 24th of June, after the battle of Bannockburn, the Order of Saint Andrew of the Thistle, to which he afterwards united that of H.R.D., for the sake of the Scottish Freemasons who made a part of the thirty thousand men with whom he had fought an army of one hundred thousand English. He reserved forever to himself and his successors the title of Grand Master. He founded the Grand Lodge of the Royal Order of H.R.D. at Kilwinning, and died, covered with glory and honor, on the 9th July, 1329.

I think that this is yet more tantalising evidence of a crossover between the brotherhoods, that of the Freemasons with the Knights Templar, who were also linked to the Culdees. Fascinatingly, the Order of the Thistle has the same distinction as the English Order of the Garter – they are the two most prestigious knighthoods in our country.

Freedom and the Declaration of Arbroath – The Most Eloquent Blackmail Note in History

> It is in truth not for glory, nor riches, nor honours that we are fighting, but for freedom – for that alone, which no honest man gives up but with life itself.
>
> from the Declaration of Arbroath

Tragically, Robert the Bruce's defeat of the English at Bannockburn in 1314 did not end the 20-year War of Independence and King Edward II continued in his attack upon the Scots.

It was this domination by King Edward and his continued goal of making Scotland his own which was the catalyst for the landmark

Declaration which we shall now explore. King Edward had continually plagued King Robert and at the ascension of Pope John XXII to the Holy See managed to convince the newly fledged Pope that Scotland was the culprit for all the years of battle. Consequently, King Robert and his bishops were all excommunicated. More than this, every English priest was ordered to hold a service each day cursing the king. King Robert rose to this with a prowess and flourish that struck back into the very core of that establishment. The Declaration, which was born from this confrontation, stands alone as being of resounding significance to the history of Scotland, but as we shall see it holds amazing truths. It was drawn up by Scottish barons, clergy and other nobles who formally set out Scotland's case for independence. It was drawn up at Arbroath Abbey on 6 April 1320, probably by Abbot Bernard of Kilwinning, Chancellor of Scotland, and delivered to Pope John XXII. The Declaration is the sole survivor of three documents submitted at the time, the other documents are thought to have been a letter from King Robert the Bruce, and a letter compiled by four Scottish bishops.

The content eloquently explains Scotland's struggle to become an independent state, and tries to persuade the Pope of the legitimacy of Scotland's case. It also warns the Pope that unless he accepts the Scottish argument the war will continue, and any deaths would be his responsibility. See the full text of the Declaration, as shown on the National Archives of Scotland website, in Appendix Two. The extracts below are taken from the same translation.

It seems to me that there is an element of blackmail in the Declaration:

> But if your Holiness puts too much faith in the tales the English tell and will not give sincere belief to all this, nor refrain from favouring them to our undoing, then the slaughter of bodies, the perdition of souls, and all the other misfortunes that will follow, inflicted by them on us and by us on them, will, we believe, be surely laid by the Most High to your charge.

Even more so does this:

> This truly concerns you, Holy Father, since you see the savagery of the heathen raging against the Christians, as the sins of Christians have indeed deserved, and the frontiers of Christendom being

pressed inward every day; and how much it will tarnish your Holiness's memory if (which God forbid) the Church suffers eclipse or scandal in any branch of it during your time, you must perceive. Then rouse the Christian princes who for false reasons pretend that they cannot go to help of the Holy Land because of wars they have on hand with their neighbours.

This surely is one of the most eloquent blackmail letters in history! The most cogent and arrogant expression of nationhood ever written. For that very reason, it is no wonder that the United States of America took it for the template for their Declaration of Independence, because in it we find a plea for the right of freedom for all men and man's right to defend this freedom to the death as had never been witnessed before.

Where did these nobles get their confidence from, given all they knew of the might of the Roman Catholic Church? But confident and arrogant they evidently were, and that confidence must surely have come from that knowledge of their genetic heritage and of the presence of Christ's blood on Scotland's land.

It was a threat that would be foolhardy for the papacy to ignore. Remember, Rome knew the true history of our islands. It also knew that a mighty enemy, which included an ancestry rooted in the tree of knowledge of the Culdee, which had branched and flowered to that of the Masons and the Templars, was standing braced to defend its truth.

It is why the Knights Templar had fled to Scotland, just as the Judean refugees over a millennium earlier had done, confident in their knowledge of those shared roots of their family tree and the various branches of the line which spread out from it – the royal bloodline.

For what the Declaration so brilliantly underscores is the ancient ancestry of the Scottish people:

> Most Holy Father and Lord, we know and from the chronicles and books of the ancients we find that among other famous nations our own, the Scots, has been graced with widespread renown. It journeyed from Greater Scythia by way of the Tyrrhenian Sea and the Pillars of Hercules, and dwelt for a long course of time in Spain among the most savage peoples, but nowhere could it be subdued by any people, however barbarous. Thence it came, twelve hundred years after the people of Israel crossed the Red Sea, to its home in the west where it still lives today.

Yet another tantalising point mentioned in the Declaration is the one referring to Christ's instruction:

> The high qualities and merits of these people, were they not otherwise manifest, gain glory enough from this: that the King of kings and Lord of lords, our Lord Jesus Christ, after His Passion and Resurrection, called them, even though settled in the uttermost parts of the Earth, almost the first to His most holy faith. Nor did He wish them to be confirmed in that faith by merely anyone but by the first of His apostles – by calling, though second or third in rank – the most gentle Saint Andrew the Blessed Peter's brother, and desired him to keep them under his protection as their patron forever.

The word which I find perplexing is 'after'. Are we to take it that this means post-Crucifixion, in the accepted historical sense? It must be and yet note the word 'Passion' is used, not Crucifixion. And then the reference to 'first of His Apostles'. But not Peter. So could it have been (it must be) Mary, the one who cannot be named, who is the 'Apostle of the Apostles'? Given all this it comes as no surprise that Freemasons hold this document in such high esteem, which they evidently do. It couldn't really have been set out much better for it beautifully sets out in its veiled threats that further harm by the English to the Scots will not be tolerated, and emphasises the distinguished history of the Scots people and what will happen if the Pope doesn't respect that pedigree. What an awesome thing it is.

I wonder whether that heritage they mention (which we share) wasn't the theological brilliance which compelled King James VI of Scotland and I of England in 1611 to commission a book, and such a book that has had more influence on the English language, and therefore upon the world, than any other work. Namely a translation of the Bible into English. That staggering translation took seven years by fifty scholars and had the aim of gifting the Bible to the nation. Just reflect back on the time: until then the Bible was locked away from the people, as until the King James Bible it was commonly written in Latin. Now, though, King James had given them the key, and it could be opened and explored. This meant emancipation from the dictates of the clergy – for those who could read, at least – as now they were free to explore the text, quite a threat to the supremacy of Church

domination of thought. Its prose, together with the Declaration of Arbroath, shaped the Declaration of Independence of the United States of America.

So, a dynamite declaration of Scottish pedigree and history. It was all true, which is why they could proudly declare it as such in defiance to the very head of the Church.

The American Declaration of Independence

Remarkably, all this is acknowledged by the United States of America. In deference to the pedigree of this document and the involvement of the Scots Masons in the founding of America and the American Declaration of Independence (which took the Arbroath Declaration as a template) it was officially recognised in 1998 when the US Senate passed Resolution 155, designating 6 April annually as National Tartan Day. That date was chosen because it was the date on which the Declaration of Arbroath was signed in 1320, and it is lauded by them as one of the earliest known documents to assert the sovereignty of a people and as such was influential in the wording of the American Declaration of Independence. What is less well known is the involvement of Scottish Freemasonry – before, during and after the creation of the United States of America.

In the view of E. Raymond Capt, who wrote in *Our Great Seal: The Symbols of Our Heritage and Our Destiny*:

> It is to the honor of Freemasonry that many of the men who framed the Declaration of Independence and served on the various committees to design the Great Seal were members of the fraternity. The pattern of the 'New World Order', as shown by the symbolism of the Seal, rests upon the Masonic virtues of 'Fortitude', 'Prudence', 'Temperance' and 'Justice'. It was also the Masonic teachings of liberty, equality and fraternity that became the foundation of Americanism.

This is hardly the action a new country would have taken had they not believed in the tenets of the Arbroath Declaration, the foundations of which were to be the building blocks for what would become the most powerful country on Earth.

King Robert the Bruce was, as we have already seen, a Master Freemason and the Grand Master of the Lodge at Kilwinning in

Ayrshire; George Washington, the first President of the United States, was also a Master Freemason.

In Masonic circles, it is well recognised that it was the Culdees who were the architects of the Abbey at Kilwinning and who first established the institution of Freemasonry in Scotland. And remember 'heredom' in Latin means 'heir to', which does seem to confirm my thesis of the one morphing to become the other.

So now it is finally clear why the stamps had to be part of this story. My father must have known of this connection and had maybe even pieced some of this mesmeric puzzle together. It was his hand which had slipped the stamps into their hiding place, waiting for the day when his daughter would later bring them out into the light of the day. I find some consolation in that connection.

Stone of Destiny

The Stone of Destiny is both a sacred and powerful symbol of Scottish nationhood. The account of its provenance appears in Genesis 28:10–22:

> Jacob set out from Beersheba and went on his way towards Harran. He came to a certain place and stopped there for the night, because the sun had set; and taking one of the stones there, he made a pillow for his head and lay down to sleep. He dreamt that he saw a ladder [this immediately makes me think back to the ladder in the engraving], which rested on the ground with its top reaching to heaven, and angels of God were going up and down upon it.

Next the Lord speaks to Jacob:

> The Lord was standing beside him and said, 'I am the Lord, the God of your father Abraham and the God of Isaac. [Remember that they were Chaldeans.] This land on which you are lying I will give to you and your descendants. They shall be countless as the dust upon the Earth, and you shall spread far and wide, to north and south, to east and west. All the families of the Earth shall pray to be blessed as you and your descendants are blessed.' [. . .] Jacob rose early in the morning, took the stone on which he had laid his head, set it up as a sacred pillar and poured oil on the top of it.

The early kings of Israel were said to have received their crowns in the temple, in close contact with the pillar set there by their forefather. P. Gerber in *The Search for the Stone of Destiny* says that biblical lore tells us that after the destruction of Solomon's temple the pillar stone was transported with Gaythelos, a Scythian prince living in Egypt, together with his princess Scota, via Spain to Scotland. This is the migration to which the Declaration alludes. It tallies as well with another woman of royal stock who also came to our shores in the name of Mary Magadalene and, as with Scota, she was not alone. Yet again as so often happens in our biblical scripture, history has a tendency to repeat itself.

It is thanks to my father then that those two stamps have underscored the other pieces in our cache. Central to everything of course is the painting, from which all else springs, from the true story of Christ to the ensuing lore of the Culdees, who re-formed to the Knights Templar to evade dissolution by the papacy. A rose by any other name would smell as sweet, and the brotherhood of Freemasonry and the Knights Templar are practically interchangeable. I find it comforting that the Freemasons, whom one is so often schooled to fear, have such a proud lineage.

One of the leading names in that Masonic/Templar brotherhood is the famous Sinclair family, who were one of the signatories of the Declaration of Arbroath – as St Clair (meaning Holy Light in French). This was the St Clair of Rosslyn Chapel fame. It is to him we now shift our attention.

The St Clairs' Legacy of Rosslyn Chapel

At the Battle of Bannockburn in 1314, King Edward was surprised by the calibre of well-trained men who fought alongside the Scots. Not surprisingly, a large number of these men were of course the famous Knights Templar, who had taken root in Scotland to be hidden far away from Catholic tyranny and papal armies. Intriguingly in the context of this story, immediately after the battle Robert the Bruce rewarded the St Clair family with lands near Edinburgh in the Pentland Hills. These are the very lands associated with hundreds of Templar graves, sites, symbols and of course the now celebrated Rosslyn Chapel.

The St Clair family (Sinclairs) were responsible for the Kirkwall Scroll, reputedly one of the oldest and most important Masonic artefacts in the world, which at one time was housed in the scriptorium at Rosslyn Castle. It is thought to date from some time in the fifteenth

century. This is now displayed in the temple of Lodge Kirkwall Kilwinning No. 38(2) in Orkney. The whole scroll would appear to allude to the '18th degree', or the Knight of the Rose, and is rather cryptic in its content. Various legends link the scroll to the Knights Templar and location of the holy grail, and there is a theory that the scroll is a treasure map taken to Orkney for safekeeping after a fire at Rosslyn. As with many things, it brings with it some controversy but its connections to such an illustrious family I believe give it merit. Also associated with this famous family is the chapel of Rosslyn, which lies on the outskirts of Edinburgh and is well known for its Masonic connections and symbolic carvings. The chapel was founded by Sir William de St Clair, who, legend has it, formed a secret order to protect the Templars a century earlier. It was he who after the fire relocated the scroll to Kirkwall.

What isn't so well known is that in Rosslyn Castle there was an important scriptorium:

> About this time [1447] there was a fire in the square keep by occasion of which the occupants were forced to flee the building. The Prince's chaplain seeing this, and remembering all of his master's writings, passed to the head of the dungeon where they all were, and threw out four great trunks. The news of the fire coming to the Prince through the lamentable cries of the ladies and gentlewomen, and the sign thereof coming to his view in the place where he stood upon Colledge Hill, he was sorry for nothing but the loss of his Charters and other writings; but when the chaplain, who had saved himself by coming down the bell rope tied to a beam, declared how his Charters and Writts were all saved, he became cheerful and went to reconfirm his Princess and Ladys.
>
> Fr R.A. Hay, *Genealogie of the Sainteclaires of Rosslyn*

The most important document to survive from the library is the Rosslyn-Hay manuscript, thought to be the earliest extant work in Scots prose (written by Father Richard Augustine Hay, the heroic chaplain at Rosslyn, *c.* 1690 and now in the National Library of Scotland), and a translation of René d'Anjou's writings on 'Battles and the Order of Knighthood and the Government of Princes'. King René was also a conduit to Rosslyn of Oriental, Gnostic and Cabbalistic teachings – it was partly due to him these teachings were spreading

209

from Medici Florence throughout Europe. I don't think it is beyond the realms of imaginings that he may have visited Rosslyn. It's extraordinary to reflect how this net of knowledge was cast over Europe, and that tangled in the fabric of it were some very big fish: René d'Anjou, the close friend of Leonardo da Vinci and the Medicis. All of them were members of a powerful brotherhood, an elite who were dedicated keepers of the truth, that of the true, unedited history of sacred beliefs. These were the bankers, the movers of the Renaissance world. Contemporary with them was one of the most extraordinary constructions in history, Rosslyn Chapel, the story of the origins of Freemasonry carved in stone.

Rosslyn Chapel

I first visited Rosslyn Chapel some 30 years ago. This was well before it captured the public's imagination and my memory is of rather isolated, dank abandonment. Yet, what I also remember was that there was a feeling of sanctity about the place, one which on my recent visit was not so palpable. In contrast to then, now there is a vibrancy, as if it is alive again, whispers have gained their strength, light is being cast on shadows and forms and meanings exposed. Today the consensus is that this it is indeed a special place, a sacred braille in stone, to be deciphered by the few who feel the compulsion to do so.

It was built in 1446 and at first sight the building of the chapel seems remarkably small and rather like an elaborately decorated wedding cake. The roof is barrel-vaulted and covered in a profusion of lilies, roses and stars. What is striking is its scale, almost overdone and in a way ostentatious. Stars and pentagrams, together with the flowers, are all over the place. It reminds me of being caught deep in woodland, with the stars in the ceiling making me feel I am looking up through a canopy of trees to the night sky above. These are symbols which we know play an important part in Freemasonry.

Significantly, the stars also represent the Milky Way. Above the two pillars guarding the image of the portal of the original temple in Jerusalem are carvings of lilies, which signify the descending bloodline of the kings of Israel. The fleurs-de-lys recall those featured in the engraving of the Culdee monk.

Interpretations of this chapel vary, but what is agreed is that it is full of Masonic symbolism and therefore of ancient mysteries.

Once I acclimatised myself it became like a treasure hunt: here a

picture, there a sign and over there a sculpted Hebrew letter meaning 'In God's Hands' or Hu. Hu the god which in folklore is represented by a serpent, the symbol found as handles on so many of my quaichs and yet another connection to the Druids, with the serpent representing reincarnation and wisdom.

This is a mysterious gem of a building. Of the founder, Father Hay said this:

> Prince William, his age creeping on him, came to consider how he had spent his times past, and how he was to spend his remaining days. Therefore, to the end, that he might not seem altogether unthankful to God for the benefices he received from Him, it came into his mind to build a house for God's service, of most curious work, the which that it might be done with greater glory and splendour he caused artificers to be brought from other regions and foreign kingdoms and caused daily to be abundance of all kinds of workmen present as masons, carpenters, smiths, barrowmen and quarries . . . the foundation of this work he caused to be lain in the year of our Lord 1446, and to the end, the work might be more rare, first he caused draughts [plans] to be drawn upon eastland boards [imported Baltic timber], and he made the carpenters carve them according to the draughts thereon and he gave them for patterns to the masons, that they might cut the like in stone and because he thought the masons had not a convenient place to lodge in . . . he made them build the town of Roslyn that is now extant and gave everyone a house and lands. He rewarded the masons according to their degree, as to the Master Mason, he gave nearly £40 yearly, and to everyone of the rest, £10 . . .
>
> Rosslyn Chapel website (www.rosslynchapel.org.uk/p/building-the-chapel-I90/_), accessed May 2012

Underneath the basement of the chapel are sealed chambers which are filled with pure white Arabic sand, which was rumoured to have been brought to the chapel by the Knights Templar from the Dome of the Rock. Ultrasonic scans have revealed six leaden vaults buried there. What on Earth are they? What do they contain? Why were they sealed in 1690? So many tantalising questions. As I continued with my exploration I was reminded of Rennes-le-Château in France, another secret hiding place with clues in abundance. Both these enigmatic

structures hold truths about the grail and are central to this story. This place of worship in Scotland is cryptic and tantalising in its nature and yet at the same time I felt an uneasiness there. For me, the chapel had been built on a place of sacred knowledge, and yet on the particular day I was there it seemed we visitors were scurrying around like ants on a dung heap, all searching for something but not knowing quite what.

Back to the tangible. The layers of carving in the body of this celebratory cake of a building are impressive. There are some 120 'green men' (nature's spirit source) depicted in seasonal ages from spring, the young man on the east wall to autumn, the bloated, overfed, middle-aged man on the west wall, finishing off with a skull representing winter.

All of the fronds or vines that sprout from the top of the Tree of Life pillar (also known as the Apprentice Pillar) represent the different seasons also, these fronds, made up of plants common to each particular season, create a garland which runs up and across the pillar arches and frames the windows as if building a protective natural canopy. It echoes the Druidic belief that the original temple was a special tree in the forest, and some believe that tree to be the yew. The more I explored, the more convinced I was that this was a representation in stone of what was there before – a sacred wood with the Milky Way, the highway of the Gods, as part of it marking the cosmic trail of knowledge leading to this spot – and of the pilgrimage of the Milky Way.

The vines of knowledge tendril straight from the mouths of ancient dragons, perhaps guardians of even more ancient wisdom. I wonder if the dragon isn't synonymous with the serpent and maybe represents the God Hu and his progeny.

Investigations like the one I am embarked on have led some to say there are notes carved in stone and they have orchestrated music to define it. Amazingly, the markings carved on the face of the cubes seem to match a phenomenon called cymatics or chladni patterns. Chladni patterns form when a sustained note is used to vibrate a sheet of metal covered in powder, producing marks. The frequency used dictates the shape of the pattern, for example the musical note A below middle C vibrates at 440 KHz and produces a shape that looks like a rhombus. Different notes can produce various shapes including flowers, diamonds and hexagons – shapes all present on the Rosslyn cubes. I find that extraordinary and when I saw it demonstrated was

absolutely enraptured. Ernst Chladni first documented the phenomenon in the late eighteenth century, yet it appears to be present in a fifteenth-century building. Which begs the question whether Sir William St Clair and his associates who built the chapel were familiar with sciences far in advance of their time, much as Leonardo, in his depiction of DNA at Chambord.

Stuart Mitchell, a musician who has composed a piece called 'The Rosslyn Motet' incorporating the notation of the stones, believes so:

> The symbolism in Rosslyn is reaching back to a civilisation that is lost to us now, that had sciences that are the roots of all the mechanics of the universe.

If this science was used in the carvings at Rosslyn, then there needs to be an explanation of how this information came to be lost for centuries. According to Mitchell, the Church suppressed the knowledge as a means of controlling the public.

Fascinatingly, the devil's chord – or *diabolus in musica* – makes an appearance in the music. On his website, Mitchell writes: 'In the ceiling is this jump of an augmented fourth, in fact it opens up with an augmented fourth.' The Catholic Church had banned this interval (seven semitones) from medieval music, as it was believed to transport the listener to the realms of the divine. This devil's chord made me think of how the Church used to call the left hand the devil's hand. Was that because the use of the left hand enlivened the right side of the brain, the intuitive side – comparable to the devil's chord taking the listener to another level? What an intriguing thought.

In my opinion, thanks must go to Stuart Mitchell (who incidentally, has composed many works which are absolutely exquisite and well worth experiencing) and his father who were the musicians who discovered this extraordinary feature that was hidden in Rosslyn, and boy, what a discovery that was. This is the beauty of the Masons: they hide stuff and do us the favour of leaving us clues so we can, if we have the inclination to do so, find them.

If you haven't appreciated it yet, those clues are everywhere, just waiting to be found. Each one takes you deeper into the labyrinth of world wisdom and mystical truths. It has taught me to reappraise my surroundings, and to look again, and to question. Even the engrailed cross of the Sinclairs, so easy to take for granted, tells us that he was a

grail knight. Right under our noses, lying cosily undisturbed until somebody with the eyes to see, and the ears to hear breaks cover. Then it runs and if you follow it you will find your quarry.

The colourful term of devil's chord, or 'devil's interval', (so-named by the Church), which the Mitchell father-and-son team found in Rosslyn, applies to a chord which the Church of Rome chose to ban in the Middle Ages; it is, from what I can understand, a tritone, which is when the note C is followed by F#.

The late Kay Gardner in her book, *Sounding the Inner Landscape*, has this to say about it:

> Personally, I feel that the tritone, when sung at length as harmony by a group of meditators, will take singers and listeners to a place where they will be in touch with Divinity. Perhaps this is a reason why it was so threatening in ages past.

So Stuart Mitchell and his father quite remarkably stumbled on the same chord in Rosslyn, a chapel said to be the dimensional Masonic truths carved out in braille. It then occurred to me that Mozart, a Freemason, who it is said encoded Masonic beliefs into his exquisite opera *The Magic Flute* also did a quite astonishing thing. Something which had always made an incredible impact on my psyche.

It is documented (and substantiated by family letters) that at the young age of just 14 Mozart, whilst visiting Rome, heard a bewitching piece of music, the 'Miserere'. This emotionally charged piece of sacred music was written by Gregorio Allegri to a setting of Psalm 51. Then entrance stage right came Mozart: a young boy who was so overwhelmed by the beauty of the piece that when he got home he transcribed it from memory, this genius of a being. However, knowingly or not Mozart had transgressed Church dictate, one that had forbidden copies of the 'Miserere' being taken or performances being made outwith the Sistine Chapel, and declared that anyone who did such a heinous act would be punishable by excommunication.

Yet extraordinarily the Pope, on discovering what the young Mozart had done and summoning him back to Rome, broke his own edict, and instead of excommunicating the prodigy, extolled his musical genius.

Knowing the story, I was intrigued to know whether this sublime piece of music contained the tritone of the devil's chord. It does, and

it is a perfect example of the transcendence of music. I am listening to it now, and who can deny this touches the sacred. For me, as Kay Gardner says in her book, it certainly does beautifully take me to a place where I am in touch with divinity.

This tritone is evident in the 'Rosslyn Motet'. It links hands with all else that Rosslyn's builders put before us to lead us to the truth, to the way. It could possibly also be evident in Leonardo's score in his portrait of *The Musician*.

Richard Merrick lays out further fascinating theories about this in his essay, 'The Frozen Music of Rosslyn Chapel', which can be found online. I admit to being in awe of what lies hidden:

> The angel points to B with his right hand and to A and C with his left. This was taken to indicate that the music was in the key of C major, or relative A minor, with the 'leading tone' B balanced symmetrically in the centre. From this, each of the cube patterns was matched against a particular frequency using a square Chladni plate tuned to C. The resulting pitches were ordered from bottom to top, left to right around the columns beginning with the stave angel to produce a haunting melody. [. . .]
>
> In looking at the columns, we see a series of pentagrams supporting the musical angels. But oddly, the angels replace the missing top triangle in each pentagram. Cross-referencing this to Hermetic lore, this missing triangle is the very same 'golden' triangle symbolic of resonance. The question is how can this particular triangle, as part of a pentagram, be considered resonant and why was it so important that it should be carved into a stone chapel?

Please keep this in mind: this was music which was banned by Pope Gregory IX in 1234, the tritone was and could still be outlawed in Catholic music. So the Freemasons hid the use of this forbidden interval by encoding it as cymatic symbols in the chapel architecture. What a stroke of genius. This was their way of preserving what they considered sacred Egyptian knowledge at a time when Europe was hostile to such beliefs.

The Trinity of Tartan

Stained glass has always been used to tell a story. In earlier times it was

a form in which the Church could relay a story, and this was particularly true before the Bible was translated into the vernacular, when it was entirely in the charge of the clergy. In Rosslyn, the windows have a story to tell too, and there is one of them which I don't believe has ever been mentioned and which, for me, is the most intriguing. It depicts Jesus wearing a tartan bonnet. It is almost overstated. Even a little ridiculous. At his side is a woman carrying a basket which holds a dove; a dove which also is the symbol of Iona. God is to their right, holding a baby in his arms which he is offering up to them with his blessing. Decorating the window at the base is the fleur-de-lys. This is unarguably a most bizarre image but one whose intimation is very clear, and what it alludes to is staggering: Jesus Christ as an adult with Mary Magdalene and child in Scotland with the dove, which I now believe represents the Island of the Dove, in other words, Iona. This is even backed up by the fact that this portrayal of Christ and Mary in Scotland is not unique to Rosslyn. On the Island of Mull at Dervaig, which lies on the route to the Island of Iona, there is a church called Kilmore. Beautifully portrayed in one of its stained-glass windows is a pregnant Mary Magdalene with Jesus Christ at her side. At its base it reads: 'Mary hath chosen that good part, which shall not be taken away from her'. This is a statement made by Jesus Christ to his apostles which directly relates to Mary Magdalene and which can be found in Luke 10:42.

These two representations were confirming what was in the painting and what I believed had followed on from it. They were both placing Jesus Christ and Mary Magdalene as consorts on Scottish soil and alluding to their migration to Scotland. It would possibly explain why the Scots took the thistle as their national emblem as a representation of the body of Christ, the colour purple denoting the age-old symbol of royalty, the thorns representing Jesus's crown at the Crucifixion, and the flowering head which represents his seed blossoming and then dispersing.

As discussed, another little-known fact that I discovered in my research is of course that the chapel at Rosslyn, or more accurately its location, was the goal of an ancient pilgrimage, the Pilgrimage of the Milky Way, which took believers along the route from Santiago de Compostela in Spain, up through France and England, to Scotland. The badge of the pilgrimage was a scallop shell. This Pilgrimage of the Milky Way was one which was taken long before the construction of

the chapel, when this was an ancient sacred place with just the trees and sky as canopy; when the Druids worshipped here.

As we have seen, my view is that this sacred route was masterfully deconstructed by Rome and the northern leg of it to Scotland erased from the picture. They strategically did this to head us off in the wrong direction, to confuse the truth. And they succeeded. Few even know of the connection and assume that all roads lead to Santiago.

There is a wall in the crypt with an outline of an arch and an almost circular mark. Legend has it that this represents the presence of some hidden secret. Could this be why pilgrims made the long, arduous journey from Santiago de Compostela – to deposit their scallop shells there?

I looked again at the Apprentice Pillar, with the apparent reference to DNA in its design. It's strikingly similar to Leonardo's architectural plans years later for a double helix staircase at the château at Chambord, one which was later reproduced at Holyrood Palace in Edinburgh. It suggests they shared a knowledge of the structure of genetics even though the DNA double helix wasn't to be discovered for another 400 years by Sir Francis Crick and James Watson in 1953. Interestingly, Francis Crick proposed the concept of 'directed panspermia', the idea that life was brought to Earth by an advanced civilisation from another planet.

I know there is much more for me to discover at Rosslyn, but I had had enough for one day. In acknowledgement of its sanctity, I knelt and prayed before leaving. Outside the chapel I rested on the grass in the sunshine. Blackbirds were singing and clouds were scudding across the sky. I contemplated all that I had seen, and mused about some stories that I had heard about William Sinclair, the founder of this mesmerising place. I didn't want to head home yet, so pulled out a book on Rosslyn and read further.

More secrets

The year is 1546. Somewhere in continental Europe my painting of the Madonna and her child was hanging on a wall, but in the meantime Mary Queen of Scots' mother, Mary of Guise, visited Sinclair. She had come to ask him to return the Holy Rood or Black Rood, which was said to be a piece of the true cross upon which Christ had been crucified brought to Scotland by St Margaret. Bizarrely St Margaret (c. 1045–93) was of royal stock, a Saxon princess of England who was born in

Hungary and went on to marry King Malcolm III of Scotland. Whilst in Scotland she had set herself the task of reinvigorating Catholicism and established a beautiful church in Dumfermline, where she installed Benedictine monks. She was evidently a devout woman, hence her beatification, but she loved her husband so much that when he was killed she died within the month of a broken heart. Her one comfort, her cherished possession of the 'Black Rood', could not save her from passing over, and maybe helped her soul rise free.

Apparently it is recorded that William Sinclair showed Mary of Guise something very important which convinced her to leave the Holy Rood with him and prompted her to write a letter two days later. It is almost akin to what we read in relation to Rennes-le-Château.

This letter is in the National Library of Scotland. In it she swears to be a 'true mistress' to him in gratitude for being shown 'a great secret within Rosslyn' (this is also cited by Father R.A. Hay).

Whatever she saw must have been very impressive to merit such an action on her part.

As I read more books I also discovered from A. Sinclair in his book *The Secret Scroll* that a simple wooden oak bowl was discovered in the vaults of Rosslyn Chapel. The wooden cup, eternal symbol of the grail, and which you will remember is commemorated by the Scottish quaich. He also says that whilst conducting various groundscans of the chapel:

> Evidence of lower chambers revealed by the process bore out ancient drawings and medieval tales of buried St Clair knights in vaults below the chapel floor. The radar pulses also detected reflectors which indicated metal, probably the armour of the buried knights. Particularly exciting was a large reflector under the Lady Chapel, which suggested the presence of a metallic shrine there, perhaps that of the Black Virgin, which still marks so many holy places on the pilgrim route to Compostela, a sacred way that has one of its endings in Rosslyn Chapel.
>
> A. Sinclair, *The Secret Scroll*

Here we have it again, the pilgrimage trail. A pilgrimage to a building which I believe portrays Christ and Mary with a child. Not only this, a further connection is an intriguing one: Sir William was a Knight of Santiago, an order which was founded in the twelfth century, which

means that the pilgrimage predated the construction of the chapel – a possible indication that Rosslyn was a much older site – that of the original destination. As discussed earlier, I wonder if that destination could have then encompassed Iona.

At the time when Sir William joined the Order, it was stated that the novice must spend six months aboard ship. Could this have been to replicate other initiations, or to mirror other journeys, those of Joseph, of Mary, of others? Perhaps. The Knights of Santiago were closely related to the Order of St James and the Sword. The emblem of St James was again the scallop shell, which pilgrims carried with them, and still do, to their final place of pilgrimage on the Pilgrimage of Santiago de Compostela, or more correctly the Pilgrimage of the Milky Way. Reflecting on the scallop shell, there is an amazing comparison to be drawn between the outline of the Milky Way and the scallop shell, the swollen central portion with hinged wings. Both carry the sun and moon hidden in their body.

So it would seem a distinct possibility that medieval pilgrims travelled from Santiago de Compostela (the field of stars) in northern Spain, all the way up to Rosslyn by way of France.

The day with its revelations had been good to me. I needed to head back to Perthshire and record all that I had seen. Back along the bypass, a sidelong glance at our old family house at Swanston and then northwards and home.

Now to flamboyance and style, and back to France to rendezvous with King Louis XIV.

The Apollo Who Would be King

Every time I gaze at the Magdalene in my painting I wish she could tell me how she has survived for the last 500 years. Maybe she would tell me that she had travelled back with Melzi to Italy after Leonardo's death, or maybe the truth lies nearer to the other scenarios proposed earlier. Her face may have looked back at Napoleon, and who else? Could the Sun King in the engraving which this chapter focuses on have met her gaze?

What I do remain convinced of, in the lack of any other secure evidence, is that she was in all probability commissioned by King Francis I of his court painter Leonardo da Vinci. If so, there is the distinct possibility that it may even be the 'lost Madonna' which was recorded as being in the possession of Louis XIV. If she was in his possession I find it an amazing concept to think that she may have been hanging on the walls of Versailles, her image caught in the Hall of Mirrors as she was carried by his courtiers. Captured there she would have been almost three-dimensional. I wonder what kind of frame she would have been in, and where he would have displayed her – in his private apartments, perhaps even his own bed chamber? Such ponderings and scenes to stage-manage. Orchestrations of gigantic proportions in the imaginings of man.

On this point of scenarios I have often questioned whether my quest has been part of some cruel farce, with me acting out some kind of Umberto Eco exercise. I am happy to tell you it's no farce, this is a serious drama, with absorbing actors who walk the stage with us.

So, on to the next act as we move to the final curtain of this story.

For me the only other possible act in this concert of probabilities is that René d'Anjou could have been involved in some way. The reason I have for thinking this is that the setting of Aix puts it in the same

location as where good King René resided, and we know he associated with Leonardo. As mentioned earlier, I even have a fanciful notion that John the Baptist has a look of René, the same squat features, the snub nose – forgive me René – but even his ugliness belied his inner beauty. Even if Leonardo did portray René as St John the Baptist, I still hold true to my conviction that it was the king who would have commissioned it. In the context of this story though, whether Leonardo decided to portray René as John, or the king, is not important. What is important is the story the painting is determined to tell; that he, Leonardo, is resolute to communicate to us.

It, and his time, has come.

As we have seen in the previous chapters, the only definitive clues as to the painting's travels remain in the wayfaring tickets. These prove she was definitely in France in the nineteenth century, but evidently and not surprisingly in Italy many centuries earlier, when the papal bull would have been attached to it – the mysterious bull with the remains of writing underneath it which I am more and more convinced has written in it the word Madalena or Madalene. When the painting goes to the Hamilton Kerr Institute in Cambridge, I am hoping that the writing can be deciphered, and any other drawing or clue to confirm her true provenance.

The wayfaring tickets of Parigi and Torino 23 look older than the chemin de fer ticket, but I can't tell for sure. It is too simple to orchestrate the sequence of events and I do try to keep to a true perspective and translation of what has been laid before me. In reflection of those journeys she took, those clues to it and the spaces in between, it also never fails to amaze me how these tickets were just stuck on the back. Was this work of art just transported from place to place exposed and unprotected? Was she, this exquisite mother, manhandled whilst in transit? What a terrifying thought!

What I must now add to this story, to interject into the chemistry of it all, is yet another observation, a discovery if you will. Please look back at the painting, reacquaint yourself with her. OK. Now here is something new to consider. Take a line from St John the Baptist's reed cross down to the lamb. Now take that line upwards, follow it. It cuts across the periphery of the baby's genitals, to align with the wonderful lacework of the Madonna's robe. Take a moment, what do you see?

A massive V. The sign of the Sacred Feminine. It dominates the picture. It complements the V in her hairline, but this dominant aspect

of the painting is really quite enthralling. Look at *The Last Supper*, that V is evident there too, between Christ and the controversial figure on his right.

You see I've missed signs, I don't have the full vocabulary. For that reason I need your help. Go online to my Facebook page or www. fionamclaren.co.uk and tell me what you see that I have missed and let's shake the truth out of this picture so she can fully tell her story. If you don't have access to the Internet please contact me directly through the publisher. But onward to this next section of my quest, to discover what King Louis XIV had to do with it all.

Louis XIV

Mercifully, we do know that King Louis XIV was devoted to the grace of Mary Magdalene, much as his predecessors had been. It was after all Charles II of Naples who had all his most favoured lovers portrayed at one time or another as the Magdalene. King Louis, though, even went so far as to pay homage to her by, in 1660, committing himself, with his mother at his side, to a form of pilgrimage to Mary's shrine at St Baume in the south of France. One has to pose the question, why? Why would they revere her and want to associate their women with her if she wasn't someone sacred to them, sacred to Christ? For remember, they ruled by divine right, or so they believed, so if Christ associated intimately with Mary, then so should they. It was all a replay of their destiny, their lineage. It is also why royal families have always tried to keep their bloodline intact, never marrying outside their gene pool, that is until recent times. Some religions adhere to the same doctrine of keeping the integrity of their bloodline pure. I suppose it may be the foundation stone for the term 'mixed blood'. On the other hand, the Culdees, the Christos family, I believe saw it as their mission to flood the world's gene pool with theirs, to endow us all with the God gene. More of that later. For now, let's walk with Louis and find his place in this. We left him a moment ago heading south to pay homage to Mary.

Imagine, it must have been quite an ordeal and undertaking, to say the least of a very arduous journey down through France. When Louis and his mother finally met their destination they presided over the placement of Mary's silver casket of small relics into a porphyry crystal urn, which had been placed at the supposed site of her burial. Let's face it, this is not something one would undertake unless one were totally committed to that ideal.

St Baume was the site where legend has it that St Maximinus, who I believe to have been Christ, supposedly had her body buried. I don't know, maybe it was, or maybe it wasn't. Whatever the truth is, that embalmed body had a basilica built over it to honour and protect it. With what I now know about the Christos family, I'm not sure I can subscribe to the belief that Mary died in Provence. She may have gone back and died there, but I somehow have a sense that she may be buried elsewhere. The fact is, nobody knows. Maybe her body and that of Christ's were taken as holy relics and dispersed amongst various sites, maybe even Rennes, Santiago, Rosslyn or Iona. However, what is certain is that St Baume is a special place and Mary did have strong associations with it, may even have hidden something there, the Gospel of Love perhaps, or other sacred texts.

What is abundantly clear though is that this area of the Languedoc certainly beguiled King Louis and of course reconnects us to our painting, for this is the region associated with Aix and Mt Ste Victoire, and so too the map in the next chapter. Can you sense it, the smell of lavender and wild rosemary? It is a magical place of white chalk and blue skies, with a special light which has always attracted artists. Yew, the tree which I think could be depicted in this painting, pine, oak and other native woods grow here as do an abundance of wild flowers and herbs. The fragrance in the air is intoxicating and quite unlike any other I have experienced. It is marred only by the occasional crack of the gun as the '*chasseurs*' have their grim fun.

The story of Mary's grotto is central to Provençal lore, and the record of Mary Magdalene and St Maximinus, and place names associated with them are scattered throughout the region: Maximinus gives St Maximin its name, the place where they landed in the Camargue; Saintes-Maries-de-la-Mer; and of course I have also suggested that Aix is a pseudonym for Christ. Apparently the grotto at St Baume was inaccessible for years but since the thirteenth century it has been a pilgrimage site and is even now in the charge of the Dominican order. To this day it is associated with the fertility of Mary and is still visited by young women who have difficulty in conceiving.

I found the climb to the grotto well worth the effort and once I reached the top I spent a considerable time in thought, having found the surrounding views most moving. To think that the ranges of hills and scrub land haven't changed that much since Mary and her family would have surveyed them. That touched me profoundly.

So King Louis XIV journeyed there, but not only him. The incentive to go there was not only his and assures the lineage and intrigue of the Magdalene: some hundreds of years before the arrival of Louis and his mother, during the basilica's construction, in one day alone *five* kings arrived from different parts of Europe to worship before it (Philippe VI of France, Alfonso of Aragon, Hugh IV of Cyprus, John of Bohemia and Robert of Sicily).

So what can this engraving in my charge tell us of the man it portrays and his part in this story? For one thing, the least of it, it always strikes me when looking at it that if you ever wanted to know what it felt like to be godlike, then look no further. Louis XIV, the Sun King, epitomises it beautifully.

This colourful, charismatic Sun King believed himself to be Viceroy to the Almighty, and that accordingly the day started and ended with him. Yet, almost in contradiction to his divine power, he humbly submitted himself to Mary Magdalene. For Louis perhaps she was the moon, the night to his day, of the Sun King. This theme of his divinity was carried through into his daily life, for whilst taking worship in his private chapel, which he had decorated with fleur-de-lys and scallop shell masonry, he demanded that his courtiers in their turn worship him, as he in his worshipped Mary Magdalene.

Here was a god on Earth, who fully realised the power and necessity of the Sacred Feminine.

Just imagine the setting; once a week foreign ambassadors from Paris would come to visit Louis at Versailles, and would ascend the awe-inspiring staircase of his magnificent creation to meet with the sovereign. The mirrors in the hall would capture their image too, just as they may have the Madonna of my painting. Today Versailles is still breathtakingly beautiful but it is in fact just a mere shadow of its former glory. The sun is setting on his majesty casting the long shadow of Louis XIV on the fabric of his glittering creation, one fit for a God. It's hard to imagine, but in its day 1,500 jets of water fountains cascaded and glittered, and were supplied by superbly engineered underground water channels, channels which are still in use today for the mere 300 fountains which remain. In celebration of his status as Sun God, Louis planted vast extravagant orange groves, the fruitful symbol of the sun, with the heady scent of their blossom filling the air. Inside his palace silver furniture adorned the rooms, furniture which he miserably would later have to sacrifice to pay for national defence. This was opulence

The engraving showing the monk with the skull. (© Fiona McLaren)

Glastonbury Tor. 'And did those feet in Ancient Time . . .' (Photo by Jim Champion)

The isle of Iona. For Columba, Christ was a Druid.

Exquisite demonstrations of the power
of the Grail and all that it symbolises.

Coat of arms of Galicia, Spain,
13th–16th centuries.

Coat of arms of Galicia, Spain,
16th–18th centuries.

Coat of arms of Spanish Monarch/
Arms of Galicia.

Escudo de Santiago de Compostela.

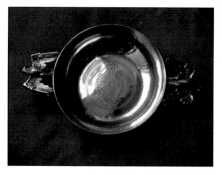

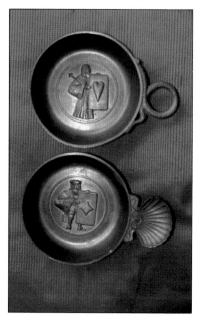

A quaich showing the heraldry of George Washington. This together with the pewter quaich from the House of Representatives in the United States is, for me, irrefutable proof of a strong Masonic connection.

Three examples of quaichs bearing their secret doctrine. (© Fiona McLaren)

The eighth Station of the Cross at Rennes-le-Chateâu, showing a child in tartan/plaid.

Quaichs showing the heart and pentangle (diamond) of the Tarot. (© Fiona McLaren)

The Tour Magdala at Rennes-le-Château.

Two sections of *Triptych of the burning bush* by Nicolas Froment. Note the fleur-de-lys. Look for other whispers in this – the demons at the feet of the Pope, the Monk. It is brimming with communication.

Louis XI surrounded by the Knights of the Order of St Michael by Jean Fouquet. Again, note the prominence of the fleur-de-lys.

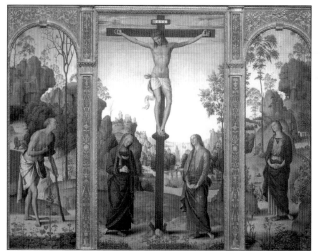

Crucifixion with Virgin, St John, St Jerome and Mary Magdalene by Pietro Perugino. See how the two figures to the right are mirror images; are they saying that they are one and the same?

Montsegur, last stronghold of the Cathars. (© Kathleen McGowan)

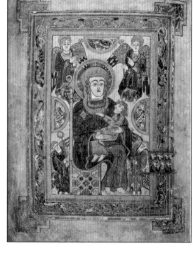

Folio 7v from The Book of Kells, Virgin and Child. See how it follows the imagery seen in Coptic art. If you can, please access other images in this glorious work of art.

George VI in Masonic regalia. Note the scallops and fleur-de-lys. The power and control of the brotherhood of Freemasonry stretch through every echelon of society.

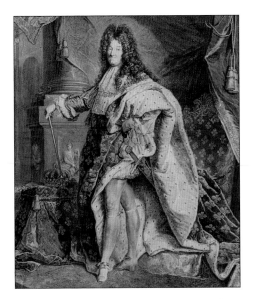

Engraving of Louis XIV by Hyacinthe
Rigaud. Once again the fleur-de-lys are
prominent.

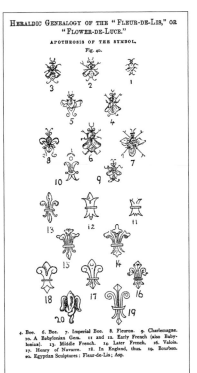

HERALDIC GENEALOGY OF THE " FLEUR-DE-LIS," OR
"FLOWER-DE-LUCE."
APOTHEOSIS OF THE SYMBOL.
Fig. 40.

4. Bee. 6. Bee. 7. Imperial Bee. 8. Fleuron. 9. Charlemagne.
10. A Babylonian Gem. 11 and 12. Early French (also Baby-
lonian). 13. Middle French. 14. Later French. 16. Valois.
17. Henry of Navarre. 18. In England, thus. 19. Bourbon.
20. Egyptian Sculptures: Fleur-de-Lis; Asp.

A diagram showing the
development of the fleur-de-lys
image.

The mysterious *Et in Arcadia ego* by Nicolas Poussin – the enigma of Poussin
and his connection with the secret that Louis XIV so ardently pursued.

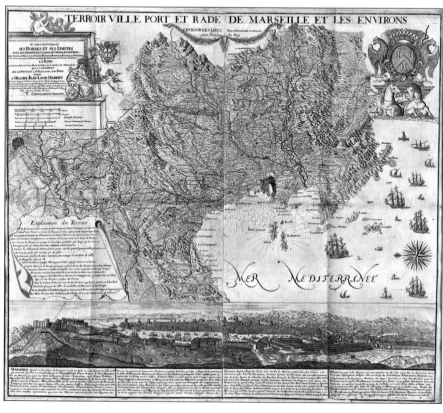

The engraved map. To see it online and enlarge it see www.bnf.fr
or google P. Chevallier de Soissons. (© Fiona McLaren)

and grandeur on an unprecedented scale, but for all this bravado it is nevertheless one which he balanced with a certain grace. He allowed his public to enter and marvel at the creations of their ruler by Divine Power, to be awestruck by his majesty.

It niggles doesn't it, the question, could the painting of the Madonna have been there? Possibly. A great deal was lost after the bloody French Revolution, and much was sold in a public sale which lasted a year. The legacy of the former royal household dispersed to the four corners of Europe, amongst it maybe even my painting. The chandeliers from which flickered 100,000 candles were snuffed out. Paintings in the royal collection which were not sold went to the Louvre, amongst those the *Mona Lisa*, which Leonardo had brought with him to the French court of Francis I.

It was a tragic end to a dynastic inheritance. For let it be remembered that Louis had been a keen art lover. During his reign he had added substantially to the 200 paintings in his charge and by the time of his death that number had increased to 2,000. His favourite ones he kept in his bedroom and amongst those was one of St John the Baptist by Caravaggio (where John is portrayed with a lamb beside him), and another of Mary Magdalene by Guido Reni (in both his paintings of her he has portrayed her with her hand on a skull with a cross beside it).

The Skull

To know more of Louis XIV it is interesting that these paintings of the Magdalene also tell a story, for they allude once again to the mysterious traditions involving sacred and venerated skulls. Back to the enigmatic skull. A skull which is also mysteriously camouflaged in the painting *The Ambassadors* by Hans Holbein, which depicts French exploration under Francis I! There is some controversy as to why the skull should be associated with both Mary and John and, after years working on this, I believe I have found an answer.

My view is that the skull must be taken as a universal symbol of the Godhead. In this case the skull symbolism therefore legitimately shares its sacred allusions, not to an individual, but to the Whole. The skulls which decorated the Celtic portals were representatives of their Godhead – a frame of sanctified bone possessing corporeal power, that is perhaps why the sides of the forehead are referred to as the temples. As reverence for skulls, whether of dear departed, royalty, warriors or

holy people, is universal, I would suggest the skull venerated here represents John the Baptist, Mary Magdalene and Jesus Christ in that they are all One with God and a focus to contemplation.

Another important aspect in all this is to stress that John the Baptist, also seen in Caravaggio's portrayal, is clearly meant to have the lamb at his side, implying without doubt that *he* was the 'sacrificial lamb', not Christ. It reaffirms what is depicted in my painting, where John is clearly portrayed in another dimension with the lamb looking up to him, within that shared dimension, clearly indicating that it was he who was the one who died and did so without hope of physical resurrection, attaining an ideal in that respect as he entered spirit. That by implication demonstrates that Jesus did not, for he was physically resurrected to fulfil his destiny of 'flesh becoming flesh'.

On this subject of John the Baptist there is an exciting comparison to make between Leonardo's *John the Baptist*, now known as *Bacchus*, and the infant John the Baptist in my painting. In both paintings he is portrayed with his reed cross undeniably pointing in the direction of an undermined tree – drawing the observer's attention to it in a most obvious way. Does this signify the sacred tree of knowledge – symbolising that it has been, and perhaps remains, perilously undermined? More than this, and again this is something I have only just discovered, in earlier chapters I mentioned the Priory of Sion, but a friend has just pointed out to me that Sion is Welsh for John. Is that the link, a connection with those who held allegiance to John as the Agnus Dei, the sacrifice, the one who died?

Poussin

But back to King Louis's art collection. As for the rest of Louis XIV's paintings, many of which came from the collection of King Francis I (again a link), they were displayed in his lavish private apartments and included amongst them were several inherited works by Poussin including *The Lady of the Columns*, and ultimately, *The Shepherds of Arcadia*. Yes, *The Shepherds of Arcadia* (better known as *Et in Arcadia ego*) which as we have seen was implicated in the Rennes-le-Château story.

This same Nicolas Poussin had been court painter to Louis's father, Louis XIII, and this connection with Poussin brings us to a very intriguing tale, one concerning the artist and Louis's Superintendent of Finances, Nicolas Fouquet.

Nicolas Fouquet's brother, Abbé Louis Fouquet, wrote from Rome in 1656 to tell him of an exciting encounter:

> Poussin and I have planned certain things that I will speak to you in detail about soon, and which will give you, through Mons. Poussin, advantages that kings would have great trouble in drawing from him, and that, after him, perhaps nobody in the centuries to come will ever recover; and what is more, this would be without great expense yet would turn a profit, and these things are so difficult to find that nothing on this Earth now could have a better, nor perhaps equal fortune.
>
> Quoted in Jean Robin's *Le Royaume du Graal*

This is where it gets interesting, for this channels us back to Rennes and the mystery there, a mystery which may tally with the same secret we came across earlier in reference to Mary of Guise and Sir William St Clair, and the letter which she sent him in 1546: 'Likewise that we shall be Leal and trew Maistres to him, his Counsill and Secret shewn to us we sall keep secret.'

The question in both events is what 'the secret' might be and whether they could be connected in some way. Could this relate to the Knights Templar, or to the hidden cache of the Cathars and ultimately to the royal bloodline?

Whatever was involved held great power and was held in the highest of esteem, and understandably Louis wanted to know what it was Poussin knew.

Frustratingly, Nicolas Fouquet refused to tell him and would ultimately pay the price. King Louis orchestrated a charge of corruption to be trumped up against him and had him imprisoned for life in the Bastille. Later, this wretched man was moved to the fortress of Pignerol, where the man in the Iron Mask was incarcerated in solitary confinement. In this respect, another interesting fact to consider is that, according to a broadsheet housed in the Bibliothèque Nationale de France, during the taking of the Bastille in the French Revolution of 1789, it was reported that a skeleton was found, still chained to the wall, with an iron mask next to him. An inscription beside the cadaver apparently claimed that his name was 'Fouquet'. There are also some who say that it was Louis's older illegitimate brother and others who say it was his twin. It's difficult, isn't it? Contemporary life is hard

enough to decipher, so what chance have we got when looking back?

Poussin was, of course, the artist who was famously implicated in the enigmatic mystery of Rennes-le-Château and the painting of *Arcadia*, and that is the link to the Pyrenees and Mary's route through them. No wonder Louis was so exasperated at not being told what Fouquet knew, it must surely have had something to do with his birthright.

Et in Arcadia ego

Jonathan Black in his excellent investigative work *The Secret History of the World* postulates that what the shepherd (Poussin) is pointing to in the painting is the tomb of Mary Magdalene. The incarnation of the goddess redeemed by her beloved. It is worth wondering too whether this tomb was actually in existence when Poussin painted it, with those words inscribed.

What I am certain of is that it confirms something I do believe, that Mary Magdalene travelled there and that just as Leonardo knew, so too did Poussin.

Whether Louis XIV got his hands on the secret we will never know. What we do know however is that the map which he commissioned, which follows this chapter, conceals some enticing hidden meanings. Codes to secret locations which undoubtedly have to do with some kind of treasure.

After Nicolas Poussin's death, Louis XIV made concerted efforts and acquired a mass of his paintings in what can only have been a desperate attempt to discover his secret. Even more mysteriously, why did Fouquet never reveal the secret to him? What was so important that it was worth life imprisonment?

The fact remains that the king had to make a rigorous effort to acquire Poussin's most important work, *Et in Arcadia ego*, and it seems that when he finally got hold of it, he did not put it on public display, choosing instead to keep it in his private quarters and let no one view it without his express permission. There is even a rumour that he in some way tampered with it and that he had the tomb it portrayed destroyed.

Not surprisingly in this context, René d'Anjou also had an involvement with *Et in Arcadia ego* (or *The Shepherds of Arcadia*). In 1449, nearly 100 years before Poussin, he staged a curious type of theatre called *Pas de la Bergère*, or 'Passage of arms of the Shepherdess'. The spectacle was a fusion of Arcadian philosophy, the Round Table and the holy grail

romance, and it would seem that the theme of *Pas de la Bergère* of René d'Anjou is continued in the paintings of Guercino and Poussin.

The paintings bearing the inscription 'Et in Arcadia ego' obviously contain an 'underground stream' of esoteric knowledge and symbolism which embraces an occult tradition in Gnostic and hermetic philosophy – 'And even I am in Arcadia.'

As mentioned earlier, some interpretations suggest that it could possibly be an anagram in Latin – *I! Tego arcane Dei* – which translates as 'Begone! I keep the Secret of God.' Both uses by Poussin had been preceded by that of an earlier painting by Giovanni Francesco Guercino, dating from 1618. In this there features a chilling image of a skull with a mouse beside it and a bee (or bore hole) in its temple. The Godhead under threat? Apparently this seemingly unambiguous phrase 'Et in Arcadia ego' would appear to have been a code of some kind. As a place signifying the ideal the concept of 'Arcadia' seems to have been implicit as a hermetic principle, symbolising the quest for a new world based on cosmic principles of divine order. And of a rebirth of a world which mirrored one that had once existed in antiquity, namely the 'Golden Age' of which the ancients spoke. The origin of the word 'hermetic' stems from the name Hermes and relates to a stone pillar used to communicate with the deities, and yet again we are told their philosophy was neo-Platonic and Gnostic in its beliefs.

At Shugborough Hall in England there is a continuance of this theme, as the phrase 'Et in Arcadia ego' appears on a piece of stone garden sculpture. What is perplexing here though is that the shepherd points at a different letter from that in the painting, and an extra sarcophagus is present. Could that be Christ's? To translate all this is nigh impossible, as interpretations are open to misunderstandings. What I find is that it is helpful to stand back and see what the bulk of information throws up and whether it makes sense. But what makes sense to me may obviously not make sense to you. We need to combine our artillery of musings to see what hits the right spot.

Intriguingly, in the context of this connection, Nicolas Fouquet was also a member of a secret society called La Compagnie du Saint-Sacrement (Company of the Blessed Sacrament) whose headquarters were in St Sulpice. Many have alluded to this being an organisation also called the Priory of Sion, of which René d'Anjou was at one time Grand Master, and so too Leonardo da Vinci. This organisation was known for performing great deeds for the ill and infirm and also as

being guardians of an awesome secret. Strangely I sense that secret may also be one that we are on the trail of, a secret though which is not necessarily of material gain.

The priest Saunière of Rennes-le-Château fame also made the gruelling journey north to visit St Sulpice and, as we know, whilst there he spent some of his time viewing Poussin's painting.

What did they know that we don't? What was of such extraordinary merit that it has been kept from us?

The line of this intrigue continues because King Francis I also has an involvement with St Sulpice. He saw fit to commission two enormous scallop shell sculptures to be placed either side of the grand entrance to it – shells that we know symbolise the Sacred Feminine. Metaphorically, the hinges of those shells remain tight shut, yet in the right conditions they open and there we can almost catch a glimpse of the truth. Clear waters run deep even though there are those who seek to muddy them.

Ancient Connections

Let's now concentrate on the famous portrait of Louis XIV by Hyacinthe Rigaud. Without question it certainly alludes to that divine truth that King Louis manifestly wanted to promote. Ingeniously, to that end he has given us abundant clues and you can almost feel him prompting us, nudging us to look this way, now that. He even looks a little smug!

The first thing to note is how he poses before us posturing in gartered silk stockings and draped in the finest velvet and ermine. Hanging magnificently around his shoulders is his precious gold necklace of decorated fleurs-de-lys and the Maltese cross; within that cross is a dove, which represented Louis's own Order, that of the Order of Saint Louis, the holy messenger, the feminine sacred dove, and also the messenger of Noah. Flowing about him in a sea of blue and gold is his extravagant ermine cape lavishly decorated in fleurs-de-lys. In Masonic realms blue and gold represent a wedding robe of the spirit – and more mundanely a sign of rank and glory.

Strikingly evident are the emblems of the fleur-de-lys everywhere, sumptuously embroidered on his clothes, the curtains, the carpet, the chair.

It signifies all that he believes in: that he is indeed a direct descendant of the divine line of rulers; the incarnation of ancient truths, of ancient wonders, and consequently of his own divinity and right to rule. What

a man he is, how humbled we are to gaze upon him, can you sense the awe he wishes to inspire in us? Possibly not, but of no matter to him, the invincible, almost lovable King Louis.

In his hand he holds a sceptre, one of the most enduring symbols of the power of royalty and the deities, and yet again we find it is decorated with the emblem of the royal bloodline, the fleur-de-lys. Have no doubt, the fleur-de-lys is everything in this, as it is in the painting, it says it all, but only to those who have ears to hear!

Then look, to his left, lurking in the shadows behind him, barely discernible, is a classical column. In a master stroke, just as the ancients incorporated images and hieroglyphic symbols in stone so that their story would not be lost, so too does Louis XIV. You can just make out a woman holding a balance (or scales) and sword, who bears a faint resemblance to Lady Justice, and on the left panel a man making off with a column. This signifies that the thieves of truth would seek to conceal it. Or that Louis doesn't want us to ever discover what it says, a secret to be kept hidden out of sight of prying eyes. I sense he is toying with us, telling us everything without saying a word.

Look now, on the richly covered stool at his side beside the royal crown (decorated as one would expect with the fleur-de-lys) lies yet another sceptre. But this time with a hand at its apex fashioned with two fingers extended, two held down. Then there is the luscious, extravagantly tasselled silk curtain draped around him.

It is a splendid portrait of an extraordinary man.

Yet it is even more than that. It's one of the most blatant visual oratories of the symbolic library of Masonic beliefs. On examination, the sign language in this is a proclamation of Louis's secret allegiance to Freemasonry.

Why secret? Well it would not be long before the Roman Church was to take up arms against Masonry officially. Their eyes were always on the lookout for adversaries, their ears alert for words of dissent from their dogma. Even to this day it holds true that Freemasons are not welcomed in the Catholic faith. Remember, the Cathars were gone, so too the Knights Templar, and the Culdees were all but forgotten, but Rome knew they still had their enemies and that the Freemasons were from the same branch of that shared tree.

Louis's instinct was proved right for in 1738, just 15 years or so after his death, Pope Clement XII issued a Bull of Excommunication; it consigned a Mason to hell in the future and ostracised him from the

Church, his family and his property here and now. The *modus operandi* of arrests, tortures, penalties, etc., was left to local tribunals, but the Cardinal Secretary of State published in 1739 a model for these tribunals to use which pronounced 'irresistible pain of death, not only on all members but on all who should tempt others to join the Order, or should rent a house to it or favour it in any way'.

Yet again another age was set to bear witness to the ravages of a monstrous Inquisition. This one though was to provide a model for others to follow, for even the policies of secret police from the czars to the Fascists, Nazis and Lebanese Phalangists were patterned on it. Heinrich Himmler and his staff made a detailed study over a period of years of the methods used by the Inquisition and incorporated them into their own devil's work. How shameful that the Church delivered up such a means of torment to the world.

What makes it even worse is that yet again this heinous machine of the Inquisition was directed against men accused of simply questioning the Church, of, as they would put it, heresy. It was to prove an exceptionally flexible term, because perversely the Inquisition could decide for itself, and on the spot, what it meant by heresy. I was struck by a horrible phrase that was once applied to this which sends a shiver down my spine; those arrested were 'put to the question', a seemingly benign term which cloaked the torturous ordeals that were served up to punish them for the heresy of questioning what they, the Church, ordained as truth. As a result thousands of the men and women destroyed by it were of irreproachable reputation and character and not even the Inquisition could accuse them as criminals. Horrifically it is something I am only too well aware could be levelled at me; that is however one of my strongest validations for writing this. Would I do it if I were not convinced that it were true? Should I be condemned for merely questioning what the Church dictates? Hardly surprising that so many have subscribed to teachings rather than question them.

Surely if one body is telling the truth, questions are invited. What speaker at the podium who does not invite questions can be taken seriously? Are we to surmise that their points are therefore so dubious that they cannot bear investigation? Do they not applaud personal endeavour on the path to enlightenment? Why is it wrong to question? Why should we submit to dogma? If someone pleas the right to remain silent or 'take the fifth' doesn't it make us suspicious of their intent?

The callous presumption on which the Inquisition operated was

that it should search out heretics and make them confess, and the penalty would then be sanctioned by the confession; but if a man refused to confess or had nothing to confess, torture was used to reduce him to a state where out of agony or when out of his mind he became willing to confess to just about anything.

That repeatedly causes a shadow to stalk my soul for obviously in that context I too am a heretic. Just think of it; if I had dared to write this book in an earlier century I too would have been deemed a heretic and been 'put to the question' and just as others before me have done, I would have had to resort to cloaking this truth in fiction. It takes courage to stand up and question; I barely have it in me as I dodge confrontation, but what is scored in my spirit is that, as Edmund Burke said, 'all it takes for evil to prosper is for good men to do nothing'. I may not be right on all that I put before you, even though I think I am, but I can only judge what is right and true and then act in good grace on that judgement. That is why one of the main tasks of this book is to engender the need to question, and to take responsibility of knowledge.

Back to the heinous instrumentation that was structured to prevent just such lines of inquiry as I have been following. The Inquisition was not given exclusive jurisdiction over men accused of Masonry, for the regular Church and civil courts also continued to have jurisdiction over other matters which concerned the Masons. However, their prime objective was the rooting out of clandestine brotherhoods. The Inquisition was especially held responsible for what in later years Adolf Hitler, in some ways a spiritual descendant of the Inquisition, was to describe as 'the liquidation of Freemasons'.

His basis came from historic record which cited that in 1751 Benedict XIV confirmed and renewed the edict of Clement XII against Freemasonry. It was little wonder, given the circumstances, that initiates into the brotherhood continued to resort to clandestine methods to safeguard themselves and their deeply held beliefs. But why would they risk so much if what they knew wasn't precious? More than this, why have so many members of the higher echelons of our society, and indeed global society, even our royalty, given their allegiance to it? It must offer some truth that forms the soul that feeds the body of the brotherhood.

How does the saying go? Knowledge is power. In this case evidently so. Of course, King Louis XIV would have been well aware of the

undercurrent which was gathering ferocity and that even he was not immune from the wrath of the papacy. It is for that reason that he had his own portrait cloaked in covert symbolism to enable him to communicate his position as an initiate of the knowledge. To his credit this did demand courage and his stage management of the portrait is a masterly one; or possibly not, maybe he believed in his divinity and that he was invincible. Could he have been thumbing his nose at the clergy? Nice thought.

Behind him in the portrait, as previously pointed out, are some intriguingly decorated pillars. They are massive in scale and bear a story of their own in their depiction, for pillars hold an important position in Masonic lore and in esoteric hermetic thought.

That is because pillars were regarded as the supporters of the Earth, and were adopted as a symbol of strength and firmness. They are one of the most common symbols of Freemasonry and usually depicted as a pair, two columns derived from Solomon's temple that support celestial and terrestrial spheres. The two are known as Joachim and Boaz and signified the entrance to the Temple Lodge, not only as a memory of the temple of Jerusalem but also as a reminder of the seeking, finding and keeping of lost wisdom.

So what do the depictions in stone communicate in the context of Louis's portrait? The maiden holding a pair of scales from Masonic doctrine is a biblical reference and is also seen in Egyptian texts, but to the Masons it is a most important symbol which symbolises a strict observation of justice and integrity: 'Let me be weighed in an even balance, that God may know mine integrity,' said Job, and Solomon says that 'a false balance is abomination to the Lord, but a just weight is His delight'.

The sword resting in her lap is a representation of personal honour and justice.

Next of interest is the sceptred hand which rests upon the exotically furnished cushion. In Freemasonry, the hand as a symbol holds a high place, because it is the principal seat of the sense of touch so necessary to and highly revered by Freemasons. The same symbol is found in the most ancient religions, and some of their analogies to Masonic symbolism are peculiar. Thus, the author Horapollo says that among the Egyptians the hand was the symbol of a builder, or one fond of building, because all labour proceeds from the hand. In many of the ancient mysteries the hand, especially the left hand, was deemed the

234

symbol of equity. Now that makes me think once again of the 'devil's hand', the name the Roman Catholics give to a dominant left hand. In Christian art a hand is the indication of a holy person or thing and in early medieval art the Supreme Being was always represented by a hand extended from a cloud, and generally in the act of benediction.

The form of this act of benediction, as adopted by the Roman Church, seems to have been borrowed from the symbols of the Phrygian and Eleusinian priests or hierophants, who used it in their mystical processions. In the benediction referred to, as given in the Roman Church, the thumb, index and middle fingers are extended, and the two others bent against the palm as in the illustration. The Church explains this position of the extended thumb and two fingers as representing the Trinity; but the older symbol of the pagan priests, which was precisely the same, must have had an altogether different meaning, one which aligns more closely with that of the Mithraic mysteries in which it was, as I understand it, symbolic of the light emanating not from the sun, but from the creator as a special manifestation. This divination by the hand is an art founded upon the notion that the human hand has some reference to the decrees of the supreme power peculiar to it above all other parts of the body of man, man being the microcosm of the whole. Complicated yet simple. It is for all of those reasons that the hand is so important to the Freemasons as the symbol of that mystical intelligence by which one Freemason knows another in the dark as well as the light.

The 'magical finger rituals', which we all now think of as the so-called 'Masonic handshakes', are a quite recent example of an entire spectrum of 'finger magic', most of which is now lost.

Back to Louis in all his sartorial elegance. Louis's garters of course refer to the other prestigious Order, the Order of the Garter, of which I have already spoken in previous chapters. For me all that is left to discuss are the heavy, luscious corded tassles which hang from the thick silk curtains for they, once again, have a strong Masonic association and are also of significance in Leonardo's *The Last Supper* for the same reasons.

The first degree tracing boards were created as visual aids to illustrate the meanings and principles of Freemasonry as taught within the degrees. Demonstrating how yet again everything is conveyed by signs and symbols in a universal language, signs which transcend the dogma of speech. In the English and French tracing boards of the first degree

there are four tassels, one at each angle, which are attached to a cord that surrounds a tracing-board, and which constitutes the true tessellated border. These four cords are described as referring to the four principal points, the Guttural (throat), Pectoral (breast), Manual (hands) and Pedal (feet), and through them to the four cardinal virtues, Temperance, Fortitude, Prudence and Justice; rather similar to the Buddist or Hindu chakras on the body. Their symbolism was of great importance:

> Speak unto the children of Israel, and bid them that they make them fringes in the borders of their garments, throughout their generations, and that they put upon the fringe of the borders a riband of blue: That ye may remember, and do all my commandments, and be holy unto your God.
>
> Numbers 15:38–40

If you think back these tassels can also be seen on the cloth which covers the table of *The Last Supper* by Leonardo da Vinci.

Masons assert that they were there at the very beginning of time and were the most prestigious order of godly men – brothers in the fraternity proud of their positions and all part of the same family tree. I would concur with this and feel that this portrait informs us that Louis XIV too was involved in that brotherhood. In respect to this there is further evidence to support this. It ties in again in a loop with Scotland.

The Jacobites

Louis had a strong alliance with the Scots and wholeheartedly supported the Jacobite cause of returning a Stuart to the throne. There were two reasons for this – not only were they related and shared a divine bloodline, but they were both Masons bound by their shared sacred knowledge.

The very name 'Jacobite' is derived from the name James (II of England) and according to the *Oxford English Dictionary* gives reference to the Israelite descendants of Jacob. There may be a double meaning in the name, linking back to the claims alluded to in the Declaration of Arbroath and referring to a bloodline which at this stage in our story had estuaries throughout the world. The spring of the Culdee monks had seeped into the fabric of our nations and has a contemporary name: Freemasons.

Louis XIV stood by James II through thick and thin and proved this

when hearing that James was on the point of death by travelling to St Germain and declaring to him:

> I come to tell your Majesty that, whenever it shall please God to take you from us, I will be to your son what I have been to you, and will acknowledge him as king of England, Scotland and Ireland.

Louis XIV died on 1 September 1715 and, lamentably for the Scots, the French played no part in the rising which took place in the autumn of that year. Louis, the flamboyant Sun King, had been the best friend the Jacobites had ever had, and on his death the golden age of French involvement with the Jacobites ended.

It would not be until 1743, 28 long years later, that France once again wholeheartedly embraced a scheme for the military restoration of the Stuarts.

It is clear then that the personal attitude of Louis XIV towards the Jacobites was not without significance. There can be no doubt of the Sun King's affection for the Stuarts, which was a direct consequence of Louis's conviction that James was, like himself, one of God's anointed and indeed of his own blood, as cousin to him. In recognition of those blood ties he allowed him to wear the fleur-de-lys on his coat of arms and raised no objection when James insisted on retaining his title of Defender of the Faith. In doing this he confirmed his knowledge of the true heritage of the Scots and the bloodline that the Culdees had bestowed upon them.

Madame de Sévigné, a renowned writer and member of seventeenth-century French society, remarked:

> The king's magnanimous soul enjoys playing the grand role. What could be more in keeping with the image of the Almighty than standing by a king who has been expelled, betrayed and abandoned like this one?

There is no question but that the Jacobites had a crucial influence on the further development of Freemasonry in France. They lit the touchpaper which fired a blazing trail to Pope Clement XII and his infamous edict against them.

In this perspective, it should be noted here that the young Prince

Charles Edward Stuart, Bonnie Prince Charlie, was educated by Chevalier Ramsay, who was a Freemason and a Knight of St Lazarus, at the instigation of James III. Lazarus you remember having landed in Provence with the other Judean refugees and who preached in Marseilles. Prince Charles Edward was not only 'Substitute Grand Master of the Chapter of Heredom', otherwise Chapter of the Knights of the Eagle and Pelican, but was also Grand Master of the Temple. The measured pulse of Masonic credentials continued to beat strong. Reflect back to the definition of Heredom: heirs to.

In the reflected light from that flare we can catch the glimpse of the unmistakable face of Louis XIV, the Freemason whose whole bearing testifies to his allegiance, as do his leanings to the ancients and the gods.

Napoleon

Napoleon tried desperately to be part of the divine bloodline, which had by now merited a name: the Merovingian line.

This is the man who famously followed his own star and of whom Goethe (a Freemason) said:

> The daemon ought to lead us every day and tell us what we ought to do on every occasion. But the good spirit leaves us in the lurch, and we grope about in the dark. Napoleon was the man! Always illuminated, always clear and decided and endowed at every hour with energy enough to carry out whatever he considered necessary. His life was the stride of a demi-god, from battle to battle, and from victory to victory. It might be said he was in a state of continual illumination. In later years this illumination appears to have forsaken him, as well as his fortune and his good star.

That is a sad indictment of the man. His good star hadn't forsaken him, his ego just got in the way.

I must say, I have looked in depth at this Merovingian bloodline. The Culdees, as we know, were strongly associated with the bloodline of Christ. They were, after all, bound to the family of Christ, and St Columba in his turn has long been connected to the Merovingian line. However I feel this story was almost fabricated by monarchs to attach themselves to that line. It started with Clovis, a Frankish king who in AD 466 declared Christianity to have been brought to the Franks by

monks (Culdees, I would submit) and that he was, presumably, part of that royal bloodline descended from King David. In view of that, the Merovingian culture was thoroughly imbued with Christianity. It is a tradition of noble families to have a son stationed in the Church which has survived until quite recently. They established powerbases in institutions that had influence over the population – not just the Church, but also the army, government and on the land.

I feel now at this stage in history we should submit the idea of a divine royal bloodline to the back rooms of our belief systems. This bloodline that every ruler wanted to be part of is by now an ocean. Just think of it: if Jesus and Mary had children, what would their family tree look like today? It would be a vast forest with millions of people on those trees! That was the point after all, wasn't it? To people the Earth. It was never meant to be the sole domain of a super-elect who would hold sway over the masses. No, the goal was much more ambitious and it was to that end of peopling the Earth with their bloodline that Christ and Mary had children. For me, the Merovingian line now became almost a false construct, manipulated for a select few who wished to see it as their birthright and a right to divine rule, with power over the general populace. The real goal was to give power *to* the people. The Freemasons and other bodies associated with safeguarding and transmitting the true word have indeed sought to protect this bloodline, but by ringfencing an elite, they are safeguarding the truth of a bloodline and DNA which has by now structured the world.

Even so, and in testimony to the power that link with a perceived Merovingian royal bloodline held, Napoleon craved that royal status. He should have known better. Yet it was Napoleon who commissioned the catalogue of Egyptian antiquities, *Description de l'Égypte*. It is dedicated to Napoleon le Grand, who chose to be initiated into the brotherhood of Freemasons in the Great Pyramid, a spot at the centre of the Earth's longest land contact meridian correlating to three of the stars of Orion's Belt, the constellation whose ancient name in Egypt was the Tree of Life.

Following in the footsteps of Louis XIV he was portrayed on the front of the catalogue as Sol Invictus, the Sun God! And it was Napoleon who with such passion employed a team of scholars to reach the conclusion that Isis was the ancient goddess of Paris and that she and her star should be part of the coat of arms for Paris. Prior to this it had been held that Mary Magdalene was the goddess of Paris, yet to

many they are both just two of the representations of the Sacred Feminine. Indeed, some say it was Napoleon who had the beautiful Eglise de la Madeleine built.

In another grand gesture, on the Arc de Triomphe he had his empress, Joséphine, portrayed kneeling at his feet carrying the laurel of Isis, he egotistically therefore being Osiris. So much in pursuit of power!

Intriguingly, Napoleon claimed the *Mona Lisa* from the Louvre and subsequently hung it over his bed. It then returned to the Louvre after his exile in 1815. As we have seen, he too adhered to Celtic lore (carrying Ossian poetry into battle with him), just as Louis XIV had before him.

The French Revolution, which many believe was orchestrated by the Freemasons, had rid France of their royalty but not of the brotherhood. That artery still pumped strongly, oxygenating the body of cosmic thought, and Napoleon was the epitome of that.

On the note of the Revolution, it is most probably fair to say that there were Masons on both sides, however in its context it is interesting to see that the French Freemasons in 1877 included in their list of ideals and self-definition that 'Its device is Liberty, Equality, Fraternity' and erased God from their remit.

Intrigue was ever thus!

Horticultural Masonic Design
Before we leave this section on Louis XIV, let's look at another way in which he and others like him demonstrated their allegiance to Masonic thought. In fact, still do.

In horticulture.

The landscaped formal garden of the early eighteenth century dovetails beautifully with the diffusion of Freemasonry, the geometric designs and the classic features reinforce the owner's association with antiquity and sacred knowledge. It is, if you like, an astral illustration to Masonic belief that God is the 'Great Architect of the Universe'.

The lines and shapes of the ornate garden represent a philosophical symbolism and are an expression of the Masonic ideals of the garden's owner. As grand gestures to this obelisks were erected. On one, which featured in the Place Royal in Provence, Louis XIV had placed a golden sun.

Obelisks in Masonic symbolism were associated with the sun and

mythologised astronomical phenomena. They were symbols of continuity, power, stability, resurrection, fertility and immortality, and dated from the time of the ancients.

Contextually therefore in the perspective of Louis's portrait, his relationship with James and his title of the Sun King, we can unreservedly link him with Masonic thought and practice.

On the back of this knowledge come more tantalising goals which take us back to Poussin. King Louis XIV was on the trail of something, as attested by his passion for Poussin's intrigue. It was evidently something of great importance and to this end he commissioned a map. It is fitting that I should conclude this book with the tangibility of an actual map, for we have been following a symbolic virtual one as we have travelled the road of pilgrimage in these last chapters.

We go now with a freer mind set. I hope you have now been released from dogma and can freely question what our lives and world mean. Even if we ask the wrong questions, or get the wrong answers, we will eventually shake the truth out of the layers of intrigue which have cloaked it and no longer remain captives of a police state of the mind.

We are free to question . . .

It is where this story ends and we go there next.

NINE

Return to Provence

We may be in the Universe as dogs and cats are in our libraries, seeing the books and hearing the conversations, but having no inkling of the meaning of it all.

William James, *A Pluralistic Universe*

Now we come back full circle, to the white limestone hills of Provence and the story of the enigmatic Mary Magdalene. It is where this tale began and where, for now, it ends. All the pieces of the puzzle that were destined for me to piece together have, I believe, fallen into place, save this last one – a puzzle in itself, an engraved map. It is a map to end all maps of discovery and a fitting end to this exploration of our shared past.

I believe this beautiful work of cartographic art depicts enigmatic clues and destinations and is, in itself, a mystery still open to interpretation. The reason for that is that I am sure there is more which lies hidden in its topography than I have found. It's an exciting note upon which to end for I think this map could involve us all in a shared quest for whatever this final trumpet call of symbolism inspires in us. Let's combine forces, good ones of course, to see where it can take us.

I have always loved this map, though never understanding quite why, and it has metaphorically tapped me on the shoulder for the last 50 years. Each time I looked at it more closely than the time before, but its essence frustratingly eluded me. I suppose that is why I used to tuck it away, in books mainly. Then, sometimes months, sometimes years later I would think of it again and have to find it. I remember many panicky occasions when I couldn't remember where I had put it and then the overwhelming relief when it would turn up again. Then

242

with great care I would hide it away again, safe and sound awaiting the day when we should finally come to terms with each other. It has never let me down and will probably keep my attention for the rest of my life, offering goals, imaginings and leaps over chasms of time.

So what is this map meant to convey to us, or actually not to us, but its intended recipient. For this map was never designed to enter the public domain. Intrigued? You should be.

Let me explain.

Despite my many initial doubts and rigorous questioning I now believe it is to all intents and purposes a map to the holy grail and a further link in the chain of which Poussin was a part, Otto Rahn too and now us. It speaks of secrets and possible treasure, encompassing both to equal a truth. For truth is power.

Truth is power. What a wonderful concept that is, especially when we are surrounded by lies which stifle our growth and keep us in the dark. Let's see what light we can shed on it.

Let's start at the basics. This large map measures approx 30 × 26 inches and is titled 'Terroir Ville Port et Rade de Marseille et les Environs' which basically means the suburbs (what an awful come-down of a word that is) of Marseilles, or the hinterland (much better word). It also conveys to us the basic commercial profile of the area and at its base where there is a staggering engraving of the city itself there is further commentary on the history of Marseilles. I think what is written as such is just what it says on the can, and doesn't hold any clues. I may be wrong.

If you have access to the Internet you can see it online at www.bnf. fr, which will make this much clearer. I think what will strike you as it did me as a child and still does is that it is packed full of intrigue, writing, pictures and detail. It is more complex than a painting. A map combines more, to allow you travel in it, that is its point, to tell you where to go and how to get there, turn left, right or go straight ahead, what signs to look for to take you there. The ambiguity of the thing is supremely tantalising for it demands more than a painting since it is not purely decorative, it is, what is the word, challenging. There is terrain here to cover and we are being invited in to explore it. Though actually that is not the case, we are the last people this was destined for, this was a royal commission by King Louis XIV – a government document.

It was commissioned in the 1690s by King Louis XIV of P. Chevallier

de Soissons for Jean Louis Habert, who as 'intendant' was responsible for supervising finance, police and justice in the Marseilles area, and maps for him the area surrounding Marseilles. It includes the offices and brigades of the *fermiers généraux* (tax collectors), the former to be marked by the fleur-de-lys, the latter by a letter B. In larger print it documents that it also marks out the positions of the battery of canons etc. pointing out to sea in defence of the coastline. The key I think is just that, the key to the mystery of this exquisite thing. We'll look at that in more detail in a moment.

So first things first, who were these people? King Louis, of course, we have encountered but what of the others? Immersion into the period gave me the profiles of the beneficiary Jean Louis Habert, who was apparently Count Mesnil of the prestigious Montmor family and who was the commander of the garrison of ships and finances in Marseilles. He was also a member of the parliament in Aix so evidently wielded much power and influence. A financier of King Louis XIV would have held, much as today, the most powerful seat in his ministry, similar to the Chancellor of the Exchequer today. It was not so easy to find out more of P. Chevallier de Soissons, the cartographer. I'll get back to him shortly. For now let's look at the fundamentals of the map.

To the right of the dedication is the town heraldry of Marseilles. You will see this boasts a large scallop shell at its apex and a cross at its centre, in my view relating either to the Knights Templar or to Christ. From all that has gone before, we now know the significance of that scallop shell. There is also a rather impish face at the base, almost a joker. Initially I dismissed any relevance to this but I'm glad I revisited it because the joker linked me back to what I knew of the importance of the tarot, for he is the fool who always wins; his legacy comes from:

> The Lord knoweth the thoughts of the wise,
> That they are vain. Therefore let no man glory in men.
> 1 Corinthians 3:20–21

> We are fools for Christ's sake
>
> 1 Corinthians 4:10

This brought me back to thinking about my quaichs and their symbolism of the holy grail, for as you will recall four of them are *tastevins*, the French equivalent, which have the tarot trump cards

engraved on them. We have covered this ground before, which makes me feel more sure-footed. One of those *tastevins* portrays a man holding up a card which represents the heart and he carries a staff bearing the fleur-de-lys, another is of a king displaying the diamond, the third bears the club and the fourth bears a spade. The handles of two are scallop shells while those of the other two are serpents. They had always struck me as strange, so, though it seemed a slight deviation backwards on my road, I felt that I had to re-check if the tarot are important to our story – and it seems they are, for they are yet another clandestine tool in delivering the grail message.

Yet again we have a grail message and it is worth reflecting back on the vehicle of the tarot to transmit it. Margaret Starbird, the author of many books about Mary Magdalene, puts forward a theory of tarot cards and the holy grail which she bases on historical evidence, that the original trumps of the Grigonneur tarot deck were a 'visual catechism'. That is, a tool for communicating the message and preserving the traditions of the Church of the Holy Grail, at a time when the overt activities of their faith were suppressed as heresy by the Catholic Inquisition. According to Starbird, the grailists believed that 'Jesus was married, that his wife and child found political refuge in Gaul, and that his bloodline, the *sang real* of the royal house of David, survived in Europe'.

Her belief is that the tarot is tied to the tenet of the Albigensian heresy, spreading the word of God. Isn't it a comfort to see how this weaves through and interconnects with everything that has gone before? It is for me anyway because, when I have repeatedly questioned my discoveries, the thing that ballasts me is that one affirms then reaffirms the other. This is not me making up a story, it is merely me following the thread of its weave and then interpreting the picture. In that context then, it would follow that the joker on the map could be symbolising that the secret is known.

As we have already witnessed, according to Starbird and others, the four suits were originally swords, cups, pentacles and batons which were later redefined to spades, hearts, diamonds and clubs, the heart symbolising the chalice of the holy grail and the club the sprouting rod of Jesse, the undermined tree in our painting. By pure chance this links in with something else I had seen during my investigations: in an amazing understated church at Grandtully in Perthshire I found a connection to this tarot theme taken one step further. St Mary's

Church was built in 1636 and is more like an old bothy or outbuilding than a church. Unless you know it is there you would miss it, for it is tucked up a dirt track beside farm buildings. You almost have a sense that you shouldn't bother to make the detour it seems so unreal, but make it, for it is well worth a visit. Whoever took the time to illustrate this devotional scene was committed to telling and recording what they knew. Come with me: it's raining outside, you park, walk up by a field, challenged by curious cows, to a small building. On entering this little building, almost a byre, you fumble for a light switch. Even now you feel rather foolish. But then illumination, and mystery, for you are overwhelmed by murals.

The central feature is the Judgement tarot symbol, and the figures which are depicted between the heraldic designs are intriguing, one possibly depicting a grail knight, holding a chalice and a stone, and another St John holding a book, possibly his book. There is the sun, there the moon. Too much, and it leaves you feeling that there is so much you don't know. So much you just have never been told. Then you reflect back on the Church at Amulree (mentioned in a previous chapter), where a monk is shown carrying the scallop shell as he pays homage to Grace. Then you make the leap to another interesting stained-glass window in Glen Lyon, of St Andrew, with two Templar crosses at its base. Then there is Mull, and a pregnant Mary Magdalene, and of course Rosslyn with Christ in a tartan bonnet. Scotland is shouting out from all quarters that it knows something, but can't speak it out loud.

You even get it in the objects which define Mary: the kilt, Egyptian; her wonderful scriptural books, Egyptian. The shepherd's crook, Egyptian. There will be more, but I haven't spotted them yet.

Then of course, we have made the connection between France and Scotland with King Louis and Prince Charles, and of the route of the Judean refugees. The question now is: what does the map add to our orientation and knowledge?

For this we have to study the minutiae, and I would appreciate any help you can offer in this.

What I have discovered is that the coat of arms of Marseilles is not a standard one and has, I believe, been modified in compliance with the essence of the map. The large coat of arms to the right with what look like three H's and an upside-down V is that of the Count of Mesnil, one of the titles held by Habert. He assumed his titles and responsibilities

for Marseilles around 1688, which makes it likely that the map was drawn between 1688 and 1694. Jean Louis was a formal counsellor to the French crown, which might have put him in the same court circle as that of P. Chevallier de Soissons, the author of this map, whom I latterly discovered was of the Bourbon-Condé family who were cousins to the king. Fascinatingly, the coat of arms of the Bourbon-Condé family is the fleur-de-lys. This was a man King Louis could trust, for he was related to the royal line.

The consensus amongst cartographers and antique map dealers I have contacted is that this map is a rarity, for no information exists of its ever appearing at auction, nor in specialist books. It's exceptional too as it is a separately issued broadsheet map, printed on two sheets joined with an exquisite engraving at its base by L. Brémond. He was a Marseilles map and chart maker best known for his series of charts of the Mediterranean and its islands. I do now know that other than mine there are possibly only three other originals of this map, one in the British Museum, another in the Bibliothèque Nationale in Paris and yet another in the municipal archives in Marseilles. This latter one is part of the D'Anville Collection, which adds to the pedigree and stabling of my map because Jean Baptiste Bourguignon d'Anville, born in Paris in 1697, was arguably the greatest geographical author of the eighteenth century. For a copy of this map to be in his collection underlines its trophy status and its significance in the history of cartography. But yet nobody at the Bibliothèque Nationale de France nor the British Museum could tell me anything about it. They didn't even know the date it was drawn up. Accordingly, this map has been inordinately hard to research and has taken me all over the United Kingdom, to France and even to the USA for information.

It was in America that I learned the most and I owe a debt of gratitude to the Senior Reference Librarian at the Library of Congress in Washington, who was most helpful but wrote to me: 'Furthermore, a search of various biographical dictionaries, bibliographies, encyclopedias and other reference sources at hand has failed to identify any certain information about P. Chevallier de Soissons.'

It would seem apparent from the fact that there were so few copies that the map was intended only for the eyes of the king, the cartographer and Jean Louis Habert. Obvious really, when you transpose the time to this. Would the king commission a map for his chancellor with any other intent than that it was for him alone? For whatever reason that

might be. In this case it will become all too clear why.

Finally, after a great deal of trawling, my thanks go to Dr Marguerite Ragnow, curator of the James Ford Bell Library at the University of Minnesota, to whom I am most indebted, for it was she who told me who the elusive P. Chevallier de Soissons was:

> . . . most likely Louis-Henri de Bourbon-Condé, known as the Chevallier de Soissons. Born *c.* 1640 died 1703. He was the illegitimate son of Louis de Bourbon-Condé, Count of Soissons (1604–1641). Louis-Henri entered the priesthood and became the Abbot of the Benedictine Abbey of La Couture, a foundation closely tied to the House of Bourbon. However, circa 1694, he left the priesthood and married. Given the initial P before his name I suspect that he undertook this project while still a priest and thus the P stands for Père, or Father. That means that the map was initially drawn prior to 1694. At about that time he married and claimed the titles of Count of Noyes, Prince of Neufchâtel, Count of Dunois, and others.
>
> . . . Congratulations on owning such an interesting piece of history!
>
> Marguerite Ragnow, letter to the author

So he died in 1703: interesting, as this was not all that long after the completion of the map. And we have a date: pre-1694.

Now, finally I had something to go on. This was sounding more exciting, because why get an abbot to draw you a map, why not your usual court cartographer?

The Abbey La Couture is in Le Mans in northern France. Its full name is Abbaye Saint Pierre de la Couture. It still exists and I believe it was a powerful unit in the time of the Chevallier. I also discovered that he was a Knight of Malta, which has affiliations with the Knights Templar. That in itself is a rather compelling discovery and bound yet again with the Freemasons.

The heraldry of the abbey is the fleur-de-lys in representation of France and three lions in representation of England. Folklore holds that St Michael set foot there, and as I have mooted before, St Michael amongst some beliefs signifies Jesus Christ. The woman for whom Soissons left the ecclesiastical world was Angélique Cunégonde de Montmorency (1666–1736), daughter of François Henri de

Luxembourg. According to one description of the couple they were an unprepossessing pair:

> It may be said of her that she is truly a poor Princess. Her husband, Louis-Henri, Chevallier de Soissons, was very ugly, having a very long hooked nose, and eyes extremely close to it. He was as yellow as saffron; his mouth was extremely small for a man, and full of bad teeth of a most villainous odour; his legs were ugly and clumsy; his knees and feet turned inwards, which made him look when he was walking like a parrot; and his manner of making a bow was bad. He was rather short than otherwise; but he had fine hair and a large quantity of it. He was rather good-looking when a child. I have seen portraits of him painted at that period. If the Comtesse de Soissons' son had resembled his mother, he would have been very well, for her features are good, and nothing could be better than her eyes, her mouth, and the turn of her face; only her nose was too large and thick, and her skin was not fine enough.
>
> Elizabeth Charlotte, Duchess of Orleans, *Memoirs of the Court of Louis XIV*

Let's hope he had greater virtues than we can possibly know!

As for the recipient of this commission, Jean Louis Habert, he was born in 1648 and was known as Seigneur du Fargis. According to his contemporary at the court of Louis XIV, Madame de Sévigné, he was charismatic and charming, and 'one of the prettiest society men'.

Habert's illustrious career began in 1675 as parliamentary advisor to the king, then at the age of 36 he joined the navy and in September 1684 was the commanding officer at the port of Le Havre.

I find it helpful to conjure up the time in my imagination: the era of big wigs, fine clothes, scented handkerchiefs and extravagance of lifestyle. It was a time so very different from our own: pomp and ceremony at its finest.

It was in 1690 that Jean Louis was posted to the charge of administration of the ships of the royal navy in Marseilles. In this same year Louis XIV visited the area, paid homage to Mary Magdalene and visited Marseilles and Aix.

It would have been quite a significant state visit. In the south, just as in the style of Versailles, Louis inspired excellence and for that reason sumptuous private residences and public buildings were commissioned.

Incredibly, but not unusually for the period, some of the public buildings took as long as 200 years to build. Think of our grey era, of fast food, fast architecture; I wonder what they would have made of us. Fittingly, Aix, which is a glorious city, had blossomed under the care of René d'Anjou, and under Louis's ambitious stewardship was to be further enhanced and glorified.

Nine years later Habert married the daughter of the famous Nicolas de la Reynie, who has gone down in history as the founder of the first modern police force. By all accounts the couple led an extravagant lifestyle in Marseilles right up until the end of 1709, when the navy – and Habert – were relocated to Toulon. He died in 1720.

So now, finally, we have a little colour to add to the mixture: two aristocrats, two confidants of the king, one an abbot in the north of France, the other a naval administrator in the south. That position of abbot has to be important and makes me reflect back to the enigmatic Nicolas Fouquet, financier to Louis XIV, and his mysterious correspondence with his brother, also an abbot, and of his punishment of life imprisonment for not divulging his secret.

Significantly in the context of this map it was Charles Fouquet, brother of Louis and Nicolas, who, as Bishop of Narbonne, later took sole control of Notre-Dame de Marseille for a period of 14 years!

Coincidence? I'm not sure.

Was this then another secret alliance? It was certainly beginning to feel that way. In my view and after all my research, I would suggest that Louis XIV commissioned this work from Père Chevallier de Soissons because, like Abbé Fouquet, Soissons possibly had access to the same information to share with the king, and between them they might even have been able to retrieve Poussin's secret, which Mary de Guise spoke of at Rosslyn Chapel. Certainly the name Chevallier in Soissons' title associates him with the brotherhood, as it is an acknowledged signifier of such an allegiance to the Knights Templar, one borne out by him being a Knight of Malta. If anyone could help discover the secret, the grail, the treasure, call it what you will, in Louis's view the Chevallier of Soissons could. I think, and I admit this is pure conjecture, it would follow that Père Chevallier de Soissons would know of locations which Jean Louis Habert could then inspect. King Louis could trust these men, two confidants who would keep their mouths shut. Sites which the king wanted Jean Louis to investigate would be cloaked in this map, the key to it would be known only to them.

Jean Louis Habert would, I imagine, send out forces to explore these locations, then report back. I would have thought he would go with each sortie to oversee the whole affair.

Intrigue of the highest order

Knights Templar sites could possibly be the key and Soissons, with his ecclesiastic connections and affiliations to the Knights of Malta, would have been able to discover them. They had certainly been numerous in the Middle Ages, and the vestiges of them and their locations would have been a matter of record. To that end Père Chevallier would chart them in this grail map. A map which you need magnification to fully explore.

Why would the Knights Templar be the answer? Well, that was simple. History records that the Knights Templar headquarters were in Marseilles and that their fleet was docked there. Ships which not only took cargo out to Acre in the Middle East but also brought cargo back; sometimes a very precious load that would have included artefacts, financial investments and documents. Perhaps this map was meant to pinpoint the secret locations where various caches may have been concealed, maybe including important documents.

For Louis, I think it was the material treasure he was after, because he needed resources to get him out of a horrendous financial mess. And he needed them fast. For me, though, I think it may well also give locations where more ephemeral treasure is hidden. The thing is, did he find anything, or is it, whatever it is, still there?

King Louis's position of insolvency was an unwarranted position for him to find himself in; he wasn't a bad man and in many ways is regarded as one of the more industrious monarchs in the history of Europe. To his credit, he had accomplished an inordinate amount in the worlds of the arts and finance, sciences, architecture and music. But on the other hand he also, miserably, had his failures. Kingship is a costly business and the Sun King had been heavily involved in colonial expansion. To compound this his 'reunion' policy broke down in 1697 and as we have seen, his support of the Jacobites came to nothing. This fruitless cycle of warfare had been enormously expensive and his navy stood in testimony to his shattered dreams. It had expanded from 18 vessels to 276 in 1683 and their maintenance was crippling him; in consequence the public debt was getting out of control.

The Sun King needed money. This map was intended to get him out

of a financial disaster, and possibly see the realisation of another dream, that of Poussin's secret of the grail. Two birds with one stone: money and sacred knowledge of some kind.

Between them, Louis and de Soissons most probably devised the key. Imagination can take you back to the time of when it was born, de Soissons meeting with him in private conference at Versailles. On its completion and approval by the king it would have been passed to Jean Louis Habert with the cipher – the symbolism and geometry to look for – on receipt of the map.

Did those men pass under the gaze of our Madonna, their breath rising up to her? What a tantalising thought – did she hear their whispers, their intrigue? Maybe in his prayers he addressed her, the Magdalene, and asked for guidance in his quest.

Now, though, some 300 years and more later, this 'treasure map' is in our domain and so we, as Jean Louis Habert before us, need now to study it and decide which direction to take.

Get ready to journey back in time. Try to think the way they would have. It might also help to have a modern map to compare with the historic one, but always bear this in mind: this is the region where Mary, Jesus and their family lived, and where their apostles preached.

First things first: the key – *fermiers généraux* are marked with a fleur-de-lys. Who on Earth were they? Well, tax collectors, but, and this is an important point, *fermier* was also a rank in the Knights Templar. The ranks were:

> The knights, equipped as heavy cavalry.
> The sergeants, equipped as light cavalry and drawn from a lower social class than the knights.
> Farmers (*fermiers*) who administered the property of the Order. This is the important one: *the property of the Order*. This is crucial.
> The chaplains, who were ordained priests and saw to the spiritual needs of the Order.

The farmers are the ones we are interested in here. Farmers in French is *fermiers*, I feel that *généraux* is a red herring to link the word with the tax collectors who went under that name. I don't believe this map indicates tax collectors, the locations don't follow the general rule of thumb of where they were positioned, so in my view it's just a clever

semantic ploy. More than that, the locations are sited in extremely rough terrain and don't represent any significant boundaries. No, in my view the term was intended to fob off anyone who happened to view the map.

Although the mention of a 'grail map' is a rather ambiguous one, it is worth re-emphasising that Heinrich Himmler instructed Otto Rahn to scout southern France for the Templar treasure. It is not such a great leap of the imagination to assume that this map could well relate to it. Louis XIV, as the men who were to follow him, was after the same thing – the lost treasure of the Knights Templar and their other cherished possessions.

The Templar fleet as I have said was harboured at Marseilles. Though we know that when they fled France some went via La Rochelle to Scotland, we don't know what happened to their fleet in the Mediterranean, or more importantly (for this search) what happened to their treasure. One thing we do know for certain is that there is no record of its ever having been discovered.

It is no stretch, therefore, to see that this mysterious map is steeped in testimony to where that treasure could be. If you are not sure then all you have to do is question why Père Chevallier de Soissons, not a known cartographer, drew this extraordinarily detailed map. A map so exquisitely engineered that Nicolas de Fer, a highly esteemed court cartographer of the same period, admitted on his later map of Marseilles in 1708 that it was taken from our map by the Chevallier de Soissons! On it he only says 'taken from C. de S.' Rather cryptic for an acknowledgement and an attribution which nobody would understand, save of course for the chevallier and the king. That surely bears witness to the provenance and mystery which surrounds it.

Proof, if proof were needed, of an abiding Templar connection to the time of the construction of this map comes in the tantalising record recorded by A.E. Waite in his *New Encyclopedia of Freemasonry*: 'there was a little resurrection of the Templars in France in 1681 and that this little resurrection passed out of existence in Paris in 1705'.

Freemasonry we know was firmly established there, so it is no presumption that these two men presumably were part of that brotherhood, a brotherhood which the French date back to Charles Martel in the 700s. King Louis XIV, of course, shouts his allegiance from the rooftops.

Aix-en-Provence, the only other major city mentioned on this map,

was up until the Middle Ages known as Aquae Sextiae. It was only then named Aix, and only in the time of René d'Anjou was that prefixed to 'en Provence'. It is at Aix that the traces of the Christos family can still be seen. The Cathedral of Saint Saveur was founded by Saint Maximinus (which I believe to be an alias for Jesus Christ) who built a small chapel here on the site of an ancient pagan temple. In it was the small oratory where Mary Magdalene and Maximinus prayed together and in recognition of this as being the cradle of Christianity René d'Anjou chose to be entombed there.

Aix is also home to one of the three Black Madonnas in the area and the Church of Saint Jean de Malta, the tower which appears on my painting, is annexed to the cathedral. Note here its orientation on the map is west, in line with the migration of Mary Magdalene and her group, not north – its true physical orientation.

Marseilles and the Grail

Having familiarised ourselves a little, let's go a little deeper into our exploration of this unique map and try and find out what hidden meanings lie concealed in it – beginning with the appropriate fundamentals. Our first footfall follows that of the Judean refugees as they reached the coast of this mystical place. I used to love visiting this part of France, the unmatched isolated beauty of the Camargue, with the biggest sky I have ever experienced, contrasted against the backdrop of the hedonistic lifestyles of the towns and cities. Wild horses roam the rough, bleak terrain, trampling a marshland which is alive with wild iris, whilst on the banks you can find spectacular displays of smaller wild flowers. It makes for one of the most heavenly fragranced memories I carry and one which I try to recapture on coastlines in Scotland but never can. Another keepsake I carry in my head is the sight one evening, as the sun was setting, of the pink flamingoes gracefully, peacefully feeding in the waters with the reflecting sun casting hues of pink and gold onto the water.

This is life for me, peace. Until recently I never fully understood that blessing of 'peace be with you'. It doesn't mean peace versus war, it means peace. That haven and bay of our beginnings and our end. The closest I can get to that in this mortal world is by looking at nature and letting my soul transcend. The ocean does that, the hills, the sky. But yet again I digress, sorry, and have to refocus from my room in Scotland back to the vision of the map which confronts us, challenges us. Like a

hill it crooks its finger, inviting you to delve deeper into its fabric. Walk with me a while longer and let's journey together.

With the pictures of the wild Camargue, of the sublime beauty of Aix-en-Provence in my head I gaze once more at this map. On my periphery, an image of the painting with St Victoire teases me; this is the same area, revisited. Different time, similar context.

At first it made no sense as the orientation is all wrong, with Aix located west of Marseilles rather than north. Why was that? Why confuse the true orientation? After some research I discovered that in the medieval period maps were commonly orientated east, towards Jerusalem being one reason, but that was after already rotating it. Specialists have informed me that sometimes, however, maps were orientated east to west to fit in with the dimensions of the paper – but this was on two sheets and so did not need to conform to that custom. Here, on this map, which incidentally I find quite beautiful, cardinal north isn't clearly defined, save for the fleur-de-lys on the symbol to the right which directs left. So I had to wonder: why this orientation? Why is everything a mystery? Maybe because its aim was to confuse the casual looker but to prompt enquiry of the recipient who was meant to question, to discover. So in that vein I endeavour.

Once more it appears to me that this orientation could have a Masonic link, for in the reasoning of the Freemasons 'East' has always been considered particularly sacred. You can see this in the fashion in which they construct their lodges, for they are always orientated east–west, to symbolise the rising and setting sun. Makes you think of the journey westward doesn't it, from Marseilles to Santiago, to the land of the setting sun, even bringing back into focus the scallop shell, and its ridges so perfectly symbolising the rays of the sun.

There is further confirmation of this, for if one looks at the French Masonic cloth of the first degree you will see that it too follows this orientation. Doesn't it therefore make sense that the Sun King would wish to follow the same principles laid down for this particular veneration? For surely it alluded to him and his position as a divine being.

More and more this makes perfect sense; it would also mystify the uninitiated. It would be like spinning someone around and completely disorientating them: which way is north, which way east? Locations would be protected. This wasn't for those who have ears to hear but those who have eyes to see, and instructions to follow.

As one world continent wakes so another sleeps. We lose sight of the light but it is there – illuminating another sphere of our planet, both sun and moon being powerbases which ordain generation, the tides and the fertility of this Earth. In the ancient mysteries of the Egyptian rites, especially, and those of Adonis, which were among the earliest forms of divination and from which the others derived their existence, the sun was the object of adoration, and his revolutions through the various seasons were fictitiously represented. Consequently that is why King Louis called himself (in all humility!) the Sun King. The spot, therefore, where this luminary made his appearance at the commencement of day, and where his worshippers were wont anxiously to look for the first darting of his prolific rays, was esteemed as the figurative birthplace of their god, and honoured with an appropriate degree of reverence. Even among those nations where sun-worship gave place to more orthodox doctrines, the respect for the place of the sun's rising continued to exist. You only have to imagine how wonderful that must have made the Sun King feel.

The references I made in the research of the orientation of this map led back over centuries and I found them fascinating. Even the camp of Judah was placed by Moses in the east as a mark of distinction; the tabernacle in the wilderness was placed due east and west; and this practice was continued in the erection of Christian churches. Hence, too, early Christians always turned towards the east in their public prayers, a custom which Saint Augustine (Serm. Dom. in Monte, ch. 5) accounts for: 'because the east is the most honourable part of the world, being the region of light whence the glorious sun arises'.

Confuses religion doesn't it, this continual reference to the universe in her glory. This underpinning of Apollo of ancient mysteries. There's no place to investigate further in this book but I'm already being drawn into the web of the cosmos, from which I doubt an emergence, into what this is all about. Maybe this is for the book which gestates from this, for there is evidently much more to tell, more questions to ask. But for now, for the present, let's keep within my remit and this Masonic link.

In respect of this all Masonic lodges, like their great prototype the temple of Jerusalem, tend to be built, or are supposed to be built, due east and west; and as the north is esteemed a place of darkness, the east, on the contrary, is considered a place of light.

In the early Christian Church, according to Saint Ambrose, in the

ceremonies that accompanied the baptism of a beginner in religious instruction, 'He turned towards the west, the image of darkness, to abjure the world, and towards the east, the emblem of light, to denote his alliance with Jesus Christ.' And so, too, in the oldest lectures of the second century, the Freemason is said to travel from the west to the east, that is, from darkness to light. I question this thesis, as you will if you are following me. In that case, why did they head west, to the setting sun?

I don't know, that is the vexing thing about a quest, the more one knows the more one appreciates, sadly, dismally, robbed of our elders, we know nothing. And there a great loneliness of spirit resides.

Back from that loneliness, I hope to find ballast and support in whatever I may unearth.

Masonic law dictates that the east, being the place where the Master sits, is considered the most honourable part of the lodge, and is distinguished from the rest of the room by a dais, or raised platform, which is occupied only by those who have passed the chair. Étienne François Bazot, who compiled a French dictionary of Freemasonry in 1810, is quoted as saying:

> The veneration which Masons have for the east confirms the theory that it is from the east that the Masonic cult proceeded, and this bears a relation to the primitive religion whose first degeneration was sun-worship.
>
> Albert G. Mackey, *Encyclopedia of Freemasonry*

East then in reverence to the light and ancient teachings. In Jesus's demise, his waning, then did he head west? Once the spirit of his prophecy had been fulfilled did he head for the ocean of his beginning with his consort Mary to the lands at the edge of the world?

I believe so, but obviously I don't know, it just has a resonance, for me at least. Maps in life are oftentimes called destiny; I believe I am following mine, a few dead ends for sure, but I think in the end I am getting there. In that spirit let's revisit this tangible map and see where it can take us.

Now to locating the fleur-de-lys, the symbol of the *fermiers*, the rank of the Knights Templar who oversaw their domains.

They were hard to find. I have discovered four, however there may be more. Four aren't many for a map which is supposed to be

concentrating on them. But enough if they hold a great significance.

The ones I have found stand like lone chess pieces on the board of southern France. One stands sentry at La Gavotte, another west towards the Church of Notre Dame. Then trace your finger east and at La Bourdonnière north of Aubagne stands another, then one more at Allauch. Strangely for so few these are almost coupled in locations following a vertical line, left of centre of the map. None appear in the right side of the map. In reality they flank Marseilles, two to the west, two to the east. Even now these places are sparsely populated and in the seventeenth century they would have been treacherous, desolate places. Just looking at the map you can see that there aren't even any villages or hamlets close to them. The two to the west are in limestone hills, so too to the east. White hills fragranced with wild herbs. Why there? Were they sacred locations? One thing we can be sure of, they were not random choices, they were important.

It takes me back to the caves of the Pyrenees, of Lombrives, of Sabarthes, of the Dead Sea Scrolls. Caves were important places to hide things, caches held in stone until they met the light of day once more. I have never liked caves, I feel smothered and seek the day and fresh air. The thought of delving in the cavernous interior of this planet frightens me. I feel much the same when swimming out of my depth in dark waters, fearing what lurks beneath me, out of sight, of my knowing. There is maybe a link here with my trepidation at exploring the world of the Sworn Book. For me, there are places I don't want to go. So in my limited capacity I continue onward.

Nothing much resonated with me; I did know, for instance, that the gavotte was a well-known dance in the medieval period. Was that another covert reference to the grail? Similar to the troubadours and the tarot themes, here we have dance. Then something else struck me, this would almost match the position of our Madonna, with Aix to her back, did the locations match and if they did was that significant? The next location I spotted was Allauch, which sits on the southern flank of a big rocky desert and as in these chalk hills there are caves of interest here too; those of the Grotte des Pestiférés, which is like a gaping mouth and the Grotte de Grosibou. This one is much smaller and narrower. I mention these caves for they are still there for us to check, not just names on a map.

I find this area of France to be quite exceptional, the white of the chalk contrasting with the greens of the native woodland, full of

wildlife and flowers, offering breathtaking views of the Mediterranean and surrounding landscape. The air gloriously perfumed with herbs and flowers. And memories, imprints infuse the place. Souvenirs of past times, like music fill the air. Do you sense it, are you in tune with the harmony that surrounds you? I believe I am, just about.

An additional point of interest in relation to Allauch is that they hold various festivals there which could be relevant to our quest. One is to commemorate St John (which lasts a week), St Clair (linked to the story of Rosslyn) and St Laurent. Pilgrims still go there to the Church of Notre Dame du Château. I would suspect though that that Notre Dame refers to Our Lady Mary Magdalene and not the mother of Christ. More on these place names I cannot give you, I am at a loss, though I do know they are relevant to our quest and would love to go back to explore the caves. Though not on my own!

Unfailingly whenever I immerse myself in study of this very old map I can't help but become absorbed by it. What a fascinating thing it is. I almost get a sense when I look at it that I have just entered an empty room which just seconds before was buzzing with activity and that I have missed something incredibly important. People have stopped talking, whether to welcome me or keep me from it, I can't be certain.

The scenery of the area this map covers is some of the wildest and most beautiful that I have experienced, and the Pilon du Roi, which is on the map, is one of the most extraordinary, spellbinding visions I have ever encountered. Hang on, I have only just discovered a boundary mark which leads through this, which contrary to the key of the map seems to be decorated by Templar crosses. When I re-examined the map to have a closer look at an ink spot which is breaking into the heraldic design on the right my eye travelled along what I had always assumed was a boundary marker line, down to Courtiou. I can't be certain they are not boundary markers, as in the key they look markedly different, but I think I have fallen upon Knights Templar crosses, in total about seven or eight of them. They are similar to the key notes but yet again distinct from them. A blind alley? Possibly. Please have a look and tell me what you think.

Anyway, this wonderful beauty of the Pilon stands like some fossilised luminous giant towering over you, almost phallic in its separation. It crowns this extraordinary range of hills, called the Chaîne de l'Étoile. In local folklore this is in reference to the Magi, or Three Wise Men, who celebrated Christ's birth. I have to question whether in our context it isn't in celebration of a further birth and whether that phallic image of

the rock also bears testimony to it. Chain of stars. Milky Way. Causes a sigh of familiarity, doesn't it? I tread water in this sea of unknowing; there is a map, but where does it take me?

That strange observation of the phallus link made me think again of controversies which have raged over Leonardo, and of one particular work of his, the *Madonna of the Rocks*. I have mentioned her before; her profile matches the Madonna in my painting, and the little boy has a look of the boy in it too. I appreciate this is a leap of imagination, but could this be a portrayal of her in one of the caves in Provence, and that is why Leonardo illustrated it with such phallic rocks about her? I don't know, but look again, the hairline, the V. Leonardo changed this painting quite dramatically in the second version, even changing the iris in the foreground to something else, and the way the angel looks out at us I find compelling. But I am aware this is a major intuitive step and absolute conjecture. You see, there are some things of which I am practically certain, others, well, let's see.

It is just one interpretation of the facts, which is why I suppose a jury comprises 12 good men and true. For me the rocks in the forefront of the *Madonna of the Rocks* is a chasm, for others a pond. It is what speaks to you, personally. Seek and you shall find. You may be troubled, but that is par for the course. What in life is worth seeking which is easy?

Even today the hinterland of Aix and Marseilles can be inhospitable terrain best negotiated on foot, and you can imagine how over 200 years ago it must have been terrifying. It was a land inhabited principally by hermit monks and desert anchorites, as of old.

These hills in Provence are perfect for grottos and there is another one which sticks in my mind, that of the Grotte Notre Dames des Anges, part of the Massif de l'Étoile, which I mentioned earlier. Could it too have some bearing on this map? It is without question an awe-inspiring, thrilling place to visit. According to legend the cave of Notre Dame was named in 1220 by a hermit named Father Jean. He installed himself in this cave which had been inhabited since Neolithic times, and of significance to this story, allegedly by St Mary Magdalene after she had arrived at St Baume; hence the name and why the other Notre Dames in the region I believe also are in reference to her. Look to the right of this location on the map and you find one of the four fleurs-de-lys sited at Bourdonnière. Frustratingly I hadn't known all this when I lived in France, I wish I had.

Maybe one day soon I will return, to have a look.

Obsessed by this sense of a compulsion to study the map and become involved in its machinations, I keep searching, examining, staying alert for signs as to the direction one should take. When to turn next? What signs to look for that were incorporated there for Jean Louis Habert to follow, ones which we have to discover for ourselves. I have to admit to being surprised that it doesn't encompass the Massif de la Ste-Baume or St Maximin but at least it confines the study to a smaller area. The places with the fleurs-de-lys certainly seem to be located in the chalk-white hills and not in the more habitable areas. Chalk hills where there are caves, places where since time immemorial things have been hidden away.

There is a pressure to keep scanning everything, but I found I needed a regular map at my side to help me orientate myself to it all. Strange too that everything is so hard to find. Were the Templars having fun, hiding clues as Poussin had done? Was King Louis excited about the reports coming back to him from Habert? Were they getting warmer in this game of hide and seek, or colder?

Then another thing happens as you try to orientate yourself; it doesn't tally, or am I just getting confused? It's driving me crazy as there is no order in it, but maybe even in its irregularities there is a clue. South in orientation to the map of Aubagne we find Nazaret, I think it is that, or maybe Mazaret, certainly I know west of the Massif de la Ste-Baume there is a Nazaret, commemorating the birthplace of Christ, or possibly in this instance that of his son.

It is place names which give me the confidence to think this is something special. I knew from walking the Grande Randonée route that to the west of the little village of Nazaret and in the direction of Plan d'Aups there is also the small commune of La Magdala, both in obvious connection to the story.

I come back again and again that this has to be some form of a grail map but I have more questions than answers. Why mark a place called the Arab's Tower, and there east of Marseilles we find St Jean du Désert. That is obviously a reference to St John the Baptist and his life in the desert.

Churches dot the landscape, and there just north of Marseilles is a heavily etched structure. It is in the shape of a syringe and evidently denotes a gigantic abbey of some kind. A replica of Solomon's temple? The outline certainly closely resembles that of Rosslyn Chapel, which is said to follow the architectural design of Solomon's temple. Close to

it is written the word Chartreuse, which may well refer to a monastery, and below this massive structure is a church dedicated to Mary Magdalene. There are B's also associated with the *fermiers* at Pennes which is still further west. Unlike the locations of the fleur-de-lys this is evidently quite a large village, then another lies just outside Aix, represented by one lone building, another closer to Allauch, again a small hamlet.

Seven locations which are possible places to explore and which are all marked for a reason – a good one. The grotto of Notre Dame keeps nudging me, and I think the main clue is to look for caves, good hiding places, and all these are within a reasonable distance from Marseilles.

This is not a map for anyone, it was one for the confidant of the king. We were never supposed to be looking at it, let alone studying or decoding it. No, this was never intended to enter the public domain, if it had been there would be more copies – this is one of only four.

We are in the hall of mirrors of King Louis XIV, we are privy to his dealings, but can we become a part of his dealings?

Last but not least, what of the detailed engraving by Brémond which decorates the base. I don't know but I think that maybe it ties in with the key, a landmark there tallying with one in the topography. I'm looking at something of inherent interest but I draw a blank. Something is there right under my nose but I can't see it.

To console me I have the reassuring feeling that maybe now is not the time, it will come.

One thing though, on a greyer level than the tantalising journey that the map takes us on: that engraving certainly reflects the sheer scale and rigid geometry of the harbour which Louis created in 1666 for the French military fleet. Two magnificent fortresses defend the harbour, the Fort Saint-Jean to the north (which importantly incorporates a twelfth-century command post built by the Knights Templar) and the Fort Saint-Nicolas, its counterpart on the newly developed southern side. Apparently after installing their seaward-facing artillery, the king's military engineers added an additional battery of cannon fire aimed in the opposite direction – towards the town – just in case his people were ever tempted to waver in their loyalty to their king!

As it happened, the navy eventually outgrew its facilities and sailed off to a new home along the coast in Toulon. With them went Habert. Was his mission accomplished? Did he find the Templar cache, was that

the explanation of his extravagant lifestyle? Was King Louis rewarded by this commission of the map, did it lead him where he wanted to go? I haven't a clue. But I don't think so.

Then, just as I am about to admit defeat in finding more, I look again. As I feel sure I will in the future too.

Words echo in my head, the engraving beckons me once more, there must be stacks of clues there, frankly maybe too many. Hang on though, if you head north from the tower in the engraving you get to St-Julien, head north again and there is a templar cross, is that something? It's also in alignment with the syringe-like symbol associated with Mary Magdalene. That syringe symbol for a church isn't actually named, it just lies between La Madeleine and Chartreuse. I think it is quite important too! But of course there will be numerous sites, otherwise it wouldn't have been necessary to commission the map. So maybe that is the thing to do, align the direction with features in the landscape of the engraving, particularly the towers. There are other landmarks which intrigue me, one central one of a castle in the form of a coronet in the hills, but I am chasing my tail if I follow it up. Though it is tempting. I imagine there must be something concealed in this, but believe the fleurs-de-lys and the Bs are the real clues. The Bs: brigades – maybe they are the places to look, where the fighting monks were billeted. All in all it is infuriatingly perplexing, almost too much to think about – as if it needed an Enigma Code machine to progress.

In summary, in an aspiration to clarify it all and put it in perspective: primarily this map is of importance for it concentrates on Marseilles. The Knights Templar made much use of the great port of Marseilles (we haven't even looked out into the sea and there could be something there), shipping out supplies etc., and had a strong presence around the port. Amongst the Templars one could see the wealthiest men of Europe and the leading bankers from London and Paris: Hugh de Champagne, Alphonse de Poitiers, Robert d'Artois, the ministers of finance of James I of Aragon, and Charles I of Naples, the chief advisor of Louis VII, King of France, were all Templars.

These groups dealt with any kind of business under the control of the Order's members; from navigation to trade and from agriculture to construction. Simple calculations show that at the time of their persecution, the Templars employed a staff of at least 160,000. It is worth repeating: 160,000. This framework of essentially monks,

surrounding Europe and all shores of the Mediterranean, was also the most powerful and widespread organisation of its time.

Neither the Pope nor the King of France had been able to confiscate the Order's property, which had expanded into such a great area, and when the Templars were fleeing the Inquisition, their assets – which were then comparable to the wealth of kings – were enough to provide the protection and security they required. Yet what did they do with their spoils? Some escaped north to Scotland, but what happened to the rest? In southern France they had greater notice of what the Pope was doing and had time to secrete things away. Montségur, the Cathar stronghold, has long been thought of as a possible location for a suitable hiding place, so too the caves of the Pyrenees. However, Louis XIV knew of something else, and that was Poussin's secret. To discover it, whatever he had gleaned made him concentrate on Marseilles, the area Nicolas Fouquet's brother the abbot would have been intimate with. That gives credence to this map and its meticulous detail. Something is hidden here, or alluded to, for Jean Louis to look for. Did he find it? We will never know.

For me though, the grail of this book, the heart of it, is the beauty of the flight of Jesus Christ and his beloved Mary Magdalene to the foothills of southern France and their migration west to Santiago, then north to Scotland. The conviction that they made landfall in southern France, with a little girl named Sarah who was possibly their daughter, and then went on to give birth to a further child, the baby in my painting.

The map for me is testimony to them in the names it records. Whether there was treasure there I don't know. It may be there still. For me the only material treasure I would hope to be found would be that of the Gospel of Love, the lost Gospel of John which the Cathars so venerated. Somewhere, maybe alluded to on this map, I think it lies buried. I feel it is in the chalk caves that it would most probably have been hidden, waiting for the right time to be found. Did the Christos family, or the Cathars or the Knights Templar do as the Essenes before them had done, and buried their secret gospels in the limestone hills to preserve them?

King Louis was after tangible treasure. What an irony for him – or maybe not – if he found documented proof of his belief in Mary Magdalene and Jesus Christ.

Do they lie there still, waiting to be discovered, the true holy grail

and the Gospel of Love, buried deep? Or maybe there is another treasure, that which is found within each of us: the sacred truth of pure love?

I hope I have fulfilled the remit gifted to me in my pursuit of that truth and told the story which Leonardo's last commission ordained that I should.

Their genes flow through us even to this day. All of us. Christian, Muslim, Jew, Hindu, Buddhist, Sikh, followers of Shinto, Confucianism, Baha'ism, Zoroastrianism, Jainism, Taoism. All brothers in that Christos spirit and the union of male and female. Nothing divides us, only misconceptions.

God be with us all in our quest for 'truth against the world'.

Our Father's House has many rooms, let's keep the light alive in them all, united in our shared goal as worshippers of God and the light.

Remember, please give me your thoughts and discoveries at www.fionamclaren.co.uk or on my Facebook page – then we can really shake the truth free.

New Beginnings

On the horizon a rainbow capped the limestone hills of southern France. A channel of sunlight beamed a spotlight to the shore, and there was the crunch of wooden timbers hitting shingle, a leaden splash and water spray as the group anchored. Silence for a moment. A benediction given in the lullaby of the sea as it caressed the sandy shore and lapped against the boat's hull. Amen. Jesus jumped into the clear crystal water and stretched out his hand to his beloved. Together they walked, the two of them, a young girl skipping behind them, a girl known as Sarah. They had made it. Safe at last on dry land. The first stage of their journey completed.

In the far distance, the white mane of a wild horse caught the sea breeze, nostrils flared, then the rogue stallion galloped out of sight. Pink flamingoes dropped heads back into the low water and resumed their feeding. Peace on these shores of southern France.

> While the king reclines on his couch,
> My spikenard gives forth its scent.
> My beloved is for me a bunch of myrrh
> As he lies on my breast,
> My beloved is for me a cluster of henna blossom
> From the vineyards of En-gedi.

Jesus took Mary's hand, then raised it to his lips:

> How beautiful you are, my dearest,
> O how beautiful,
> Your eyes are like doves!

Her head nestled in his neck and she whispered the next line,

How beautiful you are, O my love,
And how pleasant!

<div align="right">Song of Songs 1:12–16</div>

New beginnings: Jesus in the guise of Maximinus, Lazarus to become Bishop of Marseilles. Mary chief apostle and priestess. Martha to Tarascon, and other apostles spreading the word up the Rhone valley.

Solitary places and the underground crypts of chalk hills scaffolded their teachings. A small flock formed from the blood transported from the cross by those who had seen it flow. Time ripened the seed and brought it to fruition. Their congregation grew and nourished the land with the truth of the vine. Sermons sheltered by the sacred yew whose sinuous trunk stretches out to the sky and over land, then the Christos family moved westward before journeying northwards to the mystical island of Britannia, then Scotland. The land of Neolithic sacred temples, the land of the outer reaches of the world.

Sacred Connections

From there their sacred rays of teachings would spread once more back across the Continent in the word of the Culdees.

The End.

Or could it be a new beginning?

Epilogue

During my writing and research for *Da Vinci's Last Commission* there has been much for me to think about. In consequence I have been forced to confront religious dogma, and subsequently I've had to battle with myself over some aspects of my findings. To that end I am only too aware that I am undermining a belief system which structures many people's lives and that is not something one takes on lightly.

I have no desire, none whatsoever, to destabilise anybody's faith, but I do wish to shed light into shadowy corners which have not been explored and which, I believe, hold the truth. Discovering the truth is my prime objective. The scales in life's balance must be weighted correctly and for that to happen truth must have its say and be in equal measure. Until relatively recently in our history biblical texts were kept solely in the domain of the Church and it was they who decided what should be told to the people. Staggeringly, even Henry VIII set a fleet out to prevent copies of William Tyndale's (1492–1536) translation of the Bible from getting to our shores as his translation was seen as being directly in opposition to the authority of the Roman Catholic and English Church and State. He was tried in England for heresy and impaled and burnt at the stake. The authorities didn't like to think the general populace would be able to access the texts which they wanted to interpret for us. Knowledge is power, power is knowledge, so they wanted to ringfence the Bible for themselves.

I have heard commentators declare that if Christ did not die on the cross then the Christian faith would fall. I don't subscribe to this view. Instinctively I have always felt that a loving God would not sacrifice a son nor demand the death of others. In that context the cross for me has always been anathema. Fortunately others share the same view.

Accordingly and with a beautiful harmony, writing *Da Vinci's Last*

Commission has been a form of pilgrimage for me. I believe entirely and sincerely in all that I have placed at your feet and stand by it. I have struggled with my own faith in writing this book, for I too have been submitted to the same teachings that most of you will have been. What I have come to believe is radical and I do respectfully ask your tolerance in considering it. Happily, I now feel a tremendous sense of freedom at what I firmly believe to be true. Contempt prior to investigation is certainly the strongest ally perceived religion has, and I believe that analysis of all things is our personal responsibility: seek and you shall find.

If you have any doubts as to the discovery and genesis of that beautiful painting, then this is my final offering to you. If however what you have read resonates with you, then what follows communicates and underscores all that has gone before. Much is founded on the factual content of the biblical texts. Texts which hold a certain legitimacy, whether it be in allegory or code.

Huge portions of the Bible were, we know, omitted by the Roman Emperor Constantine in AD 325 at the Council of Nicaea. It was then that it was decided which books would be included in what was to become the New Testament. Texts that supported the Gnostic position were destroyed and dissenters exiled. Historic record therefore has been manipulated to further an end; if there was testimony of Jesus having survived and landed in Gaul then it is scant and not in our domain. However, they would hardly have made a great deal of it, as Gaul was under Roman rule, those who knew would have been few, and staunch supporters of Rome. It takes courage to stand and be counted.

In Jerusalem Jesus's brother, James the Righteous, was left in charge of his ministry. Christ meanwhile took flight with his consort, possibly firstly to Egypt, then on to Gaul. Investigators worthier than me have stated it, and now in my late 50s I too subscribe to it. Why manipulate this truth of Christ's deliverance from death?

Question: To what end?

Answer: For power and ultimate control over the people.

In my view it is high time that we regained the knowledge that has been misappropriated, seize back the power and take responsibility for what we believe in. I do not profess to be a biblical scholar, but that maybe is my strength not my weakness, for I come to the Bible with fresh, enquiring eyes. On that point, if I had been an academic in any

of the fields which I have covered in this book, it quite simply would not have been written as the scope of vision of academia focuses on clearly defined areas. I, over an extensive period of study in excess of seven years, have taught myself and so, rather than being entrenched in a certain way of thinking, have the freedom of an overview, another perspective. That for me is my strength, not my weakness. I had no end goal to this, the painting and artefacts told their story, I just deciphered and transcribed it. My reward has been an enlightenment and a fulfilment of a destiny.

The message of Christ's life is a simple, pure Gnostic one: love your brother. The house of God has many rooms, let's fling the doors open and embrace one another:

> Dear friends, let us love one another, because love is from God. Everyone who loves is a child of God and knows God, but the unloving know nothing of God. For God is love; and his love was disclosed to us in this, he sent his only Son into the world to bring us life. The love I speak of is not our love for God, but the love he showed us in sending his Son as the remedy for the defilement of our sins. If God thus loved us, dear friends, we in turn are bound to love one another. Though God has never been seen by any man, God himself dwells in us if we love one another; his love is brought to perfection within us.
>
> 1 John 4:7–12

God and the Word would not have destroyed the light which was Jesus. The sacrifice was to be that he would suffer and live amongst us as our Messiah and teacher. It was also to reintroduce the Sacred Feminine to the equation, this through the exquisite grace and beauty of Mary Magdalene his consort. To fulfil this Christ had to comply with what had been written in the scriptures.

> I am that living bread which has come down from heaven [. . .] If anyone eats this bread he shall live forever. Moreover, the bread which I will give is my own flesh; I give it for the life of the world.
>
> John 6:48; 50–51

That is, to be intrinsic in our fabric and DNA. In us, part of our being. Die for our sins, or live amongst us? That was his supreme sacrifice, to

live and to forego spiritual realms for another turn in material form.

I sense that this fractured age of ours desperately needs the reintroduction of the Sacred Feminine, and for our time her name is Mary Magdalene. Up until our era she has always been there, as Isis to Osiris, and as the formidable goddesses of Greek and Roman antiquity. It is only relatively recently that she has been relegated. In partial abeyance to the principle to her the official Church paid due reverence to Mary the mother of Christ, but Mary Magdalene's true position as Apostles to the apostles has been denied to her. This must be put right in order to correct the balance and harmony of our natures and the spirituality of women. Some would argue that the Sacred Feminine is the life-sustaining power of all creation, it is after all why we call this planet of ours Mother Earth. There must be balance in all things. The female is counterbalance to the male and of equal merit.

> It is impossible for anyone to get established in the experience of reality, being-consciousness, except through the power of grace, the Mother.
> Other than through grace, the Mother, no one can attain reality . . . Which is truth.
> Except through that exalted light, which is grace of consciousness, the supreme power, it is impossible to transcend the conceptualising power of the mind.
> The ego can only be destroyed by the power of grace . . .
>
> Bhagavan Sri Ramana Maharshi (1879–1950)

I believe we must reconcile and surrender to the balance of masculine and feminine principles in order to achieve the ineffable glory of the One. For that to be accomplished we need a relinquishment of the Ego and the androgyny of the soul to determine authority and peace.

To that end, this is my penultimate revelation to you before I conclude: it has troubled me why the Cathars would carry St John's Gospel, why Jesus loved him more than the others, and why John would rest his head on Christ's chest. Then I had it. Was there more to St John's Gospel than just the fact that it was written contemporary with Christ's life? Could John be part of this remit of mine to discover the truth?

Intriguing certainly, but I am open to radical thinking and to question.

So what was my intuition directing me to explore now? Well, could it be that John is Mary? The apostle whom Christ loved. Makes more sense doesn't it? So would it then follow that that is another reason why Leonardo portrayed him as Mary at the Last Supper? His message being multi-layered, not only that Mary was Jesus's consort, but that the gospel she had written had been misattributed to a man, John.

Yes I appreciate it is yet another leap I am asking you to take; but John the beloved disciple was the one 'whom Jesus loved'. It makes more sense that this is a woman. Mary Magdalene and the mother of Christ were at the foot of the cross, and it was to his beloved disciple that he gave charge of his mother: Mary Magdalene who was first to see him, Mary to whom he entrusted his teachings. Now it was becoming clearer to me why the Cathars should revere St John's Gospel: because it was a misattribution whose authorship rightly belonged to Mary. Why, even the Culdee tonsure was called the St John's tonsure.

Then there is another painting which inclined me with confidence in my theory. Perugino, a contemporary of Leonardo's, painted *The Crucifixion with the Virgin, St John, St Jerome and St Mary Magdalene*. Have a look at John and Mary: don't they bear an uncanny resemblance? See their postures, how they mirror each other, as though they are one and the same?

Is that why my great-aunt always said that the only gospel that it was necessary to read was that of St John? She had dedicated her life to working in India, had she gleaned some knowledge there of the true identity of the author? Remember too the testimony of the writer of St John's Gospel, of being there and that they had much more to tell. Was it because the author was a woman that dictated that this could never be recognised as her work?

Consider it. Gently allow the sands of time to filter through and make your judgement. Also ask yourself if you are feeling that it is outrageous to propose such a thing. Would you feel equally outraged if I had suggested it might have been by another of the disciples, but a male one? Why such outrage at my proposition that it was a woman?

Now to conclude. So here is my final vision; I submit it to you now in the spirit of love, peace and light.

A leap of faith, to take you to the other side of knowing.

The Sacred Marriage at Cana; Hieros Gamos of Jesus Christ to Mary Magdalene

A gown of embroidered silver with a necklace of shells and amber. A crown rich with precious stones catching the sun and reflecting back glints of a unifying dance to the sky. About her waist a silver cord trailing down to skim the Earth's surface in a tantalising dance of a snake, she alights in the shimmer of jasper and cornelian set in a rainbow of refracted light. About her are attendants in white with golden headdress, before them stretches out a sea of glass which mirrors the universe above. To the music of trumpets accompanied by pipes made of the sacred yew the glorious bride graciously walks through the orange blossom and almond grove, shadows gently playing on her face, slowly, deliberately in time, towards her true love.

Dressed in his vivid purple robe fragrant with aromatic oils he waits. Then as his priestess approaches he bows, takes her hand in his and with the music to accompany them leads her to their shared throne. There he kisses her tenderly on the mouth and with the seal of that kiss seven doves are simultaneously released. The harp now strikes up as the pipes fade.

A waning moon holds its position in a celestial balance with the risen sun as they face each other, as the east faces the west. Neither now in ascendancy, but on a level. Now too a man faces a woman, ready to make the sacred commitment to become One.

Bride:
Your love is more fragrant than wine,
Fragrant is the scent of your perfume,
And your name like perfume poured out;
For this the maidens love you.
Take me with you, and we will run together;
Bring me into your chamber, O king.
Let us rejoice and be glad for you;
Let us praise your love more than wine,
And your caresses more than any song.
Groom:
How beautiful you are, my dearest,
O how beautiful, Your eyes are like doves!
Bride:
How beautiful you are, O my love,

And how pleasant!
Groom:
Our couch is shaded with branches;
The beams of our house are of cedar,
Our ceilings are all of fir.
Bride:
I am an asphodel in Sharon,
A lily growing in the valley.
Groom:
No a lily among thorns
Is my dearest among girls.

<div align="right">Song of Songs Verse 1 and 2:1–2</div>

With that to the joyous melody of the lute and harp the congregation joined

Let us rejoice and be glad for you;
Let us praise your love more than wine,
And your caresses more than any song.

<div align="right">Song of Songs 1:4</div>

A long embrace now to seal their union, followed by a gentle tracing of her face and then dancing and music.

The dark of the night took the light of the day to bring a new dawn. The Magdalene had married the man who guarded the flock and it was his dark compassionate eyes that now looked into hers.

Celebrations and feasting continued for three days. Dust bowls of merriment swirled into the skies, toes darkened by movement, sandals scuffed by grains of sand. Colour filled the groves and arbours as did the sweet scents of citrus and almond. All was filled with the joy of things to come, of scriptures fulfilled. A holy light sent in a glory of a perfect day, whose image would leave its mark on the testament of the world's eternal realm. In the darkness fires would burn but this was consecrated in the light of a day. Light destined to burn for eternity.

Hieros Gamos: The Sacred Union

Yet scripture had to be fulfilled. Each era would fulfil its destiny as prescribed in the holy books. There was to be a reincarnation of time, of belief and of the spirit of the world which needed to be consummated

for the world to take another turn. Time would orchestrate the season when a great sacrifice was conducted to be offered up. That of a time to wed to Earth and a time of renewal.

> When the master of the feast tasted the water become wine, not knowing where it came from – though the servants knew, those who had drawn the water – he called the bridegroom and said to him, 'Everybody serves the good wine first, and when the guests are drunk brings out the inferior kind. You have been saving the good wine till now.'
>
> John 2:9–10

Could that be why John referred to Christ as the bridegroom?

> I am not the Messiah; I have been sent as his forerunner. It is the bridegroom to whom the bride belongs. The bridegroom's friend, who stands by and listens to him, is overjoyed at hearing the bridegroom's voice. This joy, this perfect joy, is now mine. As he grows greater, I must grow less.
>
> John 3:28–30

In respect and acknowledgement of the truth, I wonder is that why the Church refers to nuns as the brides of Christ, or is it to muddy the waters of our understanding?

> Three Marys walked with the lord: his mother, his sister, and Mary of Magdala, his companion.
>
> Philip 59:6–11

I have reflected on this blessed Union of Mary and Christ and these are my thoughts: if Jesus, the most idealised man in history, was sexual and loved a woman, this would radically challenge cultural views about relationships and sex. If Mary Magdalene, the mythical lover in the Song of Songs, who searched for her beloved Jesus is also presented as the most spiritually advanced disciple, the spiritual consort of Jesus, the one who knew him best, she would personify several aspects of the eternal goddess that have been missing from traditional Christian portrayal. She would reintroduce into our culture the missing link of the Sacred Feminine, the link that has left

us with our broken inheritance. She would signify our restoration and heal the rift that has fractured our era and, importantly, would end the misogyny that has dominated world culture. The Yin would merge once more with the Yang to become one, a whole, a circle of light.

The wedding of Jesus to Mary was undoubtedly an ancient sacred union, one that was referred to as the Hieros Gamos. This is a term that was used to denote a 'holy wedding' or marriage between a god and a goddess. In this case it was between Jesus and his high priestess Mary Magdalene.

Temple prostitution emulated that union in worship of the divine, and I suppose it was for this reason that the Church labelled this sacred woman with that inflammatory title of 'prostitute'; anathema for which some have mercifully since recanted and for which there is no written evidence.

The Passion of Christ

Consensus is mounting that Jesus and Mary married but what comes now challenged me more than anything else, so deeply embedded is it in our cultural psyche. Christianity expounds that Christ died on the cross; died for our sins, which I never quite understood.

I now subscribe to the beliefs postulated by other faiths that mercifully he survived. On reading the Bible and the Gnostic gospels it is abundantly clear. I now offer this to you and want to reiterate that this is taken from my interpretation of the biblical text and the Gnostic gospels, books which Rome omitted from the authorised Bible.

Now in fulfilment of scripture we move to the appointed hour:

> A little while, and you see me no more; again a little while, and you will see me.
>
> John 16:16

> The hour has come when the earthly son is glorified.
>
> John 17:1

One Week Before the Crucifixion

Six days before the Passover, Jesus and Mary had a celebration dinner. Martha her sister presented the food and Lazarus their brother sat with them and their guests. When they had dined, Mary left and then

returned with a pound of very expensive perfume of pure oil of spikenard.

Its heady bewitching fragrance filled the air. Lazarus and others talked but Judas was becoming uneasy, jealousy had taken root and a conversation echoed deep in his core:

> The companion is Mary of Magdala, Jesus loved her more than his students. He kissed her often on her face, more than all his students, and they said, 'Why do you love her more than us?'
> The saviour answered, saying to them,
> 'Why do I not love you like her? If a blind man and one who sees are together in darkness, they are the same. When light comes, the one who sees will see light. The blind man stays in darkness.'
>
> <div align="right">Gospel of Philip</div>

Mary placed the jar of balm on the table. They kissed, she cupping his head in her hands whilst stroking his cheek with her palm. The beloved Mary then anointed his head.

'My sweet lord, how fine you are to me. How much I love you.'

Mary's body sank to the ground, then lifting the hair shirt of his robe she lifted his foot to her knee. Her strong hands massaged the ointment into his flesh and up his calf. Then to be part of that anointing she pumiced his skin with her hair. His beautiful feet, the second toe so long and defined, the bones distinct and strong. These were features they shared, these and other physical traits which marked them as royal descent. The genetics of their shared DNA which set their roots and passed through to their growing tree.

She kissed them, then replaced the leather sandal. For a moment her head rested against his knee, then looking up she spoke;

'My lord. I have served you. This tincture from my alabaster jar will guard you and keep you safe.'

Judas could no longer contain himself:

> 'Why was this ointment not sold for three hundred denarii and given to the poor?'
>
> <div align="right">John 12:5</div>

Jesus's hand stretched out and caressed her hair. Then knotting it

around his fist he pulled her to him and kissed her on the cheek.

'Let her be, so she may keep it for the day of my burial. The poor you always have with you, but me you do not always have.'

John 12:7

With his words tears welled in her eyes. Always scripture to be followed. Was her faith strong enough to bear the Crucifixion and resurrection? She excused herself, and went to fetch some more wine. In her solitude she wept.

He took the twelve aside and said: 'We are now going up to Jerusalem; and all that was written to the prophets will come true for the Son of Man. He will be handed over to the foreign power. He will be mocked, maltreated, and spat upon. They will flog him and kill him. And on the third day he will rise again.'

Luke 18:31–33

Later at the House of Mary Magdalene

'Please Mary do not weep so.'

Joseph of Arimathea placed a comforting arm around her.

'You know this has to happen in accordance with the fulfilment of Scripture. Jesus must comply with the Word and do as he is ordained. He must be seen to die then rise again.'

Her torment escaped in an unearthly cry, then between sobs she tried to speak.

'Death. Not death. It must be life for the light, not darkness.'

Joseph struggled with his conscience.

'It will be. Remember the raising of your brother Lazarus?'

She nodded.

'Then that must be your guide. Have faith; for as ordained he will rise from the dead and fulfil the scriptures. Trust in me.'

Mary's crying grew weaker. Her hollow eyes searched longingly into his. How could she contain this eruption of painful emotion? How could feeling hurt so much, the strings tuned so taut as to nearly snap.

'You are going to save him. Oh thank you Joseph. I knew you wouldn't let him die. As Jesus saved my brother, so you will save him.'

Prostrating herself at his feet she cried out.

'Oh praise be to God. Ever merciful.'

Joseph could say no more. Not of his visit to Pilate, nor of Nicodemus's role. It was of paramount importance that Jesus should remain ignorant of how the scripture was to be interpreted.

Passover Celebrations

The next day a great body of pilgrims who had come for the Passover festival heard that Jesus was to be there and so took palm branches and went out to greet him.

'Hosanna! Blessings on him who comes in the name of the Lord! God bless the King of Israel!'

Jesus found a donkey and mounted it, in accordance with the text of Scripture:

'Fear no more, daughter of Zion; see, your king is coming, mounted on an ass's colt.'

His disciples didn't understand what he meant by this and only realised its significance when they realised that it had been prophesied.

Jubilant cheers rose from the crowd. Each looked to the other in shared euphoria, hands clasped hands and there was great beating of chests. This was indeed a time for celebration for the second coming was upon them.

> Still others, the Pharisees and those in power, were subdued; 'You see you can do nothing. Look the world has gone over to him!'
>
> John 12:19

Sand bowls swirled in the gathering ferment. A sweet smell of dates and hay, flocks of birds flying and hungry dogs weaving their way through robed corridors of colour and movement. The sun was high in the sky cut by the flight of a buzzard; time was ebbing to the hour of the last supper and the climax of his deliverance.

> The hour has come when the earthly son is glorified.
> Truly, truly I say to you,
> Unless a grain of wheat falling into the Earth dies
> It remains alone.
> But if it dies it brings forth a great harvest.
>
> John 12:23–24

Then Jesus was afraid.

'Now my soul is shaken
And what shall I say?
Father, save me from this hour?
But I came for this hour.
Father, glorify your name.'
With that from a cloudless sky cracked thunder and a distant voice:
'I have glorified it, and will glorify it again.'
Startled faces in the crowd looked up into the sky. Some cried out;
'It has thundered.' and others declared, 'An angel has spoken to
 him.'
Jesus looked to them and spoke:
'Not because of me has this voice come
But because of you.
Now is the judgement of the world,
Now the ruler of this world will be cast out.
And if I am raised above the Earth
I will draw everyone to me.'

<div align="right">John 12:27–32</div>

The joy of the crowd turned to confusion. How could this be happening?

'What son of man is this?'
 Jesus answered them:
 'The light is among you still, but not for long. Go on your way
while you have the light so that the darkness may not overtake you.
He who journeys in the dark does not know where he is going.
While you have the light, trust to the light, so that you may become
men of light.'

<div align="right">John 12:34–36</div>

They turned to one another in confusion. When they looked back he had vanished.

Again scripture had been fulfilled.

The crowd fell into a state of disbelief with euphoria overtaken by uncertainty. His words had undermined their exhilaration of a Messiah's coming, even those who believed in him denied him for fear of being

banned from the synagogue by the Pharisees. Isaiah's prophesy fulfilled.

> The word I spoke not from myself but from the one
> > Who sent me,
> The father has given me his commandment,
> > What I should say and how I should speak.
> And I know his commandment is life everlasting.
> So what I say,
> > As the father told me, I say it.
>
> > > John 12:49–50

This is the Gospel truth taken from St John.

In the meantime Joseph of Arimathea, the great-uncle of Jesus and a prominent member of the Sanhedrin, the high court of the Pharisees, was in dialogue with Nicodemus a fellow member and one who had met Jesus and been convinced by him. 'We must stop the handing over of Jesus to the Romans. To kill him on Passover eve is to invite the wrath of God.'

Nicodemus had already decided to intervene. 'I know that, Joseph. I talked into the night with my wife. We know where we stand on this. God is evidently with this man. We must call for a plea of mercy. I will forever be haunted by his words, "the wind blows where it wants to and you hear its sounds, but you cannot know where it came from and where it goes". I had already made my decision. I am going to see Pilate and make a personal plea on Jesus's behalf.'

'Thanks be that we both know him. Let's hope we can influence his decision.'

'And that of Jesus.'

The Last Supper

Jesus and his followers made their way through the streets past men carrying lambs for sacrificial slaughter to a side street and to an upper room to eat their Passover feast. Jesus believed this was to be his Last Supper and was mentally prepared.

The large room was ready with all they needed, a table set for thirteen, a batch of Passover bread, decanted wine, eggs to symbolise sacrifice and rebirth, nut and fruit paste, the bitter herbs of slavery, and a prepared lamb. Trumpets sounded from the temple as people settled for their celebrations. Seated beside him his beloved disciple rested her hand against his. A slight flicker of contact and humanity. To

his left and right the others talked. Then during supper, Jesus rose from the table, laid aside his garments and taking a towel tied it around him. Then he poured water into a basin and began to wash his disciples' feet and to wipe them with a towel.

After washing their feet he took his garments again and sat down. Then asked his disciples, 'Do you understand what I have done for you? You call me "Master" and "Lord" and rightly so, for that is what I am. Then if I, your Lord and Master, have washed your feet, you also ought to wash one another's feet. I have set you an example; you are to do as I have done for you. In very truth I tell you, the servant is not greater than his Master, nor a messenger than the one who sent him. If you know this, happy are you if you act upon it.

'I am not speaking about all of you. I know whom I have chosen. But there is a text of scripture to be fulfilled: "He who eats bread with me has turned against me."

'I tell you this now, before the event, so that when it happens you may believe that I am what I am. In very truth I tell you, he who receives any messenger of mine receives me; receiving me, he receives the One who sent me.'

Judas was to be the man to whom he gave the piece of bread.

'Do quickly what you have to do.'

Then once Judas had left Jesus said, 'Now the son of Man is glorified, and in him God is glorified. If God is glorified in him, God will also glorify him in himself; and he will glorify him now. My children, for a little longer I am with you; then you will look for me, and, as I told the Jews, I tell you now, where I am going you cannot come. I give you a new commandment; love one another; as I have loved you, so you are to love one another. If there is this love among you, then all will know that you are my disciples.'

After saying these words Jesus went out with his disciples and across the ravine where there was the garden of Gethsemane. It was there that he was overcome with anguish and dismay. He turned to Peter and two others, 'My heart is ready to break with grief. Stop here, and stay awake with me.'

Then he walked on a little, fell on his face in prayer and said, 'My Father, if it is possible, let this cup pass me by. Yet not as I will, but as thou wilt.'

When he joined his disciples he found them asleep.

'What! Could none of you stay awake with me one hour? Stay awake

and pray that you may be spared the test. The spirit is willing, but the flesh is weak.'

Sweet courageous Jesus left them again and went back to pray.

'My Father, if it is not possible for this cup to pass me by without my drinking it, thy will be done.'

Then once more he returned to his followers and once again he found them sleeping. So he went to prayer for a third time. Then he went back and woke them: 'Still sleeping. Still taking your ease? The hour has come! The Son of Man is betrayed to sinful men. Up, let us go forward; the traitor is upon us.'

Mary had not been with him, Mary would not have gone to sleep. It was the male disciples who ignored his pleas.

Then through the darkness broke the light of torches and lamps. It was a large group of people, soldiers, high priests and Pharisees. There, as ordained by scripture, Jesus was arrested and taken to Caiaphas, the High Priest who had previously advised the Jews that it would be in their interests if one man died for the whole people.

The cock crowed. Three times the apostle Peter denied him. Then in the early morning the chief priests and the elders agreed that Jesus should be put to death. They put him in chains and led him away to the governor's house.

When Judas saw that Jesus had been condemned he was distraught. He had been handed the piece of bread as a sign to betray his master. Judas could not live with what he had done, but which he had been ordained to do. Miserably he went and hanged himself. His name would be forever vilified, though he too was fulfilling scripture. (Maybe the hangman's noose associated with the Freemasons is taken from his final act.)

Gospel of Nicodemus/Pilate

The following extracts are taken from *The Apocryphal New Testament*, translated with notes by M.R. James, as shown at http://www.gnosis. org/library/gosnic.htm (accessed May 2012)

Chapter V:1

But a certain man, Nicodemus, a Jew, came and stood before the Governor and said: I beseech thee, good (pious) lord, bid me speak a few words. Pilate saith: Say on.

Nicodemus saith: I said unto the elders and the priests and Levites and unto all the multitude of the Jews in the synagogue: Wherefore contend ye with this man? This man doeth many and wonderful signs, which no man hath done, neither will do: let him alone and contrive not any evil against him: if the signs, which he doeth are of God, they will stand, but if they be of men, they will come to naught. For verily Moses, when he was sent of God into Egypt did many signs, which God commanded him to do before Pharaoh, Jannes and Jambres, and they also did signs not a few of them which Moses did, and the Egyptians held them as gods, even Jannes and Jambres; and whereas the signs which they did were not of God, they perished and those also that believed on them. And now let this man go, for he is not worthy of death.

Chapter V:2

The Jews say unto Nicodemus; Thou didst become his disciple and thou speakest on his behalf. Nicodemus saith unto them: Is the governor also become his disciple, that he speaketh on his behalf? Did not Caesar appoint him unto this dignity? And the Jews were raging and gnashing their teeth against Nicodemus. Pilate saith unto them: Wherefore gnash ye your teeth against him, wherens ye have heard the truth? The Jews say unto Nicodemus: Mayest thou receive his truth and his portion. Nicodemus saith: Amen, Amen: may I receive it as ye have said.

In the early morning sun Jesus faced Pilate. As he stood there the governor asked the gathering of priests: 'What charge do you bring against this man?'

'If he were not a criminal,' they replied, 'we should not have brought him before you.'

Pilate had a great sense of disquiet. His meeting with Nicodemus and the council from his friend Joseph had convinced him that to be part of this man's death would not bode well for him.

He addressed them impatiently: 'Take him away and try him by your own laws.'

The Jews argued back: 'We are not allowed to put any man to death.'

Pilate dropped his head in confusion and went back into his quarter. There he summoned Jesus.

'Are you the King of the Jews?'

Jesus replied: 'Is that your own idea, or have others suggested it to you?'

'What, am I a Jew?' said Pilate, 'Your own nation and their chief priests have brought you before me. What have you done?'

Jesus was calm. Courageous. Passively he responded, 'My kingdom does not belong to this world. If it did, my followers would be fighting to save me from arrest by the Jews. My kingly authority comes from elsewhere.'

'You are a king then?' Pilate questioned.

'King is your word. My task is *to bear witness to the truth*. For this was I born; for this I came into the world, and all *who are not deaf to truth listen to my voice*.'

'*What is truth?*' (Was this a password for the knowledge, the Druid 'truth against the World' connecting Pilate to Scotland and Fortingal?)

Pilate decided to go out again to the gathering crowd and address the priests. 'For my part,' he said, 'I find no case against him. You have a custom where I can release a prisoner. Who shall it be, Barabbas or Jesus, called Messiah?'

While Pilate waited for a response a message came to him from his wife, 'Have nothing to do with that innocent man; I was much troubled on his account in my dreams last night.'

Meanwhile the chief priests and elders had persuaded the crowd to ask for the release of Barabbas and to have Jesus put to death. So when Pilate asked 'Which of the two do you wish me to release to you?' they shouted back, 'Barabbas.'

'Then what am I to do with Jesus, called the Messiah?'

And with one voice they shouted all the louder, 'Crucify him!'

'Why, what harm has he done?' Pilate asked, but they shouted all the louder, 'Crucify him!'

Pilate despaired. He could see nothing was being gained, and a riot was starting, so he took water and washed his hands in full view of the people saying; 'My hands are clean of this man's blood; see to it yourselves.'

And with one voice the Jewish people cried, 'His blood be on us, and on our children.'

Pilate then ordered the release of Barabbas to them.

Soldiers then took Jesus into the governor's headquarters. They stripped him and dressed him in a scarlet mantle, and plaiting a crown

of thorns they placed it on his head and mocked him. Then they once again disrobed him, flogged him and led him away to be crucified.

Pilate had a placard made to be placed on the cross: 'Jesus the Nazarene the King of the Jews.'

The high priests complained: 'Do not write, "The King of the Jews" but write what he said. "I am king of the Jews."

Pilate dismissed them. 'What I have written, I've written.'

As they led him to execution they seized upon a man called Simon, from Cyrene, on his way in from the country, put the cross on his back and made him walk behind Jesus carrying it. Great numbers followed, many of them women who were weeping.

Jesus turned to them: 'Daughters of Jerusalem, do not weep for me; no, weep for yourselves and your children. For the days are surely coming when they will say, "Happy are the barren, the wombs that never bore a child, the breast that never fed one." Then they will start saying to the mountains, "Fall on us," and to the hills, "Cover us." For if these things are done when the wood is green, what will happen when it is dry?'

When they reached the place called the Skull, they divided his clothes and Jesus Christ was borne up on the cross. The screams of agony and sobs punctuated the still calm witness of the day.

It was midday. Overhead in a cloudless sky darkness fell. A huge cloud hovered and shadowed the land; the sun's light failed to disperse it. There it remained, looming.

At the tree of death where Jesus hung stood the women. His mother Mary, his consort Mary of Magdala. All were frightened, heavy-hearted and utterly bewildered.

Time seemed to be a farce, a capture and suspension of disbelief. Surreal. A hideous enactment of some kind, by actors under the direction of an unseen power. All were now captives in a time which was to be forever seared on the conscience of the world.

The caw of a crow as its black cloak shrouded the sun. Tear-streaked faces, inflamed eyes, shredded throats. All looked up. Then heads fell in despair.

Wretched.

All of them.

Save him, his face in half-shadow, his racked body near broken, was beauty, was light. Was grace.

Ever benign in his countenance, loving and magnificent in his

surrender to death. Even now in his suffering there was glory.

His words echoed in their ears. All had gone so fast, time had shifted and dominated them all, and was now taking him from them. Strangely there was beauty here. A profound strength of love that surmounted the jeers and goads of the ghoulish spectators.

Time was in abeyance. An enactment playing out with each of them there to play their part. Male apostles, not one, they were in hiding.

Ever benign in his countenance, loving and glorious. Even now in his suffering there erupted beauty.

Words echoed. Freeze-framed pictures filled their heads. Mary lowered her head and prayed. Prayed for life, and for love.

A calm. This too would pass.

Mary looked up at the gathering darkness above. Her ears tightening to listen for what was to approach.

It was time. Mid-afternoon. Straining, Jesus looked down on his mother and Mary. Flies were black upon his festering wounds and sweat poured from his brow. Then his head fell in a faint. Moments only, then a return to torment. He pulled his head heavenward. A glint of sunlight in the leaden gloom. Then knowing that all had been done to fulfil the words of the scripture Jesus said; 'I am thirsty.'

The jar which Joseph had given them was at their side. So Mary as instructed took the sponge and soaked it with the mixture. Placing it on a branch of hyssop they held it to his mouth.

Jesus's face flinched with the sting and bitter taste. Then a smile crossed his face and he looked down on them. 'It is accomplished.' His head bowed and he was gone.

His last look in the direction of Mary. Of his beloved disciple, he asked this, look after my mother. His last vision one of love. The women collapsed into each other's arms. A great wail escaped them and rose into the ever-darkening skies. A sole bird skirted the charcoal scene, then took flight towards the western horizon.

It was over.

Mary Magdalene beat her chest and closed her eyes in prayer. It was over.

Soldiers loomed into her vision. It was Friday and the Jews had demanded of Pilate that all legs of the victims should be broken so that they would die in time for the Sabbath Passover celebrations. Screams pierced the sky.

Unearthly agony of those condemned.

Dull thuds and cracks of splitting limbs.

Their souls about to break free from earthly torment.

Then they reached the cross of Jesus. The women held their arms. 'He has already gone to the Lord. Don't break his legs. We beseech you.' A particular centurion pushed them aside and took his position, then raising his lance he speared the side of Jesus. At once blood and water came out but the shell of the Messiah remained statuesque. A trickle of blood wormed its way down his abdomen. Slowly it made its journey, joining the other dying tributaries of suffering that had been inflicted upon him.

According to St John's gospel these things happened to fulfil the scripture. 'No bone of his will be broken' and elsewhere, in the Gnostic Bible, it says, 'They will look at him whom they stabbed.' This centurion was to become St Longinus. A man of God who declared Jesus as the son of God. Was he there working to fulfil scripture in compliance with Pilate and Joseph?

Resurrection

Pontius Pilate was approached by Joseph of Arimathaea, Jesus's secret disciple whilst also a Pharisee and member of the Sanhedrin. He requested permission to remove the body of Christ, to which Pilate willingly agreed. A relieved Joseph took Jesus to a private tomb in a garden where he anxiously awaited Nicodemus, who brought with him over half a hundredweight of aloes and myrrh with which to treat Christ's mangled body. Once they had tended him they wrapped him in aromatic spices and cool, fresh linen. The tightness of the linen curtailed the flowing blood from his wounds. The women took note of where the tomb was and went home to prepare spices and perfumes. They would leave the tomb until Sunday.

All of the above is taken from the gospels and therein lies its truth.

Truth against the World

Question if you will.

There in the coolness of his tomb Jesus recovered from the opiate elixir. He awoke drowsy, his vision blurred, his mind delirious. Gagging, he struggled against his numbness to sit up. The smell of the aloe and myrrh bandages cloyed. In the distance he could hear a cockerel and a screech of a peacock, a beetle scuttled over his foot. Darkness surrounded him, but yet there was light. Was this death? Would one

want to come back to the living? A sudden surge of nausea swept over him. A loud knocking pounded in his head. Questions tumbled through his daze.

Where was he? What place was this? Was he in his Father's house? Why so cold? Shivers started in him and took over his whole body. An eruption of his awakenment. He couldn't think, couldn't remember.

Suddenly out of his control, his hands, heavy, sore and very stiff moved to the bandages and clawed at them. His stomach heaved, the sound of his wretch, then exquisite pain as the wounds broke open. Panic and a sense of capture. He frantically pulled at his bandages. He cried out in pain. Vomited. Then, struggling, made himself free. This was not death, this was life, sensation, suffering.

Chinks of light, dust caught in the beam. A dawn chorus of birdsong. This dead man was awake. Bandages and linen fell away to the ground. He was left with unspeakable pain and an overriding sense of being alone. He tried to walk, stumbled. Steadied himself with a hand to bare forbidding rock. Cried out in pain. Then read the contours of his tomb. Disorientated, alone. Water, he needed water. His tongue rasped against his teeth.

Into his void came a thunder. A quake of energy. Then a light which blinded him. He fell to the ground, returned to his darkness and to dreams.

Time passed, two men in 'dazzling garments' appeared at his side. The tomb was opened. Light-headed with the rush of fresh air, and the agony of his mutilated feet and body. More time, sedation and sleep then days passed into night which turned once more to the third day.

On the third day together they made their escape, turned their backs on darkness and walked to the light.

All was attended to. The scripture was again fulfilled; he had risen on the third day. The two had treated him and made him whole once more.

The sun rose in the east once more. Mary would soon join him from the west.

Early on the Sunday morning, while it was still dark, Mary of Magdala went to the tomb. Everything was strangely quiet. She had expected to see guards, but there were none. She found the tomb and was shocked to see that the stone had been removed and the entrance was open. Frightened, she ran to get help from the disciples. When

they got there they peered inside. The linen wrappings were there. Then Simon went in. The tomb was empty. Talking one with the other they then returned home, but Mary stood at the tomb weeping. As she wept she too peered into the tomb and she saw two men in dazzling white. Their faces shone like lightning.

'Why are you weeping?' they asked. Mary tried to explain.

'Why search among the dead for one who lives? Remember what he told you while he was still in Galilee, about the Son of Man; how he must be given up into the power of sinful men and be crucified, and must rise again on the third day.'

Her face ashen, startled and afraid. 'Where have they taken him?' Then her knees buckled for her prayers had been answered.

Then Jesus saw her there. 'Mary, my sweet Mary. Mary, don't be afraid. I am alive.'

She rushed to him. Sobs of joy filled the mists of early morning.

Prostrate before him she clasped his feet. Jesus bent down to her, 'Mary, don't be afraid. I have risen, but now you must go and tell the others. They will see me shortly. For now there are things I must do. I have yet to ascend to my Father.'

Late that Sunday evening Jesus came and stood in their midst, 'Peace be with you.' He could see they couldn't believe their eyes so showed them his hands and feet. Then he breathed on them, saying, 'Receive the Holy Spirit.' They were still startled and terrified. They thought they were seeing a ghost.

'Look, it is I myself. Touch me and see, no ghost has flesh and bones as you can see that I have.' Still unconvinced, still wondering, for it all seemed too good to be true. So he asked them, 'Have you anything to eat?' With that they offered him a piece of fish they had cooked, which he took and ate before their eyes. And he said to them: 'This is what I meant by saying, while I was still with you, that everything written about me in the Law of Moses and in the prophets and psalms was bound to be fulfilled.'

Then he opened their minds to understand the scriptures. 'This,' he said, 'is what is written that the Messiah is to suffer death and to rise from the dead on the third day.'

But Thomas, who was one of the 12, called the twin, was not with them when Jesus came. But he said to them, 'Unless I see the mark of the nails in his hands and I put my finger into the place of the nails and I put my hand into his side, I shall not believe.'

Eight days later

Then Jesus said to Thomas:

'Bring your fingers here and see my hands,
And bring your hand and put it in my side,
And do not be without faith but of faith.'

Thomas answered, saying to him,

'My Lord and my god.'

They were assured and uplifted. They would see him again of that they were sure. For now he must conceal himself. He was still in danger of his life.

He was to meet them one last time. It was to be some time later, by the Sea of Tiberias. The disciples were fishing, it was morning and Jesus was standing on the beach.

'Friends have you caught anything?'

They couldn't make out who it was but shouted back, 'No.'

'Then shoot your net to starboard and you will make a catch.'

They did as he suggested and found the net was so full they could not land it. Then one said to Peter, 'It is the Lord.'

'Come and eat,' shouted Jesus.

Then he instructed them for the last time. 'This is the student who testifies to these things and who has written these things, and we know that his testimony is true.'

And there are many things that Jesus did. If they were written down one by one, I think the world itself would not have room to hold the books that would be written.

This is the truth as taken from the Gospel of Luke and John. This man was not a ghost. A ghost is not flesh and blood. A ghost does not breathe nor eat. A dead body does not exude blood and water. This man was alive. Praise be to God.

From here a new chapter was to start. In fear of the Jews and the Romans Mary Magdalene and Jesus first fled to Egypt. A girl child was gifted to them as their seed. From there on across the waters of the Mediterranean to Gaul.

Mary's brother Lazarus would come too, as would Martha, Mary's sister, who would also preach and others, including Joseph of Arimathea. Their boat was to be small, but big enough to spread the word.

The crossing was fraught with danger. Storms raged, then calm stranded them. Days passed. Hunger and exhaustion ravaged them as

they waited and prayed. Sea-faring Joseph kept their course. Then on the seventh day a dove flew overhead. A light drizzle hung in the air, misting on their drawn faces. Then the sky slowly cleared as a strengthening sun dispersed the storm. A clear passage to salvation. On the horizon a rainbow capped the chalk mountains of southern France. Voices lifted. It was an omen.

'Land!'

Excited arms outstretched.

'Look! We have arrived.'

A channel of sunlight glimmering like thrown stars from the Milky Way guided them ashore. Seagulls posted on rocky outcrops warily watched them sail in. Then the crunch of wooden timbers touching shale, the leaden splash of water and spray as the anchor was dropped. Silence for a moment. A benediction.

In Summation

The spikenard which Mary rubbed over Jesus has known medicinal properties, notably for fractures and bruising. Was this prophylactically applied pre-Crucifixion to aid his recovery? It also has healing properties for both emotional and physiological needs. When inhaled it has a calming influence. The fragrance is very heady and Jesus would have been aware of its perfume as he faced submission on the cross.

Nicodemus and Joseph procured 100 pounds of aromatic substances.

> So Joseph came and took the body away. He was joined by Nicodemus (the man who had first visited Jesus by night), who brought with him a mixture of myrrh and aloes, more than half a hundredweight.
>
> John 19:38–39

That was a substantial quantity in weight. If it was in powdered or dried form it would have filled numerous sacks. More so if it were mixed with oil. More intriguing are the qualities of the herbs mentioned.

Myrrh was used as an ingredient in Egyptian embalming, but not for the Jews. The Jewish custom prescribed that the body be washed and oiled, the hair cut, the corpse dressed again and the face covered with a cloth. None of which is mentioned in the Gospels. Indeed, we are told Mary came the following day to oil the body. A contravention

of the burial rite. So what was going on, what was the significance of these herbs?

For me it is clear that they were a healing treatment. Aloe vera was used in medicine and for incense as far back as antiquity. The sticky gel of its core was used, amongst other things, for healing wounds. Myrrh was a sacred anointing oil but it also has strong disinfectant power. It was used for healing wounds from very early times. These substances combined were commonly used for the treatment of large injured areas, because they could easily be made into ointments and tinctures.

There can therefore be no doubt that Nicodemus procured an astonishing quantity of highly specific medicinal herbs with the sole purpose of treating the wounds on the body of Jesus.

My conviction is that from the Gospels and particularly John's Gospel, there runs a secret narrative which was and is intended to reveal a tremendous event to the attentive reader, whilst being concealed from the eyes of others. Namely that Jesus did not die, Joseph and Nicodemus hatched a plan to ensure he didn't. In the tomb they brought Jesus back to life, not by miracles, but by applying the art of healing.

There was no intention to bury Jesus, he was to be healed in peace. The Gospels report that Jesus was subjected to the cross for six hours. This unexpectedly rapid death still challenges the medical fraternity today. Pilate too was puzzled by it and asked the leading centurion if everything was in order (Mark 15:44). Some say it was because of his generally weak condition that he succumbed in such a short period of time. The consensus is that this is unlikely.

The centurion who speared Christ's side was called Longinus. According to tradition he later became a bishop in his Cappadocian homeland and in some countries is venerated as a saint. I think this indicates that he may well have had some connection with Jesus, maybe even been a secret follower. By lancing Christ's side he released pressure that could have been hampering his breathing. This would make many of the events during the Crucifixion understandable. Both Joseph and Nicodemus knew that the Crucifixion could not be avoided BUT if they could bring him down early it would be possible to keep him alive. He would be able to continue his mission. The special emphasis about the blood and water flowing from Jesus's side is testimony to the fact that he was still alive, since corpses do not bleed.

Nicodemus and Joseph had been given permission to lay Jesus in a

new tomb which had never before been used for burial, there in that tomb they tended him. That it was a tomb was an alibi, the new structure was simply to be a place where they could treat the seriously wounded Jesus.

The vinegar drink, again mentioned in John's Gospel, offered up to Christ before he succumbed to unconsciousness was in context with this and was some form of narcotic, most probably opium dissolved in some fluid. This has the combined effect of being a narcotic and a very effective pain killer. The dose would have been designed to make him lose consciousness in a short time and so be able to hang on the cross as if dead. Heart beat and respiration lower on absorption of it. The body goes limp, mirroring death itself.

Further proof of his survival, and 'resurrection' come in the testimony he gives to others when they see him. Of his being material, flesh. If not, why would the stone have been rolled away from the tomb, he would have walked through it! Christ had indeed risen but from a drug-induced coma, not death.

> Why seek ye the living among the dead?
>
> Luke 24:5

Does that not compel us to assume that Jesus was alive? We have an interesting confirmation of this in the Gospel of Peter, where a guard states that he saw three men leaving the tomb, 'and two of them supported the other one'.

Not a resurrected Jesus but an injured one. One who needed physical support.

He confirmed his earthly reappearance to his apostles:

> There he was standing among them. Startled and terrified, they thought they had seen a ghost. But he said 'Why are you so perturbed? Why do questionings arise in your minds? Look at my hands and feet. It is I myself. Touch me and see; no ghost has flesh and bones as you can see that I have.' They were still unconvinced, still wondering, for it seemed too good to be true. So he asked them, 'Have you anything here to eat?' They offered him a piece of fish they had cooked, which he took and ate before their eyes.
>
> And he said to them. 'This is what I meant by saying, while I

was still with you, that everything written about me in the Law
of Moses and in the prophets and psalms was bound to be
fulfilled.'

<div align="right">Luke 24:36–44</div>

The Gospels confirm it: Jesus survived the Crucifixion.

As Pope Leo X pronounced in John Bale's *Acta Romanorum
Pontificum* ('The Pageant of the Popes' tr. 1574): 'It has served us
well, this myth of Christ.'

Now we have the true story and may it serve us well. Amen.

More books testify to Christ's survival, it is even alluded to, as we have
seen, in the Declaration of Arbroath. I believe there are also manuscripts
that attest to it which are housed somewhere in the 20 miles of
corridors in the Vatican, books we will never read, possibly the
documents Saunière discovered at Rennes-le-Château amongst them.
More knowledge lies hidden or forgotten. For this story, the beauty is
that his flesh was made our flesh. He survived. His wounds healed.
From here a new chapter starts.

This is the trail of truth that the painting, the engravings, the stamp
of the Declaration of Arbroath and the other things have taken me on.

What an extraordinary pilgrimage it has been. One of a lifetime. It
has been a daunting experience to be part of and a tremendous
responsibility to do of my best. I have faith that those who believe in
God, in Jesus and the Sacred Feminine will resonate with what I have
striven to place before you, and pray to God that orthodox religion
does not coax others further into their shell of dogma and blind belief.
Please, I beseech you, question.

Finally, I never knew when I set out on this venture that this would
be the outcome. I held no preconceived ideas and my aim was merely
to question what had been submitted to me to investigate. I truly
believe it, and would not have subjected you to it if I didn't. There are
lots more books to read on this subject, which I urge you to do. Thank
you.

Another thought to leave you with. What of the shroud and the
significance attached to it by so many, particularly the Knights Templar?
Again so much controversy. Obviously, as I believe Jesus survived the
butchery of Crucifixion I can't subscribe to its being a death shroud,
but that doesn't negate its significance.

If there is indeed blood on the linen, then the implications are staggering and link back to the DNA double helix at Rosslyn, Leonardo's double helix staircase at Chambord. Yes DNA, what could be more tantalising, more challenging than that Christ's DNA is held in the blood in that cloth?

What would it mean, could we find a match? If we did, there would be proof of the bloodline. A line oceans deep, covering the whole planet. All in one with Jesus and Mary.

I am left with one last thought; I wonder if the shroud has his second toe longer than his big toe. It was the feet of the shroud that the Templars kissed.

One last leap, and I am gone. Thank you for bearing with me.

> In the normal course of events many men and women are born with remarkable talents; but occasionally, in a way that transcends nature, a single person is marvellously endowed by Heaven with beauty, grace and talent in such abundance that he leaves other men far behind, all his actions seem inspired and indeed everything he does clearly comes from God rather than from human skill. Everyone acknowledged that this was true of Leonardo da Vinci, an artist of outstanding physical beauty, who displayed infinite grace in everything that he did and who cultivated his genius so brilliantly that all problems he studied he solved with ease.
>
> Giorgio Vasari, *Lives of the Artists*

Timeline for Leonardo da Vinci

1452–1519

1452	15 April	Illegitimate birth of Leonardo da Vinci to a 16-year-old peasant girl, father a wealthy notary, Piero Fruosino di Antonio da Vinci. Various propositions that he lived with his mother initially then with his father and grandparents. Father moved to Florence and Leonardo remained with grandparents until his father took him to join him in Florence. Those formative years in the Tuscan landscape shaped his thinking and spirit of enquiry which were to continue throughout his life.
1467		Apprentice to Andrea del Verrocchio, leading Florentine painter and sculptor.
1472		Entered San Luca guild of painters but stayed at Verrocchio's studio. First documented work of his of an angel kneeling in a work of Verrochio's titled *The Baptism of Christ*. Verrochio was so chastened by the excellence of Leonardo's execution that he gave up painting. At this time too Leonardo adopted the Flemish/northern use of oil rather than tempura, which was to change painting practice.
1472–75		*The Annunciation.*
1475		*Madonna with Carnation.*
1475–78		*Madonna Benois.*

1478–80	Portrait of Ginevra de' Benci. NB same V in hairline as shared with Last Commission and *Madonna of the Rocks* and figure in *The Last Supper*.
1480–82	*St Jerome in the Wilderness* (unfinished).
1481–82	*Adoration of the Magi* for the Church of San Donato a Scopeto (unfinished).
1482	Move to Milan to patronage of Ludovico il Moro, where he remained for nearly 18 years, offering his services as a military engineer primarily, and sculptor and painter.
1483	Commission for the Franciscan Confraternity of the Church of San Francesco Maggiore for the *Madonna of the Rocks*. Not paid as the monks said the commission had not been properly fulfilled. Similarity between the profile and hairline of this Madonna with the one in my painting.
1487	World-famous drawing of the 'Vitruvian Man'. The drawing represents the proportions of man and is part homage to the Roman architect Vitruvius.
1490	Portrait of Cecilia Gallerani (*Lady with an Ermine*).
1490	Portrait of an unknown woman (*La Belle Ferroniere*).
1490	*Madonna Litta*.
1490	Work on model of equestrian statue for Ludovico Sforza. (unfinished).
1492	Contemporary of Leonardo's Christopher Columbus's voyage to America.
1494	Charles VIII of France (Order of St Michael, as were leading aristocrats including René d'Anjou bearing scallop shell as their emblem) occupies Naples.
1495–98	*The Last Supper* for the refectory of the Dominican church, Santa Maria delle Grazie. Controversial painting referred to in Dan Brown's book *The Da Vinci Code*. Note profile and hairline match with *Madonna of the Rocks* and my painting. Apparently three matching profiles and hairlines.

1498	Louis XIV, a patron of Leonardo's succeeds Charles VIII.
1499	Leonardo leaves Milan for France after nearly 18 years of patronage at the court of Ludovico Sforza.
1500	Return to Florence.
1500	*The Virgin and Child with St Anne and St John the Baptist* possibly sketched at the Servite monastery in Florence.
1502–16	*Virgin and Child with St Anne.*
1502	Employment as architect and military engineer for General Cesare Borgia. Whilst in his employ created *Madonna of the Yarnwinder* and military maps for Borgia.
1503	Return to Florence and possibly commission by Francesco del Giocondo to paint his wife? *Mona Lisa* ('La Gioconda') 1503–06 and the creation of a new technique '*sfumato*' in which the features are softened. The portrait, if it was commissioned by del Giocondo, was never delivered to the client and Leonardo kept it at his side for the remainder of his life.
	Whilst in Florence Leonardo also performed dissections in the hospital of Santa Maria Nuova, and provided a comprehensive account of the structure and function of the human body. He also made detailed studies of other natural phenomena, from the flight of birds to the movements of currents, and created vast collections of data pertaining to them. The act of human dissection, of course, was seen by the Church as heretical and was brought to an end.
1504	Francesco da Vinci, Leonardo's uncle, bequeaths his estate to him. This is contested by his stepbrothers in 1507 and Leonardo battles it out in law.
1505	Leonardo studies the flight of birds and is unsuccessful in creating a flying machine.

1506	Commission for the Grand Council Chamber in the Palazzo Vecchio, the Florentine seat of government, *The Battle of Anghiari* (unfinished). Opposing wall to be painted by Michelangelo, *The Battle of Cascina* was also left unfinished.
1506–12	In Milan under the patronage of Charles d'Amboise, French governor of the city for French King Louis XII.
1506–10	*Leda and the Swan*
1507	Appointed painter and engineer to Louis XII.
1511	Death of Charles d'Amboise; allegiance moved to Giuliano de' Medici, brother of the future Pope Leo X. Move to the papal court in Rome. No major works commissioned of him by the Pope, much to his chagrin most commissions were given to Raphael or Michelangelo.
1513–16	*St John the Baptist* (which remained with him until his death) and one too of *Bacchus* ('St John the Baptist').
1513	Leonardo moves to Rome where he lives in the Belvedere with his companions Melzi and Salai. Whilst here Pope Leo halts his human dissections and cites the possible heretical act of necromancy and magic.
1515	Death of King Louis XII. Successor King Francis I reconquers the Milanese region.
1515	Commission by Pope Leo X to make mechanical lion which displayed the fleur-de-lys at its heart. The lion to represent Pope Leo and the fleur-de-lys the French king. This was to be centrepiece for the peace negotiations between the French King Francis I and Pope Leo X. Possible first meeting of Leonardo and King Francis. Though the French King Louis XII who commissioned works of Leonardo and asked for his attendance, where Louis failed Francis was to succeed. We have record of two portraits of 'Our Lady' recorded for King Louis XII.

1516		Leonardo finally accepts an invitation by King Francis I to enter the French court as 'the first painter, engineer and architect of the king'. He takes with him the *Mona Lisa* and *St John the Baptist*. His two companions Salai and Melzi also go with him. He moves into the Château of Cloux.
		There is no record of any paintings undertaken by him during his three-year stay: painter to the king and yet no artwork.
1516–19		Hypothesis: *The Last Commission* drawn by Leonardo for King Francis I. Due to stroke possibly aided by Melzi, possibly unfinished due to his death.
1519	23 April	Leonardo makes his will.
	2 May	Leonardo dies in Cloux.
1605–21		Papal bull attached to rear of painting by Pope Paul V, instigator of the Vatican's secret archives.

Please note: all Leonardo's paintings show the anatomical detail of an extended second toe, but not on all his subjects, generally just the higher ranking of his subjects. This is known as Morton's toe or Greek toe (*piede Greco*) which affects a relatively small proportion of the general public. It is often to be seen in classical sculpture.

The visible sign of a V in the hairline as shared with *Last Commission* and seen in *Madonna of the Rocks*, figure in *The Last Supper* and Ginevra de' Benci. Leonardo did not follow this hairline in all his portraits.

Translation of the Declaration of Arbroath

To the most Holy Father and Lord in Christ, the Lord John, by divine providence Supreme Pontiff of the Holy Roman and Universal Church, his humble and devout sons Duncan, Earl of Fife, Thomas Randolph, Earl of Moray, Lord of Man and of Annandale, Patrick Dunbar, Earl of March, Malise, Earl of Strathearn, Malcolm, Earl of Lennox, William, Earl of Ross, Magnus, Earl of Caithness and Orkney, and William, Earl of Sutherland; Walter, Steward of Scotland, William Soules, Butler of Scotland, James, Lord of Douglas, Roger Mowbray, David, Lord of Brechin, David Graham, Ingram Umfraville, John Menteith, guardian of the earldom of Menteith, Alexander Fraser, Gilbert Hay, Constable of Scotland, Robert Keith, Marischal of Scotland, Henry St Clair, John Graham, David Lindsay, William Oliphant, Patrick Graham, John Fenton, William Abernethy, David Wemyss, William Mushet, Fergus of Ardrossan, Eustace Maxwell, William Ramsay, William Mowat, Alan Murray, Donald Campbell, John Cameron, Reginald Cheyne, Alexander Seton, Andrew Leslie, and Alexander Straiton, and the other barons and freeholders and the whole community of the realm of Scotland send all manner of filial reverence, with devout kisses of his blessed feet.

Most Holy Father and Lord, we know and from the chronicles and books of the ancients we find that among other famous nations our own, the Scots, has been graced with widespread renown. It journeyed from Greater Scythia by way of the Tyrrhenian Sea and the Pillars of Hercules, and dwelt for a long course of time in Spain among the most savage peoples, but nowhere could it be subdued by any people, however barbarous.

Thence it came, twelve hundred years after the people of Israel crossed the Red Sea, to its home in the west where it still lives today. The Britons it first drove out, the Picts it utterly destroyed, and, even though very often assailed by the Norwegians, the Danes and the English, it took possession of that home with many victories and untold efforts; and, as the histories of old time bear witness, they have held it free of all servitude ever since. In their kingdom there have reigned one hundred and thirteen kings of their own royal stock, the line unbroken by a single foreigner.

The high qualities and merits of these people, were they not otherwise manifest, gain glory enough from this: that the King of kings and Lord of lords, our Lord Jesus Christ, after His Passion and Resurrection, called them, even though settled in the uttermost parts of the Earth, almost the first to His most holy faith. Nor did He wish them to be confirmed in that faith by merely anyone but by the first of His apostles – by calling, though second or third in rank – the most gentle Saint Andrew the Blessed Peter's brother, and desired him to keep them under his protection as their patron forever.

The Most Holy Fathers your predecessors gave careful heed to these things and strengthened this same kingdom and people with many favours and numerous privileges, as being the special charge of the Blessed Peter's brother. Thus our nation under their protection did indeed live in freedom and peace up to the time when that mighty prince the King of the English, Edward, the father of the one who reigns today, when our kingdom had no head and our people harboured no malice or treachery and were then unused to wars or invasions, came in a guise of a friend and ally to harass them as an enemy. The deeds of cruelty, massacre, violence, pillage, arson, imprisoning prelates, burning down monasteries, robbing and killing monks and nuns, and yet other outrages without number which he committed against our people, sparing neither age nor sex, religion nor rank, no one could describe nor fully imagine unless he had seen them with his own eyes.

But from these countless evils we have been set free, by the help of Him Who though He afflicts yet heals and restores, by our most tireless prince, King and lord, the lord Robert. He, that his people

and his heritage might be delivered out of the hands of our enemies, bore cheerfully toil and fatigue, hunger and peril, like another Maccabaeus or Joshua. Him, too, divine providence, the succession of his right according to our laws and customs which we shall maintain to the death, and the due consent and assent of us all have made our prince and king. To him, as to the man by whom salvation has been wrought unto our people, we are bound both by his right and by his merits that our freedom may be still maintained, and by him, come what may, we mean to stand.

Yet if he should give up what he has begun, seeking to make us or our kingdom subject to the King of England or the English, we should exert ourselves at once to drive him out as our enemy and a subverter of his own rights and ours, and make some other man who was well able to defend us our King; for, as long as a hundred of us remain alive, never will we on any conditions be subjected to the lordship of the English. It is in truth not for glory, nor riches, nor honours that we are fighting, but for freedom alone, which no honest man gives up but with life itself.

Therefore it is, Reverend Father and Lord, that we beseech your Holiness with our most earnest prayers and suppliant hearts, inasmuch as you will in your sincerity and goodness consider all this, that, since with Him Whose vice-regent on Earth you are there is neither weighing nor distinction of Jew and Greek, Scotsman or Englishman, you will look with the eyes of a father on the troubles and privations brought by the English upon us and upon the Church of God. May it please you to admonish and exhort the King of the English, who ought to be satisfied with what belongs to him since England used once to be enough for seven kings or more, to leave us Scots in peace, who live in this poor little Scotland, beyond which there is no dwelling-place at all, and covet nothing but our own. We are sincerely willing to do anything for him, having regard to our condition, that we can, to win peace for ourselves.

This truly concerns you, Holy Father, since you see the savagery of the heathen raging against the Christians, as the sins of Christians have indeed deserved, and the frontiers of Christendom being pressed inward every day; and how much it will tarnish your Holiness's memory if (which God forbid) the Church suffers eclipse or scandal in any branch of it during your time, you must

perceive. Then rouse the Christian princes who for false reasons pretend that they cannot go to help of the Holy Land because of wars they have on hand with their neighbours. The real reason that prevents them is that in making war on their smaller neighbours they find a readier advantage and weaker resistance. But how cheerfully our Lord the King and we too would go there if the King of the English would leave us in peace, He from Whom nothing is hidden well knows; and we profess and declare it to you as the Vicar of Christ and to all Christendom.

But if your Holiness puts too much faith in the tales the English tell and will not give sincere belief to all this, nor refrain from favouring them to our undoing, then the slaughter of bodies, the perdition of souls, and all the other misfortunes that will follow, inflicted by them on us and by us on them, will, we believe, be surely laid by the Most High to your charge.

To conclude, we are and shall ever be, as far as duty calls us, ready to do your will in all things, as obedient sons to you as His Vicar; and to Him as the Supreme King and Judge we commit the maintenance of our cause, casting our cares upon Him and firmly trusting that He will inspire us with courage and bring our enemies to nought.

May the Most High preserve you to his Holy Church in holiness and health for many days to come.

Given at the monastery of Arbroath in Scotland on the sixth day of the month of April in the year of grace thirteen hundred and twenty and the fifteenth year of the reign of our King aforesaid.

Translation of the Declaration of Arbroath, rev. 2005 by Alan Borthwick, based on Sir James Fergusson *The Declaration of Arbroath 1320* (1970). Accessed from http://www.nas.gov.uk/downloads/declarationArbroath.pdf, May 2012

Bibliography

Adil, Hajjah Amina. *Lore of Light,* Vol. 1, Institute for Spiritual and Cultural Advancement 2008

Affianti, Eraldi. *Leonardo da Vinci Prophesies,* Hesper US Press 2002

Allen, Paul; Allen, Joan de Ris. *Fingals Cave: The Poems of Ossian and Celtic Christianity,* Continuum Ref. 1999

Andrews, Richard; Schellenberger, Paul. *The Tomb of God,* Little Brown 1996

Armit, Ian. *Celtic Scotland,* Batsford 1998

Arrases, Daniel. *Leonardo da Vinci,* Konecky & Konecky 1998

Saint Augustine. *City of God,* Penguin 2003

Baigent, Michael. *The Jesus Papers,* Element 2006

Baigent, Michael; Leigh, Richard; Lincoln, Henry. *The Holy Blood and the Holy Grail,* Arrow Books 1996

Barber, Richard. *The Holy Grail: Imagination and Belief,* Penguin, Allen Lane 2004

Barnes, Dr. Ian. *World Religions,* Eagle Editions 2007

Barnstone, Willis; Meyer, Marvin. *The Gnostic Bible,* New Seeds 2006

Baxandall, Michael. *Painting and Experience in Fifteenth Century Italy,* Oxford Paperbacks 1988

Bayley, Harold. *The Lost Language of Symbolism,* William and Norgate 1912

Begg, Ean. *The Cult of the Black Virgin,* Penguin 1996

Bely, Lucian. *The Cathars,* Sud Quest 1995

Black, Jonathan. *The Secret History of the World,* Quercus 2007

Bower, Walter. *A History Book for Scots,* Hercat 2007

Bowker, John. *The Complete Bible Handbook,* Dorling Kindersley 2004

Bramley, Serge. *Leonardo The Artist and The Man,* Penguin 1988

Brown, Dan. *The Da Vinci Code,* Corgi 2004

Burstein, Dan. *Secrets of the Code*, W & N 2004

Cabassoles, Philippe de. *Life of St Mary Magdalene*, 1355

Capt, E. Raymond. *Our Great Seal: The Symbols of Our Heritage and Our Destiny*, Artisan Sales 1979

———*The Traditions of Glastonbury*, Artisan Sales 1983

Carradice, Ian. *Greek Coins*, British Museum Press 1995

Cashford, Jules. *The Moon: Myth and Image*, Cassell 2005

Cavallo, Adolfo Salvatore. *The Unicorn Tapestries*, Yale University Press 2010

Cellini, Benvenuto. *Autobiography*, Penguin Classics 1999

Clark, Kenneth. *Looking at Pictures*, John Murray 1972

Clarke, William Newton. *Outline of Christian Theology*, T & T Clark 1908

Coelho, Paulo. *The Pilgrimage*, HarperCollins 2003

Cox, Ian. *The Scallop*, Shell Transport and Trading Co. 1957

Daraul, Arkon. *Secret Societies*, Tandem 1965

Davies, Paul. *The Mind of God*, Penguin 1992

Devereux, Paul. *Sacred Geography: Deciphering Hidden Codes in the Landscape*, Gaia 2010

Dickinson, William Croft. *Scotland From the Earliest Times to 1603*, Thomas Nelson and Sons Ltd 1961

Driver, Jack. *Freemasonry: Illustrated History of the Once Secret Order*, Kandour Ltd 2006

Dunford, Barry. *The Holy Land of Scotland*, Sacred Connections 2002

Dunn, Mary Jane; Davidson, Linda Kay. *The Pilgrimage to Compostela in the Middle Ages*, Routledge 2000

Eckhart. *Meister Eckhart Selected Writings*, Penguin Classics 1994

Ehrman, Bart D. *Lost Scriptures*, University Press Oxford 2003

Elder, Isabel Hill. *Celt, Druid and Culdee*, Covenant Publishing 1994

Eliade, Mircea. *Images and Symbols*, Princeton University Press 1991

Ellis. *Awakening Osiris*, Phanes 1988

Epic of Gilgamesh, Penguin Books 2003

Feather, Robert. *The Secret Initiation of Jesus At Quamran*, Watkins 2006

Ferguson, George. *Signs and Symbols in Christian Art*, Oxford Paperbacks 1961

Field, Reshad. *The Last Barrier; A Journey into the Essence of Sufi Teachings*, Lindisfarne Books 2002

Forsyth, Thomas Miller. *God of the World*, George Allen & Unwin 1952

Foster, Sally M. *Picts, Gaels and Scots,* Batsford 1997

Foxe, John. *The Acts and Monuments of the Christian Church* or *Foxe's Book of Martyrs,* first published 1563

Frale, Barbara. *The Templars and the Shroud of Christ,* Maverick House 2011

Fraser, Antonia. *Love and Louis XIV,* Orion 2006

Frazer, Sir James. *The Golden Bough: A Study in Magic and Religion,* Wordsworth Reference 1993

Freke, Gould, Robert. *The Ancient Mysteries: The Essenes, the Roman Collegia and the Culdees,* Kessinger Publishing 2010

Freke, Timothy; Gandy, Peter. *The Hermetica: The Lost Wisdom of the Pharaohs,* Tarcher Cornerstone Editions 1997

—— *Jesus and the Lost Goddess,* River Press 2001

Gardner, K. *Sounding the Inner Landscape: Music as Medicine,* Thorsons 1997

Gardner, Laurence. *Bloodline of the Holy Grail,* Element 2002

—— *The Magdalene Legacy,* Element 2005

—— *Realm of the Ring Lords,* Element 2003

Geismer. *Lectures on the Religious Thought of Søren Kierkegaard,* Augsburg 1937

Gelb, Michael J. *Da Vinci Decoded,* Delacorte 2004

Gerber, P. *The Search for the Stone of Destiny,* Canongate 1992

Gitlitz, David; Davidson, Linda Kay. *The Pilgrimage Road to Santiago,* St Martin's Griffin 2000

Gordon-Cumming, C.F. *In the Hebrides,* Chatto & Windus 1883

Graves, Robert. *King Jesus. A Novel,* Farrar Straus Giroux 1981

—— *The White Goddess,* Faber 1999

Greer, John Michael. *Element Encyclopedia of Secret Societies and Hidden Histories,* Element 2006

Guiraud, Jean. *The Medieval Inquisition,* Kessinger 2007

Hageneder, F. *Yew: A History,* The History Press 2007

Hall, Manly P. *Lectures on Ancient Philosophy,* Tarcher/Penguin 2005

—— *The Secret Teachings of All Ages,* Tarcher/Penguin 2003

Hall's Dictionary of Subjects and Symbols in Art, John Murray 1974

Hancock, Graham. *The Sign and the Seal,* Touchstone 1993

—— *Supernatural,* Century 2003

Hartley, Christine. *The Western Mystery Tradition,* Thoth Publications 2003

Hassnain, Fida. *A Search for the Historical Jesus,* Gateway 1994

Hay, Fr R.A. *Genealogie of the Sainteclaires of Rosslyn*, Thomas G. Stevenson 1835

Helminski, Kabir Edmund. *Living Essence*, Tarcher/Putnam 1992

Hopkins, Marilyn; Simmans, Graham; Wallace-Murphy, Tim. *Rex Deus: The True Mystery of Rennes-le-Château and the Dynasty of Jesus*, Element 2000

Hughan, William James. *Masonic Sketches and Reprints*, Kessinger Publishing 1999

Hutton, Ronald. *Blood and Mistletoe: The History of the Druids in Britain*, Yale University Press 2009

Huxley, Aldous. *The Perennial Philosophy*, Harper Perennial Modern Classics 2009

James, M.R. (tr.) *The Apocryphal New Testament*, Clarendon Press 1924 [http://www.gnosis.org/library/gosnic.htm (accessed May 2012)]

Jamieson, John. *A Historical Account of the Ancient Culdees of Iona*, Kessinger Publishing 2004

Jansen, Katherine Ludwig. *The Making of the Magdalen*, Princeton 2000

Jennings, Hargrave. *Rosicrucians: Their Rites and Mysteries*, Kessinger Publishing 1997

Johnstone, Michael. *The Freemasons*, Arcturus 2006

Jowett, George F. *The Drama of the Lost Disciples*, Covenant Publishing 2009

Keene, Michael. *World Religions*, Lion Access Guides 2002

Knight, Stephen. *The Brotherhood*, Granada 1984

Kriwaczek, Paul. *In Search of Zarathustra: Across Iran and Central Asia to Find the World's First Prophet*, Weidenfield & Nicolson 2002

Ladurie, Emmanuel Le Roy. *Montaillou*, Penguin 1978

Landrus, Matthew. *The Treasures of Leonardo da Vinci*, Collins 2006

Law, Joy. *The Midi: Languedoc and Roussillon*, John Murray 1991

Leloup, Jean Yves. *The Gospel of Mary Magdalene*, Inner Traditions 2002

Lincoln, Henry. *The Holy Place*, Corgi 1991

Mackey, Albert. *Encyclopedia of Freemasonry*, Masonic History Co. 1912

Madden, Thomas F. *Crusades: The Illustrated History*, Duncan Baird Publishers 2004

Marani, Pietro C. *Leonardo da Vinci*, Abrams Inc. 2003

Martin, Malachi. *Jesus Now*, Collins 1973

Marvelly, Paula. *Women of Wisdom*, Watkins 2005

Matarasso, P.M., tr. *The Quest of the Holy Grail*, Penguin Classics 1975

Matthew, Caitlin. *Sophia: Goddess of Wisdom, Bride of God*, Quest Books 2001

Matthews, John. *Taliesin, the Last Celtic Shaman*, Inner Traditions 2002

McLynn, Frank. *The Jacobites*, Routledge 1988

McNulty, W. Kirk. *Freemasonry*, Thames and Hudson 2006

Meehan, Bernard. *The Book of Kells: An Illustrated Introduction*, Thames & Hudson 1994

Merrick, Richard, 'The Frozen Music of Rosslyn Chapel' [www.interferencetheory.com/Articles/files/544e307e7c540c745a0340683695d1a0-3.html, accessed May 2012]

Mitford, Nancy. *The Sun King*, Sphere 1966

Montgomery, Hugh. *The God-Kings of Europe*, Book Tree 2006

Morton, H.V. *In the Steps of the Master*, Methuen 1988

Nichol, Charles. *Leonardo da Vinci: Flights of the Mind*, Penguin 2004

Norwich, John Julius. *The Popes*, Chatto & Windus 2011

——— *Revelations of Divine Love*, Penguin Classics 1998

Nozedar, Adele. *Element Encyclopedia of Secret Signs and Symbols*, Harper Element 2008

Oldenbourg, Zoé. *Massacre At Montségur: A History of the Albigensian Crusade*, Phoenix Press 2001

Oliver, George. *The Historical Landmarks and Other Evidences of Freemasonry Explained*, Masonic Publishing & Manufacturing Co. 1867

Oliver, Neil. *A History of Ancient Britain*, W & N 2011

——— *A History of Scotland*, W & N 2009

Orleans, Elizabeth-Charlotte, Duchess of. *Memoirs of the Court of Louis XIV*, L.C. Page & Co. 1899 [http://www.gutenberg.org/files/3859/3859-h/3859-h.htm#image-0002]

Pedretti, Prof. Carlo. *Leonardo da Vinci*, Eagle Editions 2004

——— *Leonardo da Vinci The Codex Leicester: Notebooks of a Genius*, Powerhouse Museum 2000

Picknett, Lynn; Prince, Clive. *The Templar Revelation*, Corgi 1998

Plumb, J.H. *The Horizon Book of the Renaissance*, Collins 1961

Porter, R. *The Lost Bible Forgotten Scriptures Revealed*, Duncan Baird Publishers 2001

Poynder, Michael. *The Lost Magic of Christianity*, Green Magic 1997

Prophet, Elizabeth Clare. *Fallen Angels Origins of Evil*, Summit University Press 2000

Rahn, Otto. *Crusade Against the Grail*, Inner Traditions 2006
—— *Lucifer's Court: A Heretic's Journey in Search of the Light Bringers*, Inner Traditions 2004
—— *Rosicrucian Forum 1945, The*, Kessinger Publishing
Ralls-McCleod, Karen; Robertson, Ian. *The Quest for the Celtic Key*, Luath 2005
Robin, J. *Le Royaume du Graal*, Maisnie Tredaniel 1990
Saltus, Edgar. *Mary Magdalen: A Chronicle*, Kessinger Publishing 2006
Schama, Simon. *A History of Britain*, BBC Books 2005
Scherman, Katharine. *The Flowering of Ireland: Saints, Scholars and Kings*, Little Brown 1981
Sévigné, Madame de. *Selected Letters*, tr. Leonard Tancock, Penguin 1982
Sharp, William. *The Divine Adventure: Iona; Studies in Spiritual History*, Duffield 1910
Sharp, William, writing as Fiona Macleod. *Iona*, Floris Classics 1991
Shepherd, Michael. *Friend to Mankind: Marsilio Ficino*, Shepheard Walwyn 1999
Short, Martin. *Inside the Brotherhood*, Grafton 1989
Sierra, Javier. *The Secret Supper*, Simon & Schuster 2004
Simmans, Graham. *Jesus after the Crucifixion*, Bear & Co. 2007
Simon, Bernard. *The Essence of the Gnostics*, Arcturus 2004
Sinclair, Andrew. *Rosslyn*, Birlinn 2005
—— *The Secret Scroll*, Birlinn 2002
—— *The Sword and the Grail*, Birlinn 2005
Squire, Charles. *Celtic Myth and Legends*, Lomond 2001
Starbird, Margaret. *The Woman with the Alabaster Jar: Mary Magdalen and the Holy Grail*, Bear & Co. 1993
Steiner, Rudolf. *The Fifth Gospel*, Rudolf Steiner Press 1995
—— *The Mysteries of the Holy Grail: From Arthur and Parzival to Modern Initiation*, Rudolf Steiner Press 2010
Stokes, Margaret. *Early Christian Art in Ireland*, Kessinger Publishing 2004
Strathearn, Paul. *The Medici: Godfathers of the Renaissance*, Pimlico 2005
Stemp, Richard. *The Secret Language of the Renaissance*, Duncan Baird Publishers 2006
Stoyanov, Yuri. *The Other God*, Yale University Press 2000

Suh, H. Anna. *Leonardo's Notebooks*, Black Dog and Leventhal 2005

Tabor, James. *The Jesus Dynasty*, Element 2006

Taylor, J.W. *The Coming of the Saints*, Covenant Publishing 1969

Thorndike, Lynn. *Leonardo Da Vinci: The Magician of the Renaissance*, Kessinger Publishing 2005

Tully, Mark. *An Investigation into the Lives of Jesus*, Penguin 1996

Turner, Richard. *Inventing Leonardo: The Anatomy of a Legend*, Papermac 1993

Vasari, Giorgio. *The Life of Leonardo da Vinci*, Kessinger Legacy Reprints 2011

———— *Lives of the Artists*, Penguin Classics 1987

Voragine, Jacobus de. *The Golden Legend*, Penguin 1998

Waite, A.E. *Culdees and Culdee Worship*, Kessinger Publishing 2006

———— *The Holy Grail*, Dover 2006

———— *The Holy Kabbalah*, Oracle 1996

———— *The New Encyclopedia of Freemasonry*, Wings Books 1996

Wallace-Murphy, Tim. *Cracking The Symbol Code*, Watkins 2005

———— *An Illustrated Guide Book to Rosslyn Chapel*, Friends of Rosslyn Chapel 1993

———— *What Islam Did for Us: Understanding Islam's Contribution to Western Civilisation*, Watkins 2006

Wallace-Murphy, Tim; Hopkins, Marilyn. *Rosslyn: Guardian of the Secrets of the Holy Grail*, Element 1999

Webster, Nesta H. *Secret Societies and Subversive Movements*, Boswell 1924

Wood, Juliette. *The Celts*, Duncan Baird Publishers 1998

Wray, William. *Leonardo da Vinci in His Own Words*, Arcturus 2005

Wright, Dudley. *Druidism: The Ancient Faith of Britain*, Banton Press 1991

Zollner, Frank. *Leonardo da Vinci*, Taschen 2010

Index